THE
DUCHAMP
BOOK

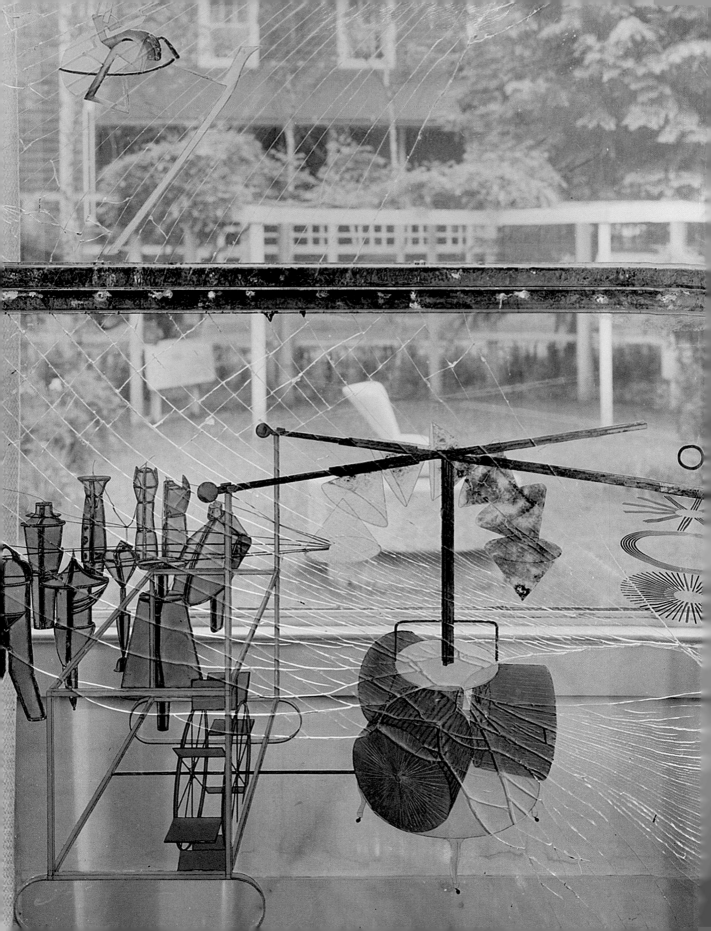

GAVIN PARKINSON

THE
DUCHAMP
BOOK

TATE PUBLISHING

First published 2008 by order of the Tate Trustees
by Tate Publishing, a division of Tate Enterprises Ltd,
Millbank, London SW1P 4RG

www.tate.org.uk/publishing

British Library Cataloguing in Publication Data
A catalogue record for this book is available from
the British Library

ISBN: 978 1 85437 766 1

Distributed in the United States and Canada by
Harry N. Abrams, Inc., New York
Library of Congress Cataloguing in Publication Data
Library of Congress Control Number 2007934784

Designed by Susan Wightman at Libanus Press
Template designed by Esterson Associates

Printed in Spain by Grafos

Front cover: *Fountain* 1963 (replica of 1917 original)
(see fig.40)
Frontispiece: *The Large Glass* installed before a window
overlooking the garden at Katherine S. Dreier's home,
Milford, Connecticut (detail, fig. 28)

Measurements are given in centimetres, height before width

*I mean Negative Capability, that is when
man is capable of being in uncertainties,
Mysteries, doubts, without any irritable
reaching after fact & reason.*

John Keats, letter to George and Thomas Keats,
21 December 1817

For Alessandra and Greta, with uncomplicated love

At Tate Publishing I would like to show my deep
appreciation to Alice Chasey and Roger Thorp for
demonstrating their confidence in me, among other
things. My thanks go to Sally Nicholls and Beth
Thomas for efficient and thorough picture research.
I am grateful to my anonymous readers for their
good humour, generosity and encouragement, and
for helping confirm me in the direction I took with
this book. Thanks also to Lesley Bell, Kiki Benzon,
Joanne Bernstein, Ian Brooks, David Cunningham,
Zavier Ellis, Flea, John Frusciante, Gloria, Jane and
Faruque Hussein, Anthony Kiedis, la famiglia
Mazzoli, Robert McNab, Sarah Monks, Rosalind
Neely, Chad Smith, Marquard Smith, Michael Taylor
and Rita Zuccari.

Well before the end of the twentieth century, the reputation and work of Marcel Duchamp (1887–1968) had surpassed those of Picasso in the eyes of art historians, artists and Duchamp's admirers alike, as exemplifying all that we think of when we consider the prototypical life and work of the avant-garde artist. We are now accustomed to thinking of Duchamp as one of the first to challenge the idea of painting as the premier medium for innovative art and a pioneer in widening immeasurably the choice of media available to the artist to work in. Suggesting much greater scope for artistic activity than had been considered before through his behaviour, diverse projects and controversial works such as *Fountain* 1917 (fig. 39), Duchamp provoked the audience for art into asking more urgently than ever what art is, what it is for and what artists are and do. As much as the body of work he created, his legacy is this set of debates, as well as his bearing on the work of several generations of artists since the 1930s who have drawn on his work and example, and in these ways he contributed far more to the art of the last fifty years than any other figure we would associate with the visual arts of the twentieth century.

Early in that century, Duchamp experimented with the established styles of Impressionism, Post-Impressionism, Fauvism and Cubism, and worked briefly in a style close to Futurism, before making important contributions to canonical movements such as Dada and Surrealism.

But the impact of his work on a generation of young US and British artists beginning in the 1950s – among them Jasper Johns, Robert Rauschenberg, Andy Warhol, Claes Oldenburg, Richard Hamilton and Peter Blake – who wanted to challenge the primacy of the Abstract Expressionism of Jackson Pollock, Mark Rothko, Barnett Newman and others, was decisive. From that point on, Duchamp's work took on an extraordinary level of visibility that has remained undiminished to the present day, with succeeding generations of artists involved with movements such as Neo-Dada, Fluxus, Pop art, Op art, Conceptual art, Performance art and even Land art, up to today's Young British Artists, joining the chorus to sing his praises or complain about his predominance.

There were various reasons for the new importance attached to Duchamp, but the main one was that, in the face of the primacy given to the experience of *vision* or the *eye* in art (particularly so in the case of painting, which would have epitomised his derogatory category 'retinal art'), Duchamp had always sought to make art a thing of the *mind*. Impatient with the entrenchment of aesthetic values in art criticism and practice and the ponderous adherence to the superficial effects of paint, marble and bronze, Duchamp aimed to deepen the consequences of art by making it an activity of what he would sometimes refer to as the 'grey matter'. Relocating art from the sphere of the emotions and senses, where it had been situated by Abstract Expressionist artists,

Introduction

to that of the intellect, where the work of art contained ideas, artists who followed his lead were able to discover new objectives, materials, subjects and themes for art.

One of the purposes of this book is to indicate these elements in Duchamp's *œuvre* by dispensing with the chronological format and positing a set of key themes. It was through these that Duchamp upended accepted ideas of what an artist does and what art is by choosing objects instead of making them; by taking pseudonyms, switching genders and giving over an inordinate amount of time to playing chess; by creating things that seemed beyond the categories of art and unfathomable by common sense, or by making no new work at all and recycling and recontextualising old work instead; by using eroticism as a provocation where art and its institutions had made it conventional and banal through the medium of the nude; by drawing on the literature, science and technology of the day so that he could sidestep both the mainstream of artistic tradition and the latest fashions of the avant-garde; by bringing language to bear on visual practice, so that puns and other wordplay could act as springboards for thought; by making use of chance and indeterminism in the creative act, often with recourse to secrecy and concealment to short-circuit closed interpretations of the work; and by puncturing the inflated presuppositions of the art crowd towards art's 'higher purpose' through baser contemplation on and through scatology, irony, humour and play.

Because of its value for subsequent artists, the nature of Duchamp's work and its departure from orthodox artistic practice is one concern of this book. The other is the sheer difficulty it creates for an old discipline like art history, which developed its methods though consideration of the kind of art that Duchamp rejected. Like many others, I have found over the years that thinking about his work from the standpoints made available by art history can become, at a certain point, a self-indulgent, self-contradictory or tautological exercise. This book is not exempt from such criticism, but I want also to assert its aim to analyse not only Duchamp's work but also writings about it (which requires, of course, that it criticise itself).

These writings of Duchamp's audience are frequently self-indulgent in the sense that art historians or art theorists project their own set of meanings into the work (as Duchamp noticed) to a greater extent than with other artists, producing deeply subjective, overarching interpretations that often bear disquieting parallels with conspiracy theories. And they are self-contradictory and tautological in the sense that in trying to escape from this usually holistic, sometimes 'paranoid' form of interpretation, art historians find themselves in a writing labyrinth, where the denial of the possibility of interpreting Duchamp's work simply adds another layer of interpretation – the theory that there is no theory – to an *œuvre* already heavily burdened with interpretations.

For more than half a century, culminating in the inauguration in 1999 of two journals devoted solely to Duchamp, as well as a new stack of books on him, art historians and academics have laboured to uncover what his work means, frequently assembling spectacular esoteric and arcane theories in their quest to discover its secret, which have only served to make Duchamp seem more enigmatic.

In *The Duchamp Book* I give descriptive, interpretative and sometimes playful readings of individual works by Duchamp, woven together with critical considerations of the weird and wonderful ways his diverse output has been construed by art historians and others. This is because this volume is meant as both a general introduction to the work of one of the most significant figures of twentieth-century art, and also, in the self-contradictory, tautological, playful spirit of his work, an argument against books – or books of a certain kind – on Duchamp. Who needs another one of those?

The interlacing of these two strands means that *The Duchamp Book* can be read not only by individuals who are curious about Marcel Duchamp's life and work, but also by another audience that probably overlaps with that one, which takes an interest in the critical reception of his *œuvre* and might be drawn to contemporary reflections on the inadequacies of the traditional language of art history. To connect with these two communities of readers, some arguments are explored in greater depth through comments and references in the notes.

This twofold intention is also built into the structure of the chapters, which tend to begin with fairly literal discussions situating Duchamp's works within individual themes, before developing in their second halves into more historiographical discussions of the interpretations those works have received up to now.

The thematic discussions of language and secrecy, and humour and play in the last two chapters overlie an examination of the manner in which art history deals with Duchamp's work and the art it has influenced up to our own day (often collected under the heading of 'postmodernism', and beyond the scope of this book). In the final chapter, I suggest an alternative approach to the routine theoretical rationalisation and co-ordination of Duchamp's unruly work; one adjusted to the Duchampian atmosphere of humour and play, which all writers agree is present. This last part of the book maintains that the most sensitive and enriching responses to Duchamp have been made by artists, and that, in order to remain vital in the face of the challenges posed by him and those who have followed in his wake, the discipline of art history might dispense with its ingrained methods inherited from history and science and adopt instead ambiguous, playful strategies from art.

In keeping with the arguments in my final chapter, in sympathy with its unpretentious subject, and attuned to its diverse audiences, I have tried to make *The Duchamp Book* jargon-free. However, as an academic myself, I have probably lost touch

over the years with the point at which
I depart from making clear statements and
enter into the stodgier side of art-historical
'business-speak', which was originally
meant to facilitate understanding but is now
in some quarters a language of affectation
or means of obfuscation. But then, I write
as an active participant in the Duchamp
Interpretation Industry and as a
professional art historian, both of which
turn out to be fair game for provocation in
the strange world of Marcel Duchamp.

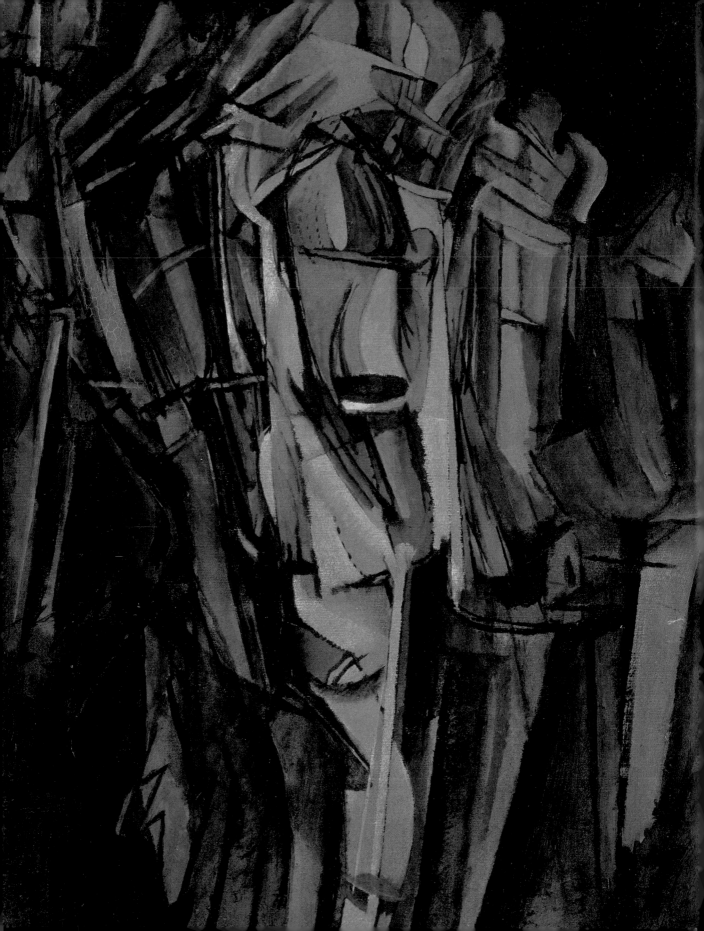

Even by the standards of the avant-garde, which prided itself on its originality and individualism, the 'art' of Marcel Duchamp displays a peculiar unpredictability and relative autonomy. The term is used cautiously, as it is far from certain that much of Duchamp's work was or is what is called art. Moreover, for most of the period spanned by this work, his behaviour was nothing like that which had traditionally constituted an artistic life or career. That is not to say that Duchamp and his work exist in isolation, of course, and the purpose of this first chapter is to present chronologically a set of historical, cultural and artistic contexts through which we can gain a better understanding of his output over sixty years and his general way of thinking about art, both of which, at first sight, seem very strange indeed. Much emphasis is given in this chapter to Duchamp's early paintings because they are, by necessity, underrepresented in the rest of the book.[1]

Early life, art and inspiration

Throughout his life, Duchamp benefited socially and creatively from an ordinariness and simplicity observed by all who knew him, which was largely the outcome of an uncomplicated upbringing and happy provincial family life. The son of a notary (a significant bureaucratic position in France, combining the services of solicitor and civil servant), Duchamp was born on 28 July 1887 into an upper middle-class family who lived in the village of Blainville, Normandy,

twelve miles or so from Rouen. The fourth of six children, he would reach intellectual maturity at a time when the new inventions ushering in modernity – the camera, telephone, radio, car, aeroplane, X-ray and so on – were helping bring about artistic and literary styles, thematic preoccupations and subject matter that sought to revise the roles of art and representation more generally, and which we place under the rubric of 'modernism'. Dynamic, experimental styles and movements such as Realism, Symbolism, Impressionism, Post-Impressionism and Fauvism convinced young people such as the Duchamp children that there was more to life than plodding office work. Soon after arriving in Paris to study in the mid-1890s, Marcel's two older brothers – Gaston, who changed his name to Jacques Villon (1875–1963) and Raymond, known as Raymond Duchamp-Villon (1876–1918) – experienced second thoughts about their respective plans to become a lawyer and doctor, and began attending art school. By the time he went to the Lycée Corneille in Rouen in 1897, the ten-year-old Marcel already had two years of sketching behind him, and, not surprisingly, he excelled in that area at school. Initially inspired by early twentieth-century modernism, the Duchamps, including sister Suzanne, would play a significant role in its development. Their legacy is to be found in their contributions to Cubism, Futurism, Dada and Surrealism, recognised by the bronze plaque on a later family home in Rouen, on which its author (Marcel) identified them

1 Work and Contexts

Does the world really present itself to perception in the form of well-made stories, with central subjects, proper beginnings, middles, and ends, and a coherence that permits us to see 'the end' in every beginning?
Patrick Hannahan, *Gigamesh*, 1971

as 'a family of artists from Normandy'.[2]

Marcel's first oil paintings in 1902 were completed under the spell of Impressionism, specifically the influence of Monet to judge by *Landscape at Blainville* 1902 (fig.1), which reproduces a scene close to the Duchamps' home. If this is really his very first painting (as the scholarship claims), it is a surprisingly good effort, the fruit of much drawing practice and close attention to composition and pictorial structure. Later Duchamp said of this and his two other paintings from the same year, *Church at Blainville* and *Garden and Chapel at Blainville*, that their Impressionist style was the outcome of discussions with 'two of my classmates' and the suppression of Impressionism at 'official art schools'.[3] Speaking of his childhood 'subversion' sixty-two years after the execution of these paintings, he could well have been remembering instead discussions with his two brothers, which led to their collective filial and artistic disobedience.

Aiming to discover and account for an underlying, hidden pattern in Duchamp's *œuvre*, his commentators have pointed to two or three later landscapes with trees and water (for instance, the readymade *Pharmacy* 1914 and the minor picture *Moonlight on the Bay at Basswood* 1954) in an effort to make a connection between these first attempts at painting to his later, radically dissimilar work.[4] However, efforts to create a link between his artistic origins and the path his work later took can mislead and tantalise while offering little of what they promise. Indeed, Duchamp was fond of making his

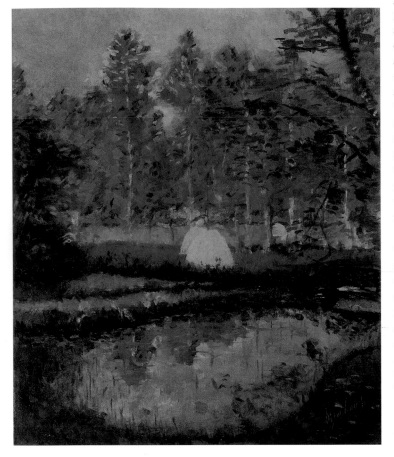

1
Landscape at Blainville
1902
Oil on canvas
61 x 50 cm

2
Hanging Gas Lamp
(*Bec Auer*) 1903–4
Charcoal on paper
22.4 x 17.2 cm
Former collection Alexina Duchamp

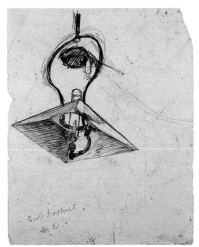

own inscrutable links between his works, which have intrigued and bemused his audience. Around the same time he tried his hand at Impressionism in 1902 he produced a realistic drawing of a '*Bec Auer*' gas lamp (fig.2), which we might assume was an object that took on private symbolism for him, as it recurs in his last work, *Etant donnés* 1946–66 and elsewhere, but we shall never know its significance for Duchamp. Equally, it has been argued of *Landscape at Blainville*, 'this landscape of water and woods finds curious echoes in much later works', but, as we shall see, there is nothing particularly curious about discovering similarities between paintings, objects, sentences and words within a body of work generated by Duchamp over a period of sixty years or more, in religious, mythological, philosophical, psychological or hermetic bodies of knowledge.[5]

A mediocre pupil in just about every subject taught at the Lycée, Marcel passed the second part of his *baccalauréat* in 1904. However, guided largely by the example of his older brothers, he had found his painterly vocation (temporarily, anyway), helped on his way when he was awarded the medal of the Société des Amis des Arts at his graduation. In the Autumn of 1904, he moved to Paris to live with Gaston in Montmartre, the epicentre of avant-garde activity. At that time, Pablo Picasso (1881–1973) was making the transition in his painting from a Blue to a Rose Period, and Henri Matisse (1869–1954) was about to start work on *Luxe, calme et volupté* 1904 (fig.3), which would contribute

3
Henri Matisse
Luxe, Calme et Volupté
1904
Oil on canvas
9.8 x 11.2 cm
Musée d'Orsay, Paris

to the latest avant-garde scandal created at the 1905 Salon d'Automne by the Fauves, with the reluctant revolutionary Matisse at their helm. Although he later claimed he went to Paris disinterested in fame and fortune, unlike his brothers, Marcel tried (and failed) to gain entry to the Ecole des Beaux-Arts. Initially occupying himself with figure studies in his sketch-book, his time in Paris ended abruptly when a new conscription law was passed, making every young able-bodied Frenchman eligible for two years of military service (as opposed to the previous law which had recruited a limited number by lot to serve for three years). By passing himself off as an *ouvrier d'art* after serving an apprenticeship at a print shop in Rouen and blagging his way through the relevant exam, Marcel was able to get away with only one year in uniform.[6]

The Puteaux group and Cézanne

By the time he returned to Montmartre in October 1906, his brothers had moved to the rural Parisian suburb of Puteaux, where they began the artists' colony that would make the name of that district famous. In Puteaux, the artists were experimenting with Cubism, which was evolving in the painting of Picasso, Georges Braque (1882–1963) and Juan Gris (1887–1927), particularly the more theoretical and scientific side, as exhibited in the book published by the Cubist artists Albert Gleizes and Jean Metzinger, *Du Cubisme* in 1912.[7] Exposed to these discussions, Duchamp would later contribute in his own idiosyncratic way to Cubism, but for now his interest lay in illustrations and Fauve painting. The former – 'witty', single frame, one-liner drawings often driven by puns and sexual innuendo (see fig.4) – have more in common with his subsequent mature work than the latter. These are passionless stabs at Fauvism, such as *Red House Among Apple Trees* 1908 (fig.5), inspired by the spectacle of the 1905 Salon d'Automne, where the bold, feral canvases of André Derain, Maurice de Vlaminck and, especially, Matisse gave Duchamp something to think about. If both sets of work have dated badly, then we should add that Duchamp was quite successful as a humorist and late Fauve at the time. He had five drawings accepted for the first Salon des Artistes Humoristes in 1907 and four in 1908, while *Le Courrier français* published one of his drawings in November 1908. In addition, three of the 1907 paintings found their way into the 1908 Salon d'Automne, where his brother Jacques Villon sat on the executive committee. Matisse was a member of the painting jury, which made a name for itself in the history of art by rejecting the landscape paintings submitted by Braque due to their strange geometric propensity for turning things into little cubes (see fig.6).

Duchamp had now moved from Montmartre to Neuilly, closer to Puteaux. Over the next two years he lost interest in humorous illustration, showing work at the Salon des Indépendants and the Salon d'Automne in 1909, and selling at each exhibition a painting (one to the dancer Isadora Duncan), now both lost. The

4
Experience 1909
Drawing
Dimensions unknown
Original lost

5
Red House Among Apple Trees 1908
Oil on canvas
55 x 43 cm
Collection Silvia Schwarz Linder and Dennis Linder, Milan

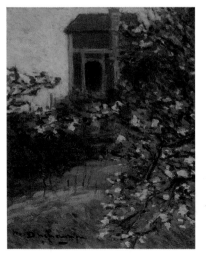

7
Portrait of Dr Dumouchel
1910
Oil on canvas
100.3 x 65.7 cm
Philadelphia Museum of
Art. The Louise and Walter
Arensberg Collection,
1950

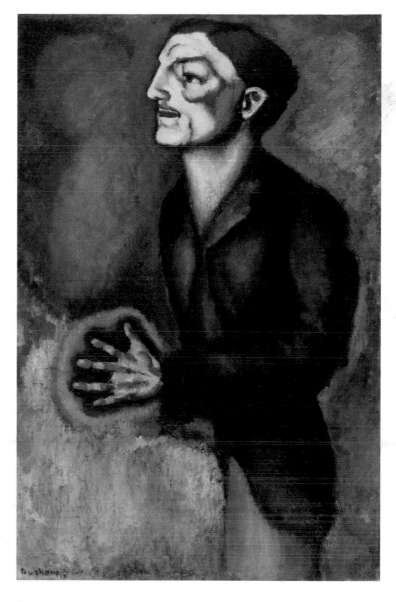

6
Georges Braque
House at L'Estaque 1908
Oil on canvas
Kunstmuseum, Bern
73 x 60 cm

painting of a friend entitled *Portrait of Dr Dumouchel* 1910 (fig.7) is an attempt to combine humour/caricature and the generically 'modern' style of painting, which he would not try again; Duchamp's irresistibly droll sense of humour would be expressed in a variety of more sophisticated ways over the years. He had also started to draw and paint heavy nudes, sometimes in a Fauvist manner, and begun a flirtation with what we might call 'Symbolism'. Fatalistic, mysteriously erotic paintings such as *Paradise* 1910, *The Bush* 1910–11 (fig.8), and *Young Man and Girl in Spring* 1911 are infused with a 'mystical' or 'metaphysical' atmosphere indebted to Symbolism, though it is hard to imagine the later, ironic Duchamp entertaining such dreamy ideas seriously.[8]

From here, the influence of Paul Cézanne (1839–1906) extended Duchamp's run through the modern 'classics', overlapping and nuancing his continuing interest in Fauvism. Like a whole generation of modernist artists, he was undoubtedly exposed to the full force of Cézanne's achievement through the exhibition held at the Salon d'Automne in 1907, the year after Cézanne's death. Duchamp's appropriation of aspects of Cézanne's style and technique was rather belated, perhaps due to lack of confidence this time (he remained somewhat in awe of his older brothers), showing through only in 1910 in his *Portrait of the Artist's Father* (fig.9) and *The Chess Game* (fig.10). The first of these is by far the more successful, in which a portrait full of personality and vigour, and a tight, powerful

8
The Bush 1910–11
Oil on canvas
127.3 x 91.9 cm
Philadelphia Museum of
Art. The Louise and Walter
Arensberg Collection,
1950

9
*Portrait of the Artist's
Father* 1910
Oil on canvas
92.4 x 73.3 cm
Philadelphia Museum of
Art. The Louise and Walter
Arensberg Collection,
1950

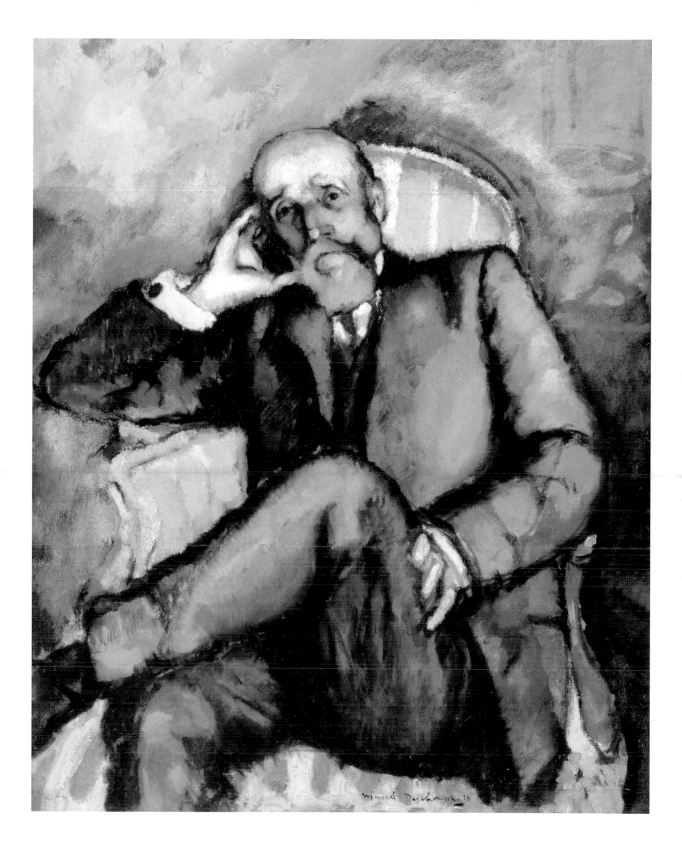

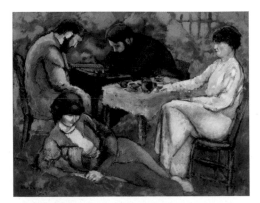

10
The Chess Game 1910
Oil on canvas
114 x 146.5 cm
Philadelphia Museum of
Art. The Louise and Walter
Arensberg Collection,
1950

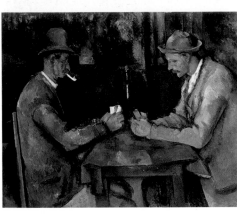

11
Paul Cézanne
The Card Players
c.1890/95
Oil on canvas
47.5 x 57 cm
Musée d'Orsay, Paris

12
*Marcel Duchamp, Jacques
Villon and Raymond
Duchamp-Villon with a
dog in Puteaux* c.1912
Gelatin silver print
9.5 x 16.4 cm
Philadelphia Museum
of Art: Gift of Jacqueline,
Paul and Peter Matisse in
memory of their mother
Alexina Duchamp

composition emerge through a feathery
Cézannean patchwork. The second, lumpy,
clumsy group portrait of the Duchamps at
play is dosed with a sentimentality absent in
the later Duchamp. It pays homage to the
'Master of Aix' in the hunched concentration
of his heavily bearded brothers over a
chessboard, resembling two Cézannes posing
as that artist's own, revered *Card Players*
1890–2 (fig.11). In later life, Duchamp was
sometimes forgetful, making contradictory
statements about the exact apportionment
of his youthful attraction to the Fauves on
the one hand, and Cézanne on the other.
However, he also said later that his 'cult for
Cézanne' had lasted two years, and 'opened
new vistas for my general development'.[9]

Cubism on his terms
This influence receded in 1911, when
Duchamp's work took a new direction.
He was at a crucial stage in his evolution as
a painter. Although he had work at both
the Salon des Indépendants and Salon
d'Automne in 1910, he would never show
at the latter again. Regularly visiting his
brothers in Puteaux, where *The Chess Game*
was painted (all the Duchamps were keen
players), he had learned a great deal about
contemporary currents in Parisian art. Yet
he had also acquired an aversion to becom-
ing a mere acolyte of the leading lights of
the Parisian avant-garde (Picasso being
the brightest of the lot in the decade
immediately preceding the First World War),
as well as a keen scepticism about artistic
fashion dressed as radical innovation. This

extended to a brooding suspicion of the identity and roles that artists were supposed to adopt, demonstrated vividly in a photograph taken in Puteaux in 1912 in which the clean-shaven, sharply dressed Duchamp (it is probably a Sunday) poses with his brothers, closer to the aloof businessman than the bohemian cliché (fig.12).

Aware of Cubism's *conceptual* revolution (in which painting offered an *idea* of what it depicted) against the *perceptual* Renaissance portrayal of reality (which had emphasised the *visual* sense), he was also close to those, like Gleizes and Metzinger, who presumed to interpret it in their writings. In short, if he were to take on the Cubism of Picasso and Braque, elaborated and theorised by the Puteaux artists, as the final stage of his artistic 'training', it would be on his own terms. Increasingly independent, he would take a speedy journey from a rather literal and awkward use of Cubism's styles and lessons, to a unique rendering of Cubism. Resulting in some of the most important pre-war paintings by a Frenchman, this brief period culminated in Duchamp's retirement from painting and, ultimately, it seems, from art.

His brief excursion into Cubism began early in 1911 with the painting *Sonata* (fig.13). At this stage, Duchamp was not yet able to exploit the full resources of Cubism, which he had admired at the gallery of Picasso's and Braque's dealer, Daniel-Henry Kahnweiler, among other places. His depiction of a musical performance at his parents' home (which was now at Rouen) uses Cubism's

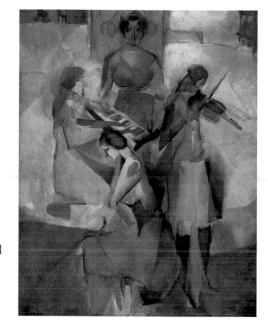

13
Sonata 1911
Oil on canvas
145.1 x 113.3 cm
Philadelphia Museum
of Art. The Louise and
Walter Arensberg
Collection, 1950

famed rejection of Renaissance space and perspective merely through clumping together in the foreground the figures of his sisters, Yvonne, Magdeleine and Suzanne, watched over by their mother. Built around a vertical axis, the solid construction of the painting is not in doubt; unfortunately neither is its overly literal deployment of the Cubist stylistic devices, most visible in the too self-consciously 'Cubist' frontal/profile face of the mother (presuming this is not a caricature of the stern and distant matriarch). However, looking back at its 'tender tonalities', 'angular contours' and 'evanescent atmosphere', Duchamp came to regard *Sonata* as a key work in his development as a painter.[10]

Close to this in their free interpretation of Cubist theories are *Yvonne and Magdeleine Torn in Tatters* and *Apropos of Little Sister*, both of 1911. These paintings share Cubism's concern to acknowledge the flat surface of the canvas while giving a more rounded, subjective sense and understanding of the object than the emphatically visual medium of painting had traditionally allowed. We also see some of Cubism's wish to depart from the 'snapshot' effect of realist painting and embrace the dimension of time, frequently expressed with reference to music (as an art that unfolds in time) in the paintings and collages of Picasso and Braque.

Towards the end of that year, Duchamp had another go at Cubism (all of this interspersed with the more 'Symbolist' works discussed earlier) in the experiment with temporality and eroticism that is *Portrait (Dulcinea)* (fig.14). Purportedly based on erotic fantasies about a woman he saw on the street but to whom he never spoke, the picture effects a partial stripping of the female through five separate stages, and is therefore an imaginative rather than realistic depiction of the subject. Enveloped within a single form that emerges and spreads like flames or a bunch of flowers from the centre of the lower edge of the canvas, the five-figure composition of the anonymous female losing her clothes in the eyes of the artist can be viewed as Duchamp's final homage to Cézanne through its urban evocation of his Bather paintings (fig.15), while the five primitive whores of Picasso's proto-Cubist *Demoiselles d'Avignon* 1907 also come to mind in Duchamp's tampering with Cubist form and theory. In all of these inelegant paintings of 1911, including the strange *Portrait of Chess Players*, which is again slightly too crudely concerned with the imagination (what goes on in the minds of people playing chess), it is debatable whether Duchamp's take on Cubism was personal and idiosyncratic or simply naive – it could well have been both.

Rendering movement and *Nude Descending a Staircase*

This state of affairs would continue for a few more months before Duchamp found his own voice. Another breakthrough took place in December 1911 with his *Sad Young Man on a Train* (fig.16), upon which the Cubist influence is more emphatic and Duchamp's grasp of the analytical Cubist style more in evidence. As in *Portrait (Dulcinea)*, with

14
Portrait (Dulcinea) 1911
Oil on canvas
146.4 x 114 cm
Philadelphia Museum of Art. The Louise and Walter Arensberg Collection, 1950

15
Paul Cézanne
Cinq baigneuses 1885/7
Oil on canvas
65.5 x 65.5 cm
Kunstmuseum Basel

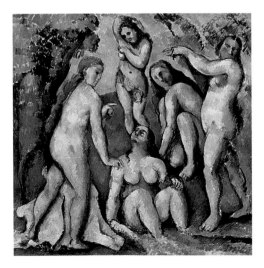

which it shares compositional similarities, Duchamp seems anxious here to capture a sense of dynamism, movement and temporality, to the point where these themes become more or less the whole point of the painting and the anecdotal specifics of the subject matter are only secondary. Duchamp said as much, while noting a certain autobiographical aspect of the work, later stating that the title had less a descriptive purpose than an alliterative one (the French is *Jeune Homme triste dans un train*).

This painting is significant because it was an exercise in Cubism combined with his own notion of 'elementary parallelism', a mix soon to be presented to an amused public at the Armory Show in New York, which would bring him fame and change his life inexorably. The concept of 'elementary parallelism' was meant to lead to a kind of formal repetition, supposed to suggest movement (the optical equivalent of alliteration or the rhythmic sound of a train moving over tracks). It was inspired partly, as Duchamp admitted, by the sequential photographs of humans in motion, galloping horses, birds in flight and so on, taken by the Parisian physiologist Etienne-Jules Marey (1830–1904) and the English photographer Eadweard Muybridge (1830–1904), both of whom worked and published in the 1880s and 1890s (fig.17).[11]

Duchamp could well have been the first painter to suggest movement through the deployment of photography's use of multiple snapshots of the same object in motion. The Italian Futurists took up the

16
Nude (Study), Sad Young Man on a Train 1911–12
Oil on cardboard, mounted on Masonite
100 x 73 cm
Peggy Guggenheim Collection

same idea, though no conscious connection between his work and theirs suggesting a direct influence has ever been found by art historians. The *Technical Manifesto of Futurist Painting*, published in 1910 by a handful of painters who admired Filippo Tommaso Marinetti's Futurist 'manifesto' of 20 February 1909, envisions the world as viewed through the camera lenses of Marey and Muybridge:

All things move, all things run, all things are rapidly changing. A profile is never motionless before our eyes, but it constantly appears and disappears. On account of the persistency of an image on the retina, moving objects constantly multiply themselves; their form changes, like rapid vibrations, in their mad career. Thus a running horse has not four legs, but twenty, and their movements are triangular.[12]

Although this passage brings to mind the floating profiles of Duchamp's 1911 *Yvonne and Magdeleine Torn in Tatters* as much as any Futurist painting, his first contact with Futurism was almost certainly at the Galerie Bernheim-Jeune in February 1912, where forty-five Futurist paintings made a splash with a Parisian art public long used to avant-garde shenanigans.

By then, Duchamp had already had a go at rendering movement in a comparable way with the *Nude Descending a Staircase*. The first version, *Nude Descending a Staircase, No.1*, is usually dated to December 1911 and the second, better-known composition, *Nude Descending a Staircase, No.2* (fig.18), to January

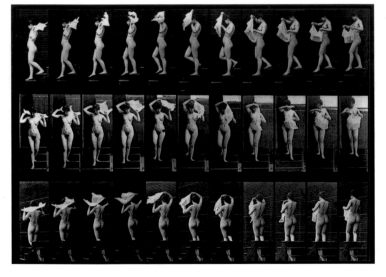

17
Eadweard Muybridge
Chronophotograph of a woman walking down stairs
Kingston Museum and Heritage Service

18
*Nude Descending a
Staircase, No. 2* 1912
Oil on canvas
147 x 89.2 cm
Philadelphia Museum
of Art. The Louise and
Walter Arensberg
Collection, 1950

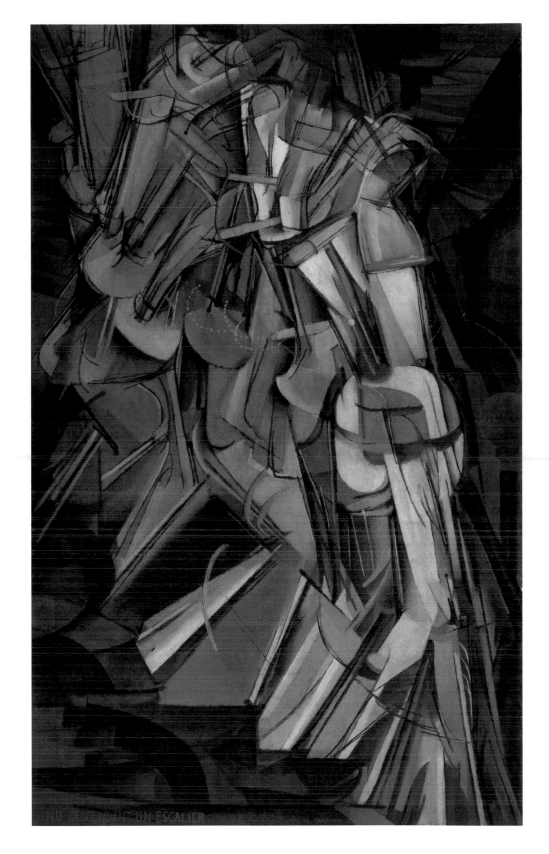

1912, while the subject derives from one drawing from a series made to illustrate the poems of the late Symbolist poet he admired, Jules Laforgue, entitled *Once More to this Star* 1911. Close to a century later, it is not so easy to see why the *Nude* caused such a fuss among Duchamp's fellow artists and the general public. We must bear in mind firstly the significant position the nude – posed heroically, seductively or symbolically – had traditionally held in French and European painting and sculpture. Secondly, we must recall modernism's rejection of classical form and its reinvention of the nude, from Edouard Manet's naked courtesan *Olympia* 1863 to Picasso's five aggressive female figures in *Les Demoiselles d'Avignon*, which caused a ruckus among the critics and confusion among Duchamp's more faint-hearted contemporaries.

Duchamp had already contributed to this recent revision in the fleshy nudes he painted in 1910, but, like Manet's and even Picasso's nudes, they were relatively conventional in their appearance and pose compared with the one in *Nude Descending a Staircase, No.2*. Wildly out of context (not reclining or posed classically), this nude seemed to combine Cubism, Futurism, chronophotography and film, while mocking all of them through its sheer absurdity. Or was Duchamp's *Nude* just a failed experiment in Cubism, which is, thereby, itself worthy of derision? Again, Duchamp's still incomplete apprenticeship in modern art, together with his mischievous wit and desire to bring Cubism closer to his own personal erotic themes, suggests both.

Duchamp's machine-like *Nude* would soon give him his first taste of notoriety, but before that he would experience a disappointment that would leave him with a lasting feeling of bitterness. He had entered the *Nude Descending a Staircase, No.2* for the Salon des Indépendants that was to open on 20 March 1912. The self-appointed theorists of Cubism and leading figures of the Puteaux group Albert Gleizes (1881–1953) and Jean Metzinger (1883–1956), who were involved in hanging the works, now took a dislike to the *Nude Descending a Staircase, No.2*. Reluctant to reject the painting, yet believing it to be a mockery of Cubism and out of step with the current preoccupations and practices of the Puteaux group, as well as a little too close in appearance to Futurist painting, which was now widely known in Paris, they sent Duchamp's brothers to persuade him to alter it in some way (perhaps by changing the title, which was printed to the bottom left of the canvas), to make it seem less strange. Without arguing, though obviously upset by the lack of support from his brothers, Duchamp withdrew the canvas. Although the *Nude* was shown at two Cubist exhibitions later that year (including one in Paris overseen by the Puteaux group), his scepticism about group activity from this time on hardened into a withdrawal from such manifestations.

The following year, after Duchamp had withdrawn from group shows, he was suddenly thrown into the limelight. His *Nude Descending a Staircase, No.2* caused a great

controversy at the Armory Show, the huge International Exhibition of Modern Art meant to introduce America to modern art, held at the 69th Regiment Armory in New York in March 1913. The painting was startling to the critics and public, though laughter rather than outrage seems to have been the chief response. All four of the paintings by Duchamp, including the *Nude*, were sold, but he was not tempted to continue in the same vein. Duchamp showed no interest in being the talk of America.

The beginnings of the *Large Glass*

After the bitter experience of the Salon des Indépendants, Duchamp embarked on the series of paintings and drawings that is his most significant contribution to the painting of the time and the seed of his most important work, *The Bride Stripped Bare by Her Bachelors, Even* or the *Large Glass* 1915–23. A number of remarkable erotic, violent, near-abstract Cubist drawings led to another study in movement, the painting *The King and Queen Surrounded by Swift Nudes* 1912. Shortly after, accompanied by the iconoclastic Spanish artist Francis Picabia (1879–1953) and his wife Gabrielle Buffet-Picabia (1881–1918), and the poet, friend of Picasso and spokesman for Cubism, Guillaume Apollinaire (1880–1918) – though some argue he had not yet met Apollinaire at this time – Duchamp went to see a performance of the bizarre play by the remarkable writer Raymond Roussel, *Impressions d'Afrique*, in May or June of 1912. Largely concerned with the presentation,

then explanation, of at first seemingly irrational, elaborate machines, the play gave Duchamp the chance to draw upon an imaginative source beyond the artistic avant-garde in Paris with its pretensions to radicalism. Many of Roussel's imaginative scenarios grew out of his brilliant wordplay, for which Duchamp was already primed and of which he now took careful note.[13]

In Munich for a two-month stay that year, Duchamp produced another two paintings and several preparatory drawings for the *Large Glass*, including the first preliminary study of it, though his purpose in going to Germany was less that of meeting contemporary artists relevant to his work than avoiding those in Paris who might impinge on it.[14] This temporary shift towards a kind of laboratory-like isolation did not end his flirtation with Cubism. However, if the two remarkable paintings he produced in Munich, *The Passage from Virgin to Bride* (fig.19) and *Bride*, have the earth tones and extreme fragmentation and complexity that characterises the analytical Cubism of Picasso and Braque, they also possess a fleshy sensuality that came out of Duchamp's professed admiration for the light, buttery nudes of Lucas Cranach the Elder, while displaying organic and machine-like qualities and a mysterious personal mythology that are quite alien to Cubism. If the modernist fascination they display with the machine gives evidence of Duchamp's budding friendship with Picabia and the ambivalent attitude they shared towards technological progress, then the

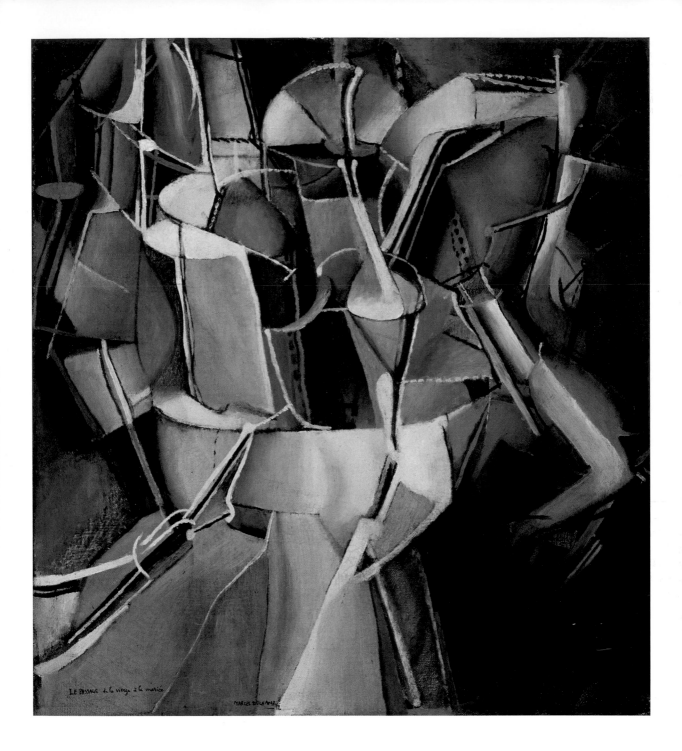

Le Passage de la vierge à la mariée MARCEL DUCHAMP 12

THE DUCHAMP BOOK

19
The Passage from Virgin to Bride 1912
Oil on canvas
59.4 x 54 cm
Museum of Modern Art, New York

'narrative' aspect of these obscure, superbly painted works derives presumably from Roussel, but that does not make them easy to 'read'. On the contrary, Duchamp was already plying the arational, non-sequential, non-narratives that would come to fruition in the *Large Glass*. Indeed, the richly painted, insect-like concoction of tubes and vessels surrounded by further pipes and machinery that is *Bride* could itself have been a study for a detail of the *Large Glass*, as it would crop up in that work later as well.

Returning to Paris in October after a brief European excursion with his future securely wedded, so to speak, to the idea of the *Large Glass*, Duchamp showed several of his new batch of paintings at the Section d'Or, the most important Cubist group exhibition until then. As ever, Picasso and Braque preferred not to show their work, which that year had taken a turn towards collage and could still be seen only at the gallery of Kahnweiler, who spoke of the Puteaux group in terms of contempt. Picasso's friend Apollinaire, however, had taken a liking to Duchamp's work and to the man himself, and, shortly after Duchamp's return to Paris, Picabia drove them in one of his many cars to the Jura Mountains in Switzerland to join Picabia's wife Gabrielle, who was staying with her mother in the small village of Etival. Under the influence of the Spanish artist and the poet, the strange ideas that would feed into the project of the *Large Glass* came thick and fast to Duchamp, who jotted them down on his return:

The machine with 5 hearts, the pure child, of nickel and platinum, must dominate the Jura–Paris road.

On the one hand, the chief of the 5 nudes will be ahead of the four other nudes *towards* this Jura–Paris road. On the other hand, the headlight child will be the instrument conquering this Jura–Paris road.

This headlight child could, graphically, be a comet, which would have its tail in front, this tail being an appendage of the headlight child appendage which absorbs by crushing (gold dust, graphically) this Jura–Paris road.[15]

Meant to describe a painting, and extending an elliptical note-taking practice that began in Munich and would continue for the rest of his life, the jottings from the Jura–Paris journey detail the beginnings of a mythology told in the materials and machines of modernity.[16]

The notes were made public in the 1930s, by which time Duchamp was an ex-artist. This process of 'retirement' was already well under way by the end of 1912 because, amazingly, at the moment of his greatest triumphs as a painter, Duchamp decided to abandon painting. The Jura–Paris mythology would never make its way onto canvas because Duchamp, apparently bored with the process of painting, had now given up the idea of a career as a painter, enrolling in a librarian's course at the Ecole des Chartes in late 1912 instead. So ended the most important year of his life.

The readymades

After giving up his career as a painter, Duchamp began to muse on the nature of art, asking himself in a note of 1913, 'Can one make works which are not works of "art"?'[17] Subsequently, the practical side of his life as an artist (studio work) receded as its conceptual side (thinking) increased enormously, carried out for at least some of the day from his desk at the Bibliothèque Sainte-Geneviève, Paris, where he had taken a librarian's job after completion of his course at the Ecole des Chartes. Part of his spare time was spent on the lengthy task of conceiving and creating the *Large Glass*, making studies such as the near-naturalistic painting titled *Chocolate Grinder, No.1* 1913, which shares a similar function to an occasional painting he completed at the end of 1911, *Coffee Mill*, now regarded as a kind of premonition of the *Large Glass*.

As well as the studies for the *Large Glass*, Duchamp's reflections on the nature of 'making' and 'art' resulted in the three-dimensional objects called 'readymades', which were chosen by the artist, not made by him. Meant to hold as little appeal to the observer as possible (neither attraction nor repulsion, but indifference), they represent the main thrust of Duchamp's rejection of style, taste, aesthetics and what he later referred to as 'retinal' art: that which attends solely to the eye at the expense of addressing itself to the mind. Again, the artistic context for readymades seems to be that of Cubism, in the sense that the collages of Picasso and Braque had already shifted into a mode of the direct *selection* of urban odds and ends in their collages – bits of oilcloth and newspaper, calling cards, pamphlets, leaflets – instead of their painted *representation* (fig.20). If collage showed that a fragment could be made by another hand and claimed by an artist for use in his or her work, then it was only a short step to the assumption that a complete, already made object could be appropriated by an individual, and that this could constitute the entirety of the creative act.

Duchamp's first tentative step in this direction was made with *Bicycle Wheel* 1913 (fig.21), where he fixed a found bicycle wheel with forks still attached upside down to a stool. As the first readymade and first kinetic sculpture, it is regarded today as the point of departure for a revolution in art, yet Duchamp downplayed *Bicycle Wheel* as an idea, saying later that he made it for the pleasure he gained from gazing at its spinning wheel, in the same way one could enjoy the hypnotic effect of the dance of flames in a fireplace. Scholars have discussed the aesthetics of the work, while suggesting it mocks conventional sculpture (the absurdity of raising to prominence something like part of a bicycle in place of a bust or heroic figure, on a common stool that could be read as a parody of a museum pedestal). However, Duchamp was emphatic and consistent as to its pleasurable pointlessness.

The idea of the readymade was still in its infancy in 1913, but over the next few

20
Georges Braque
Still Life – Gillette 1914
Collage
48 x 62 cm
Musée national d'Art
moderne, Centre Georges
Pompidou, Paris

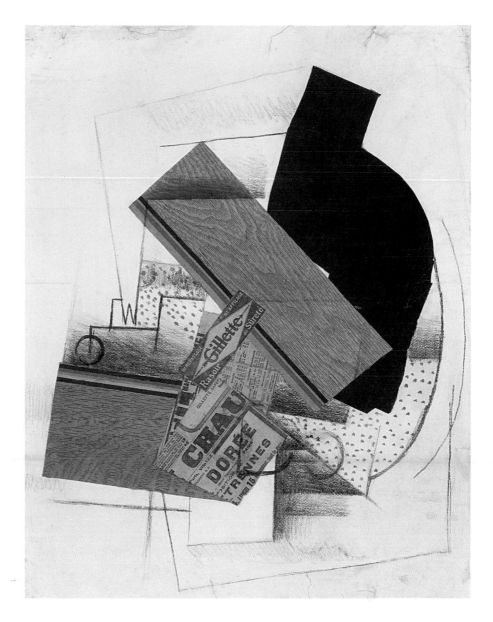

21
Bicycle Wheel 1964
(replica of 1916 original)
Wheel, painted wood
64.8 x 59.7 cm
Philadelphia Museum
of Art

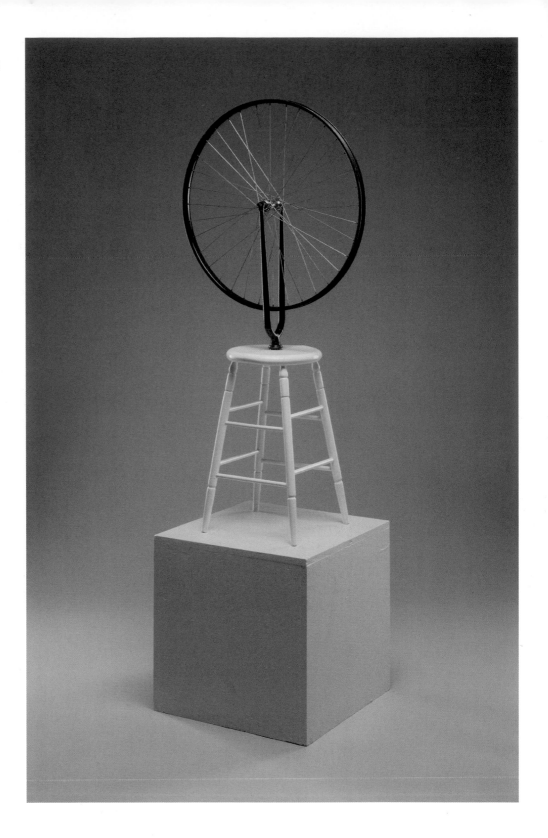

years several more followed, along with a limited number of variations on the theme (sometimes called 'assisted' or 'rectified readymades'). The readymades were for years largely ignored by the avant-garde and its support system of critics, dealers and patrons, which from then until the 1950s would recall Duchamp only periodically. This is because the gestures set in train by his abandonment of painting for other kinds of activity (such as the experiment with chance that is *3 Standard Stoppages*, also begun in 1913) seemed initially beyond categorisation or even comprehension, which is today part of their fascination.

The pattern of 1913, when Duchamp thought a lot and made little, set the tone for the remainder of his 'career' as an artist. The following year, he continued to consider the *Large Glass* and to make studies for it, including the evocative line painting *Network of Stoppages* (made from templates created from the wavy lines of the *3 Standard Stoppages*) and several studies of the 'chocolate grinder' component (one of which appeared as a painting in 1913), as well as actual works on glass, demonstrating that elements for the *Large Glass* were taking shape. He produced two more readymades, *Pharmacy* (fig.22) and *Bottle Rack*, in 1914. The first consists of a set of three identical commercial prints of a watercolour of a landscape, to each of which Duchamp applied a red and green dot in gouache, the colours of the jars of liquid displayed in pharmacy windows. The second was the most economical gesture he would ever make: the original *Bottle Rack*

was simply bought from the Bazar de l'Hôtel de Ville and taken to his studio in Paris.

The First World War, New York, Dada

The year 1914 marked the beginning of the First World War, in which several of Duchamp's family served, as well as many of his artist friends. Duchamp was exempted from service, apparently due to a minor heart condition. During the war, Parisians were hostile towards young, apparently healthy men out of uniform. Together with his growing discomfort about the obligation to lead an artist's life in Paris, this potential antagonism spurred him into moving to New York in June 1915, taking with him some of his research notes and studies for the *Large Glass*.

The artist of the *Nude Descending a Staircase* was widely known and well-received in New York, but he had no intention of knocking out paintings in the same vein as the notorious *Nude*. However high the price, Duchamp did not care to repeat himself and remained an ex-painter. His geniality and sharp intelligence ensured he soon found enough friends and patrons to make him feel at home, most importantly the wealthy collectors, Louise and Walter C. Arensberg, who became lifelong friends and supporters, and the lawyer and collector, John Quinn, whom he met while earning money giving French lessons. As well as a handful of language-based or -inflected works prompted by his exposure to a new language, Duchamp produced a few more readymades: the snow shovel he bought at

22
Pharmacy 1914
Rectified readymade:
gouache on a commercial
print
26.2 x 19.2 cm
Moderna Museet,
Stockholm

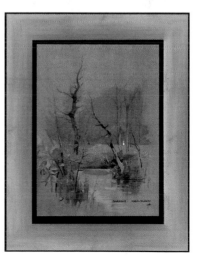

a hardware store, which he inscribed with the title *In Advance of the Broken Arm* 1915; the typewriter cover called *Traveller's Folding Item* 1916; and the metal dog comb, *Comb* 1916, on the spine of which he painted the nonsensical legend '3 OU 4 GOUTTES DE HAUTEUR N'ONT RIEN A FAIRE AVEC LA SAUVAGERIE' ('Three or four drops of height have nothing to do with savagery'). Like his experiments with language (*The* 1915, *Rendez-vous du dimanche 6 février 1916* 1916), the idea behind the absurd inscription on *Comb* was to free language of its descriptive function, just as one of the ideas behind the readymade was to free the object of its utilitarian function.

Although this step away from 'making sense' by recourse to decontextualisation of words and objects from their accepted usage can be traced back to 1912 in Duchamp's work, when he began to create his own mythology for the *Large Glass* under the wing of Picabia and Apollinaire, Duchamp was about to be carried further in this direction by the crosscurrents of history. About two weeks before he inscribed *Comb* in New York in February 1916, the first cabaret organised by the German Hugo Ball (1886–1927), including songs performed by Emmy Hennings (1885–1948) and readings of Romanian verse by Tristan Tzara (1896–1963), took place at the Cabaret Voltaire in Zurich in neutral Switzerland, signalling the arrival of Dada. This would soon attract other refugees from the First World War, such as the German Richard Huelsenbeck (1892–1974), the Alsatian Jean

or Hans Arp (1888–1966) and the Romanian Marcel Janco (1895–1984). Tzara became the energetic leader of the group, ultimately bringing Dada to Paris in January 1920 with Picabia's enthusiastic backing.

Dada became notorious in Zurich and, subsequently, in its various manifestations in other European centres such as Berlin and Cologne, for its provocative, boorish performances and manifestations, meant to incite complacent audiences through ridiculous behaviour, untrue claims (the Dadaists would shave their heads, Charlie Chaplin would join them), mad recitations of absurd poems and manifestos, outlandish costumes and collages and more. While the most devastating war in history raged in Europe, the Dadaists seemed to share in a spirit of nihilism. Insisting the world and human condition were crazy, they acted this out through various media cathartically. Although we tend to locate Dada in a specific time and place, making it seem as though the movement was a raucous and spontaneous phenomenon, it had cultural predecessors from the nineteenth century such as the brilliant French writer Alfred Jarry (1873–1907). There were also eccentric contemporaries who closely preceded, or ran parallel with, Dada in their misbehaviour, such as Arthur Cravan (1887–?1918) and friend of future Surrealist leader André Breton, Jacques Vaché (1896–1918).

The iconoclasts Picabia, Duchamp and the American photographer Man Ray (1890–1976), with whom Duchamp now began a lifelong friendship, are among them,

and, once they became aware of Dada, they collaborated on an American version of it. Dada activities in New York were based at the 291 Gallery belonging to the pioneering photographer Alfred Stieglitz (1864–1946), who had done much from there to introduce the European modernism of Cézanne, Matisse and Picasso into America, and at the home of the Arensbergs, reaching a larger public in 1917 through journals such as *The Blind Man*, *Rongwrong* and *New York Dada*. These publications demonstrate that the indignancy experienced by European Dada at the horror of the First World War did not reach as far as distant New York, which was removed from the theatre of war, and where irony and humour were, therefore, more in evidence. While it would be simplistic to say that Duchamp assimilated Dada's attitudes to art, both he and the Dadaists certainly shared the same sense of humour, mockery and negation of reason, as well as a conviction that art should not be made banal.[18]

The readymades were a significant element in this attack upon complacency, of course, as was Duchamp's interest in chance and his ongoing creation of the *Large Glass* in New York, which would enact a near-complete rejection of orthodox reason. Away from his older brothers and the legendary figures of the Parisian art scene, bolstered by comparable activity in Europe in the form of Dada's assault on convention, Duchamp grew more confident in questioning what was viewed as artistically acceptable and respectable.

His most notorious gesture came in April 1917 with the pseudonymous submission under the name 'R. Mutt' of a urinal entitled *Fountain* to the first exhibition of the Society of Independent Artists. Modelled on the Salon des Indépendants, this organisation had been set up by Duchamp himself and others in 1916. It could be joined by anyone for a small sum with the promise that two of their works would be shown. The Society's Board of Directors was made up mainly of American artists: William Glackens, George Bellows and Maurice Prendergast (who all belonged to the social realist group the Ash Can School), Rockwell Kent, John Marin who was close to Stieglitz, John Covert, Morton Schamberg and Joseph Stella, who were all enamoured of European modernism, the collector Walter C. Arensberg, Duchamp's friend and patron Katherine Dreier, Man Ray and Duchamp himself. The Board agreed to show every work submitted at the society's inaugural exhibition at the Grand Central Palace on Lexington Avenue, which featured 2,125 works of art by 1,200 artists (it was nearly twice as large as the Armory Show, in fact) hung alphabetically in accordance with Duchamp's suggestion.

When the Board voted by a small margin to reject *Fountain*, Duchamp resigned without revealing his authorship of the scandalous work. *Fountain*, along with the moustached Mona Lisa of 1919 *L.H.O.O.Q.* (Duchamp simply added facial hair to a reproduction of the *Mona Lisa* he found back in Paris in the year of the 400th anniversary of Leonardo's death), can be regarded as

his most self-consciously Dadaist works, prompted by and mirroring Dada in the near-yobbish confrontational bluntness of their comment on art and its institutions.

During this period of innovative activity, Duchamp shuttled back and forth between Paris and New York. He had left New York in August 1918 for a ten-month stay in Buenos Aires (from where he received news of his brother Raymond's death in the war), possibly to avoid the draft after the United States entered the war in April 1917. He then returned to Paris bearing the shape of a star and stripe shaved into his hair, before heading back to his beloved New York in January 1920, returning to Paris in June 1921, then back to New York again early in 1922 for another year. His cheerful departure from Paris early in 1920, almost exactly as Tzara arrived there from Zurich, speaks plainly enough of his lack of interest in taking a greater part in Dada activities, in spite of appeals from Tzara.

Indeed, during the period from 1916 to 1921, he made a series of works subtler in tone than the Dadaist *Fountain* and *L.H.O.O.Q.*, which required greater technical input than the readymades and are therefore usually called 'assisted readymades'. Among them are the object *With Hidden Noise* 1916, a ball of string held between two plates carrying a secret object and enigmatic script; the rectified advertisement for Sapolin enamel paint, *Apolinère Enameled* 1916–17; the empty glass ampoule, *Paris Air* 1919, a charming and playful 'souvenir' reflective of Duchamp's personality, which he took to New York for his friends the Arensbergs; the scaled-down French window whose glass is covered with black leather, entitled *Fresh Widow* 1920 (fig.23), copyrighted by his female alter ego 'Rose' or 'Rrose Sélavy', who made her first appearance in this work; and *Why Not Sneeze Rose Sélavy?* 1921, a birdcage altered in size, containing white marble cubes, a cuttlebone and a thermometer, which some have suggested offers a wry comment on classical sculpture or Cubism (it was rejected by Dorothea Dreier, sister of Katherine Dreier, who had commissioned it for $300, perhaps because it was unfathomable). During this period he also painted his final canvas, *Tu m'* 1918, commissioned by Katherine Dreier for her library. Apart from *Tu m'*, all these works have at one time or another been lumped together with the readymades, yet most of them are constructed objects and not simply bought or chosen and presented with minimal alterations like *Fountain* and *Traveller's Folding Item*, demonstrating further the instability of (or at least the diversity covered by) that category.

Work on the *Large Glass* had been slow, partly because Duchamp was becoming bored with it and taking up other things such as non-artistic experiments with optics (the pulsing spirals of *Rotary Glass Plates (Precision Optics)* 1920) and becoming more involved in exhibiting and dealing, which was an adjunct to his important friendship with the Romanian sculptor Constantin Brancusi (1876–1957). During this period he gave free rein to his love of wordplay and

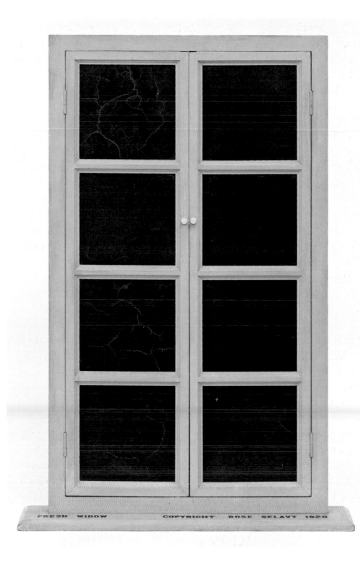

23
Fresh Widow 1964
(replica of 1920 original)
Wood, glass and leather
77.5 x 45 cm
Israel Museum

puns, often under the authorship of his alter ego Rrose Sélavy. Man Ray photographed Duchamp in drag as Rrose, who would exist in one form or another for the remainder of Duchamp's life, latterly only through 'her' signature.

He had also obtained a camera and, having taken an interest in film, expressed his wish in November 1921 in a letter to the Arensbergs to become an assistant camera-man in America.[19] Anything to avoid art and the burdensome *Large Glass*, apparently. A few months later, bored again, Duchamp was telling his lifelong friend, the 'general introducer' Henri-Pierre Roché, that he had about as much interest in being a cinematographer as he had in being a painter (none), and only 'a wonder drug that would make me play chess divinely' would break his malaise.[20] In letters sent to Walter Arensberg from Buenos Aires, Duchamp already describes himself as 'playing night and day' and 'all set to become a chess fanatic'.[21] By the early 1920s, Duchamp's passion for the game had made him an exceptional player, and chess, even more than boredom and distraction, had become the main obstacle to the completion of the much-anticipated *Large Glass*.

André Breton and Surrealism

The death of Apollinaire in 1918 and demise of Dada in the early 1920s created a cultural void in Paris, swiftly filled by Surrealism and its leader, the poet André Breton (1896–1966). Over the years, most scholars have preferred to put Duchamp in the context of Dada,

arguing Duchamp remained aloof from Surrealism, but this view conceals the nuances of his lengthy association with the Surrealist group. Breton was nine years younger than Duchamp and part of the generation after Cubism and Futurism. His first appreciation of Duchamp was composed after he had departed from Dada with several of his friends in tow, during the time the principles of Surrealism were being codified. It is stated in the fawning appraisal published in the review *Littérature* in October 1922, which set the tone for his lifelong admiration for Duchamp.[22] Accompanied by some punning phrases by Rrose, Breton's text is written in a grandiose style way out tune with Duchamp's unpretentiousness, in which the young ambitious poet ambivalently played Balzac to Duchamp's Cézanne:

We need only to think of the glass painting to which Duchamp will soon have devoted ten years of his life, which is not the 'unknown masterpiece' and around which, even before its completion, the most fabulous legends are being woven.[23]

Stressing Duchamp's importance to contemporary art and thought, Breton also wrote of his admiration for Duchamp's detachment from all group formations, 'even before a particular cluster of ideas – whose originality largely derives from him – has taken on that systematic cast that eliminates others'.[24]

This piece would be the first of four monographic texts on Duchamp by Breton (in 1922, 1934, 1940 and 1945). Thirty years later, Breton's regard was undiminished, demonstrated in 1952 in the course of the interviews he gave on the history of Surrealism for French radio in which he described Duchamp as 'the great hidden inspirer of the artistic movement – as much in the 1940s as in the years 1918 to 1923'.[25] By this, Breton meant to indicate not only the role Duchamp played in helping create the cultural conditions that allowed Surrealism to emerge in the period after the First World War, but also his importance in influencing Surrealism's initial core project to overturn existing social and cultural values in the wake of that catastrophe by harnessing and assimilating the powers of the unconscious in the service of 'freedom' (even though Duchamp was never attracted to psychoanalysis like the Surrealists). Ironically, the principles of Surrealism, enshrined by Breton in a formulaic manner in the *Manifesto of Surrealism* in 1924, demanding an unswerving commitment to a fixed set of theoretical precepts and listing those who had 'performed acts of ABSOLUTE SURREALISM', added up to a doctrinaire attitude that already promised difficulties with the affably, though incorrigibly recalcitrant Duchamp.[26]

It is already clear that Duchamp did not like to be tied down to a fixed position; his arbitrary decision to give up being a painter in 1912 offering a good example of his waywardness and unpredictability. In 1923 he went further, abandoning work on the *Large Glass* and declaring it 'definitively

unfinished', before moving back to Paris, where he would remain until the outbreak of the Second World War. For the next thirty years Duchamp would produce only a few works that had the tiniest public, made up largely of Surrealists, while devoting himself mainly to chess. Whether he thought he was an artist or not for the second half of his life is still disputed.

In the 1920s, Duchamp's obsession with chess, indifference to creative activity and lack of interest in politics annoyed Breton at the time of the Surrealists' increasing adherence to Communism. Although he had known and admired Duchamp for over ten years, Breton had run out of patience with him by 1929, and, 'as a measure of mental hygiene', as he put it, he struck out at the non-committal, apolitical Duchamp in the *Second Manifesto of Surrealism* in a single sentence seething with frustration that condemned Duchamp's immersion in 'an interminable game of *chess*'.[27] As sensitive as ever to language, in italicising the French *échecs* the poet Breton meant to expose its tripartite pun, on 'chess', 'check' and 'failure'. Breton still viewed Duchamp's fugitiveness as he had seven years earlier, as 'capable of freeing modern consciousness from that terrible mania for fixation that we have always denounced'.[28] Yet to a Surrealism committed to specifically revolutionary *politics* in 1929, Duchamp's inability or unwillingness to explain his non-activity to Breton's satisfaction seemed incomprehensible: a game, a dead end, a failure – *échecs*.

Breton soon mended his relationship with Duchamp, who after several years of refusing to show his work, now agreed to exhibit with the Surrealists. In May 1933, under the heading 'La mariée mise à nu par ses Célibataires mêmes' (*sic*), the final number of the Surrealist journal *Le Surréalisme au service de la Révolution* (*SASDLR*) opened with three notes made by Duchamp during the preparations for the *Large Glass*, accompanied by a brief introduction by Breton.[29] The same issue carried an advertisement for the art journal *Minotaure*, to which the Surrealists would subsequently devote their energy.

At the same time, Duchamp returned to something like art practice (though he might not have regarded it in that way) after several years dedicated to optical experiments, gambling and chess. The notes that were published in *SASDLR* in 1933 resurfaced in September of the following year among the ninety-three 'assembled' in *The Green Box*. We saw that Duchamp's casual and sometimes more systematic note-taking, doodling and diagramming, constituting a crucial side of his practice, began while he was pondering and constructing the *Large Glass*, and he ultimately published three sets of notes during his lifetime all in box format, in 1914, 1934 and 1967. The 320 copies of *The Green Box* contained documents pertaining to the *Large Glass* made between 1911 and 1915, arranged in no particular order. Although the *Large Glass* is dated 1915–23, it reached completion as a project in the 1930s with the release of *The Green Box* alongside the discovery of the breakage of the *Large Glass* and its subsequent restoration. Its two panes of glass had been

broken in 1927 while the work had been transported carelessly back to its owner Katherine Dreier in Connecticut from Brooklyn, where it had been exhibited. The damage was not discovered until 1931, when it was unpacked, and Duchamp only left for America in 1936 to repair it. Along with his closeness to Surrealism, his discovery of the breakage of the *Large Glass* seems to have jogged Duchamp back into something akin to artistic creativity in the 1930s.

Duchamp's return to a place of prominence in the Surrealist pantheon was confirmed by Breton's 1934 article in *Minotaure*, 'Lighthouse of the Bride'.[30] Surveying Duchamp's limited *œuvre*, Breton wrote of the fabricated, three-dimensional object, a major focus of Surrealist research at the time, as preordained in certain of Duchamp's gestures, such as the object *Why Not Sneeze Rose Sélavy?* However, the primary purpose of the article was to give an account of the importance of the *Large Glass*. Breton had only seen Duchamp's masterpiece in photographs as it had never left America and was lying in pieces in 1934, so he had to surmise its enigmatic function from notes and sketches of the just-published *Green Box*, the pretext for his article. Breton regarded the advent of *The Green Box* as a publishing event of the greatest magnitude, and from Duchamp's jottings he was able to give the first full interpretation of the *Large Glass*, describing with a straight face the hilariously intricate and elaborate procedure by which the Bachelors fail to deflower the Bride.

Breton's text appeared in the sixth number of *Minotaure*, for which Duchamp designed the cover (fig.24). For this he recycled something old in the form of one of his *Rotoreliefs* 1935 (which had just appeared as a set of six cardboard coloured discs) set over Man Ray's extraordinary 1920 photograph of the *Large Glass* entitled *Elevage de poussière* (*Dust Breeding* or *Dust Rearing*). Reusing and reinterpreting his own work rather than making new things was becoming Duchamp's established practice, even though that number of the journal carried that rarest of items on its back cover, an original work by him in the form of a Minotaur ink blot. After this issue, works by Duchamp made occasional appearances between the covers of the journal and he sat on the editorial committee for the tenth and eleventh numbers. He was coaxed further out of 'retirement' to design the door for Breton's Galerie Gradiva in Paris in 1937, cut out to resemble the shape of a man and woman embracing, and in 1938 he took charge of the decor for the first full-scale Surrealist exhibition held in Paris, also contributing a mannequin to those lining a corridor in the form of a half naked Rrose Sélavy.

By then, with war threatening Europe once again, Duchamp was already three years into a new project, which entailed the creation of a set of miniatures of his own work and their assemblage in a portable museum, called the *Boîte-en-valise* 1941–71. Appearing in seven series, over 300 boxes were made along with a leather deluxe edition. This handmade, mass-production

24
Cover of *Minotaure*, Winter 1935
Magazine
31.7 x 34.5 cm
Tate Gallery Archive

25
John D. Schiff
Installation view of 'First Papers of Surrealism' exhibition 1942
Gelatin silver print
Philadelphia Museum of Art. Gift of Jacqueline, Paul and Peter Matisse in memory of their mother Alexina Duchamp

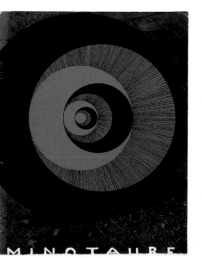

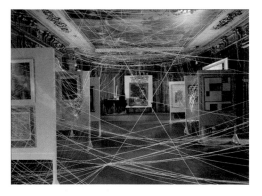

project would occupy him to varying degrees for the rest of his life (and was not even completed at his death). It is hard to think of a more Duchampian gesture than the *Boîte-en-valise* for it seems to spring directly from the notion of flight and escape from any sentiment of rootedness. Its suggestion of departure is given further poignancy insofar as it was conceived at a time war seemed imminent. When war was declared in 1939, Duchamp was on holiday in the South of France and would dither for several months over the decision to relocate to New York while he travelled back and forth between Paris in the Occupied Zone and Marseilles in the 'Free Zone', gathering together the miniatures for the *Boîte-en-valise* using the identity papers of a cheese merchant friend. Duchamp was virtually the last major figure to leave Marseilles, on 14 May 1942, following several of the Surrealists to New York, which would be his home for the rest of his life.

Evidence of Duchamp's continuing closeness to the Surrealists in New York is given in his installation of a mile of twine around the exhibits presented at the 1942 *First Papers of Surrealism* exhibition (fig.25). In mid-1943, the *Large Glass* was moved to the Museum of Modern Art, New York, where it would remain for over two years, until it was reinstalled in the home of its owner, Katchrine Dreier (fig.28). Its presence in New York helped prompt the brief monograph on the *Large Glass* co-authored by Matta and Dreier, yet if its appearance on the cover of *Vogue* in July 1945 (fig.26) showed the *Large Glass* had now found a mainstream audience, then Duchamp was still capable of confounding that larger constituency. Commissioned to create something for the cover of *Vogue* in 1943, Duchamp produced *Genre Allegory* (fig.27) a Janus-faced portrait of the USA turned anti-clockwise through 90 degrees, constructed from red-stained gauze resembling a sanitary towel, with thirteen gold-headed stars hammered through it.[31] Naturally, *Vogue* declined Duchamp's poisoned chalice (Breton bought it as an anti-American statement for $300), yet elsewhere in New York, much to his own bemusement, he gathered accolades effortlessly, becoming the subject of a special number of the New York periodical *View* in 1945, for which he designed the cover.

Duchamp and Breton continued to work on projects together during the war, while Duchamp contributed ideas, cover designs and sat on the editorial board of the Surrealist periodical *VVV*. He stayed on in New York after the war, increasingly isolated, though still willing to cooperate with the Surrealists. Eroticism provided the spur for his design of the catalogue for Surrealism's 1947 exhibition, which bore a breast on its cover and the words 'PRIERE DE TOUCHER' ('please touch') on the back. And Duchamp was the principal designer for the major Surrealist exhibitions held in Paris in 1947 and in 1959–60, as well as their exhibition at the D'Arcy Galleries in New York from 1960 to 1961, called *Surrealist Intrusion in the Enchanters' Domain*.

26
Cover of *Vogue*, July 1945
Condé Nast

27
Genre Allegory (Portrait of George Washington) 1943
Mixed media
54.8 x 42.7 x 7 cm
Musée Nationale d'Art Moderne, Centre Georges Pompidou, Paris

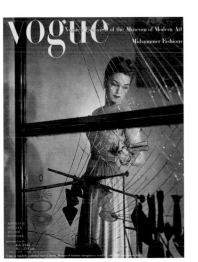

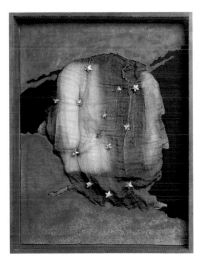

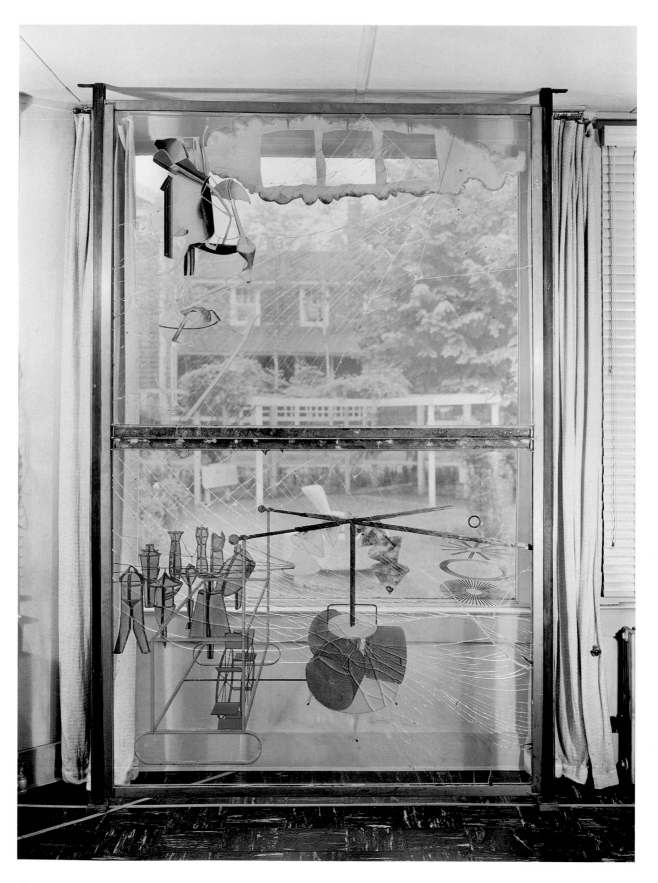

Growing influence and widening fame

A kind of cult of Duchamp continued in Surrealism in the 1950s. By the beginning of that decade, he had lived in relative obscurity in New York, detached from group activity and the wider world for some years. Things were about to change, however, stemming in part from the esteem in which he was held by the Surrealists, for the driving force behind the watershed 1959 monograph, which contributed hugely to Duchamp's great fame and influence (continuing up to the present day), was the then-Surrealist Robert Lebel, who published an extract from his forthcoming book in 1957 in the journal *Le Surréalisme, même*.[32]

Something had been stirring in Duchamp since the beginning of that decade, partly because of the deaths of several long-standing acquaintances – his one-time partner and close friend Mary Reynolds in 1950, Katherine Dreier in 1952, Louise Arensberg and Picabia in 1953 and Walter C. Arensberg in 1954 – but partly because of his marriage at the beginning of 1954 to Alexina (Teeny) Matisse, whom he had met in 1951 – a new role for the bachelor as husband. Thoughts of his own mortality, legacy and responsibilities presumably followed.

In 1950, Duchamp was included in the major exhibition *Challenge and Defy* held at the Sidney Janis Gallery in New York, and in 1952 he played a key role in promoting the Duchamp siblings' exhibition at the Rose Fried Gallery also in New York, *Duchamp Frères & Sœur: Oeuvres d'Art*, during the course of which he became suddenly recognised by a wide public as 'Dada's Daddy'.[33] Duchamp had developed some skill over the years in curating exhibitions, briefly with the Society of Independent Artists, then more notably in his efforts from the 1920s to promote Brancusi's work and in his and Man Ray's activities with Katherine Dreier's Société Anonyme, the organisation set up to collect, promote, display and vindicate modernism for a sceptical American public. In 1953, he conceived and curated the exhibition *Dada, 1916–1923*, also held at the Sidney Janis Gallery.

In the meantime, negotiations were taking place over the bequest of the Louise and Walter Arensberg Collection, containing a high proportion of Duchamp's scanty work, which was eventually given to the Philadelphia Museum of Art. It went on show to the public in October 1954. During this period Duchamp also made his first significant new works of art in thirty years, the erotic objects *Female Fig Leaf* 1950, *Dart-Object (Objet-Dard)* 1951 and *Chastity Wedge* 1954. That decade was book-ended by Robert Motherwell's classic *The Dada Painters and Poets* (1951) – which relied heavily upon Duchamp's counsel and gave evidence of his importance – and the collection of Duchamp's writings, *Marchand du sel*, edited by Michel Sanouillet in 1959, which consolidated his passage from obscurity to fame, a process furthered by the many interviews Duchamp now agreed to give.

In the 1950s, a generation of younger artists seeking to challenge the dominance of the Abstract Expressionists Jackson

Pollock, Mark Rothko, Barnett Newman and others – among them Jasper Johns, Robert Rauschenberg, Andy Warhol and Richard Hamilton – came into contact with Duchamp's work, though Duchamp himself could not decide over this period whether he was an artist, 'anartist' or 'breather'. Nevertheless, artists were inspired by the emphasis he placed on ideas in art over the simply visual and many attended openings of the numerous exhibitions of his work in America and Europe.

Duchamp was finally recognised with a retrospective exhibition of 114 works at the Pasadena Art Museum in California in October 1963. Many more young artists became followers of Duchamp as a result of that exhibition, which demonstrated that he had anticipated by half a century some of the main preoccupations of 1950s and 1960s art: questioning the role of art and the artist; giving new importance to eroticism, mass production, appropriation and repetition; incorporating ideas from science into artistic work; showing enthusiasm for performance, interest in language and pleasure in play. Duchamp was now celebrated as a major figure of twentieth-century art in two more monographic shows, *NOT SEEN and/or LESS SEEN of/by MARCEL DUCHAMP/RROSE SELAVY 1904–64* at the Cordier & Ekstrom Gallery in New York in 1965 and *The Almost Complete Works of Marcel Duchamp* held at the Tate Gallery in London in 1966. Another 'family' group show was held at the Musée de Peinture et de Sculpture in Rouen in 1967, closely followed by the unveiling of the plaque on his parents' last home in the city. Along with the extensive interviews carried out by Pierre Cabanne, published in 1967, and the appearance of Arturo Schwarz's *Complete Works* in 1969, these events, publications and honours were typical of the accolades given to a great artist, and this is the way Duchamp was viewed by the time he died in Neuilly on 2 October 1968.

Apart from a handful of occasional pieces, Duchamp had created nothing of major significance since the mid-1920s that did not recycle in some way his previous work. In the 1960s, he had continued in this vein, producing in collaboration with Schwarz in 1964 an edition of eight replicas each of thirteen of the readymades, nine etchings based on the *Large Glass* 1965 (fig.29) and nine more centred on erotic themes in Western art (dating from 1967 to 1968), as well as a collection of some early notes on the *Large Glass* in his final box *A l'Infinitif (The White Box)* 1967.

However, soon after Duchamp's death, it was revealed that he had been active in secret on a major piece over the period from 1946 to 1966, *Etant donnés: 1. La chute d'eau. 2. Le gaz d'éclairage*. Named after one of the notes in *The Green Box* and therefore associable with, if in no way a simple recycling of, the *Large Glass*, *Etant donnés* was inspired by eroticism, one of the great themes of his work. It consists of a door with peepholes, through which can be viewed a nude female figure with legs spread wide apart. Although echoes of his previous works can be inferred from it – the nude figure

might be the Bride of the *Large Glass*, while the background might be compared to that of *Pharmacy* or *L.H.O.O.Q.* – Duchamp left behind only a manual with instructions on how to set it up but no sense of the meaning of the piece or his intention in creating it. In its silence in the midst of the din surrounding Duchamp today, *Etant donnés* stands as an eloquent testimony to an individual who charged his work with poetic, allusive resonance. Like much of Duchamp's *œuvre*, as we shall see in subsequent chapters, it cannot be reduced to a single meaning, but is open to countless interpretations.

29
The Large Glass (Etching)
1965
Copperplate
35 x 22.5 cm
Graphische Sammlung,
Staatsgalerie Stuttgart

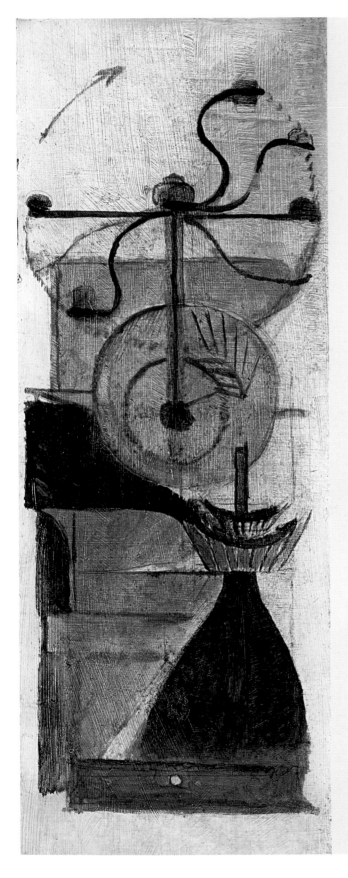

THE DUCHAMP BOOK

Coffee Mill

Puteaux was a rural suburb of Paris in the first decade of the twentieth century, home to the Duchamp brothers who began there the artist's colony that would give the district a significant position in the history of twentieth-century art. In Puteaux emerged a subdivision of the Cubism about to evolve in the painting of Picasso, Georges Braque and Juan Gris, but inflected by more theoretical and scientific concerns by artists such as Albert Gleizes, Henri Le Fauconnier, Roger de la Fresnaye, Frantisek Kupka, Fernand Léger, Jean Metzinger and the Duchamp brothers themselves who worked under the names of Raymond Duchamp-Villon and Jacques Villon. Partly because of an endemic reluctance to engage in group activity, linked to a fear of submerging his personality beneath the 'artist' cliché, Marcel was always a marginal figure among the Puteaux Cubists. Nevertheless, he was one of the artist-friends requested in November 1911 to contribute a painting to the frieze of works Raymond planned to position on the cupboards over the sink in his kitchen. Up to that time, Marcel had been painting in a Fauvist then Cézannean style. From 1911, he began to experiment with Cubism in paintings such as *Sonata*, *Yvonne and Magdeleine Torn in Tatters*, and *Apropos of Little Sister*, even though these paintings demonstrate, at the best, only a rudimentary understanding of the aspirations of Cubism and a basic deployment of its style.

Perhaps influenced by Roger de la Fresnaye's contribution of a picture of a coffee pot for Raymond's kitchen, Duchamp chose to paint a coffee mill. By presenting it in cross section, he was able to show the direction taken and process undergone by the coffee beans at centre left, which pass between a pair of grinder wheels to the right, falling as ground coffee into a realistically depicted drawer at the base of the painting. Duchamp's decision to paint the internal mechanism of the coffee mill as though the machine were transparent was faithful to Cubism's ambition to represent what was known about an object, rather than what could simply be seen. However, a curiosity about *Coffee Mill* is its multiplied turning arm in the top third of the picture, and the arrow indicating the direction it should take, almost as though Duchamp copied it from an instruction manual. While Cubism sought to embrace the dimension of time in its aim to escape the 'snapshot' effect of realist painting, Duchamp's revolving handle and pointing arrow do this in a more literal way than Cubism usually allowed.

Although it was an occasional work in the context of his other paintings of 1911, *Coffee Mill* has been regarded as the first painting to attempt to depict movement through time in such a manner, preceding by a few weeks the first version of his own *Nude Descending a Staircase*, and by a few months the arrival in Paris, in February 1912, of the inaugural exhibition of Futurism. But this little painting also prefigures Duchamp's many wheeled machines, such as *Chocolate Grinder*, *Bicycle Wheel*, and the Water Mill of the *Large Glass*, as well as his various 'rotary' machines. Duchamp even said later that it possessed a two-part structure that was the source of the *Large Glass*. Pointing forward to several of his most significant innovations, *Coffee Mill* is one of the most important works in Duchamp's *œuvre*.

30
Coffee Mill 1911
Oil and pencil on board
68.2 x 45.7 x 6.1 cm
Tate. Purchased 1981

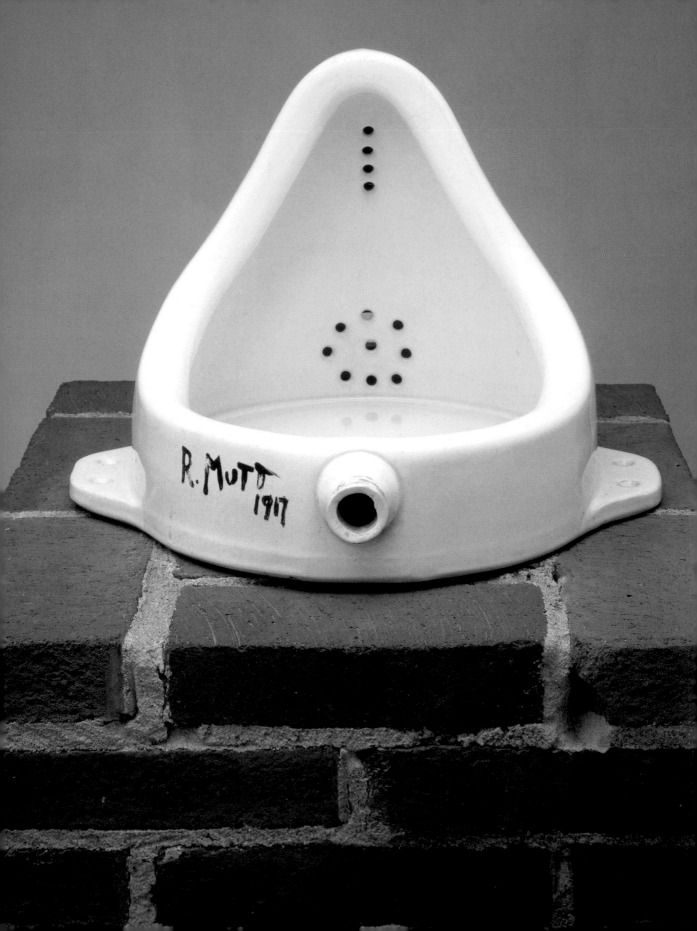

Ever since the Renaissance, when Giorgio Vasari highlighted the artist-genius in his *Lives of the Artists* (1550/1568) as master of his own work with the chief claim to authority over it, initiating the monographic, humanist discipline of art history that exists today, a direct link has been made between the artist and the work of art in art practice, history and theory. Beginning with the readymades and continuing throughout his life, Duchamp made a series of interventions that disrupt the traditional relationship between maker and object, and the intention of the artist and the final product. Consequently, his activities have destabilised the nature of artistic identity and practice because of the uncertainty they have created around this relationship. This chapter considers these points in the light of individual works by Duchamp and looks at his own attitude towards the creative act, while offering a context for the pre- and post-Duchamp attack on authorial identity and meaning in art.

Duchamp's play with authorship

As we have seen, there is a significant lapse in time between Duchamp's invention of the readymades around the First World War and the general artistic and critical responses to them, which took place largely over the second half of the twentieth century and have continued up to our own day. Duchamp's rise to prominence in the last ten years of his life up to his death in 1968 has parallels with the new emphasis given to the 'author question' in French writing during that period. In their attacks upon the institution of the author in the 1960s, writers such as Roland Barthes, Michel Foucault and Jacques Derrida did not name Duchamp as precursor or exemplar. However, their respective inquiries into what an author of a work is and does share similarities with Duchamp's own much earlier questioning of the work (of art) as a single entity springing uncomplicatedly from one authorial source. Authorship constitutes an interesting link, then, between the acceptance of Duchamp as a significant figure in art history, and broader trends in philosophy, theory and criticism in the 1960s.

As mass-produced objects chosen not made, the readymades opened Duchamp's inquiry into the value placed on the unique hand, style and signature of the artist-author. If certain readymades such as *Bicycle Wheel* evince at least a minimum level of authorial intervention in the rather leisurely creative effort Duchamp put in to bring its two halves together, others demonstrate a more accomplished withdrawal from what had been thought of as a vital task in artistic authorship: the fabrication of an original object bearing some aspect of its originator (the unique 'hand of the artist').

Exceptional, in this sense, is *Bottle Rack* (fig.31), because Duchamp did not construct it (as he did with *Bicycle Wheel*), did not get around to altering it or signing it (as he did with *Pharmacy*), did not present it differently to the way it was meant to be presented (as

2 Authorship and Identity

The danger is in the neatness of identifications.
Samuel Beckett, 'Dante... Bruno. Vico.. Joyce', 1929

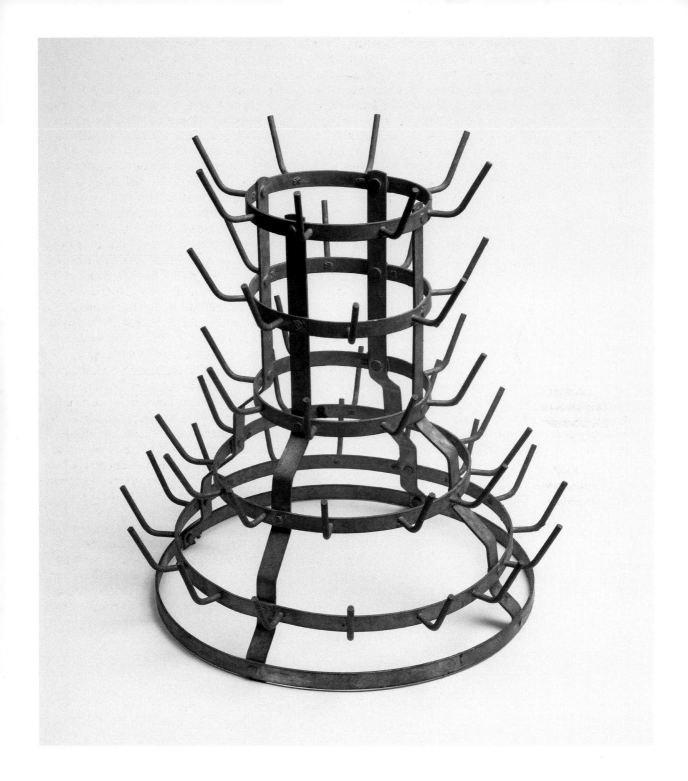

THE DUCHAMP BOOK

he would shift *Fountain* on its axis), did not append a line of script to it (as he did with *Comb* and *In Advance of the Broken Arm*), did not give it a title (as he did with several of these and *Traveller's Folding Item*) and did not even photograph, exhibit or show it to anyone else! An outstandingly obscure and literal work in the history of Western art (it is what it is), *Bottle Rack* is known to its audience primarily through a letter of January 1916 sent by Duchamp to his sister Suzanne and from later versions of the same object.[1] The 'original' was left behind in his studio in Paris in 1915 when he moved to New York, unphotographed, never to be seen again. As, quite literally, a bottle rack, which Duchamp might even have used as such, with barely any institutional context such as a museum or gallery to turn it into 'art', the first version of *Bottle Rack* has had an extremely unstable identity as a work of art or a work 'by' Duchamp, even for a readymade.[2] How can such an object, never exhibited and known only anecdotally, be preserved in the collective memory and considered as a work of art? The elusiveness of *Bottle Rack* also begins to demonstrate the difficulty of discovering a satisfactory definition to cover all those objects collected in the category 'readymades', a term Duchamp did not adopt until 1916 in his letter to his sister.

As well as the centrality it gives the mass produced object and facsimile in place of the traditional 'unique' painting or sculpture, Duchamp's *œuvre* challenges authorship on several other fronts. In an assisted readymade of 1916–17, the rectified

advertisement for Sapolin enamel paint entitled *Apolinère Enameled* (fig.32), we see in its addition of lettering a kind of *written* commentary on authorship, '[from] MARCEL DUCHAMP 1916 1917.' By isolating the 'from' between square brackets (making that word at once significant and marginal), Duchamp created a conditionality around its split, either/or designation. In other words, the bracketing in/out of the preposition 'from' splits the authorship of the work, so that it *might* be by whoever preceded Duchamp in the chain of creation, from whom he, as the named author, is merely passing it on. Emphatically, nothing is to be *authenticated* by signature here, for the unique hand of the artist-painter, sardonically parodied in the image of the young muse in the work, is supplanted by the kitsch surfaces, materials and imagery of mass culture, requiring in place of the conventional valorising signature only the name of its 'executant' printed in capitals. Duchamp had begun thinking about the way in which he could state these works were not *by* him, the artist and supposed originator, when he 'signed' the readymade snow shovel *In Advance of the Broken Arm* '(from) Marcel Duchamp 1915'. He later returned to this commentary in a more sophisticated way with the *Boîte-en-valise*.

Duchamp's 'final painting' *Tu m'* of 1918 (fig.33) invokes again the longed-for, unidirectional passage of the creative act – from artist, to work of art, to signature, to audience. Having spent five years detaching his work from gesture and self-expression, which he had come to regard as outworn and

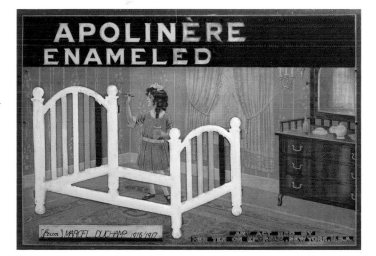

limiting clichés, Duchamp was presumably fed up at the prospect of returning to oil on canvas, only agreeing to Katherine Dreier's commission out of friendship. Duchamp came to dislike the painting later, regarding it as a mere summary of his ideas till then, with its use of the templates from the *3 Standard Stoppages* to the right and bottom left, as well as the painted cast shadows of readymades (though the corkscrew represented in *Tu m'* seems to be an imaginary readymade, while *Bicycle Wheel* has, uniquely in this work, a tyre). He soon grew bored with the task of painting, passing on the job of completing the paint samples, which descend from the top left of the canvas into the foreground, to his lover of the time, Yvonne Chastel. Duchamp also delegated the task of painting the central pointing hand to someone else, in this case a professional sign writer named A. Klang, allowing or encouraging Klang to sign his name to the gesturing hand and consequently jeopardising the security of Duchamp's authorship of the canvas by giving an odd autonomy to the signwriter's painting within the painting.[3]

Rrose Sélavy and the 'Box' format

Duchamp's wish to escape his own authorship was part of a larger programme to pass beyond any formal designation, carried as far as wanting to change his own gender and identity, to which can be attributed his creation in 1920 of a female alter ego, Rrose Sélavy (fig.34). As she appeared the year after his regendering of Leonardo's *Mona Lisa*, it is safe to assume that there is some connection between *L.H.O.O.Q.* and Rrose. More convincing than the alchemy thesis, which views Duchamp's 'androgyny' as a union of the male and female principles of creativity, the socio-cultural interpretation links his use of a female alter ego to the wider discussion of sex and gender identity at the time, specifically to the rise of the women's suffrage movement and New Woman, 'a working woman active in the public sphere, freed from reproductive slavery because of improved access to birth control'.[4]

Duchamp's pose as Rrose Sélavy in Man Ray's two sets of photographs of 1921 and 1924, together with the use of one of them for the mock perfume bottle *Belle Haleine: Eau de Voilette* (*Beautiful Breath: Veil Water*) 1921, were probably determined by a society in which women's emancipation was becoming a reality, and permitted by the increasing understanding and tolerance of the fluidity between genders, as well as the greater freedom around sex and sexuality in Europe and America during the period. It is more difficult to accept, however, the anachronistic view expressed by some of the womanising Duchamp and (especially) Man Ray as proto-feminists, parodying the social and cultural construction of femininity and codes of gender by dismantling the ideologies implicit in photography and advertising.[5] It is rarely mentioned that Duchamp later said his switch of genders was actually secondary to a decision to seek a Jewish pseudonym – which ended up being

33
Tu m' 1918
Oil on canvas, mixed media
69.8 x 313 cm
Yale University Art Gallery, New Haven

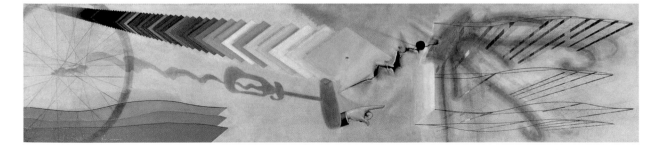

THE DUCHAMP BOOK

the female Rrose – figuring yet another escape from identity, this time a religious one, from the Catholicism of his upbringing.[6]

Under Rrose's identity, Duchamp invented the series of puns that first excited André Breton in 1922 when they were published in *Littérature*.[7] In the mechanism of the pun – of which the name Rrose Sélavy itself, of course, acts as an example, punning on 'Eros, c'est la vie' ('Eros, that's life') – we see Duchamp's 'non-fixity' exemplified. Breaking language's demand for a single, fixed meaning, the pun expresses multiple meanings within a solitary linguistic construction. Of a piece with this are Duchamp's pluralisation of his authorship and person through his use of pseudonyms such as 'R. Mutt', 'R(r)ose Sélavy', 'Marcellus D' and 'Marcel déchiravit'. Serving to fragment the straightforward association of an individual artist with a single work of art, they perform a comparable task of disunity to the pun.

If his slippages between genders and 'identitary promiscuity' were meant to dissociate Duchamp from himself, as well as from any sense of vocation as an artist-originator, then 1923 saw the culmination of this strategy.[8] In that year, he produced a work in keeping with the changeability, capriciousness and fugitiveness broached here under the rubric of authorship. Depicted twice from different angles, not only did Duchamp present himself *as* a fugitive in *WANTED: $2000 REWARD* (fig.35) – an image based on a joke 'wanted' poster he had a printer reproduce and alter – but in

its text he also jokingly gave a selection of aliases before settling on his own pseudonym rather than his given name, which goes unmentioned. Rejecting both signature and style to escape the signature style pursued by all artists in their quest for acceptance in the modern period and before, Duchamp withdrew from the scene of identity and authorship in this and other works. In doing so, he created confusion as to whether what he was doing was art and also about what can be said to be 'made' by the hand of the artist.[9]

Further significant works in this regard are his *Green Box* 1934 and *Boîte-en-valise* 1941–71. *The Green Box* was the second of Duchamp's three collections of boxed notes, the others being *The Box of 1914*, which contained sixteen notes and a drawing (held in a storage box for photographic plates) in an edition of five, and *A l'Infinitif* 1967, also called *The White Box*, containing seventy-nine notes from 1914 to 1923, published in an edition of 150. Made to contain the notes taken during the creation of the *Large Glass*, the boxes subvert the logical and sequential authorial voice – most familiar in the book format – in both the confusing and sometimes barely intelligible array of *aperçus* that they contain, and in their chance arrangement and openness to reshuffling like a pack of cards. In each of the series of boxes, Duchamp destabilises the direct interpersonal communion between the 'speaker' and 'listener', short-circuiting the notion of direct access to meaning through written language. To this end, in assembling the fragments that would comprise the

34
Man Ray
Marcel Duchamp as Rrose Sélavy c.1920–21
Gelatin silver print
21.6 x 17.3 cm
Philadelphia Museum of Art. The Samuel S. White 3rd and Vera White Collection, 1957

35
Wanted: $2000 Reward
1923
Rectified readymade
49.5 x 35.5 cm
Lost

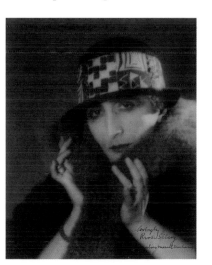

edition of *The Green Box*, he went to the trouble of seeking out identical paper stock – of texture and pattern – as that upon which he scribbled the original notes some twenty years earlier. Then he had metal templates made to mimic the ephemeral script and casually torn-off shapes of the ninety-three original notes and drawings (fig.36). In this way, he methodically engineered their mechanically reproduced 'uniqueness' in a run of 320 numbered facsimiles of *The Green Box*. Today, its status is uncertain, sliding from the unique authorship figured in the handwritten traces of Duchamp's script to the impersonal mechanically reproduced, marked in its multiply facsimiled elements.[10]

This layer of impish, self-defeating irony (the arduous invention of a handmade mass-production technique) is also evident in the creation of the tiny handmade facsimiles and containers of another series of boxes, Duchamp's witty 'portable museum', the *Boîte-en-valise* (fig.37).[11] In each of them, appearing in seven series between 1941 and 1971, he presented miniatures of almost all his work, painstakingly reproduced with the help of printers. The paintings, readymades and *Large Glass* are ingeniously arranged among sliding partitions and foldout panels. Again, the *Boîte* raises the issue of a dispersed authorship, both in its assemblage and through its signature, for many of the 300 plus versions of the *Boîte* were put together by individuals other than Duchamp, under his (rather casual) instructions and with materials made by him and others. As with the earlier *Apolinère Enameled* and *In Advance*

36
The Green Box and some of its notes
Musée nationale d'Art moderne, Centre Georges Pompidou, Paris

of the Broken Arm, the boxes were signed in a way that highlights their eccentric play with the ingrained concept of the author, for they were inscribed 'from or by Marcel Duchamp or Rrose Sélavy', a legend that fragments authorship in several ways. Uncertainty is set in train by the 'from or by', suggesting that they had either originated in Duchamp or been passed along by him from elsewhere, while the equally qualified addition of his female alter ego to a series assembled by many hands further disrupts the notion of the unique, discrete work of art safely consignable within a simple authorial field.[12] In fact, the final sets were completed only in 1971, three years after the death of their author. These last few works 'by' Duchamp were signed by his widow, Teeny Duchamp, as a kind of postmortem female alter ego, but they also carried Duchamp's signature rubber-stamped as one last ironic wink, showing he was still capable of making a mass-produced impression from beyond the grave.

Duchamp and Stéphane Mallarmé
Exactly half a century separates Duchamp's pseudonymous submission of a urinal to the first New York exhibition of the Society of Independent Artists from the appearance of Roland Barthes's widely read essay, 'The Death of the Author'. Published in 1967, the year before it reached French readers, it was the first of Barthes's writings to be translated into English, appearing in an American journal in a translation by Richard Howard that is less well-known than the version in the collection edited by Stephen Heath, *Image-Music-Text*.[13]

In 'The Death of the Author', Barthes asserts that the category of the author is a historical one; not natural and eternal but cultural and conditional, Barthes declared its time was now over. He begins his demonstration of this by inquiring into whose voice it is in the novel that narrates the action, giving opinions and explaining a world to us. The conventional answer to this would be that it is obviously the person who wrote the words of the story and whose name appears on the cover of the book. However, Barthes tells us that it cannot be that biological individual whom we call the author, for that person is subject to a multitude of preceding voices. He or she is enveloped in a variety of styles, opinions, languages and patterns of thought that speak through the author's pen as soon as it touches the paper, and the author can therefore make no claim to originality. Barthes claims that the notion of the individual author who tells a new tale in an original voice is, in fact, a product of the modern age. It does not exist in tribal cultures, for example, where the shaman *mediates* tales rather than *conceiving* them:[14]

The author is a modern figure, a product of our society insofar as, emerging from the Middle Ages with English empiricism, French rationalism and the personal faith of the Reformation, it discovered the prestige of the individual, of, as it is more nobly put, the 'human person'.[15]

From that point on, literary criticism attempted to offer definitive, final

37
Boîte-en-valise
Tate

explanations of the work through the biography of the author, and Barthes argues it has been doing so ever since. Yet the author's text is not a personal 'expression', he writes, but a composite, a bringing together, a chorus of voices, or, as Barthes famously writes, a 'multi-dimensional space in which a variety of writings, none of them original, blend and clash'.[16]

Barthes's critique of authorship and originality was given in the context of literature, which limits its usage when writing about Duchamp.[17] Yet it is equally clear that there are similarities between one part of Barthes's essay and Duchamp's work. As 'original' as Duchamp's work seems, it takes, in fact, a critical view of the esteem in which originality is held in our art history and culture. While Duchamp's approach obviously differs from Barthes's in 'The Death of the Author', in so far as it does not refer so explicitly to 'previous' voices (as Duchamp's thinking is not communicated as a theory but, rather, performed through a glaring departure from orthodox artistic practices), it consciously carries some of this in, for instance, its presentation of objects as 'from' (not 'by') their 'author', as though the artist were a mediator in a creative chain rather than an originator.[18]

The 'Death of the Author' first appeared alongside some of Duchamp's writings in the joint fifth and sixth number of *Aspen*, a journal published in New York from 1965 to 1971. The artist and art theorist Brian O'Doherty edited and designed this issue, though the editorial board changed with each number.[19] All issues of *Aspen* were published not in the conventional flat magazine format but as a collection gathered in a box (fig. 38). In its appearance as well as in its content, *Aspen* presented itself as an avant-garde journal, both debating and contributing to avant-garde practice. To this end, it comprised articles, recordings, films, poems, do-it-yourself sculpture and advertisements by commentators on the avant-garde, as well as publishing work by leading writers and artists of the time.

The texts assembled in this number of *Aspen* date from 1912 to 1967, though the modernist trajectory they trace leaves a gap between 1932 and 1952, the high years of Surrealism and Abstract Expressionism. Continuity was sought with a cooler, more methodical art, the broken arc of which spanned the 1920s and 1930s Contructivism of Naum Gabo and László Moholy-Nagy, meeting the spare contemporary explorations of John Cage, Robert Morris and Sol LeWitt of the 1950s and 1960s. This issue was augmented by contributions from Dada – including those by Hans Richter and Richard Huelsenbeck – a movement that had virtually disappeared from histories of art after expiring in Paris around 1923. By 1967, Dada was fashionable again in America following the publication in 1951 of Robert Motherwell's anthology, *The Dada Painters and Poets*, which had helped initiate the art sometimes called in America 'Neo-Dada' (Jasper Johns, Robert Rauschenberg, Jim Dine, Claes Oldenburg and others). As discussed in the previous chapter, the belated

reception of Duchamp among those artists, which continues in contemporary art today, began the moment he helped Motherwell in the compilation and design of that book.

Post-war avant-garde movements such as Fluxus were stirred by Duchamp's *Green Box* into proposing the box as a vehicle for ideas that could supplant the book, and the design of *Aspen* is a symptom of this. Naturally, Duchamp would have been very sympathetic to the box format of *Aspen*, though the number to which he contributed bears significant differences to *The Green Box*. Where the green flocked cover and flat horizontal register of *The Green Box* were fashioned from within the format of the book, the design of the fifth and sixth number of *Aspen* – its smooth, pale, blank surface and upright styling – seems more suggestive of a card index, in keeping with the magazine's implied aim to make the creative act less an expression of one person's individuality and more an administrative, impersonal process. It is fitting that a journal like *Aspen*, which concerned itself with both avant-garde practices and their reception, as much in its box-magazine format as in its content, should have published texts by Barthes and Duchamp in this issue dedicated to the great French Symbolist poet Stéphane Mallarmé (1842–98).[20]

It is equally appropriate that *Aspen* gave special attention to type settings, also meant as homage to Mallarmé, who always took a very close interest in the form in which his verse appeared on the page.

Along with Raymond Roussel and Jules

38
Aspen 5/6
Tate Gallery Archive

Laforgue, Mallarmé was one of the few literary figures for whom Duchamp had any time, though he never discussed at length Mallarmé's theoretical writings (or those of anyone else). He read and admired Mallarmé's poems from early on, and over fifty years later, in the course of a discussion of his 1911 paintings in his late interviews with Pierre Cabanne, Duchamp said that even though he 'wasn't very, very literary at the time', he 'read a little, especially Mallarmé'.[21] In the same interviews, Duchamp remarked that he continued to like the same writers as ever, 'Mallarmé very much,' adding, 'I still don't completely understand him,' while declaring he was attracted to the tonal value of Mallarmé's verse rather than 'simply the structure of his poems or the depth of his thought'.[22] This is to say that Duchamp, like many others, was drawn to the (untranslatable) *surface* of Mallarmé's poetry – the 'musical' relationship between its words spoken or 'thought out loud' – rather than its deeper metaphorical or conceptual meanings.[23] In the 1940s, Duchamp spoke of Mallarmé as 'a great figure. This is the direction in which art should turn: to an intellectual expression, rather than to an animal expression'.[24] By this, he seems to have been alluding again to Mallarmé the 'language architect', advocating the rational disorganisation of meaning in his work in favour of the sonic relationships it invoked. The cerebral approach to creativity taken by Mallarmé was one that Duchamp himself (like Barthes) took as a revolt against the emotion and 'expressiveness' ('animal expression') that he lamented in so much art of the modern period.[25]

The dedication of this issue of *Aspen* to Stéphane Mallarmé – together with the presence of two contributions to the journal from Duchamp himself – raises the question of the nature and subversion of authorship. For implicit in the dedication, 'for Stephane Mallarmé' (*sic*), is the idea of Mallarmé as a key figure in the modernist lineage *Aspen* wished to promote, and the writings by, and on, individuals linked to the avant-garde over the last century have been consistent in the role they have given Mallarmé as originator and progenitor. Indeed, Barthes was not exempt from this, including Mallarmé in his historical role-call of authors of non-authoriality.

In the context of the author debate, there is, of course, a rich irony in Barthes and Michel Foucault citing Mallarmé in the privileged position as author and origin of the modern *decentring* of the author, at the head of a lineage that includes Paul Valéry, Marcel Proust and the Surrealists. This notion of Mallarmé's paternity is grounded in his theoretical writings on poetics of the 1890s, such as 'Crisis in Poetry', in which he writes:

If the poem is to be pure, the poet's voice must be stilled and the initiative taken by the words themselves, which will be set in motion as they meet unequally in collision. And in an exchange of gleams they will flame out like some glittering swath of fire sweeping over precious stones, and

thus replace the audible breathing in lyric poetry of old – replace the poet's own personal and passionate control of verse.[26]

Mallarmé's remarks on the 'poet-speaker' and his practices as a poet prompted Foucault to comment in his book *The Order of Things*:

To the Nietzschean question: 'Who is speaking?', Mallarmé replies – and constantly reverts to that reply – by saying that what is speaking is, in its solitude, in its fragile vibration, in its nothingness, the word itself – not the meaning of the word, but its enigmatic and precarious being. . . . Mallarmé was constantly effacing himself from his own language, to the point of not wishing to figure in it except as an executant in a pure ceremony of the Book in which the discourse would compose itself.[27]

Just as Barthes aimed to replace the author with what he called the 'modern scriptor', clearly, in this quotation at least, Foucault has the 'executant' completing the tasks previously assigned to the author.[28] Duchamp himself took a similar line in downplaying the authority of the author, while showing a clear willingness to sign his name to an *œuvre*.

In keeping with his pattern of recycling and renewing in preference to the creation of completely new work, Duchamp's contributions to *Aspen* in 1967 were old news. He offered a group of texts from the third collection of his boxed notes, *A l'Infinitif*, which appeared in the same year (in,

incidentally, a comparable design to *Aspen* 5/6), the earliest example of which dates from 1912, along with the short talk he gave in 1957 in Houston, Texas, at the American Federation of the Arts, 'The Creative Act'. These writings by Duchamp did not appear as script, but were recited by their author for this number of *Aspen*, and inserted into the magazine-in-a-box as a record.

'The Creative Act'

'The Creative Act' is Duchamp's most important and lengthiest individual statement on creativity, and raises the question of the author/artist explicitly, in a manner more indebted to conventional modernism than the postmodernism Duchamp is often said to have induced or even 'originated'.[29] In that talk Duchamp reflected primarily upon the intention of the author, the interpretation of the audience/reader and the relationship between the two. For someone whose work and life always seemed so effortless, it is surprising that Duchamp's description in 'The Creative Act' of the artist's realisation of a work is tied closely to difficulty and exertion, describing a 'struggle', a 'series of efforts, pains, satisfactions, refusals, decisions'.[30] Moreover, he added that this set of manoeuvres that shaped the work of art 'cannot and must not be fully self-conscious' and that, as a consequence: 'The result of this struggle is a difference between the intention and its realization, a difference which the artist is not aware of.'[31] For Duchamp, as for Barthes, the audience/reader had the final

say in the creative act. The reputation of the artist and interpretation of the work grew from this seed of difference lodged between what the artist was aiming to do and what was achieved in the eyes of the audience.

During this period of 'rediscovery', Duchamp was still deciding whether or not he was an artist, giving contradictory accounts of his vocation at various times. In the Houston talk, he called himself a 'mere artist', putting forward the view that 'the artist acts like a mediumistic being who, from the labyrinth beyond time and space, seeks his way out to a clearing', an unusually pompous statement for Duchamp.[32] Pressing the case for the artist as a conduit who can never fully control or even know what it is he is creating, Duchamp the bibliophobe made another unexpected move in 'The Creative Act', uncharacteristically quoting from one of the principal essays on authorship by a gold-plated modernist:

T.S. Eliot, in his essay on 'Tradition and the Individual Talent', writes: 'The more perfect the artist, the more completely separate in him will be the man who suffers and the mind which creates; the more perfectly will the mind digest and transmute the passions which are its material.[33]

Duchamp is happy to see the intention of the artist, or the authority of the author over the work, compromised, as the possibilities are then left open for audience interpretation. The spectator (or audience/reader), according to Duchamp, 'later becomes the posterity'[34] (something of a later preoccupation for him)

and the artist and work are judged 'through considerations completely divorced from the rationalized explanations of the artist'.[35]

Duchamp persisted with this point:

Millions of artists create; only a few thousands are discussed or accepted by the spectator and many less again are consecrated by posterity.

In the last analysis, the artist may shout from all the rooftops that he is a genius; he will have to wait for the verdict of the spectator in order that his declarations take a social value and that, finally, posterity includes him in the primers of Art History.[36]

Duchamp's repeated use of the word 'posterity' here undoubtedly has an autobiographical bias. For his talk, which was written in 1957, was given between the publication of the two highly influential works, Motherwell's *The Dada Painters and Poets*, and Robert Lebel's 1959 monograph *Marcel Duchamp*, which highlighted his contribution to twentieth-century art.

In 'The Creative Act', Duchamp claimed that in the network of relations that brings together artist and consumer of a work, 'a link is missing'.[37] To this gap between what the artist thinks he or she offers and what the audience takes, Duchamp gave the term 'art coefficient'.[38] In quirky Duchampian fashion, then, this relation was paradoxically 'pivoted' on a gap, a lost link or absence: it was Duchamp's practice to maintain an absence where authorship was concerned – his absence from his works, articulated by the pseudonym; absence from the site of

creativity, by his selection rather than creation of works of art; absence from masculinity, by his disappearance behind his feminine alter ego, Rrose Sélavy; and absence from art and artistic identity, by his preference for chess throughout the 1920s and beyond. If much of his work from 1913 onwards suggests a desire to escape his own authorship, then towards the end of his life, Duchamp confirmed his fugitiveness and detachment, even speaking to Cabanne of his wish to escape from identity itself, in the sense of selfhood:

I don't believe in the word 'being'. The idea of being is a human invention . . . It's an essential concept, which doesn't exist at all in reality, and which I don't believe in, though people have a cast-iron belief in it. No one ever thinks of not believing in 'I am,' no?[39]

Those comments should act as a warning to those who would attempt to discover truth via meaning in Duchamp's work. For his remarks here are once again complicit with the general attack on the anchoring of meaning via a single, stable identity (authorial or otherwise) in the 1960s examined in this chapter chiefly with reference to Barthes's 'Death of the Author' and Duchamp's admiration for Mallarmé.

Incidentally, a few years after the publication of that essay, Barthes returned to the theme in his 'autobiography', *Roland Barthes* (1975), giving his own *versions* of 'Roland Barthes' the 'text', open to multiple interpretations, confirmed by his allusions

to this character as 'I', 'he' and 'RB'.[40] To this, he adds that what he says about himself, 'is never *the last word*: the more "sincere" I am, the more interpretable I am'.[41] In *Roland Barthes*, Barthes views art – including what he calls 'Duchamp's objects' (readymades, presumably) – as religious: 'fatally hallowed', 'perverse, fetishistic', in the sense that they are idealised and made into icons through their extension beyond a 'physical context'.[42] This 'religious' idealisation is augmented by the interpretation industry that seeks and finds holistic meaning in Duchamp's *œuvre*, when, as Barthes writes in 'The Death of the Author', 'to refuse to fix meaning is, in the end, to refuse God and his hypostases – reason, science, law'.[43] Ten years earlier, Duchamp might have been speaking of that industry when he said, 'God . . . is the final end of man's use of causal systems – the product of the desire for the absolute'.[44] His criticism of the 'religious appeal'[45] of the artist, and his open-ended understanding of his own work (allowing for its recontextualisation and inconsistent interpretation),[46] together with his playful contravention of the authority of the author, reject 'a single "theological" meaning (the "message" of the Author-God)'.[47]

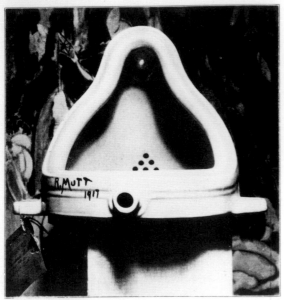

Fountain by R. Mutt Photograph by Alfred Stieglitz

THE EXHIBIT REFUSED BY THE INDEPENDENTS

THE BLIND MAN

The Richard Mutt Case

They say any artist paying six dollars may exhibit.

Mr. Richard Mutt sent in a fountain. Without discussion this article disappeared and never was exhibited.

What were the grounds for refusing Mr. Mutt's fountain:—

1. Some contended it was immoral, vulgar.

2. Others, it was plagiarism, a plain piece of plumbing.

Now Mr. Mutt's fountain is not immoral, that is absurd, no more than a bath tub is immoral. It is a fixture that you see every day in plumbers' show windows.

Whether Mr. Mutt with his own hands made the fountain or not has no importance. He CHOSE it. He took an ordinary article of life, placed it so that its useful significance disappeared under the new title and point of view—created a new thought for that object.

As for plumbing, that is absurd. The only works of art America has given are her plumbing and her bridges.

"Buddha of the Bathroom"

I suppose monkeys hated to lose their tail. Necessary, useful and an ornament, monkey imagination could not stretch to a tailless existence (and frankly, do you see the biological beauty of our loss of them?), yet now that we are used to it, we get on pretty well without them. But evolution is not pleasing to the monkey race; "there is a death in every change" and we monkeys do not love death as we should. We are like those philosophers whom Dante placed in his Interno with their heads set the wrong way on their shoulders. We walk toward looking backward, each with more of his predecessors' personality than his own. Our eyes are not ours.

The ideas that our ancestors have joined together let no man put asunder! In La Dissociation des Idées, Remy de Gourmont quietly analytic, shows how sacred is the marriage of ideas. At least one charming thing about our human institution is that although a man marry he can never be only a husband. Besides being a money-making device and the one man that one woman can sleep with in legal purity without sin he may even be as well some other woman's very personification of her abstract idea. Sin, while to his employees he is nothing but their "Boss," to his children only their "Father," and to himself certainly something more complex.

But with objects and ideas it is different. Recently we have had a chance to observe their meticulous monogomy.

When the jurors of The Society of Independent Artists fairly rushed to remove the bit of sculpture called the Fountain sent in by Richard Mutt, because the object was irrevocably associated in their atavistic minds with a certain natural function of a secretive sort. Yet to any "innocent" eye

Fountain

39
The Blind Man, no. 2

Throughout his life, Duchamp was preoccupied with the mass-produced and the facsimile, which began with the readymades in an economy that saw the recycling and recontextualisation of previous works in preference to continued production. This tactic (which may well have evolved through laziness, indifference or a lack of ideas following his disinterest in being what was then thought to be an artist) can best be seen in the various versions of *Fountain*. Chosen from the showroom of the J.L. Mott Iron Works on Fifth Avenue in the course of an expedition undertaken by Duchamp, Walter C. Arensberg and Joseph Stella, the original version began life as a gesture to test and provoke the Board of Directors of the Society of Independent Artists in 1917. This deed was defended soon after by Duchamp, Henri-Pierre Roché and Beatrice Wood in their Dadaist journal *The Blind Man*, and theatricalised in an obviously semi-fictional account of an exchange over *Fountain* between Arensberg and George Bellows told many years later by Wood.[1] As with *Bottle Rack*, this first version is lost, known only through eyewitness accounts and a famous photograph taken close up at around crotch height against the painting *The Warriors* by the American modernist Marsden Hartley and first reproduced in *The Blind Man*. Since this snapshot is by Alfred Stieglitz, what remains is as much a work by him as by Duchamp, even though it is always reproduced in the context of Duchamp's work, not Stieglitz's. Facsimiles of *Fountain* were found or made by Duchamp or others in 1950, 1963 and 1964 (the last a multiple edition of eight with two artist proofs), which were close enough to the 1917 version to satisfy Duchamp, who went ahead and 'signed' them too (as 'R. Mutt').[2] There are also many miniature versions made by Duchamp from 1938 onwards, to be included in the *Boîte-en-valise*.

However, the best example of the recycling of his past is in Duchamp's own typically casual remaking of the object *Fountain* in the exhibition context. The 1917 version was photographed revolved through 90 degrees, positioned on its flat side (which, as flat, was the most obvious side on which to present it), so that, if urinated into, the urine might pour out onto the feet of the user. For the 1950 exhibition *Challenge and Defy*, held at the Sidney Janis Gallery in New York, Duchamp arranged for the second version of *Fountain* to be attached to the wall (like a painting) at the height a child would use it, thus transforming *Fountain* back into a urinal. Three years later for the exhibition *Dada, 1916–1923* in the same gallery, Duchamp, obviously enjoying himself, had the same *Fountain* mounted upside down over a doorway with a sprig of mistletoe attached, in a position to drench kissing lovers in urine. With these minimal interventions into the body of his own work, nonchalantly reinventing for himself and a new audience an object already thirty years old, Duchamp sidestepped the authorial demand for the creation of new work, renewing and reinventing an object from his own past with a sleight of hand that is wittier still for the economy of the gesture.

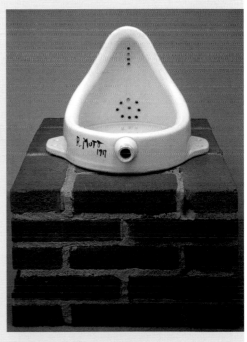

40
Fountain 1963
(replica of 1917 original)
Porcelain
33 x 42 x 52 cm
Moderna Museet,
Stockholm

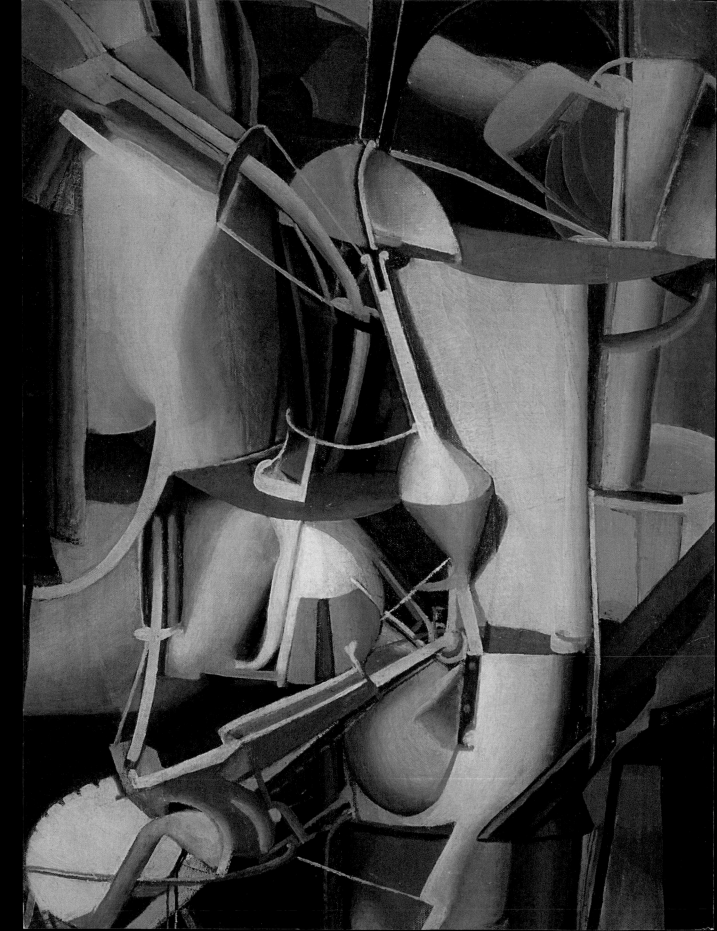

Measuring 21 x 17 cm, *Paysage fautif* 1946 (fig.41) was a rare new work by a Duchamp less preoccupied with introducing completely new objects into the world than reorganising, altering and recycling previous ideas, most evident in the *Boîte-en-valise*, into which *Paysage fautif* was uniquely made to fit.[1] Usually given under its French title, this curious painting-object is among Duchamp's strangest and yet somehow most characteristic works. It is strange in the sense that it looks like an abstract painting, when abstraction was a 'style' he had never embraced and painting a practice he had long since abandoned by the time he had created this minor masterpiece. Yet, *Paysage fautif* is also characteristic of Duchamp, in so far as its slurred blob against a background of black satin irresistibly recalls Picabia's Dada spattered-ink blot on white paper, *Holy Virgin* 1920 (fig.42), which was a daring anti-religious statement in its day, suggesting at once spit, sperm and virginal blood against pure white sheets. Alternatively, *Paysage fautif* brings to mind Duchamp's own insect-like, hanging *Bride* 1912 (fig.49), while its ambiguous, soft, amoeba-like shape declares his familiarity over the preceding twenty years with the Surrealist 'biomorphism' of Jean/Hans Arp (fig.43), Yves Tanguy (1900–55), Salvador Dalí (1904–89) and others.

Strange, then, but typical too, as the phallic shape jutting out to the right might have warned further, together with the title *Paysage fautif*, which can be translated as

Faulty Landscape, Wayward Landscape or *Inaccurate Landscape*, carrying connotations of guilt and blame. For *Paysage fautif* took its place among the great erotic statements of the twentieth century when tests carried out at the FBI laboratories in Houston, Texas, in 1989 finally determined that sperm was the mysterious substance used to create its amorphous form, verifying the importance of eroticism as a theme in Duchamp's work.[2]

The theme of eroticism

Even without the posthumous revelation that *Paysage fautif* was created with (presumably) Duchamp's own sperm – giving it the distinction of being the first object whose foremost constituent is seminal fluid to be recognised as a work of art – it was evident that Duchamp was fascinated by eroticism. Sex had already become a central theme in his work, and Duchamp later made numerous comments on the subject. The most notorious is his ambiguous remark: 'I want to grasp things with the mind the way the penis is grasped by the vagina,' (ambiguous, as it is unclear whether he meant loosely, firmly, sensually, as a woman, without intellectual effort, or something else).[3] Towards the end of his life, in a manner that was unusual for him, Duchamp went so far as to make a self-conscious statement about the 'enormous' place held in his work by eroticism:

I believe in eroticism a lot, because it's truly a rather widespread thing throughout the world, a thing that everyone understands. It replaces,

3 Eroticism and *Infra-Mince*

Any interpretation comes along and hollows out its object from the inside, comes along and substitutes what the object is supposed to hide for what it's assumed to manifest.

Jean-François Lyotard, *Duchamp's TRANS/formers*, 1990

41
Paysage Fautif 1946
Seminal fluid on astralon,
backed with black satin
21.7 x 17 cm
The Museum of Modern
Art, Toyama

LA SAINTE-VIERGE

FRANCIS PICABIA

42
Francis Picabia
Holy Virgin
Tate Gallery Archive

43
Jean Arp
Growth 1938
Marble
109 x 44.5 x 28 cm
Art Institute of Chicago

if you wish, what other literary schools called Symbolism, Romanticism. It could be another 'ism', so to speak. You're going to tell me that there can be eroticism in Romanticism, also. But if eroticism is used as a principal basis, a principal end, then it takes the form of an 'ism', in the sense of a school.[4]

Duchamp had something cooking at the time: his most explicitly erotic piece, *Etant donnés*. Revealed only after his death, this secret work-in-progress reverberates under the language of his remarks to Cabanne (probably not intentionally), about eroticism being 'hidden' (quite literally the case for *Paysage fautif*) and 'underlying' in his work.[5] Yet *Etant donnés* is only the last in a long line of works by Duchamp nourished by the theme of eroticism.

There are early stirrings of the erotic in Duchamp's humorous illustrations and heavy, painted nudes, but this is a diluted eroticism at best, par for the course for modernist painting of the day. With *Portrait (Dulcinea)* 1911, Duchamp deployed the Cubist style to the kind of imaginative ends (the longed-for undressing of a woman he had seen) that were not the aims of Cubism, which remained a realist style for all its virtuosic orchestration of form and space. The 'bachelor' motif is a constant feature in his art and writings, as well as in his life, for apart from entering briefly and inexplicably into loveless wedlock with Lydie Sarazin-Lavassor for a few months from 1927 to 1928 (with farcical results), Duchamp only escaped bachelorhood finally at the age of sixty-six

in January 1954, when he married Teeny Matisse. It brings with it references to autoeroticism in the 1912 and 1913 *Chocolate Grinder* paintings (fig.44), and some see the onanistic, 'do-it-yourself' idea behind the chocolate grinder prefigured in the 1911 painting *Coffee Mill*, and it certainly culminates in the erotic, masturbatory adventures of the Bachelors in the *Large Glass*.

It is reasonable to make a phallic reading of the protuberance on the right side of *Paysage fautif*, given that in that object the 'medium was . . . its message', but because Duchamp spoke of sex as a major preoccupation of his work and as it lies behind the tale told in the *Large Glass*, everything even slightly phallic in his *œuvre* has at one time or another been corralled into the field of eroticism by critics.[6] It has been argued, for instance, that the readymade *Traveller's Folding Item* 1916, a soft typewriter cover resembling a skirt bearing the word 'Underwood', is a smutty joke aimed at Duchamp's friend the artist Beatrice Wood, while the 'phallic' shape of *Comb* 1916 is emphasised in some discussions of that readymade, and the 'sneeze' of the altered bird cage with marble cubes, *Why Not Sneeze Rose Sélavy?* 1921, has been seen as analogous to an orgasm. The two readymades most frequently connected with sex are *Bottle Rack* 1914 and *Fountain* 1917. Although Duchamp would refer innocently to the first as the 'hedgehog', its thick column and many, angled, upward-turned prongs are strongly suggestive, especially as they are inserted into the necks of empty wine bottles to drain them

of their liquid. Duchamp never referred to the erotic side of *Bottle Rack*, though it is obvious and he would have noticed it at the time of choosing it or soon after.

The upright bearing of *Bottle Rack* is matched by the seated Buddha pose of *Fountain*, upon which Duchamp's friends and contemporaries commented.[7] At first, it gave a masculine identity to the urinal, which has subsequently been given two genders by art historians on account of its 'feminine' curves and its shadow, which mimics in its outline the shape of a madonna. Some, dissatisfied with the rather ordinary explanation that Duchamp and his friends gave to the piece – that *Fountain* was a 'vulgar' object that exposed the conservatism of the Board of Directors of the Society of Independent Artists and was afterwards innocently photographed – have added an erotic element to the gendered reading. In one case, a rich brew of psychoanalytic methodology and wordplay is concocted to portray Duchamp as a close reader of Freud and *Fountain* as a castrated Madonna. We are told that by linking the figure of Mut (the vulture-headed hermaphroditic Egyptian mother goddess) and the German word for 'mother', *Mutter* – as conjoined by Freud in his famously flawed study of Leonardo – with *Fountain*'s signature 'R. Mutt' and frontal drainage hole:

Duchamp brilliantly succeeds in cutting off both the urinal's functional potential and the anatomical associations which would confirm its 'masculinity', given the Buddha parallel. In effect,

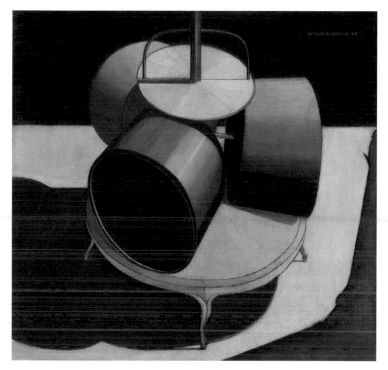

44
Chocolate Grinder (No. 1)
1913
Oil on canvas
61.9 x 64.5 cm
Philadelphia Museum of
Art. The Louise and Walter
Arensberg Collection,
1950

he 'castrates' the object doubly, as both male and female, and thereby succinctly thematizes the psychic quandary around the issue of the penis's presence/absence which, in the exact terms of Freud's discussion of the psychic determinants behind the imago of the phallic mother in the Leonardo analysis, characterizes a particular fetishistic/homosexual formation of male-gendered sexual identity vis-à-vis its castrated 'other' (femininity) at the Oedipal moment.[8]

Impressively rendered and technically proficient, this reading of Stieglitz's snapshot of *Fountain* through Freud nevertheless demands that we substantially alter our understanding of what was regarded as a Dadaist gesture in 1917 to something motivated by psychoanalytic themes actually explored by more literary, Surrealist artists such as André Masson (1896–1987) and Salvador Dalí years later. In this case, the surprising insistence on Duchamp's thorough knowledge of psychoanalytic concepts and categories based on the scantiest evidence, and assertion of his seamless adaptation of them to the urinal are meant to strengthen the argument, but they end up weakening it.

A reading linked to this one gives an important and extensive account of the gay social and cultural context surrounding the choice of *Fountain* in New York in 1917, aiming to explain its scandal by suggesting a queer subtext put in place by general knowledge and homophobic anxiety of goings-on in male public lavatories, with substantial information on homosexual

social activities, practices and slang in the period.[9] Useful and informative for noting gay references in Duchamp's work and circle as well as the larger Dada scene, it is a reading that concedes a large conjectural contribution by its author, attempting to bolster its argument by quoting Duchamp's own words on the role of the audience in the creative act. All the same, Duchamp, as a heterosexual, comes across here as implausibly knowledgeable of, and improbably preoccupied with, French and American homosexual practices and argot. Original and insightful in its inquiry, the interpretation again becomes damaged by its excessive anxiety to convince, as an assortment of susceptible objects and puns are effortlessly channelled into its presupposition.

Such is *Fountain*'s erotic charisma, so alluring, elusive and intriguing are Duchamp's work and persona, that a web of connections spontaneously presents itself from there, and *Fountain* appropriately becomes a gushing source of interpretations. Every work by Duchamp cannot be categorised as erotic (*Bicycle Wheel? With Hidden Noise?*), but, given that the variety of sex and the sexual act compares with the fabulous diversity-in-brevity of Duchamp's output (especially when we factor in the vagueness, generality and ellipticalness of his notes and puns), it is not surprising that endless connections to eroticism can be made; to the point that *Fountain* and *Chocolate Grinder, No.2* 1914 can be said to form a 'queer union' in the *Boîte-en-valise*.[10]

Certainly, some of Duchamp's gestures represent a fairly obvious investment in sex as provocation. As we have seen, one root of *Paysage fautif* lies in the Dada period, particularly in Picabia's brand of blasé goading, while the urinal *Fountain* and the moustached *Mona Lisa* entitled *L.H.O.O.Q.* seem more influenced by Duchamp's knowledge of Dada's anti-art antics than other readymades of the time. In fact, *L.H.O.O.Q.* was re-created by Picabia, minus the beard, and reproduced on the cover of his Parisian Dada review *391* in March 1920 (fig.45), which also included the reproduction of his own *Holy Virgin*. The simple gesture of adding facial hair to *L.H.O.O.Q.* is very much in keeping with the economy of Duchamp's practice, where the minimal gesture is often made to extract maximum impact. Yet *L.H.O.O.Q.* is also attuned to the puerile tone often adopted by Dada, echoing adolescent scrawls on posters in its casual besmirching of that great masterpiece of Western art along with its creator, Leonardo. Duchamp said later that his addition of facial hair made the accidental discovery that the *Gioconda* was actually a man, though its message to traditionalists is spelt out in the letters giving the object its title, for when *L.H.O.O.Q.* is pronounced in French it gives the pun *elle a chaud au cul* (idiomatically, 'she's got a great arse').[11] In the 1980s, Susan Rubin Suleiman extended the sexual relevance of *L.H.O.O.Q.* by a deft reading based on a dialectical concept of Freudian psycho-analysis, the 'phallic mother', arguing that

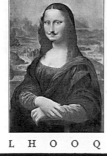

45
Francis Picabia
Cover of *391*
March 1920
Tate Gallery Archive

both goatee and moustache possess phallic appendages and, in this way, the work can be used to show 'how a certain *figure of perversion*' functions, perhaps, in some Dada and Surrealist practices.[12]

Homage to eroticism: the *Large Glass*

Eroticism as a theme came to the fore in Duchamp's drawings and paintings of 1912, such as *Nude Descending a Staircase, No.2*, which has erotic subject matter rendered in a comic manner; and it finds an idiosyncratic language through the materialisation of the 'Bride'.[13] It became a key ingredient in the project of *The Bride Stripped Bare by Her Bachelors, Even* or the *Large Glass*, his monument to eroticism. Duchamp's commentators agree that his final work, *Etant donnés*, has a close connection with the *Large Glass*, though the nature of that relationship is still open to doubt and will probably remain so. These works deserve special attention in any examination of Duchamp's view of eroticism.

Three studies exist for *The King and Queen Surrounded by Swift Nudes* 1912, one in watercolour and gouache, the other two in pencil (fig.46). They show Duchamp creating a kind of visceral, vigorous Cubism, distinct from that of Picasso and Braque. In Munich in July, straight after completing that painting, he embarked on two drawings (in pencil and pencil and watercolour), entitled *Virgin, No. 1* (fig.47) and *Virgin, No. 2*, and the pencil-and-wash *Bride Stripped Bare by the Bachelors*. Exhibiting a greater precision and sharper focus than the *King and*

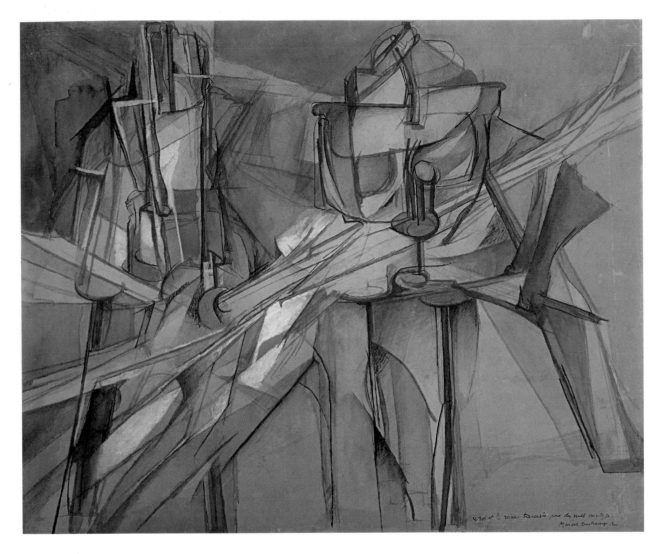

46
The King and Queen
Traversed by Swift Nudes
at High Speeds 1912
Transparent and opaque
watercolour, ink and
graphite on tan wove
paper
49.1 x 58.7 cm
Philadelphia Museum of
Art. The Louise and Walter
Arensberg Collection,
1950

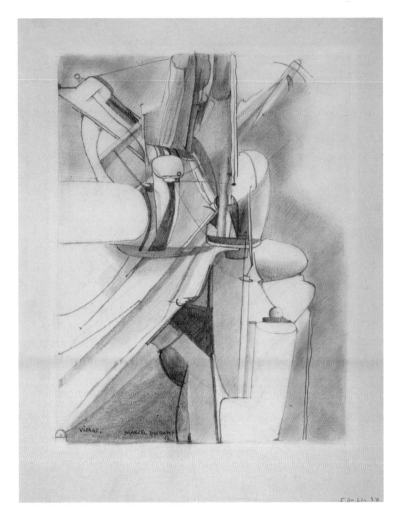

Queen drawings, the Munich works also incorporate mechanical elements, perhaps in response to Picabia's 'mechanomorphic' period, in which anthropomorphic machines exhibited sexual or procreative powers (fig.48). The *Virgin* drawings are single-figure compositions (though complex and highly abstracted), while *The Bride Stripped Bare by the Bachelors*, which Duchamp later marked as the first study for the *Large Glass* project, has three figures, two outer robotic and tubular ones (the 'Bachelors') seemingly victimising a central, semi-transparent, less heavily worked one (the 'Bride') with sharp instruments resembling spears or bayonets. The act of stripping, then, is carried out with, or at least accompanied by, violence in this work.

The premise of a Bride being stripped by Bachelors, together with the mechanical scenario, remains in the *Large Glass* (fig.50), which also includes at top left a version of the Bride clipped out from the surrounding armature of tubes, wires and pipes that exist in the 1912 painting of that title, itself derived from the two Munich *Virgin* drawings. It is not easy to dissociate the Bride from the Virgin, and, in fact, it is to this difference and transition that Duchamp keeps on returning in the titles of these works. Appropriately, then, the painting *The Passage from Virgin to Bride* 1912, which seems to stem from the first *Virgin* drawing, was painted before *Bride*, the final mysterious masterpiece of that mini series of three canvases, which has much less movement and is a more fully rounded composition

47
Virgin (No. 1) 1912
Graphite on light tan wove paper
Philadelphia Museum of Art. A. E. Gallatin Collection, 1952

48
Francis Picabia
Je revois en souvenir ma chère Udnie 1913–1914
Oil on canvas
250.2 x 198.8 cm
Museum of Modern Art, New York

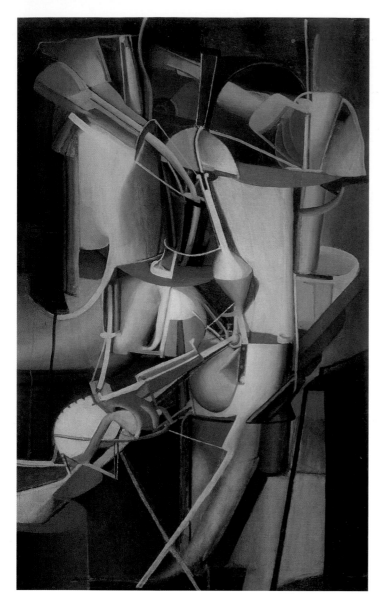

than the two previous paintings (fig.49). Although Duchamp later said – with no pun intended – that he found himself with *Bride*, 'turning toward a form of expression completely divorced from straight realism', its sensual modelling and fleshy tones give an unmistakable eroticism to a work largely free of recognisable subject matter.[14]

Duchamp himself later viewed *Bride* less in the context of these paintings than in that of the studies for the *Large Glass* carried out in New York a few years later. What is 'happening' in the *Large Glass*, though? First of all, it does not appear to possess a simple, linear narrative, which unfolds sequentially from beginning to end, as though it were structured as a traditional storyline or a set of events built around causes and effects. Duchamp did not aim to create a world adhering to either time or space as those exist in everyday life, art or thought (as in realist film, fiction or painting, for example). So familiar concepts such as 'before' and 'after' as well as the physical separation of 'here' and 'there' have no place in the *Large Glass* and are of little use in following the jumbled order of its action, as is the notion of identity, because several of the entities of the *Large Glass* are themselves ('Bride', for instance) and other (*Pendu femelle*) at the same time.

Moreover, the process of conceiving and creating the *Large Glass* was a lengthy one, lasting from 1912 to 1923 (constructed from 1915 to 1923). Progress was slow, with frequent interruptions. As the notes collected largely in *The Green Box* reveal, during the

49
Bride 1912
Oil on canvas
89.5 x 55.6 cm
Philadelphia Museum of
Art. The Louise and Walter
Arensberg Collection,
1950

50
*The Bride Stripped Bare
by Her Bachelors, Even
(The Large Glass)* 1915–23
Oil, varnish, lead foil, lead
wire and dust on two
glass panels
277.5 x 175.9 cm
Philadelphia Museum of
Art. Bequest of Katherine
S. Dreier, 1952

course of the project Duchamp changed his mind over aspects of its contents and itinerary, sometimes replacing an earlier idea, sometimes redefining one, sometimes keeping several contradictory ideas in play at once, sometimes failing to clarify elements and ultimately, of course, leaving the *Large Glass* unfinished.

Although it stands before us as a three-dimensional object, then, the notes for the *Large Glass*, along with Duchamp's comments, create an irresolvable multiplicity of points of reference, insisting that if the *Large Glass* is to be thought diagrammatically, it is palimpsestically, as an impossible, unvisualisable self-intersecting, multi-layered set of labyrinths within labyrinths, revolving on several axes at once. By making sense of it at all through describing or interpreting it in something like a book, we lose much of its richness and complexity, surely meant to exist in a disorderly, dispersive and unruly way in the mind, which is why Duchamp chose the box-and-fragmentary-note format of *The Green Box* as a 'guide'. However, some sense can be made out of this work, even though the narrative format and descriptive mode of art-historical writing are necessarily inadequate for the task.

Standing an imposing 2.75 metres high by 1.8 metres across, the *Large Glass*, which was constructed in New York, is built out of two pieces of glass of nearly equal size, joined by a metal bar and set in a frame made of wood and steel. Its use of materials is often innovative. Duchamp had completed several preparatory studies for the work: *Glider Containing a Water Mill in Neighbouring Metals* 1913–15, *Nine Malic Moulds* 1914–15 and *To Be Looked At (From the Other Side of the Glass) with One Eye, Close to, for Almost an Hour* 1918. He told Cabanne that the idea for using glass came initially from his use of a piece of glass as a palette while painting, and he thought the colours might be protected from the oxidation they suffer in conventional painting, but elsewhere he spoke of avoiding the need to include a background while using glass, which is created automatically in the *Large Glass* and changes constantly.[15] The *Glass* incorporates some innovative materials. For instance, in the rendering of the *Malic Moulds*, the figures are coloured in red lead and surrounded with lead wire as a kind of literalisation of *cloisonnisme*, the style chosen by painters such as Paul Gauguin, where a thick line is used for the contours surrounding flatly coloured forms (a term itself derived from the technique of *cloisonné* in the decorative arts, where metal strips are soldered to a surface).

Notions of temporality and change are registered in several ways in the materials used for the *Large Glass*; not only in the choice of glass – allowing it to adjust constantly with alterations in light, in background (with people seen walking behind it) and foreground (with the changing reflection) – but also in the use of dust, which accumulated on its surface when the *Large Glass* was laid face down for a spell in Duchamp's studio, subsequently fixed with spray adhesive and used as colour for the

Sieves in its lower half. At times, Duchamp took time-consuming meticulousness to absurd lengths, as when he took the *Large Glass* to somewhere near Long Island to have part of it silvered so that he could scratch off the design of the Oculist Witnesses on the lower, 'Bachelor' part of the work in a painstaking operation that he later estimated took two or three months. It is worth adding that, while working on it, Duchamp was living rent-free at 33 West 67th Street courtesy of Walter C. Arensberg, in return for the gift of the *Large Glass* when it was completed.

The *Large Glass* is part painting, part free-standing sculpture, part architectural construction (since it was cemented into the floor of an exhibition gallery in the Philadelphia Museum of Art in 1954), though Duchamp coined a new medium for the *Large Glass* – 'delay', emblematised in the collection of dust for the Sieves – to avoid those categories and hint at its 'operation' on several levels.[16] This operation takes place entirely in the mind, and speaks of the forever deferred union between the Bride suspended at the top left of her 'domain' and the nine Bachelors at the centre left of theirs. According to the notes in *The Green Box*, Duchamp's interviews and subsequent critical commentary, the idea is that the insect-like Bride or *Pendu femelle* is a motor powered by 'love gasoline' that hangs next to a cloud shape called the Milky Way or Top Inscription (or Cinematic Blossoming or Halo of the Bride), which is an alternative representation of her at her 'blossoming' (perhaps analogous to her stripping). This shape has three roughly square holes (created from photographs taken by Duchamp of three pieces of hanging black gauze altered in shape by wind or air currents) called Draft Pistons or Nets, through which the Bride telegraphs her commands to her little harem of Bachelors below, initiating sexual activity:

The motor with quite feeble cylinders is a superficial organ of the bride; it is activated by the love gasoline, a secretion of the bride's sexual glands and by the electric sparks of the stripping. (to show that the bride does not refuse this stripping by the bachelors, even accepts it since she furnishes the love gasoline and goes so far as to help towards complete nudity by developing in a sparkling fashion her intense desire for the orgasm.[17]

Collected in fragments in *The Green Box*, Duchamp's own account of the interaction of Bride and Bachelors is of necessity obscure, as ordinary language will not contain the personal mythology he is creating.

In the lower half of the *Large Glass* hover the Bachelors or Nine Malic Moulds, which are not exactly men but empty vessels, awaiting the instructions transmitted by the Bride. Illuminating Gas of unknown origin fills the Malic Moulds, who discharge it through the Capillary Tubes to the Sieves or Parasols. During this journey it solidifies to emerge broken up into Spangles. They then rise through the Sieves, which form an arch at the centre of the Bachelor Domain, drawn by the never-completed Butterfly Pump,

emerging confused, dizzy and disoriented as something akin to snow, but with the physical properties of a liquid. The Spangles are transported along spiralling Planes/Slopes of Flow on the Toboggan, which is 'more of a corkscrew' (mentioned by Duchamp but never included by him in the *Large Glass*, though its shadow might be in *Tu m'*), to the Splash.[18] With this, the operations of the Bachelors reach an end, but the Splash also effects the union of the Illuminating Gas and Scissors (balanced at the top of the Bayonet), 'dazzling' them upwards through the Oculist Witnesses (diagrams for testing eyesight) to the right of the Bachelor Domain and into the Bride's Domain to meet the nine shots (holes drilled in the *Large Glass* by Duchamp after he had marked it with matchsticks tipped with paint and fired out of a toy cannon). During this activity, the Glider (or Chariot or Sleigh) slides back and forth on runners of 'emancipated metal', singing as it does so, activated by the Waterfall powering the Water Mill attached to it.[19] Painted quite naturalistically onto the *Large Glass* like the Water Mill, the Chocolate Grinder operates according to its function and seems to have an autonomous life in the *Large Glass*, symbolic in its self-sufficiency of bachelorhood and masturbation.

This fairly literal, straight-faced description of what goes on in the *Large Glass* cannot convey the full scope of the project, which has to be experienced in the mind rather than reduced to the written word. What comes through is a pessimistic vision of disunion and enslavement to sexual desire, coloured comically by the ridiculously elaborate mechanism through which sex fails to take place. But how can an account of the operation of eroticism in the *Large Glass* be given that will be less of an attempt to understand its function through description and more of an indeterminate approach, receptive to its multifarious registers? Is there an alternative to the logic of description and definition that will bring us closer to the nature of the eroticism figured in the *Large Glass*, while preserving its swerve away from logic and allowing the *Large Glass* to retain its 'non-meaning'?[20]

Infra-mince

Some of Duchamp's work can be discussed as a kind of absurd perspective on the productivity, consumption and conservation of Western industrialised society. He expands on this idea in certain of his writings, which help create a context for his eroticism. In 1945, after years of apparent inactivity, Duchamp was the subject of a special number of the New York journal *View*, for which he designed the cover (figs.51–2). The enigmatic term *infra-mince* or 'infra-thin', with an example of its 'effect', appeared in public for the first time taking up the whole of the back of the same issue. Written in varied lettering, it mimicked the style of a ransom demand assembled from newspaper type (perhaps meant to echo the fragmentary appearance of Duchamp's scribbled notes), reading, 'When the tobacco smoke smells also of/the mouth which exhales it, the 2 odors/marry by *infra mince*.'[21] Probably

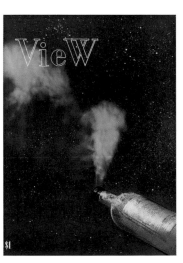

developed between about 1935 and 1945, the idea was hardly ever mentioned by him, and it was only with Duchamp's death in 1968 that his complete notes on *infra-mince* came to light and were subsequently published.

Several writers on Duchamp have argued that *infra-mince* contains a, or possibly even *the*, explanation to his work. Francis Naumann speculates 'the only ideological construct [Duchamp] might have considered a possible metaphor for his work was his own concept of "infrathin"'.[22] Yoshiaki Tono writes: 'The [*infra-mince*] notes will become a key to a new deciphering of his works . . . demanding an utterly different point of view in Duchamp studies.'[23] Juan Antonio Ramírez suggests the term should be placed at the centre of Duchamp's *œuvre*, writing of *infra-mince*: 'A systematic reorganization, seen from this perspective, of all of Marcel Duchamp's texts and works of art would doubtless provide some very interesting results.'[24] As with Duchamp's work on the whole, *infra-mince* invites overarching explanations without ever convincingly living up to them, as it is so internally inconsistent as to constitute a pseudo-theory at best. This inconvenient fact probably explains why, notwithstanding these enthusiastic endorsements of the value of the idea, *infra-mince* has garnered surprisingly little in the way of concentrated scrutiny. Apart from Tono's brief essay on the subject, its critical application to Duchamp's work has generally been given only in passing, and limited to his interest in moulds and casting and to photography.[25] Currently,

then, the significance of *infra-mince* in and to Duchamp's *œuvre* is less contested terrain than fallow ground.

In keeping with Duchamp's casual, unstructured non-methodology – a nonchalance typified by his three alternative spellings of *infra-mince* as one word, two words and hyphenated – the notes range from brief, scribbled, sometimes unfinished *aperçus* torn from the corners of envelopes (figs.53–4), to lengthy reflections using both sides of large sheets of paper headed '*infra-mince*', which appear to be the outcome of attempts by Duchamp to clarify the notion for himself. Indeed, the contemplation of *infra-mince* was fraught with difficulty for Duchamp, who expressed in a letter to his friend the writer Henri-Pierre Roché early in 1942 the awkwardness of portraying it in words without reducing it or expressing it as an essential form, writing of 'a production which is no longer manual but *coudique* (as in "elbow")'.[26] Less intellectual than intuitive, it cannot be decisively grasped as a concept, but *can* be felt. Steering clear of a restrictive presence, wholeness and totality for the idea, Duchamp avoided defining *infra-mince*, preferring instead to retain it as an open-ended category, noting, '*inframince* (adject.)/not noun – never/use as/a substantive'. For this reason, theoretical approaches that presume to gain mastery of *infra-mince* are doomed, for there will always be aspects of its 'performance' that escape such an endeavour to comprehend it in an all-encompassing way.

Duchamp's use of the term *infra*, meaning

53
Loupe pour le toucher (infra mince) 1912
Musée nationale d'Art moderne, Centre Georges Pompidou, Paris

54
Loupe pour le toucher (infra mince) 1912
Musée nationale d'Art moderne, Centre Georges Pompidou, Paris

'below' or 'beneath', was probably intended to invite comparison with scientific terminology, while, at the same time offering a kind of counter to the ascendant *sur* of Surrealism. Duchamp said later that he chose the word *mince* because it was 'a human word, emotional, and not a precise laboratory measurement'.[27] By this, he meant to allude to its colloquial usage in French phrases such as *mince comme une feuille de papier à cigarette* and *mince comme un fil* (comparable to English idiomatic phrases 'paper-thin' and 'thin as a rake'). The idea of a shortfall, failure or 'more-or-less-ness' is contained in Duchamp's term as well, for two of the Latin definitions of *infra* are 'too small for the grasp of (the senses)' and 'falling short of (a target)'.

While it is difficult to speak of a specific 'meaning' that the term *infra-mince* can encapsulate, a few examples will give a taste of its peculiar flavour. Some are concerned with the body, as when Duchamp writes: 'Velvet trousers –/their whistling sound (in walking) by/brushing of the 2 legs is an/*infra mince* separation signaled/by sound.' Elsewhere, he says: 'The warmth of a seat (which has just/been left) is *infra-mince*.' Others have a more 'metaphysical' emphasis (for want of a better word), manifesting a sense of 'slippage' – of loss, lack or infinite multiplicity – threatening at once the unity of the self and the possibility of an absolute comprehension of the world. These questions are raised by Duchamp in the *infra-mince* note reading, 'In time the same object is not the/same after a 1 second interval – what/Relations with the principle of identity?' Although the term *infra-mince* is not used in this note, its questioning of identity is closely related to another note: '*inframince* **separation** – better/than screen, because it indicates/interval (taken in one sense) and/screen (taken in another sense) – separation/has the 2 senses male and female –.' Here Duchamp unites while separating the two words 'interval' (*intervalle*) and 'screen' (*cloison*) under a single heading, the French *séparation* ('separation' or 'partition'), also taking account of the opposed genders of the two nouns (*le* for *intervalle*, *la* for *cloison*) and thus indicating the hairline fracture constituting and dividing that *inframince* word, *séparation*.[28]

Equally pertinent in what it says of a delayed identity between two is the follow-ing: 'All 'identicals' as/identical as they may be, (and/the more identical they are)/move toward this/*infra mince* separative/difference.' For Duchamp, it seems, the increasing similarity between two terms is accompanied by a corresponding *increase* in the refinement of their slim, *infra-mince* difference. The possibility of a conclusion, of arriving at identity or of perfecting *infra-mince* is promised. However, as with Achilles who constantly gains on the tortoise without reaching it, total equivalence is *infinitely delayed*.

Duchamp's 'separative distance' mentioned in the *infra-mince* notes leads on to the idea of discontinuity or separateness in eroticism in the drama played out in the *Large Glass* (and also in the peepshow of

Etant donnés). There is an obvious marker of discontinuity in both. It is taken to especially parodic extremes in what Duchamp called his 'hilarious' picture, the *Large Glass*, which he travelled to America to reassemble from June to July 1936, around the time he was thinking about *infra-mince*. But this separation is set against the promise of direct contact through stripping and mortification, closing the distance between desire and consummation. Duchamp hovers on this transgressive gap/limit (interval/screen) in the supposed 'narrative' and composition of his 'delay in glass'.

We have already seen that the notion of 'delay' is an important component of *infra-mince*, too, in the note entertaining the idea of an ever-increasing thinness achieved by means of an infinite progression. This 'delay' is mirrored in the horizontal axis around which turns the drama depicted in the *Large Glass*: the triple dividing line or Bride's Garment that both facilitates contact between the desiring Bride and the masturbating Bachelors and yet keeps them for ever separate. The Splash issuing from the Bachelors apparently travels upwards through this triple membrane of glass, yet in explaining the operation of the Bride's Garment, Arturo Schwarz describes its 'ambivalent functions' in terms echoing those of the 'screen' and 'interval' of *infra-mince*: 'On the one hand, it separates the Bride from the Bachelor and, on the other, it is the means of enabling him to reach her.'[29] Schwarz also observes, 'The very same mirror mechanism that is meant to separate the Bachelor from his Bride is also responsible for their meeting.'[30]

Other elements of the *Large Glass* support this reading of its erotic content with recourse to *infra-mince*. Already in its trailing adverb, the full title of the *Large Glass*, *La Mariée Mise à Nu par ses Célibataires, Même*, hints at its fragmentary status outside of a larger, absent discourse ('even' what?), and announces a departure from unbroken narratives and closed systems by apparently pointing to something beyond the boundary of the phrase of the title.[31]

Eroticism in later works

André Breton's lucid interpretation of the *Large Glass* with the help of the notes from *The Green Box* in his essay 'Lighthouse of the Bride' of 1934 bolstered Duchamp's reputation after a decade in which his career as an artist had either been abandoned or had slumbered while he concentrated on improving his chess. He had drawn quite close (for him) to the Surrealists by that time, and, as mentioned in the first chapter, his contributions to Surrealism would sometimes touch on eroticism. During the 1950s the Surrealists took a greater interest in eroticism and in that decade Duchamp suddenly produced a set of erotic objects that looked suspiciously like 'original' works of art after spending a quarter of a century appropriating and recycling his own work and nearly thirty years making objects that did not look much like what everybody thought was art.

The first of the set was *Female Fig Leaf* 1950

(fig.55), a three-dimensional sculpture moulded by hand in galvanised plaster from a vulva and painted pink, with versions also cast in bronze. It first came to light in 1951 when Duchamp gave one of the two original plaster versions as a gift to his old friend Man Ray, who was leaving New York for Europe. Although its title suggests an innocent and discreet object for concealing, disguising or drawing attention away from the female genitals, *Female Fig Leaf* performs the opposite function. A three-dimensional object designed, like all sculpture, to be looked at, it presents the form of the interior of a vagina in the most flagrant, literal and unambiguous way imaginable.[32]

Shortly after, Duchamp produced *Dart-Object* (*Objet-Dard*) 1951 (fig.56), also in galvanised plaster. The title of this object, which must also be given in French, contains in its pun on *objet d'art* a reference to a masculine sport, ironised by the suggested softness of the penis-like sculpture itself, as well as a further pun on *dard* (French slang for 'penis'), which speaks of male impotence.

The third in the 'series' is *Chastity Wedge* 1954 (fig.57), a hard, angular block of galvanised plaster set in the broad groove of a more gently shaped lump of dental plastic, coloured pink like flesh. Typically experimental with materials, Duchamp brought in a chess player friend and dental technician, Sacha Maruchess, to help create *Chastity Wedge*, while the English translation of the title contains a semi-rhyme on chastity/dentistry. If *Female Fig Leaf* is feminine and *Dart-Object* masculine, then the

55
Female Fig Leaf 1950,
cast 1961
Bronze
9 x 13.7 x 12.5 cm
Tate. Purchased with
assistance from the
National Lottery through
the Heritage Lottery Fund
1997

two-part *Chastity Wedge* represents both the sexual union of the genders (in its form) and their non-union (in the sexual abstinence expressed in its title). Accordingly, the piece acted as ring and gift from Duchamp to Teeny on their wedding, kept on display at home by the couple and taken with them when they travelled.[33] It is as unsentimental and idiosyncratic an expression of devotion as one would expect from Duchamp.

With this spate of new works, Duchamp played into the hands of his intrigued audience (while amusing himself) as they create or hint at potential connections within his small *œuvre*. The title *Female Fig Leaf*, for example, might remind us of the 1924 photograph of himself and artists' model Bronia Perlmutter appearing as Adam and Eve in the one-off performance of Picabia's *Ciné Sketch* (fig.58). In the same way, the use of dental plastic in *Chastity Wedge* brings to mind the enlarged, handmade *Tzanck Cheque* 1919 (fig.59), created as payment to his dentist Daniel Tzanck for services rendered, while for those prepared to play the game, its title recalls the desiring Virgin of the *Large Glass* who 'warmly rejects, (not chastely)' the Bachelors.[34]

Duchamp's use of galvanised plaster in all of these new sculptures might have suggested to his admirers in the early 1950s that something was afoot. In fact, all of these erotic works looked forward to the disclosure of his secret project *Etant donnés: 1. La chute d'eau. 2. Le gaz d'éclairage*: begun in 1946, completed in 1966, revealed after his death in 1968 and unveiled at the Philadelphia

56
Objet-dard (Dart-Object)
1951, cast 1962
Bronze
7.8 x 19.7 x 9 cm
Tate. Purchased with assistance from the National Lottery through the Heritage Lottery Fund 1997

57
Chastity Wedge 1954, cast 1963
Bronze and plastic
6.3 x 8.7 x 4.2 cm
Tate. Purchased with assistance from the National Lottery through the Heritage Lottery Fund 1997

60
Etant Donnés: 1. la chute d'eau, 2. le gaz d'éclairage 1946–66
Mixed media assemblage
242.6 x 177.8 cm
Philadelphia Museum of Art. Gift of the Cassandra Foundation, 1969

Museum of Art in June 1969. They were inspired by its uninhibited sexuality and facilitated by the skills Duchamp picked up in plaster casting while he was working on it. Indeed, two of them are offshoots of it in a way that is consistent with Duchamp's long-held penchant for salvaging, recycling and adapting elements of his own work: *Female Fig Leaf* surely refers to the open vagina displayed between the spread legs of the female figure of *Etant donnés*, while the form of *Dart-Object (Objet-Dard)* was originally part of a larger plaster support positioned under the breast of the naked figure for temporarily holding its pigskin covering in place. It broke off in that shape as Duchamp was removing the support, and as a female 'rib' used to create a sign of male impotence, *Dart-Object (Objet-Dard)* resonates powerfully with irony, carrying (for some) a further echo of the 1924 Adam and Eve photograph.

Acquired by the Philadelphia Museum of Art on its completion, *Etant donnés* stands alone in a room adjacent to the Duchamp collection and must be sought out (fig.60). When it was unveiled, it shocked the Duchamp faithful (who had swollen to considerable numbers by 1969) because it seemed so overwhelmingly visual, when Duchamp's followers had revered him since the 1950s as the artist who had provided the means whereby art could become a thing of the mind rather than the eye.

Two stages of experience are offered by the piece, each of which lays emphasis on the eye and body of the viewer. The first is chiefly a physical experience, coloured by curiosity,

58
Man Ray
Ciné Sketch: Adam and Eve (Marcel Duchamp and Brogna Perlmutter) 1924
Gelatin silver print
28.2 x 21.7 cm
Philadelphia Museum of Art. The Lynne and Harold Honickman Gift of the Julien Levy Collection, 2001

59
Tzanck Cheque 1919
Ink on paper
21 x 38.5 cm
Israel Museum, Jerusalem. The Vera and Arturo Schwarz Collection of Dada and Surrealist Art

whereby one sees and approaches across an otherwise empty, darkened room a pair of ordinary-looking wooden doors bearing two eyeholes. The second stage is an entirely solitary one and initially acutely visual, as the peephole set-up of the piece allows a kind of private viewing for one person of the scene behind the door, which consists of a naked female figure lying across some branches with legs wide apart, holding aloft a flickering *Bec Auer* gas lamp (like the one he drew around 1902) against a picturesque landscape containing a waterfall. We see her through a hole in a brick wall, which obscures part of her body, but we are insistently drawn towards her brazenly displayed vagina, along with the lamp she holds and the twinkling waterfall in the distance. Again, there is something typically Duchampian about the two registers upon which *Etant donnés* operates: discretion and concealment on the one hand, balanced against a blatant rejection of social and cultural prescriptions on the other – the delayed sting in the tail of *Paysage fautif* springs to mind.

It seems that Duchamp took inspiration for this project from his relationship in the 1940s with the sculptor Maria Martins. He had worked on the piece virtually alone for twenty years, mainly in a private extension to his studio at 210 West 14th Street, dealing with the technical problems as they arose. Several studies in diverse media exist for the nude of *Etant donnés*, made in the final version from pigskin painted on the inside, stretched over and glued to a maquette. The branches she reclines upon were collected by Duchamp and Teeny from woodland in New Jersey close to her house; the bricks for the inner wall were appropriated whenever possible from building sites in New York; and the external bricks are from the countryside close to Cadaqués, where the Duchamps spent their summers (sometimes with Salvador Dalí for company), and where Duchamp also spotted, acquired and had shipped home the large battered wooden doors through which the perplexed museum-goer spies the scene beyond. The landscape in the background of the *Etant donnés* tableau is an enlarged photograph, hand-coloured by Duchamp, of a ravine near the town of Puidoux (close to Lausanne) in Switzerland. The effect of its diminutive waterfall is created by a hidden device consisting of a light bulb set inside a *Peek Frean's* biscuit tin shining its light through a hole in the tin, which then passes through a perforated revolving metal disc so that spots of light create the convincing illusion of falling water, confirming the DIY ethic that steered Duchamp through his construction of the work.

The title *Etant donnés: 1. La chute d'eau. 2. Le gaz d'éclairage* is taken from a phrase Duchamp noted down at the time of the *Large Glass* project and included in *The Green Box*, and, because Illuminating Gas and a Waterfall were originally meant to be features of the *Large Glass*, most have seen *Etant donnés* as a kind of culmination of that project, perhaps a final stripping of the Bride.[35] If the Bachelors are present, they are

61
Gustave Courbet
The Origin of the World
1866
Oil on canvas
46 X 55 cm
Musée d'Orsay, Paris

usually thought to be either in the gas light held aloft by the naked figure (as they were receptacles for gas in the *Large Glass*) or kept apart from her on this side of the door, as the Bachelors are refused access to the Bride by the Bride's Garment.

Although there seem to be similarities between the naked figure of *Etant donnés* and those of Gustave Courbet's *Origin of the World* 1866 (fig.61) and the Surrealist Hans Bellmer's photographs of his *Doll* 1935 (fig.62), nothing is known about what Duchamp himself meant by his last major statement. Where he gave us the first 'interpretation' of the *Large Glass* (if the chaos figured in *The Green Box* can be described as such), with which all subsequent ones from Breton's onwards have had to deal, we are faced with the opposite situation with *Etant donnés*, for which we have only instructions for assembly. As he left no interpretative guide, we can only guess at its significance, piloted by his previous work.

In *Etant donnés*, writes Tomkins, 'the retinal and the idea, the appearance and the apparition, the mind and the body merge in the context of eroticism'.[36] Because Duchamp did not express an opinion on the piece, explanations like this are about the best we have at the moment. Indeed, the work has received comparatively little in the way of analysis because of the lack of interpretative leverage offered by Duchamp. Faced with the risk of losing their bearings in the infinitely wide field of interpretation left open by Duchamp with the *Etant donnés*, commentators on his work have erred on the side of

caution, preferring to say nothing.[37] Given his lack of confidence in the transposition of visual art into written interpretation, Duchamp would presumably have been satisfied by that, and by the continuing obscurity of *Etant donnés*.

Any future understanding of this work is likely to be made from the initial standpoint of eroticism, which Duchamp regarded as a liberating force, more powerful than politics, religion or ideas:

basically it's really a way to bring out in the daylight things that are constantly hidden – and that aren't necessarily erotic – because of the Catholic religion, because of social rules. To be able to reveal them, and to place them at everyone's disposal – I think this is important because it's the basis of everything, and no one talks about it. Eroticism was a theme, even an 'ism', which was the basis of everything I was doing at the time of the *Large Glass*. It kept me from being obligated to return to already existing theories, aesthetic or otherwise.[38]

As we saw, Duchamp's preoccupation with this 'ism' preceded the *Large Glass*, but it also postdated work on *Etant donnés* in the 1967–8 series of etchings entitled *The Lovers* 1968, which recapitulated erotic themes from his own *œuvre* and those of others. In these works, as in *Etant donnés*, the eighty-year-old Duchamp continued to view eroticism as a beacon of subversive, untamed provocation.

62
Hans Bellmer
Photograph of the Doll
1935

The Lovers

In 1965, with encouragement and backing from Arturo Schwarz, Duchamp returned to a medium that he had dabbled in earlier in life, producing a set of etchings on the theme of the *Large Glass*. Two years later, between December 1967 and March 1968, he confirmed the importance he placed in eroticism by preparing another set, usually referred to as *The Lovers*, this time connected in one way or another with the theme of eroticism. The sets were collected and published in two volumes in Milan as *The Large Glass and Related Works* (1967 and 1968).

Economy of expression and suppression of individual style are among the chief characteristics of *The Lovers*, delivering a bland, unadorned technique in keeping with Duchamp's detachment and air of indifference. Long satisfied with a method that set a rigid limit on 'originality', he preferred again here to work through a mode of recycling or 'appropriation' (as such strategies would be termed in contemporary art from the 1980s). This is shown in the iconography of the series, which, roughly speaking, consists of: returns to his previous output; compositions derived from advertisements; and drawing upon key works of the Western canon (though these three categories overlap). In the first group are three etchings, *Selected Details After Cranach and 'Relâche'* (1967), *The Bec Auer* and *King and Queen* (1968). The first of these was modelled on the 1924 photograph of Duchamp and Bronia Perlmutter as Adam and Eve in Picabia's *Ciné Sketch*, which pose itself mimicked Cranach's *Adam and Eve* (1528) (making the etching a representation of a representation of a representation), while the second was a schematic preview of the nude of Duchamp's then-secret project *Etant donnés* with a male figure included (taken from an advertisement, according to Schwarz), and the third largely a revisit to and modification of his 1925 *Poster for the Third French Chess Championship*. Of the two etchings based on advertisements – *After Making Love* (1967) and *The Bride Stripped Bare . . .* (1968) – the first is a naively rendered depiction of a reclining, embracing couple viewed from the waist up that Duchamp told Schwarz was taken from a photograph, and the second, less spare work, a crouching

female nude seemingly enveloped in some kind of nimbus rather like that surrounding the two nudes of an early painting *The Bush* (1910–11), though its title is obviously meant to recall the various Brides of Duchamp's *œuvre*.

The other etchings of *The Lovers* all pick out and erotically recontextualise elements from Old Master works of art, which seems at first an unexpected move by this arch iconoclast and enemy of 'retinal art.' However, we soon see what Duchamp was up to, as nearly all of the original works were around a hundred years old by the time he 'requisitioned' details from them, updating their erotic imagery to align it with the sexual revolution of the 1960s. In *Selected Details After Courbet* (1968), Duchamp sketches in outline the female figure from Gustave Courbet's *Woman with White Stockings* (1861), adding in the foreground a falcon, as he described it to Schwarz, who then notes the French pun on *faucon/faux con* (false cunt), which again anticipated the unveiling of the nude of *Etant donnés* and adds credence to the idea that Courbet's *Origin of the World* lay behind that last work.

Almost coincident with the major Ingres centenary retrospective that took place at the Musée Petit Palais in Paris from October 1967 to January 1968 (which Duchamp could not have attended because he never left New York during this period), two of the etchings, *Selected Details After Ingres, I* and *Selected Details After Ingres, II* (1968), took from that artist's work. In the first (signed with a new pseudonym, 'Marcellus D.'), the neck of the lute of the figure in the centre foreground of Ingres's *The Turkish Bath* (1863) becomes the lengthy phallus of Virgil who is derived from the same artist's *Virgil Reading the Aeneid* (1812), flipped back to front in Duchamp's version and stripped naked. The other etching combines details from *The Turkish Bath* and *Oedipus and the Sphinx* (1864), essentially extending Oedipus's gesture in Ingres's painting to its logical next (sexual) stage. The teenage fumblings of the characters that were conscripted from Ingres in *The Lovers* are continued in *Selected Details After Rodin* (1968), in which Rodin's hackneyed old masterpiece *The Kiss* (1886) undergoes the same fate as Leonardo's *Mona Lisa* had in

63
*Selected Details After
Rodin* 1968
Etching
35 x 24 cm

Duchamp's *L.H.O.O.Q.* of 1919, casually elbowed off its pedestal by a minor though amusing and telling modification. In this case, the right hand of the male figure of *The Kiss* is shifted by Duchamp from the outside of the female's left thigh and redirected to rest between her legs, which, he said to Schwarz, 'must have been Rodin's original idea. It is such a natural place for the hand to be.'

Although Duchamp's reputation rests partly on his pioneering use of materials, no one would argue that his deployment of medium was in any way innovative in *The Lovers* etchings. Nevertheless, in their amusing adjustments made to great works of the Western canon, they offer a confirmation from the last year of the octogenarian Dada's life that fifty years after his watershed decision to give up painting he remained unrepentant, and as keen as ever to take a dig at the French artistic and cultural tradition, here from the position of eroticism.

Today painting is held in lower esteem than it was in the early twentieth century, due in large part to Duchamp's example. As the artist can now choose between so many mediums, including painting, we are less surprised by Duchamp's legendary decision in 1912 to abandon his career as a painter than his contemporaries were. Asked endlessly about his renunciation of painting, Duchamp sometimes said he had run out of ideas, but he also spoke repeatedly of his wish to replace the 'retinal' in art with 'grey matter'. His conversion from the visual (art that stopped at the eye) to the conceptual (an undetermined practice focusing on ideas) opened up an immense field of exploration for him, most of which was not then called 'art', and much of which continues to be questioned as such today.

Although most writers believe Duchamp was an artist doing art all along, even when he pretended not to be, this is an anachronistic view. It relies on a contemporary definition of what art is today – in its expanded, post-Duchampian sense – into which it then retrospectively puts his work. An alternative view, anachronistic in a different way, is that, while Duchamp was not creating art in his own day, from our own different perspective, he was (or, to put it more paradoxically: he was not doing art then, but now he was). However, in its baffling variety and refusal to take itself seriously, much of his activity continues to resist the label 'art' (his optical experiments, for instance), leading some art historians to make sense of an *œuvre* that does not seem to fit neatly into the obvious category of 'art' by turning to others, such as alchemy and science (without, however, relinquishing it as 'art'). To some, these headings have offered a means of discussing Duchamp's work in its totality: he was an artist doing alchemy, or he was an artist doing science. This chapter looks at Duchamp the alchemist/scientist, who professed, in fact, little interest in the first, and much in the second.

Duchamp, alchemist?

Alchemy is often regarded as a primitive form of chemistry whose practitioners sought to transmute base metals (lead) into gold by means of the Philosopher's Stone. However, the broader and truer sense of the alchemical quest is more akin to a religious or philosophical attitude towards life, or in today's parlance, a means of self-development, which we might associate with some schools of psychology. The transformation of something mundane and without value into something else of great worth then becomes less a set of chemical formulae than a metaphor for the self, through the 'purification' of which one attains a higher level of perception, discernment and understanding. Today, alchemy is interpreted by academics and others largely through the writings of Carl Jung, for whom it became such a fascination that he explored the relations between alchemical symbolism and analytical psychology at length in three books,

4 Alchemy and Science

It is only shallow people who do not judge by appearances. The true mystery of the world is the visible, not the invisible.
Oscar Wilde, *The Picture of Dorian Gray*, 1891

Alchemical Studies (1929–54), *Psychology and Alchemy* (1944), and *Mysterium Coniunctionis: An Inquiry into the Separation and Synthesis of Psychic Opposites in Alchemy* (1955–6). Alchemy was an area of study and speculation within Surrealism at about the same time Jung was writing about it, though it is not particularly easy to find a causal connection between the two.[1]

Alchemy is usually perceived as a historical category with its origins in ancient Egypt and period of major activity in the Middle Ages (particularly in the tenth and eleventh centuries) extending into the Renaissance, even though it was still practised and theorised in the eighteenth century, by Isaac Newton among others.[2] It was partly the success of Newton's other research into the behaviour of moving bodies, creating science as we know it today, that diminished alchemy and transformed it in the popular imagination into a pseudo-science (though it had always had its detractors), revived but not rescued by the vogue for esotericism and the occult in the nineteenth century. Its high visibility in the Middle Ages and Renaissance is reflected and confirmed in its canonical figures and in the illustrations that accompany books on the subject, which are almost always lifted from those historical periods. Although most would say alchemy is something which academics and novelists write about but which is no longer practised, there are those who see it a viable activity in the modern age.[3]

Duchamp was not among them, though his interpreters are. Famously, when asked by Robert Lebel if he was doing alchemy, he replied dryly and unequivocally: 'If I have practised alchemy, it was in the only way it can be done now, that is to say without knowing it.'[4] In the absence of a straight 'no' on that, writers on Duchamp, led by Robert Lebel and followed most notoriously by the editor of the *Complete Works*, Arturo Schwarz, have decided that he was indeed practising alchemy without knowing it (unconsciously, that is, opening the floodgates to psycho-analytic theses as well), and have conse-quently felt authorised to see his work as one big alchemical text. To a certain extent, this is to be expected, given the nature of alchemical writings and their interpretation:

Though full of promises, these texts invariably contain elaborate devices to deter the unworthy. They are couched in a language often so obscure and so impenetrable that their study requires years and years of devoted attention, of reading and re-reading, before their exegesis may even be attempted. For secrecy is inextricably woven into the fabric of alchemy, and is still invoked by modern alchemists.[5]

It is not surprising, then, that the puzzling and elusive surface of Duchamp's work leads to the belief in a more cogent underpinning, as is the case with alchemy; nor that Duchamp is regarded by several writers as the alchemist of the avant-garde.[6]

This strand of scholarship on Duchamp, hinted at in Lebel's suspicions, has been traced back to Surrealism's fascination with

the occult in the 1940s and 1950s.[7] In spite of two further post-Lebel remarks by Duchamp denying knowledge of, or indeed interest in, alchemy, it found sustenance in a discovery made by Ulf Linde, one of the first of the new wave of Duchamp supporters in the post-war period.[8] In the late 1960s, Linde came across a drawing in a recent book about alchemy, originating in an alchemical treatise by the philosopher Solidonius, of two men apparently undressing a woman (fig.64), which bore a strong thematic resemblance to one of the most important of Duchamp's Munich drawings prefiguring the *Large Glass* (fig.65).[9] Although the Duchamp scholar Jean Clair later showed the figure in the drawing to be not a woman but a male hermaphrodite, Linde's finding was regarded at the time as providing further proof by those who believed that Duchamp had constructed his body of work on alchemical principles.[10]

A few years later, a remark made by the artist Robert Smithson in a critical interview about Duchamp added fuel to the flames of the *vas hermeticum*. Smithson reports saying to Duchamp on the one occasion he met him at the Cordier & Ekstrom Gallery in New York in 1963, 'I see you are into alchemy,' to which Duchamp replied (again, unequivocally), 'Yes.'[11] One of the great curiosities of the Duchamp literature, this exchange will always go unsubstantiated, as Duchamp had died five years before Smithson's interview and Smithson himself died soon after it (before it was published in the journal *Artforum*, without his edit). By then, the alchemy theory had gained considerable ground, mainly because of the writings of Schwarz and Jack Burnham.

Schwarz is rightly celebrated as the author of the remarkable and invaluable *Complete Works*, one of a handful of absolutely indispensable books on Duchamp. It comes with a personal interpretation of Duchamp's work, freely combining without irony a variety of flotsam and jetsam recovered from alchemy, Freudian psychoanalysis, Jungian psychology, Western religion, Eastern mysticism, Egyptian hieroglyphs, Gnosticism, Greek mythology, philosophy and sundry other more or less esoteric branches of knowledge and learning, into a theory grounded in what Schwarz claims was Duchamp's incestuous passion for his sister, Suzanne.[12]

In a shorter version of the same reading focusing solely on alchemy, Schwarz views Duchamp as a wielder of alchemy in the service of the reconciliation of contradictions.[13] The key work is *Young Man and Girl in Spring* 1911 (fig.66), in which this theory views the incestuous, '"chymical nuptials" between mercury (the female, lunar principle) and sulphur (the male, solar principle)' as the symbolic unification of opposites, giving 'an esoteric dimension of universal significance to some of the basic patterns underlying Duchamp's *œuvre*',[14] though these 'patterns' are 'entirely unconscious'.[15] The Marcel/Suzanne couple of the *Young Man and Girl in Spring* are said to be enclosed in a Y-shaped form (the alchemical symbol of immortality) reaching up towards a tree (both alchemical

64
Alchemical illustration by Solidonius from *Alchemie: Etudes diverses de symbolisme hermétique et de pratique philosophale* by Eugene Canseliet.

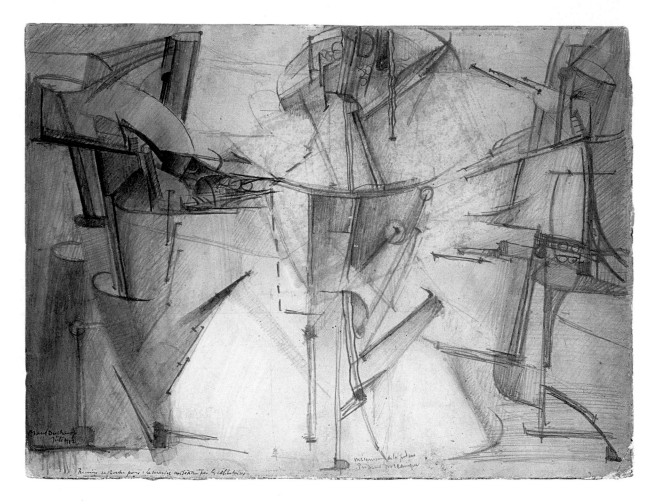

65
First study for the Large Glass 1912
Pencil and wash on paper
23.8 x 32.1 cm
Musée nationale d'Art moderne, Centre Georges Pompidou, Paris

66
Young Man and Girl in Spring 1911
Oil on canvas
65.7 x 50.2 cm
Israel Museum, Jerusalem. The Vera and Arturo Schwarz Collection of Dada and Surrealist Art

Tree of Life and Tree of Death) and arranged around a 'transparent glass sphere' (an alchemical vessel, Schwarz maintains, containing the hermaphrodite and symbol of the unity of opposites, Hermes/Mercurius).[16]

This alchemical interpretation is extended further through the identification of more alembics in the two Munich paintings *The Passage from Virgin to Bride* and *Bride*, and by means of the idea that Duchamp's selection of readymades was meant to show that art can be made by anyone and that they therefore herald 'the nonalienated man of the future' and represent 'the end result of the successful quest for the Philosopher's Stone'.[17] Leaning heavily on Jung, Schwarz sees the three stages of the alchemical process (*nigredo* or blackening, *albedo* or whitening and *rubedo* or purpling) among the multifarious operations of the *Large Glass*. He even argues that *The Green Box* 'provided us with another clue to the meaning of the *Glass*' where Duchamp writes in one note of 'a world in yellow', which Schwarz calls a 'mental [not physical] tincture to transmute the transparent, neutral colour of glass into the yellow colour of the philosophical gold' (thus avoiding the inconvenient fact that the *Large Glass* itself is *not* yellow).[18]

Schwarz introduced his elephantine reading by way of a lecture at the Institute of Contemporary Arts, London in June 1968 with Duchamp in attendance. As accepting as ever, in public, of virtually any and every theory of his work, Duchamp played the old man on the day (it was the last year of his life), claiming not to have heard the lecture properly, yet he said later it was *by* Schwarz rather than *about* Duchamp.[19]

Schwarz's writings provided the most extraordinary introduction to Duchamp until Jack Burnham came along with two articles on the *Large Glass*, which appeared in *Artforum* in 1971 and were later republished elsewhere.[20] It is almost impossible to capture in précis Burnham's acrobatic interpretation, such is the freedom and ingenuity with which it draws upon the hermetic literature and the unrestrained liberties it takes in attaching it to suitable-sounding bits of Duchamp's *œuvre*. For Duchamp's notes, he contends, are imbued with mysticism, with 'various roots in Gnosticism; in the occult religion of Egypt; the Orphic mysteries of Greece; the cabalistic studies of the Jews; the Masonic Orders; and, in the East, in the doctrines of Tantric Buddhism and the Golden Flower of Taoism'.[21] He writes that, in his early twenties, Duchamp was led through 'self-study' to refer to 'alchemical procedures', though he maintains his iconography and terminology are more dependent on the cabala.[22] In this light, his wordplay is seen as a cabbalistic conveyance of the 'inner structures of creativity'.[23] Asserting that 'readymades use the powers of the letters [of the Hebrew alphabet] in producing art yet to be made', Burnham continues:[24]

In alchemy Sol (sun) and Luna (moon) represent the King and Queen, those two polarities which spiritually merge in order to complete the alchemical process. This last process is facilitated

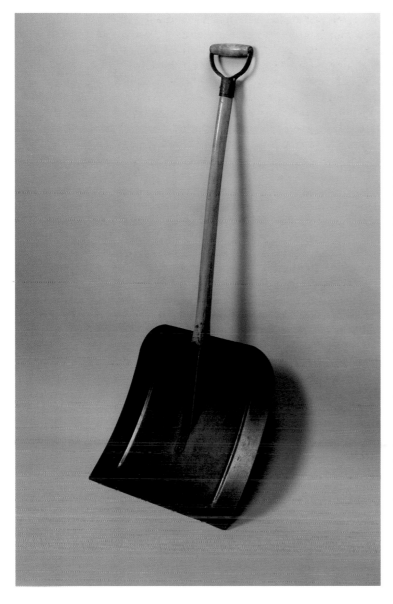

67
In Advance of the Broken Arm 1963 (replica of 1915 original)
Wood and galvanised-iron snow shovel
109 x 42 x 14.6 cm
Moderna Museet, Stockholm

by the use of the alchemical Salt, and it is here that one must not forget that in the 1950s Marcel Duchamp adopted the phonemic inversion of his name, *Marchand du sel* (merchant of salt), as the title for his published writings. This lends credence to the possibility that the readymades were, indeed, the Salt that Duchamp used and traded freely to those artists with the wisdom to understand their meaning.[25]

No evidence has emerged to suggest that Burnham's writings on Duchamp are ironic, meant to undercut interpretations of Duchamp such as that by Schwarz, and it is unlikely that he means this as a parody of an art historical reading, as it is *too distant* from good theory to work as such (a successful spoof must be very close to the quality of a genuine text to pass as one). We must therefore take such assertions as these for what they are: a genuine attempt to decode Duchamp's secret hermetic purpose.

Where Schwarz spotted alchemical alembics among Duchamp's work, Burnham sees a similarity between *Bottle Rack* and the alchemist's oven, leading to the claim that it is 'a miniature representation of the alchemical universe'.[26] His reading associates *Bottle Rack* with Earth, Air, Wind and Fire, because 'the central idea of alchemy and Cabala revolves around the relationships between the four primal elements'.[27] It goes on to draw in several other readymades with the same goal in mind, declaring that Duchamp's use of a green ink to date and sign a version of *Bicycle Wheel* in 1951 indicates its association with Earth, while the snow

shovel *In Advance of the Broken Arm* (fig.67) alludes to 'the conjunction of WATER and EARTH that produces Cold'.[28]

This analysis advances into a holistic interpretation with its claim that Duchamp's name for his alter ego, Rrose Sélavy, is a 'neologism for Rose-Cross, symbol of the great synthesis, the alchemical androgyne, that which will bring about the culmination of the alchemical process', and its further inclusion of the *Large Glass* in its scheme.[29] It draws attention to the French title of the *Large Glass*, *La Mariée Mise à Nu par ses Célibataires, Même*, divided into eighteen and nineteen letters, insisting the first 'reflects the eighteenth Arcanum of the Tarot, The Moon' (the Bride) while the second 'signifies the first physical beginnings of regeneration through the male Sun' (the Bachelors).[30] The lower, Bachelor half of the *Large Glass* is 'an interpretation of the cabbalistic Tree of Knowledge as the secret unwritten Cabala describes the evolution of art', which is then demonstrated at length through detailed scrutiny of each of its individual constituents, supported with reference to appropriate cabbalistic diagrams.[31] The Bride as *Pendu femelle*, by contrast, is connected to the Hanged Man, the twelfth Major Arcanum of the Tarot, and, although Burnham says, oddly, 'Visually and iconographically, she has no meaning,' he continues his treatment of the remainder of the Bride's Domain by analogy with cabbalistic literature, triangulated with the notes for *The Green Box*.[32] Burnham's notion that through his identification of the *Large Glass* in his notes as an 'Agricultural Machine' and 'Apparatus/instrument for farming', Duchamp covertly 'refers to one of the crucial properties of hermetic Fire' – when surely Earth would be the more obvious of the four elements to read into Duchamp's typically obscure note – gives a fair insight into the freedom allowed this kind of deductive logic.[33]

Although readings of Duchamp's work through alchemy were heavily criticised in the 1980s, they have never really gone away, and recent publications dealing with the theme are, in fact, extensions of writings that first appeared in that decade.[34] David Hopkins is right to argue that previous claims for Duchamp's hermeticism have been hampered by their 'failure to establish a plausible historical context or reason for such apparent adherence to arcane belief systems, given Duchamp's anti-dogmatism and systematic scepticism'.[35] Consequently, he goes on to argue for Duchamp's probable awareness of the Rosicrucian-Symbolist climate of the 1890s, and claims he might have known of a book by the Viennese psychologist, Herbert Silberer, *Probleme der Mystik und ihrer Symbolik* (1914), which discusses symbolic parallels between alchemy and Rosicrucianism in the framework of psychoanalysis. This is a shrewd and erudite reading, weaving an account of alchemy, Rosicrucianism and Catholicism with the relevance of the bride motif in Symbolist painting – with special attention given to Jan Toorop's *The Three Brides* 1893 and Johan Thorn Prikker's *The*

68
Johan Thorn Prikker
The Bride of Christ 1892–3
Rijksmuseum Kröller-Müller, Otterlo

Bride of Christ 1892–3 (fig.68), offering another theory of the *Large Glass* meant to be watertight, with Catholicism and Duchamp's critique of the ideological construction of 'woman' as the formerly 'missing pieces'.[36]

Taken individually, the various cultural threads indicated in Hopkins's work do not seem to bear particularly close connection to Duchamp, apart from his early knowledge of Symbolism, shared with every other member of the avant-garde of his time. We have seen Duchamp repudiate the alchemy thesis; any link between Duchamp and Rosicrucianism, which drew part of its symbolic language from alchemy, is difficult to accept without any clear evidence; even more so the sub-links suggested by Hopkins with the cell of French Symbolists led by Sâr Péladan, whose members blended Catholic and Rosicrucian ideas in their work, and to which Toorop can be attached due to a brief collaboration with Péladan; and Duchamp's disinterest in religion is a memorable feature of several interviews and remarks.

Hopkins cannily gives amplified relevance to each by weaving them together as a set of mutually resonant issues: Duchamp's knowledge of Symbolism and Rosicrucianism lend themselves to an iconography critical of a resurgent Catholicism in the period, he claims, via the 'mystical bride' of the Munich paintings *The Passage from Virgin to Bride* and *Bride*, as well as the Bride of the *Large Glass*. These themes are unified in a single feature of Duchamp's various brides; where Burnham compared the shape of *Bottle Rack* with the alchemist's oven, Hopkins follows Schwarz in detecting a clue to the meaning of the *Large Glass* in the object to the centre-right of the organic forms of the two Munich paintings and the Bride of the *Large Glass*. This is the 'sex cylinder' (fig.69), which is matched in this reading with a piece of alchemical apparatus (a diagonal stem ending in a globe shape) like the glass object in the painting by Joseph Wright, *The Alchemist* 1771 (fig.70). To this are added structural similarities noted before between, on the one hand, the two Domains of the *Large Glass* and two-tier Renaissance paintings of the Assumption and Coronation of the Virgin above and donors below, as in Raphael's *Coronation of the Virgin c.*1503 (fig.71) and Titian's *Assumption of the Virgin* 1516–18, and, on the other, the multi-level composition of a sixteenth-century alchemical diagram, bearing certain shared themes.[37]

Duchamp's persistent appeal to the 'beauty of indifference', his pleasure in sustained contradiction (not dialectical union), and even his anti-dogmatism and scepticism are put to one side in this interpretation, and the figure of the Bride generally and the *Large Glass* specifically emerge with a metaphorical purpose, and are viewed as having a fairly straightforward intention. The *Large Glass* becomes a polemic against both Cubism and Catholicism, ironising Descartes's mind-body dualism with reference to alchemy's 'unification of opposites' thesis (high and low, male and female, sun and moon), which 'constituted a kind of ironically "spiritual" mechanics',

69
Bride (detail) 1912
Oil on canvas
89.5 x 55.6 cm
Philadelphia Museum of
Art. The Louise and Walter
Arensberg Collection,
1950

70
Joseph Wright
The Alchemist 1771
Derby Museum

deconstructing (as does the *Bride*) the 'male gaze' by satirising what Hopkins regards as Cubism's gendered language of the 'dissection' of the human form.[38]

Again, irony seems to be absent from this closed account of the *Large Glass* and associated works (or it is at least undeclared and difficult to detect), which would have allowed it to be read as a riposte to previous, less astute outings of the alchemy thesis. Indeed, while they wield alchemy's rich resources in different ways, all these readings lack plausibility, mainly because there is no evidence that Duchamp was initiated into the secret art and because of an absence of either relevant or convincing historical or cultural context for Duchamp's knowledge of, or attraction to, alchemy. But beyond these objections is the one about the sheer *ease* with which the sufficiently informed reader can link selected elements of substantial religious, philosophical or psychological systems to individual components of Duchamp's work, which itself has an endlessly suggestive diversity. Like conspiracy theories, such overarching deductive theories lack falsification criteria, becoming *less* convincing with the application of each anxious layer of unfalsifiable but also unprovable speculation.

However, Duchamp had only himself to blame if readings of his work by Schwarz and others close to him were implausible, as he had for many years associated with overly credulous individuals. André Breton, for example, had a lengthy track record of far-fetched theorising, well before he

unwittingly based his portentous alchemical interpretation of Raymond Roussel's play *Sun-Dust* (1927) on an error made by the writer Jean Ferry in the 1940s.[39] And Duchamp's patron Walter Arensberg had a fascination with cryptography, keeping himself and several researchers occupied for years attempting to 'prove' Shakespeare's plays were written by Francis Bacon.[40] Duchamp was sceptical not only of Arensberg's enthusiasms, but also of comparable efforts at 'behindology':

DUCHAMP He had a fantastic hobby: cryptography, which consisted of finding the secrets of Dante in the *Divine Comedy*, and the secrets of Shakespeare in his plays. You know the old story: who is Shakespeare, who isn't Shakespeare. He spent his whole life on it . . . Then he founded a society, the Francis Bacon Foundation, or something like that, to prove that it was really Bacon who had written Shakespeare's plays.

His system was to find, in the text, in every three lines, allusions to all sorts of things; it was a game for him, like chess, which he enjoyed immensely. He had two or three secretaries working for him.

CABANNE Was his research really scientifically valuable?

DUCHAMP I don't believe so. I think it was mostly the conviction of a man at play: Arensberg twisted words to make them say what he wanted, like everyone who does that kind of work.[41]

71
Raphael
The Coronation of the Virgin c.1503
Oil on canvas
267 x 163 cm
Vatican Museum, Rome

Duchamp's friendship with individuals with a penchant for conspiracy theory such as Arensberg may have paid dividends in gaining visibility for his work and encouraging discussion of it, but sometimes it came at a price, as in the case of Schwarz's strained alchemical interpretation accompanying the *Complete Works*.

A subtler version of the Duchamp-alchemy relation is given by John Golding. Rather than setting out to prove that Duchamp was an alchemist or even that he read much about alchemy, Golding takes into account Duchamp's wit and unaffected intellect, observing that the 'machines of alchemy, the mills, the distilling apparatuses and the primitive furnaces, were . . . of a type that would have amused Duchamp and stimulated his imagination'.[42] Alternatively, he points out that Duchamp could well have been taken pleasantly by surprise at the correspondences that can be made to exist between alchemical theory and apparatus and his *Large Glass*.[43] Of his disclaimer to Lebel about practising alchemy, Golding writes:

it is possible that Duchamp's denial arose from the fact that he was reluctant to have too much read into his art; quite obviously it was an art of extraordinary depth and subtlety, but he was anxious that each spectator should extract from it what he wished and he knew that any hard and fast explanation of the *Large Glass* was not only impossible but that an attempt to produce one could only serve to kill any true contact between himself and his viewer.[44]

Golding's lighter touch strikes a chord with our knowledge of Duchamp, his practice and his body of work. In its openness, motivated by a reluctance to close the issue, this reading comes across as more persuasive, ironically, than those aiming to convince through sheer weight of circumstantial evidence. Those are symptomatic of the academic art history of our own time, which aims to pin down Duchamp's elusive work by analysing it in a way that provides neat conclusions and by turning to alchemy's vast and amenable resources as a convenient means of consolidating such interpretations.

Duchampian science: 'playful physics'

Apart from one or two popular books on alchemy that were available to him, it is difficult to make a convincing case that contemporary events or sources might have motivated Duchamp to think about alchemy around 1912, let alone make him start acting like an alchemist. This is emphatically not the case for the physics, chemistry, geometry and technology of his day, to which Duchamp consistently acknowledged a debt in his writings and interviews, and which also shed light on alchemical, occultist and even psychical components in his work.[45] Predating the Theory of Relativity and quantum mechanics, the science and technology of the period of Duchamp's paintings, the *Large Glass* and the readymades were those of the electron, radioactivity, electromagnetism, thermodynamics, the ether, the automobile, wireless telegraphy and the X-ray. Before Einstein and the Young

Turks of quantum mechanics arrived on the scene and revolutionised our understanding of nature after the First World War, artists would have read of the discoveries and theories of Sir William Crookes, J.J. Thomson, Ernest Rutherford, Henri Poincaré, Marie and Pierre Curie, Jean Perrin and Gustave Le Bon. These scientific ideas influenced Duchamp and enter into his work, especially the *Large Glass*, in complex ways, overseen by a light-hearted irony that Duchamp characterised as 'playful physics'[46] or the creation of a reality made possible '*by slightly distending* the laws of physics and chemistry'.[47]

Indeed, research on the scientific context for the *Large Glass* can actually shed light on the alchemical component of Duchamp's work. The discovery of the emission of energy by radioactive substances and their subsequent transformation into other elements was a source of widespread excitement and debate in the first decade of the twentieth century, when comparison was frequently made between that process and the alchemical dream of the transmutation of base metals into gold. Sâr Péladan discussed radioactivity from the standpoint of occultism and alchemy, arguing that the rays given off by human beings offered a kind of occultist explanation for human behaviour on both the 'spiritual' and social levels. If this sounds like pure speculation, then scientists were at it too. Both the physicist Ernest Rutherford and the chemist Frederick Soddy compared the chemical change of radioactive substances to

alchemical transmutation, and eventually even referred to alchemy in their scientific writings.[48] There was even a group, the Société Alchimique de France, active in the last decade of the nineteenth century and the first decade of the twentieth, which based some of its theory and writings on recent discoveries in chemistry, led by François Jollivet Castelot, who was known to the Puteaux circle of Cubists.[49] If such knowledge did inspire Duchamp to investigate alchemy, then it is inseparable from the broader context of the science of the day, specifically, the popular reception of radioactivity.

The earlier discovery of X-rays by Wilhelm Conrad Röntgen in November 1895 had a huge impact throughout the world. It was discussed and elaborated in newspapers, popular books, novels and films, as well as in scientific articles, where X-rays were often seen to have implications for research into telepathy and spiritualism. Many artists sought new relevance for painting, which had been challenged by photography since the mid-nineteenth century, and Duchamp was among those who turned to science for a lead in depicting that which lay beyond the visual. In this, he was probably spurred on by the Czech artist František Kupka (1871–1957) whose interest in X-rays before 1910 derived from his speculations about invisible, alternative realities, appropriate to one who was also a practising medium and Theosophist. Linda Dalrymple Henderson sees this interest in Kupka's *Planes by Colours, Large Nude* 1909–10 (fig.72), 'in which the

72
František Kupka
Planes by Colours, Large Nude 1909–10
Oil on canvas
150.2 x 180.7 cm
Solomon R. Guggenheim Museum, Gift,
Mrs. Andrew P. Fuller

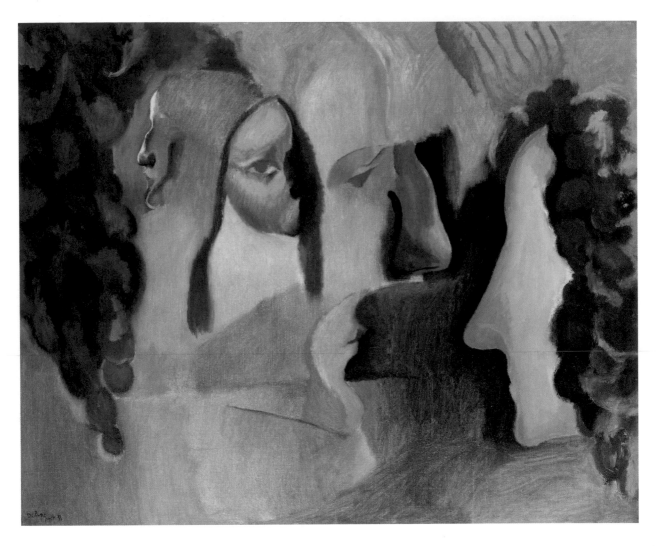

73
*Yvonne and Magdeleine
Torn in Tatters* 1911
Oil on canvas
60.3 x 73.3 cm
Philadelphia Museum of
Art. The Louise and Walter
Arensberg Collection,
1950

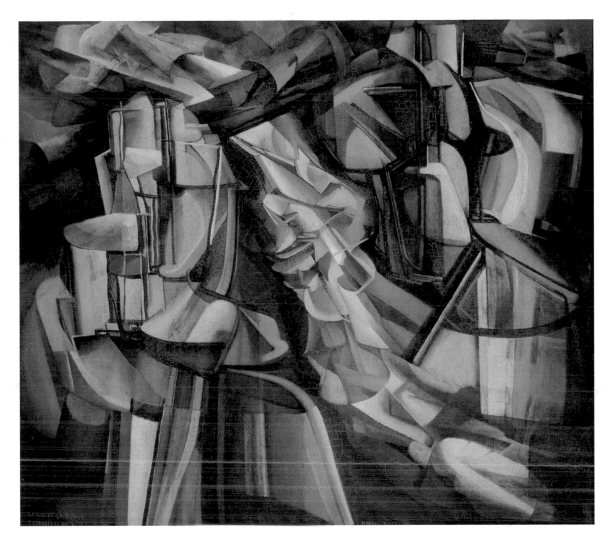

74
The King and Queen Surrounded by Swift Nudes 1912
Oil on canvas
114.6 x 128.9 cm
Philadelphia Museum of Art. The Louise and Walter Arensberg Collection, 1950

right leg of the figure is painted as if it were X-rayed in contrast to the "sensual" pink flesh modelled by visible light on the nude's left side'.[50] She argues that Duchamp's first response to X-rays is evident soon after in the painting *Yvonne and Magdeleine Torn in Tatters* 1911 (fig.73), where the darkened nose of Magdeleine second from the left reflects the triangular gap evident in X-rays, which pass through and fail to register the cartilage of the nose. In this light, the popular joke in cartoons and songs about the capacity of X-rays to strip bare passers-by has a resonance for Duchamp's imagery and iconography, beginning with *Portrait (Dulcinea)* of 1911. Duchamp's response to science at one remove for *Portrait (Dulcinea)* – filtered through a popular sensibility – compares with his slightly later reception of science as stage-managed in the writings of Raymond Roussel and Alfred Jarry, each of whom used contemporary science and technology in the service of fantastic narratives.[51]

Both Duchamp and Kupka seem to have lost interest in X-rays quite quickly, though the impact of the invention on Duchamp's 'middle period' paintings would have implications for his later work. His curiosity about science shifted in 1912 to electrons, electricity and radioactivity. Electrons were discovered in 1897 by J.J. Thomson and soon gave rise to a lively field of popular literature in which they were presented as the fundamental component of matter, travelling through space at inconceivable velocities. Sometimes electrons were ridiculously anthropomorphised, as in a 1908 essay in

Mercure de France, where they are personified as whirling, dancing fairy-like beings in the employment of royalty, and this could well have been the source for imagery in Duchamp's *King and Queen Surrounded by Swift Nudes* 1912 (fig.74) and its accompanying studies.[52] The invisible, rapidly moving electrons and kinetic theory regarding the behaviour of gas molecules that entered the public sphere in the first decade of the twentieth century seem also to lie at the origin of Duchamp's language and imagery of ballistics, scattering and collision that extends from this point through the project of the *Large Glass*.

Duchamp's take on wireless telegraphy, a technology that had evolved slowly since the late 1890s, was as idiosyncratic as one would expect. The medium was associated closely in France with the Eiffel Tower, which Gustave Eiffel had attempted to transform into a huge transmitter as one way of justifying its existence, though it had long been a beacon of modernity for modernist painters and poets such as Georges Seurat, Guillaume Apollinaire, Robert Delaunay and Fernand Léger, who all featured it in their work. Duchamp wanted to incorporate elements of electromagnetic frequency and wireless telegraphy into the *Large Glass* as the means by which communication could be established between the Domains of the Bride and the Bachelors. With its language of sparks, vibrations and oscillations, the terminology of electricity was suitable to the erotic theme of the *Large Glass*, and Duchamp exploited this to the full in the linguistic

75
Cols alités 1959
Pen and ink and pencil on paper
32 x 24.5 cm
Collection of Jean-Jacques Lebel

links he created in the notes for the *Large Glass*. In 1959, he hinted strongly at the importance of electricity to the concept of the *Large Glass* with the drawing *Cols alités* (fig.75), an ironic title punning on 'causality' but translating as 'bedridden mountains', which features an image of the *Large Glass* with a telegraph pole incorporated into its design. The language and imagery of electricity and telegraphy suggest the animating force by which the machine of the *Large Glass* jolts, sparking and juddering, into life, like something out of a silent movie. However, Duchamp probably also had in mind ideas about telepathy as a purveyor of communication analogous with Herzian waves in the popular and specialist literature, both of which were excited by the possibilities offered to psychic research by contemporary science.

The fourth dimension

In spite of the knowledge necessary to carry out his mild undermining of science, Duchamp claimed little awareness of science and mathematics in his late interviews with Cabanne, presumably meaning by comparison with scientists and mathematicians.[53] In fact, it is long established that, during the time he was working on the ideas for the *Large Glass*, he was gaining some understanding of the fourth dimension and non-Euclidean geometries by reading not only the great French mathematician and scientist Henri Poincaré, but also Gaston de Pawlowski, who wrote *Voyage au pays de la quatrième dimension* (1912) and Esprit Pascal

Jouffret, author of *Traité élémentaire de géométrie à quatre dimensions* (1903). As Duchamp mentions both Poincaré and Jouffret among the many notes of *The White Box* concerned with speculation about higher dimensions, and Jouffret himself refers to Poincaré, Charles Howard Hinton (who wrote *What is the Fourth Dimension?* of 1883) and Edwin A. Abbott (author of the much-loved *Flatland: A Romance of Many Dimensions* of 1884), there is plenty of evidence that Duchamp's interest in the fourth dimension and various geometries made their way into his work around the time of the *Large Glass*.

Jouffret's writings might have become interesting initially to Duchamp through the analogy they draw between the way a scientist might visualise the fourth dimension and the ability of a blindfolded chess player to conduct a number of simultaneous games of chess. In his notes, Duchamp cites Jouffret in direct relation with what Henderson regards as 'an idea basic to his final conception of the Bride of the *Large Glass*',[54] when he says: '*The shadow* cast by a 4-dim'l figure on our space is a *3-dim'l* shadow (see Jouffret "Géom. à 4 dim." page 186, last 3 lines.).'[55] By this, Duchamp means that, just as two-dimensional shadows are cast by objects in three-dimensional space, so three-dimensional objects could be thought of as shadows cast by objects in four-dimensional space.

Because he said later of the post-Munich canvas *Bride* 1912 that 'he could glimpse for the first time the emergence of a "fourth dimension" in the background of the work',

we can say of that painting that it was an extrapolation of the fourth dimension as a means of going beyond the 'retinal', three-dimensional.[56] Duchamp confirmed this idea for his subsequent work, saying, '"The Bride" in the *Large Glass* was based on this [idea], as if it were the projection of a four-dimensional object'.[57] Distinct from the lower, Bachelor Domain, which is structured on classical, three-dimensional perspective, the Bride is a projection from another kind of space entirely, existing in 'an unmeasured and, ultimately, immeasurable space'.[58] Duchamp's thinking about how to create such a space is one of the most important features of *The White Box* notes, which discuss architectural diagrams, glass, mirrors, shadows, hinges, moulds, photographic negatives and flat two-dimensional beings. These perambulations on the fourth dimension remained as unresolved as the *Large Glass* itself, yet the two operate together indispensably, as the notes give us an idea of how the project began and developed, how the *Large Glass* came to be what it is and the initial means by which it might be accessed imaginatively by a sufficiently curious individual.

A new, holistic scientific theory comparable in its sweeping invention to the alchemy hypotheses emerged at the end of the 1990s, weaving Duchamp's post-painting production tightly together and portraying the man himself as an artist-scientist deeply immersed in the writings of Henri Poincaré.[59] In this reading, Rhonda Roland Shearer takes the *Large Glass* to be a 'Poincaré cut' (a device that visualises an invisible fourth-dimensional system) and the ready-mades to be three-dimensional shadows from Duchamp's 'creativity machine', supposed to point us towards the meaning of the *Large Glass*.[60] Here, the notes of 1911–15 become Duchamp's 'initial conditions' generating a 'probabilistic system' as well as 'all his major work for the rest of his life'.[61] Such an interpretation, however, allows no room for Duchamp's casual and spontaneous gestures – his willingness to sign anything, for example – which escape such an all-inclusive 'system'. Based in large part on inconsistent remarks made by Duchamp, this theory concludes with the controversial proposal that he either altered or fabricated the first generation of readymades by hand to make them into 'three- and two-dimensional non-retinal objects' under-standable only to 'the 4-D mind that questions the retinal'.[62] This bold idea caused a media flurry in its day, but was given a mixed reception by Duchamp followers, who judged it implausible even by the impressive standards set by the Duchamp literature.

Uncertainty and quantum mechanics
There is one final way in which Duchamp's idiom could be set against the background of physics in the modern era, without any claim being made in this case for a direct influence (indeed, we might even prefer the term 'coincidence'). Undecidability is a feature of much of Duchamp's work and 'theory'. An

early example can be found in the essay 'Buddha of the Bathroom' by his friend Louise Norton, which is generally thought to be an extension of Duchamp's opinion about *Fountain* and its scandal: 'There are those who anxiously ask "Is he serious or is he joking?" Perhaps he is both! Is it not possible?'[63] It can be argued that such an attitude is continuous with certain strands of science, mathematics and philosophy in the twentieth century.

The formulation of quantum theory, mainly between 1923 and 1927, had a profound impact on twentieth-century philosophy, especially in the indeterminacy it introduced into the relations between human beings and nature, usually collected under the heading of Niels Bohr's 'Principle of Complementarity'. Under different experimental conditions, alternative, contradictory models of reality may be theorised, depending upon the approach taken to observation. That is to say that nature is revealed as composed entirely of particles under certain experimental conditions, and wholly of waves under others, but these two pictures cannot be reconciled in observation. The loss of a fixed, unitary description of the physical world is summarised by the physicist Werner Heisenberg:

The use of 'matter waves' is convenient, for example, when dealing with the radiation emitted by the atom. By means of its frequencies and intensities the radiation gives information about the oscillating charge distribution in the atom, and there the wave picture comes much nearer to the truth than the particle picture. Therefore, Bohr advocated the use of both pictures, which he called 'complementary' to each other. The two pictures are of course mutually exclusive, because a certain thing cannot at the same time be a particle (i.e., substance confined to a very small volume) and a wave (i.e., a field spread out over a large space), but the two complement each other. By playing with both pictures, by going from the one picture to the other and back again, we finally get the right impression of the strange kind of reality behind our atomic experiments. Bohr uses the concept of 'complementarity' at several places in the interpretation of quantum theory.[64]

For this reason, nature is fundamentally unvisualisable at the atomic level in quantum mechanics, and because the issue is never completely settled one way or the other (wave or particle), the description of nature as given by Bohr's Complementarity was seen by many (including Einstein) to have lapsed into undecidability. In 1927 quantum theory was regarded by some as incomplete and temporary pending a 'final' formulation, which has, in fact, never arrived.[65]

In 1930, undecidability made another assault upon traditional categories of logic when Kurt Gödel changed the face of mathematics by proving that '*mathematics is open-ended*. There can never be a final, best system of mathematics'.[66] Gödel's 1931 incompleteness theorem states that any broadly based mathematical system of axioms that is free from contradiction will produce certain statements that cannot

be proved true or false by the laws of the procedure and whose status thus remains undecidable within the approved terms of the system. 'Any system of knowledge about the world is, and must remain, fundamentally incomplete, eternally subject to revision,' states this new logic.[67]

Gödel studied at the University of Vienna in the 1920s under the mathematician Hans Hahn, a prominent member of the group of logical positivists, the Vienna Circle, which drew quantum mechanics closely into its philosophy.[68] The Vienna Circle would convene in a room near to the mathematics department and Gödel himself would attend meetings regularly up to the end of the 1920s, within which Wittgenstein's philosophy held a prominent position. There is strong evidence that the concerns of this group were shared by Duchamp who, as a lover of contradiction and tautology, spoke late in life in admiration of the 'Viennese logicians [who] worked out a system wherein everything is, as far as I understood it, a tautology, that is, a repetition of premises'.[69] And there is a striking similarity between Duchamp's much-quoted epigram, 'there is no solution because there is no problem' and these points of reference.[70]

We have already seen that Duchamp created an air of uncertainty around his work and self throughout his life by his reluctance to concede to individual positions or identities and his acceptance of, and even pleasure taken in, a measure of self-contradiction. In a 1954 letter to André Breton, Duchamp expressed himself as follows:

I refuse to get involved in arguments on the existence of God – which means that the term 'atheist' (as opposed to the word 'believer') is of no interest to me at all, no more than the word believer or the opposition of their very clear meanings. For me, there is something other than yes, no and indifferent – the absence of investigations of this sort, for instance.[71]

And in 1968, wary of the position of 'anti-artist', Duchamp strove to be neither for, nor against, nor both, but, rather, 'in' some unnameable, undecidable 'beyond', as expressed in this interview exchange:

Do you think of yourself as being anti-art?

No, no the word 'anti' annoys me a little, because whether you're anti or for, it's two sides of the same thing. And I would like to be completely – I don't know what you say – nonexistent, instead of being for or against.[72]

It is as though Duchamp was seeking to back away from any system of knowledge organised around definable positions, including those coordinated by binary opposites, writing as early as 1912 in a note that later entered *The Green Box*, 'the interior and exterior (in a fourth dimension) can receive a similar identification'.[73] Along comparable lines, Arkady Plotnitsky has perceived in quantum mechanics:

the final indeterminacy or undecidability of relationships between the 'exterior' and the 'interior' of any interpretative configuration. . . .

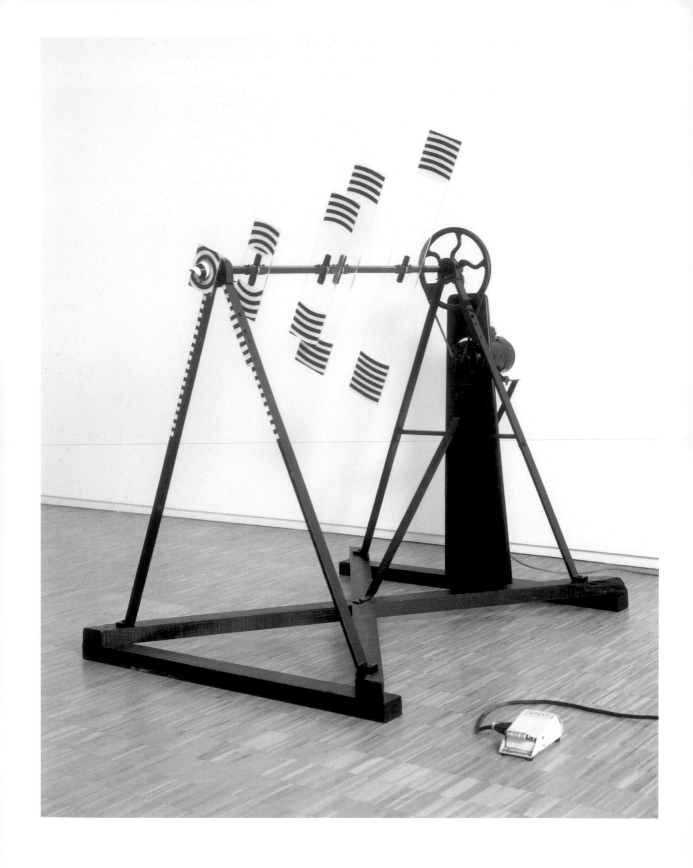

THE DUCHAMP BOOK

76
Rotary Glass Plates
(*precision optics*) 1961
(replica of 1920 original)
Motorized optical device:
five painted glass plates
braced with wood and
metal turning on a
metal axle
140 x 185 cm
Musée nationale d'Art
moderne, Centre Georges
Pompidou, Paris

One could speak of complementarity of the inside and the outside, as opposed to their unequivocal, metaphysical definability at however deep a level it may be assumed.[74]

Although Duchamp might have expressed as little interest in quantum mechanics as he did in alchemy, he did share attitudes prevalent within pioneering scientific, mathematical and philosophical fields mainly in the 1920s and 1930s. For the redefinition of the former logical categories that now allowed for a degree of uncertainty and incompleteness during that period took place when he was close to Surrealism, which was becoming fascinated itself with modern physics, creating the conditions in which *infra-mince* could make its ambiguous mark.[75]

Optical projects and technology

Given their 'experimental' status, Duchamp's optical machines can be discussed as an outcome of his interest in science. The first of these attempts to escape from conventional artistic practice was the *Rotary Glass Plates* (*Precision Optics*) 1920 (fig.76), a contraption comprising five rectangular plates of glass placed a small distance apart on an axle, which created a solid form of black-and-white concentric circles when spinning on their stand. This piece was followed in 1925 by the *Rotary Demisphere* (*Precision Optics*), a more elegant device made for the dress designer, collector and patron Jacques Doucet, on which the spiral created by the arrangement of circles under a plexiglass dome appears to throb in and out when rotating. Containing one of Rrose Sélavy's most laboured puns, 'RROSE SELAVY ET MOI ESQUIVONS LES ECCHYMOSES DES ESQUIMAUX AUX MOTS EXQUIS', it creates an illusion of space and has also been viewed as possessing a throbbing erotic motion.[76] Man Ray had become a regular collaborator on projects with Duchamp over the years, and together they made a film of the *Rotary Demisphere*, which did not survive the developing process.

They worked together again on the film *Anémic Cinéma* (1925–6) in which nine discs carrying puns pasted onto phonograph records are shown spinning alternately with, and in the opposite direction to, ten discs bearing spirals like those of the *Rotary Demisphere*. Several of the designs for these optical discs cropped up again among twelve designs collected as sets of six in 1935 and dubbed *Rotoreliefs* (*Optical Discs*) (fig.77). In letters, Duchamp called this his 'playtoy', and was so convinced of its commercial value that he earnestly asked Katherine Dreier to keep the idea secret to prevent it from being stolen.[77] As it turned out, Duchamp could barely give away the *Rotoreliefs*, selling only three sets out of an edition of 500 (two of them to friends) when he put them up for sale for a month from a hired stand at the amateur inventors' fair Concours Lépine in Paris in September. After this disaster, Duchamp largely lost interest in optical experiments with the exception of another cover design in 1936 for the Journal *Cahiers d'Art* entitled *Fluttering Hearts*. When you look slightly to one side of this image, its blue

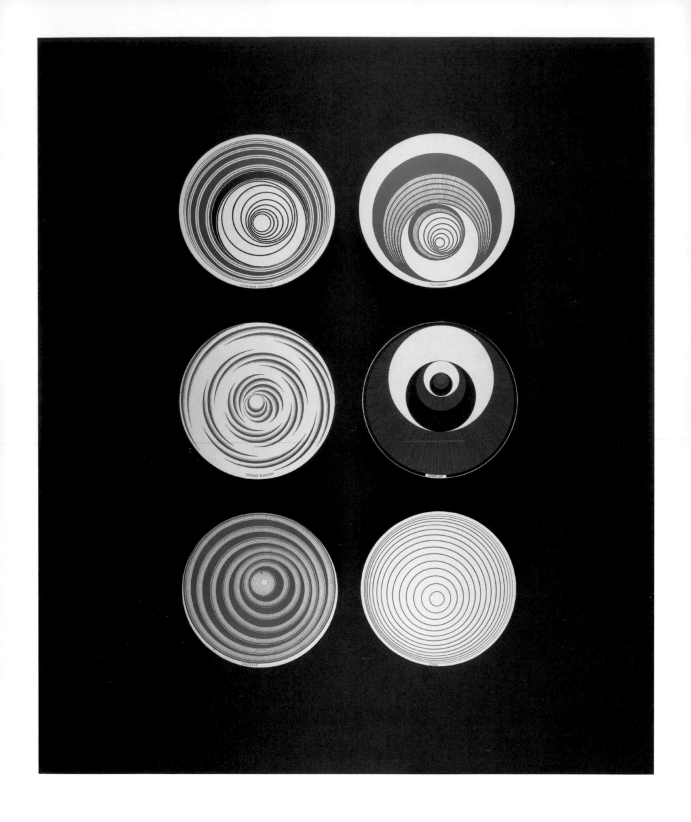

THE DUCHAMP BOOK

and red combine to create a flickering at the corner of the eye, giving a strange sense of currency and proximity to Duchamp's optical experiment, in contrast with the yellow varnish and cracked surfaces of his paintings, which unequivocally convey their age and place them firmly in the distant past.

If the *Large Glass* can be viewed in part as the outcome of Duchamp's enthusiasm for science and the fourth dimension, then it also reflects his fascination with the technology of his day. As we saw, the avalanche of ideas that would inform the *Large Glass* began to come to Duchamp in 1912 as he was escaping the Puteaux context, initially in the course of the now legendary trip he took by car to the Jura Mountains in Switzerland with Apollinaire and Picabia. Duchamp wrote 'The Bride basically is a motor,' and this line of inquiry is thoroughly researched by Henderson who sees the mechanical elements and automobile metaphors as central to the characterisation of the Bride, with her 'desire-gears', 'sort of automobiline, love gasoline', 'motor with quite feeble cylinders' and '*sparks of her constant life*'.[78] Yet Henderson also feels that the Bride cannot be reduced to a single identity, but can be interpreted, rather, through her many guises, adopted by Duchamp from the science and technology of his day, as:

X-ray image/chemical apparatus/automobile/barometer and weather vane (the latter two categories having to do with the Eiffel Tower)/incandescent bulb/wasp – the

Bride was all of these things for Duchamp, as well as the symbol of a higher-dimensional, immeasurable existence contrasting with the three-dimensional, metrical realm of the Bachelors.[79]

The lengthy, multi-layered, internally contradictory process of conceiving the *Large Glass* is laid bare in Duchamp's notes, which reveal the deep well of ideas from which he drew. Most of these notes are undated in the shuffled collections of *The Box of 1914*, *The Green Box* and *The White Box*, creating an even greater air of uncertainty surrounding the Bride and *Large Glass*. Many critics have got in a muddle by trying to bring order to the notes' disseminative, playful character.[80] The final chapters of this book look more closely at such attempts to measure the immeasurable, arguing against neat solutions to Duchamp's *œuvre*.

3 Standard Stoppages

In Marcel Duchamp's life and career, 1912 was perhaps the key year. It was then that he painted his *Nude Descending a Staircase* and the series of works placing him at the very forefront of avant-garde painting: *The King and Queen Surrounded by Swift Nudes, The Passage from Virgin to Bride* and *Bride*. The combination of a visit to Munich, his viewing of a performance of the strange play by Raymond Roussel *Impressions d'Afrique*, and a car journey with his friends the artist Francis Picabia and the poet Guillaume Apollinaire from Paris to the Jura Mountains in Switzerland also in 1912 gave him the ideas that would go into his masterpiece the *Large Glass*. But it was in that year, too, that Duchamp gave up painting to concentrate on experiments such as *3 Standard Stoppages*, which were not thought of as art at the time by Duchamp or anyone else.

Duchamp created *Bicycle Wheel* in 1913, often thought of as the first readymade, but the readymade idea had not yet received its name and Duchamp was still considering which directions his activities would take. The *3 Standard Stoppages* is not really a readymade, but belongs to the same desire to rethink his activity, and Duchamp later came to believe it had acted even more effectively than *Bicycle Wheel* to free him of the past. It comprises three pieces of sewing thread of one metre, each of which Duchamp claimed he had held over a canvas painted Prussian blue and dropped from one metre. He fixed each piece with varnish to the canvas in the configuration it assumed on landing, then trimmed three strips of the canvas and mounting them on separate glass panels (a procedure described in notes included in *The Box of 1914* and *The Green Box*). Three wooden slats were created from the curved threads, which can be used to trace lines on a surface, and in 1936 all the pieces were enclosed in a wooden box similar to those used for holding croquet equipment.

The *3 Standard Stoppages* can be thought of as a set of imaginary units of measurement and, as an alternative to the 'official' metre length (the distance between two scratches made on a platinum-iridium bar held in a temperature controlled environment at the International Bureau of Weights and Measures in the Pavillon de Breteuil, Sèvres, just outside Paris), it serves as a witty, brilliantly low-key rebellion against the potential for bureaucratic pettiness in the universalisation of precise weights and measures.[1] As much is suggested in its French title *3 Stoppages Etalon*, supposed to play on the word 'stoppages' meaning to mend invisibly (a shop sign in Paris carrying that word had inspired Duchamp), so that it can be said he is (a)mending with thread the unit of length imposed upon us legally and scientifically. This stand against conformity was motivated or confirmed by the German philosopher Max Stirner's (1806–1856) defence of individualism in *The Ego and Its Own* (1844), which Duchamp was reading at the time and would mention periodically throughout his life.

It was initially while part of the Puteaux circle that Duchamp was exposed to discussions about science, mathematics and geometry, probably consolidated by further reading during his stint as a librarian at the Bibliothèque Sainte-Geneviève. Sometimes these exchanges took place in the presence of the insurance actuary Maurice Princet, who imparted his considerable knowledge of mathematics to such painters as Jean Metzinger and Juan Gris. Spurred on by such discussions, even after he had distanced himself from the Puteaux circle and from painting, Duchamp playfully brought ideas from geometry into his work, particularly in *3 Standard Stoppages*, which can be viewed as an early manifestation of his even-tempered probing at the self-satisfied certainties of physics, partly through his genuine interest in non-Euclidean geometries and the writings of the French mathematician Henri Poincaré. Indeed, the work has been described by Linda Dalrymple Henderson as 'the purest expression of non-Euclidean geometry in early twentieth-century art'.[2] In this reading, Duchamp's simple experiment relates to the branch of geometry begun in the nineteenth century that rejects Euclid's assumption that geometrical figures do not change shape between one space and another, mentioned in *Du Cubisme* (1912) by Gleizes and Metzinger.[3] However, *3 Standard Stoppages* was not, of course, a scientific experiment, but rather meant to 'discredit' science, as Duchamp said, 'mildly, lightly, unimportantly'.[4] This ironic take on science and geometry was extended when Duchamp used

the curved metre measure templates to paint
the nine curved lines of *Network of Stoppages*
(1914) and those of *Tu m'* (1918), and in the
construction of the lower half of the *Large Glass*.
But *3 Standard Stoppages* is also evidence of
his wish to send up science by reinventing it in
the spirit of the French writer Alfred Jarry's
'science of imaginary solutions,' pataphysics, as
well as being Duchamp's first experiment with
chance, a factor he sometimes saw as subjective
and personal, which would play a significant
role in his work in the future.

The 1913–14 original entered the collection
of the Museum of Modern Art, New York, in
1953, at which point Duchamp clarified the
relationship between *3 Standard Stoppages*
and the standard metre by including two
wooden metre sticks with the work. Two further
versions were made in 1963 and approved and
signed by Duchamp, the first by Ulf Linde, the
second by David Hayes. Finally, an edition of
eight replicas of *3 Standard Stoppages* created
under the auspices of Arturo Schwarz was
supervised and signed by Duchamp in 1964.

The

If you come into ✶ linen, your time is thir~~s~~
because ✶ **ink** saw ~~some~~ wood intellige~~r~~
enough to get giddiness from a sister
However, even it should be smilable
to shut ✶ hair ~~of~~ which ✶ water
writes always plural, they have avoi~~d~~
✶ frequency, mother in law; ✶ powd~~e~~
will take a chance; and ✶ road cou~~n~~
try. But after somebody brought any
multiplication as soon as ✶ stamp
was out, a great many cords refused
to go through. Around ✶ wire's peop~~le~~
who will be able to sweeten ✶ ru~~n~~
~~it means~~ that is to say, why must ever~~yes~~ patent~~s~~
look for a wife? Pushing four dang~~er~~
near ✶ listening-place, ✶ vacatio~~n~~
had not dug absolutely nor this
likeness has eaten.

After his relocation from Paris to New York in June 1915, Duchamp put work on the *Large Glass* project on hold. There, he produced a few pieces conspicuously informed by his heightened awareness of the imperious function of language both to nurture and to block communication. There are halting letters written by Duchamp in English from November 1915, and during that period the tyranny of language was a pressing concern for him. Knowing little English, he was confronted by the organising office of what Michel de Certeau has termed 'the scriptural economy'; that is, in de Certeau's words, language as a 'scriptural system', which 'transforms the subjects that controlled it into operators of the writing machine that orders and uses them'.[1] Nevertheless, alongside this feeling of helplessness caused by the everyday difficulties presented by a new language, Duchamp also came to understand the creative freedom provided by language when it is experienced with a sense of detachment.

Language and meaning

Eager to make the most of this, Duchamp began to add to the earliest readymades unrelated script in English or French, thereby opening up a gap of non-meaning between the object and its given phrase, and sometimes removing any sense from the inscription. For instance, the lifeless, blank simplicity of *Comb* 1916 is infracted by its capitalised Mallarméan inscription in

French, which can translate as 'two or three drops of height have nothing to do with savagery', a phrase that resists definitive meaning.

Additionally, among his earliest works completed in New York were *The* 1915 (fig.79) and *Rendez-vous du dimanche 6 février 1916* 1916 (fig.80), exercises that free language from its descriptive function. Duchamp used script in both these works, arranging words into sentences so that the general constructions read rationally while sense is missing. For instance, a part of the *Rendez-vous* text reads as follows: 'From tomorrow at last I'll have put exactly there the batteries where several melt, they accept though draft their bearings. First, was pricking their leagues on bottles, despite their importance in a hundred serenities?' Similarly, in the cryptic approach taken by Duchamp in *The*, each mention of the word 'the' is replaced by a star, along with an invitation to fill in the gaps. However, even after the reader has done this, bemusement continues because the meaning is still not clear and the text continues to baffle, reading at one point: 'If you come into the linen, your time is thirsty because the ink saw some wood intelligent enough to get giddiness from a sister.' The full significance of the text seems to be available yet just out of reach, inviting further speculation so that the reader can get rid of the frustrating feeling of missing something.

The predominant structures of analysis and interpretation in our culture and society generally, in the pursuit of value, meaning

5 Language and Secrecy

There's a word in Italian. Dietrologia. It means the science of what is behind something. A suspicious event. The science of what is behind an event.
Don DeLillo, *Underworld*, 1997

The

If you come into ★ linen, your time is thirsty because ★ ink saw some wood intelligent enough to get giddiness from a sister. However, even it should be smilable to shut ★ hair which ★ water writes always plural, they have avoided ★ frequency, mother in law; ★ powder will take a chance; and ★ road could try. But after somebody brought any multiplication as soon as ★ stamp was out, a great many cords refused to go through. Around ★ wire's people, who will be able to sweeten ★ rug, why must every patents look for a wife? Pushing four dangers near ★ listening-place, ★ vacation had not dug absolutely nor this likeness has eaten.

remplacer chaque ★ par le mot: the

79
The 1915
Manuscript in ink on
paper
22.2 x 14.3 cm
Philadelphia Museum
of Art

and truth, encourage us to create a pattern, to resolve 'problems' by discovering the concealed order behind the apparent disorder. These 'incomplete' works by Duchamp play on our expectation of a future resolution, prodding us back and forth between their endless points of reference until we inevitably discover potential connections within the universal Duchampian iconography.[2] Perhaps the 'sister' mentioned in *The* is Duchamp's sister, Suzanne? Might 'pricking their leagues on bottles' in the *Rendez-vous* refer somehow to the readymade *Bottle Rack*? Could 'league' as a measure of distance be linked with *3 Standard Stoppages*? Playing upon our feeling that there is something lacking, Duchamp's objects draw us into the game of anticipation, which is a response ingrained in us by the tradition of analytical inquiry in our culture. They captivate our attention by exploiting our need to deduce through questions and answers, and academic art history is nothing if not a problem-raising and problem-solving discipline, fascinated by the problem of Marcel Duchamp.

An assisted readymade he produced a little later, the rectified advertisement *Apolinère Enameled* 1916–7, conceals letters of the original script to give the work its title, and to include another incomplete message to its bottom right, reading 'ANY ACT RED BY HER TEN OR EPERGNE, NEW YORK, U.S.A.'. Rather than attempting to decode this message, Dalia Judovitz opts for a manifestly subjective interpretation based on a mixture of iconography and punning,

80

Rendez-vous du Dimanche 6 Février 1916
1916
Typewritten text with black ink corrections on four postcards taped together
28.6 x 14.4 cm
Philadelphia Museum of Art. The Louise and Walter Arensberg Collection, 1950

-toir. On manquera, à la fois, de moins qu'avant cinq élections et aussi quelque accointance avec q- -uatre petites bêtes; il faut oc- -cuper ce délice afin d'en décli- -ner toute responsabilité. Après douze photos, notre hésitation de- -vant vingt fibres était compréh- -ensible; même le pire accrochage demande coins porte-bonheur sans compter interdiction aux lins: C- -omment ne pas épouser son moind- -re opticien plutôt que supporter leurs mèches? Non, décidément, der- -rière ta canne se cachent marbr- -ures puis tire-bouchon. "Cepend- -ant, avouèrent-ils, pourquoi viss- -er, indisposer? Les autres ont' p- -ris démangeaisons pour constrai- -re, par douzaines, ses lacements. Dieu sait si nous avons besoin, q- -uoique nombreux mangeurs, dans un défalquage." Défonse donc au tri- -ple, quand j'ourlerai ,dis je, pr-

-onent, après avoir fini votre gê- -ne. N'empêche que le fait d'éte- -indre six boutons l'un ses autr- -es paraît (sauf si, lui, tourne a- -utour) faire culbuter les bouto- -nnières. Reste à choisir: de lo- -ngues, fortes, extensibles défect- -ions trouées par trois filets u- -sés, ou bien, la seule enveloppe pour éte-ndre Avez vous accepté des manches? Pouvais tu prendre sa file? Peut-être devons nous a- -ttendre mon pilotis, en même tem- -ps ma difficulté; avec ces chos- -es là, impossible ajouter une hu- -itième laisse. Sur trente misé- -rables postes deux actuels veul- -ent errer, remboursés civiquement, refusent toute compensation hors leur sphère. Pendant combien, pou- -rquoi comment, limitera-t-on min- -ce étiage? autrement dit: clous refroidissent lorsque beaucoup p- -lissent enfin derrière, contenant

-este pour les profits, devant le- -squels et, par précaution à prop- -os, elle défonce desserts, même c- -eux qu'il est défendu de nouer. Ensuite, sept ou huit poteaux boi- -vent quelques conséquences main- -tenant appointées; ne pas oubli- -er, entre parenthèses, que sans l' -économat, puis avec mainte sembl- -able occasion, reviennent quatre fois leurs énormes limes; quoi! alors, si la férocité débouche de- -rrière son propre tapis. Dès dem- -ain j'aurai enfin mis exactemen- -t des piles là où plusieurs fon- -dent, acceptent quoique mandant le pourtour. D'abord, piquait on ligues sur bouteilles, malgré le- -ur importance dans cent séréni- -tés? Une liquide algarade, après semaines dénonciatrices, va en y détester ta valise car un bord suffit. Nous sommes actuellement assez essuyés, voyez quel désarroi

porte, dès maintenant par grande quantité, pourront faire valoir l- -e clan oblong qui, sans ôter auc- -un traversin ni contourner moin- -s de grelots, va remettre. Deux fois seulement, tout élève voudra- -it traire, quand il facilite la bascule disséminée; mais, comme q- -uelqu'un démonte puis avale des déchirements nains nombreux, soi compris, on est obligé d'entamer plusieurs grandes horloges pour obtenir un tiroir à bas âge. Co- -nclusion: après maints efforts on vue du peigne, quel dommage! tous les fourreurs sont partis e- -t signifient riz. Aucune deman- -de ne nettoie l'ignorant ou sc- -ié teneur; toutefois, étant don- -nées quelques cages, c'eut une profonde émotion qu'éxécutent t- -outes colles alitées. Tenues, v- -ous auriez manqué si s'était t- -rouvée là quelque prononciation

arguing the reflected girl's hair drawn by Duchamp onto the mirror of *Apolinère Enameled* is meant to designate her as an 'heir' to painting; that 'heir' is a pun on the French pronunciation of the letter 'r' (*air*); which when pronounced in English is a pun on the French word '*art*'; about which Judovitz then writes: 'This pun on art is a reference to another readymade, *Paris Air*.'[3] She might have found some meaning here, but, clearly, this cannot be true. Duchamp could not have been referring to *Paris Air* in *Apolinère Enameled* as the former was made at least two years *after* the latter. Given the obviousness of this historical fact, we can assume Judovitz is playing along with Duchamp and hopping from one point to another in the field of interrelated elements that make up his work; otherwise we would have to assume that such is the programmed will to deduce that it can overlook a fundamental, documented, irreducible fact: namely, that one event preceded another chronologically.

As they are being presented here, then, Duchamp's objects are gestures given to anticipation that seem to require our assistance for their 'satisfactory', 'necessary' passage from incompleteness to completeness, uncertainty to certainty, indetermination to determination, obscurity to clarity. Consequently, writers on Duchamp tend to move to fill in the 'missing' bits of the 'puzzle', as in the scholarly scramble to tell us what Duchamp *really* meant by the incomplete phrase used as the title of his final painting *Tu m'* of 1918. The consensus is that it is an abbreviation of the earthy expression, *tu m'emmerdes* (which might be translated idiomatically as 'you're breaking my balls' or 'you're being a pain in the arse').[4] Yet an interpretation that opted for delay over determination might just as easily experience indefinitely the uncertainty of the title's (in)completion.

Another work that has attracted great interest over the years is the 1921 birdcage containing cubes of marble, a thermometer and a cuttlebone, *Why Not Sneeze Rose Sélavy?* (fig.81). Visually, it and its later facsimiles remain about what they were when they were made, give or take the surface accumulation of some dust over the years, while conceptually *Why Not Sneeze?* has accumulated endless 'meanings', thanks to a scholarly approach to art rooted in a particular history and tradition of interpretation. We are readers, interpreters, pattern makers and 'behindologists', with a remit to read out the rational in the face of the unfathomable. Gestures such as *The* and *Why Not Sneeze?* are folded into rational explanations as demanded by the confrontation of art history with the shortfall in sense, which – as a rational discipline – it abhors.

Among the most mesmerising analyses of *Why Not Sneeze?* are those by Hubert Damisch (it is 'about' chess) and Jon Wood (it is 'about' Brancusi's studio).[5] These discerning and sensitive interpretations depend heavily on iconographic unpacking, which has long played a significant role in art history – that is, the identification, description and interpretation of individual elements within

a work of art that add up to its meaning. However, as John Cage has pointed out, Duchamp's multifarious *œuvre* encompasses the world ('Say it's not a Duchamp. Turn it over and it is'), and therefore iconographic readings allow anything to be linked to it, and claimed for and about individual works within it.[6] Stubbornly refusing on first showing to yield its 'secret', *Why Not Sneeze?* prompts us to anxious inquiry. What does it symbolise? What lies behind it? What was Duchamp up to?

As we have already seen in Chapter 4, when such questions are applied to the 'definitively unfinished' *Large Glass*, unusually elaborate and ingenious interpretations are the result. Although its notes demonstrate that the *Large Glass* was created over a long period in a fragmentary, multi-layered way, and imply it lacks a consistently readable metaphorical, mythological or theological symbolism while eschewing a straightforward linear narrative in what it purports to represent, Duchamp's commentators tend to see a readable itinerary in the *Large Glass* that they subsequently attempt to put down, more often than not, to the intentions of the author. Even though the jumble of *The Green Box* was the best Duchamp could do as an explanation for the *Large Glass*, writers from Arturo Schwarz and Ulf Linde to Juan Antonio Ramírez have set up the *Large Glass* and the notes in *The Green Box* as an oracle, by means of which the dots of Duchamp's disjointed *œuvre* can be connected. Although Duchamp produced very little material

compared with most artists, his work, including his writings, possesses a remarkable iconographic richness, which, when combined with the elliptical notes of *The Green Box*, opens the floodgates for massive interpretation, so the 'enamelling' of *Apolinère Enameled* can be related to the prehistoric practice of painting dead bodies, and from there to the red paint used for the Nine Malic Moulds of the *Large Glass*;[7] the galvanised *Bottle Rack* can be linked to the electric current galvanising the Bride and Bachelors;[8] and *Bicycle Wheel* can be said to resemble 'another copulating machine' like the *Large Glass*, while snow might spiral off the snow shovel *In Advance of the Broken Arm* like the Splash of sperm from the Bachelors, and the young girl in *Apolinère Enameled* can be said to be analogous with the Bride of the *Large Glass*, and so on.[9]

An example of this type of interpretation that is central to the literature on Duchamp is the dexterous 1986 article by Thierry de Duve, 'The Readymade and the Tube of Paint'.[10] In this, de Duve boldly reframes Duchamp's readymades as 'belonging to the history of painting, and not, for example . . . to that of sculpture',[11] by clarifying the 'historical context common to the ready-made and abstract painting'.[12] Where it has been generally believed that the use of wallpaper, newspaper and so on in Picasso and Braque's collages of 1912 and 1913 was the bridge that allowed Duchamp to cross from painting to the readymade in 1913 (with *Bicycle Wheel* of that year), de Duve jigsaws together a handful of fragments that have

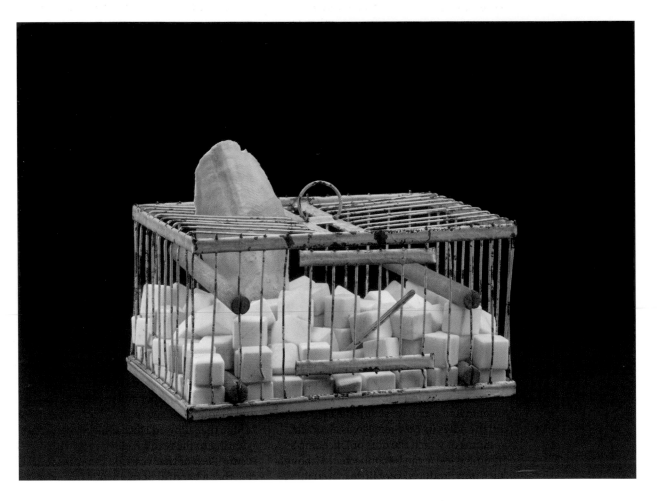

81
Why Not Sneeze, Rose Sélavy? 1921
Painted metal birdcage, marble cubes, porcelain dish, thermomter and cuttlebone
12.4 x 22.2 x 16.2 cm
Philadelphia Museum of Art. The Louise and Walter Arensberg Collection, 1950

appeared under the heading 'Duchamp' from 1912 to 1963 (paintings, readymades, passing remarks, puns, scribbled notes), making a case for the readymade as a complex, melancholy assessment of the impossibility of painting in the age of abstraction. As we have seen, put in the 'right' order, Duchamp's obscure objects and aphoristic notes can be made to mean anything you like, and de Duve's ingenuity and elegant connections take full advantage of this to produce a classic Duchamp conspiracy theory as the pivot for his essay.

As so often, the story he tells, of the readymade's commentary on and critique of painting in the midst of the move to abstraction, finds its origins in Duchamp's own authorship. For Duchamp joked about paintings being readymades in four casual asides between 1961 and 1963 – about half a century after the first readymade, and in a different cultural context – remarking that since all paintings were created from already made, manufactured tubes of paint, they were all 'readymades aided'.[13] De Duve takes this as a late confession by Duchamp finally coming clean about what readymades really mean: 'The hint is that the readymade is a sort of abnormal painting.'[14] Duchamp does not actually define this as their meaning in these late remarks (even though he said on plenty of occasions what he himself thought they meant), so, invoking Edgar Allen Poe, de Duve argues that, within Duchamp's statements, 'the clue was certainly there to be picked up'.[15]

The plot thickens from this point, with de Duve finding significance in combs throughout Duchamp's work. The title of the readymade *Comb* or *Peigne* 1916 (fig.82) – the subjunctive sense of the French verb *peindre*, to paint – becomes Exhibit A – a pun of 'genius', bent to the curve of the argument and embellished as Duchamp's expression of his abandonment of painting under industrialisation and simultaneous retention of the potential to paint.[16] The same message is found among the nonsense of Duchamp's *Rendez-vous du dimanche 6 février 1916*, in the sentence 'after many efforts towards the comb, what a pity', and inferred again from two more of Duchamp's notes, including an innocuous and amusing one from *The Green Box*, reading, 'classify combs by the number of their teeth' (while a footnote links all these combs to the Cubists' use of combs to make fake wood graining in their paintings).[17] There is even a message to us by Duchamp from beyond the grave, like a piece of paper clasped in the hand of a murder victim, which is characterised as 'an invitation handed over to us posthumous readers . . . to reinvigorate the history of modern painting as if it still had its future'.[18] De Duve sees this in the note by Duchamp reading 'The possible is/an *infra-mince* –/The possibility of several/tubes of colour/ becoming a Seurat is/the concrete 'explanation'/of the possible as *infra/mince*'.[19] Like the other clues sought, selected and connected by de Duve from an array of flotsam and jetsam covering fifty years, a fragment like this could be trimmed to suit any theory reliant on such ambiguous evidence.

82
Comb 1916
Steel
3.2 x 16.5 cm
Philadelphia Museum of Art. The Louise and Walter Arensberg Collection, 1950

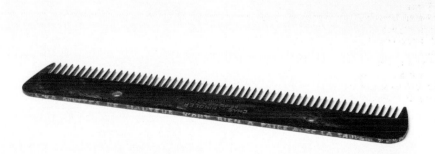

If de Duve's attempt to crack the Duchamp code sounds like a Dan Brown novel in miniature, then there has been at least one comparable attempt (probably not serious) to implicate Duchamp in a *Da Vinci Code*-type conspiracy. The book by Philippe Duboy on the eccentric French architect Jean-Jacques Lequeu (1757–1826) states that Duchamp was part of a 'secret society, or rather a "conspiratorial society", underlying the falsification of Lequeu's work inside the Bibliothèque Nationale'.[20] Duboy maintains that his fellow conspirators might have included Apollinaire, or Georges Bataille or Jacques Lacan. His evidence is entirely circumstantial, though this is never a barrier to the true conspiracy theorist for whom *tout se tient*: everything is connected.

Secrets and interpretation

Deductive methodologies in the field of literary theory were being parodied as de Duve mapped his constellation onto the Duchampian edifice. The phrase *tout se tient* is used by Umberto Eco throughout his 1989 novel satirising paranoid interpretation, *Foucault's Pendulum*, and crops up in his critical writings of the same period, too, where he assesses the adjacency of academic method and conspiracy theory in the wider world.[21]

In the latter, Eco compares contemporary theories of textual interpretation with, on the one hand, Hermeticism, the belief system distinct from Greek and Latin rationalism, which grew up in the first and second centuries of the Christian era and was revitalised in Renaissance Neo-Platonism and Christian Cabbalism in the sixteenth century; and, on the other hand, with Gnosticism, born around the same time. Both Hermeticism and Gnosticism emerged from a crisis in rationalism, seeking truth from books yet finding it 'possible for many things to be true at the same time, even if they contradict each other'.[22] The conflicting truths contained in books, then, must point to a deeper hidden Truth, through allusion and allegory, discoverable through shards of truth, which would confirm each other by means of 'a revelation beyond human utterances'.[23] Rejecting non-contradiction, Hermeticism 'embraces ideas of universal sympathy (the connection between all things) and similarity'.[24] Eco regards language and secrecy as intertwined as much in the contemporary mode of textual interpretation as in the Hermetic and Gnostic quest:

Every object, be it earthly or heavenly, hides a secret. Every time a secret has been discovered, it will refer to another secret in a progressive movement toward a final secret. Nevertheless, there can be no final secret. The ultimate secret of Hermetic initiation is that everything is secret. Hence the hermetic secret must be an empty one, because anyone who pretends to reveal any sort of secret is not himself initiated and has stopped at a superficial level of the knowledge of cosmic mystery. Hermetic thought transforms the whole world theatre into a linguistic phenomenon and at the same time denies language any power of communication.[25]

Eco goes on to quote the German sociologist and theorist of modernism Georg Simmel on the psycho-social significance of secrecy:

From secrecy, which shades all that is profound and significant, grows the typical error according to which everything mysterious is something important and essential. Before the unknown, man's natural impulse to idealize and his natural fearfulness cooperate toward the same goal: to intensify the unknown through imagination, and to pay attention to it with an emphasis that is not usually accorded to patent reality.[26]

In other words, the black veil of secrecy, in art and life, frightens us with its threat of otherness – of something different to us so threatening – and we project familiarity in some form onto or behind it to regain our equilibrium and tame that which lies beyond our understanding. We drag Duchamp's work out of the darkness of non-meaning into the light of familiar ground (the chess board; Brancusi's studio) because in its magnetic strangeness it resembles nothing we have seen before, and that is disquieting. In doing this, we are performing the same act of control as that of aesthetics as defined by art history's principle philosophers Kant and Hegel, meant to bring unity and order to the objects of perception and to remove from the world its obstinate strangeness.

Secrecy and conspiracy also play a key role in Eco's novel *Foucault's Pendulum*. Amused by the preposterous concoctions brought to them by prospective authors of conspiracy theories and the unexplained,

Eco's three young publishers decide to create their own super-conspiracy by feeding random bits of information into an advanced computer programme. They are then captivated by the interconnectedness it fabricates. "'Any fact becomes important when it's connected to another,'" insists one of Eco's characters:

'The connection changes the perspective; it leads you to think that every detail of the world, every voice, every word written or spoken has more than its literal meaning, that it tells us of a Secret. The rule is simple: Suspect, only suspect. You can read subtexts even in a traffic sign that says "No littering."'[27]

The links forged by writers seeking the 'secret cause' that will ultimately unveil Duchamp's work recalls Eco's parody of the reasoning of the paranoid reader by means of a game he suggests, in which the words 'peg' and 'Plato' can be connected in any way, 'metaphorical, metonymical, phonetic, or other'.[28] Peter Bondanella elaborates:

Thus we connect *peg* to *pig* by sound; *pig* to *bristle*, because pigs have bristles; *bristle* to *brush*, because Italian masters used pig bristles to make paint brushes; *brush* to *Mannerism*, because bristles used for paint brushes suggest an artistic movement made famous by great Italian painters; *Mannerism* to *Idea*, because Mannerism employed a notion of *concetti* or abstract concepts and ideas in its artistic theory; and finally *Idea* to *Plato*, since Plato is an idealist philosopher.[29]

This is what Eco calls 'hermetic drift': uneconomical interpretation which dispenses with the most obvious interpretive route because of its fascination with the play of signs.[30] From one fragment to another the interpreter moves, convinced that a solution lies close at hand in some future formulation lying, for now, just beyond reach. Eco sees such delayed reading as a major tendency in academic literary criticism. Along the same lines, his paranoid theorists in *Foucault's Pendulum* pursue a network of inferred links between Freemasonry, Rosicrucianism, the cabala, and all manner of esoteric and hermetic lore; a pursuit that requires the assumption of a secret in the first instance. To deny that there is a secret with the promise that holds of a future disclosure would remove the basis for these activities.

Duchamp was fairly discreet and sometimes contradicted himself when speaking about his work but that was probably because he made things that cannot be reduced to the straightforward, clear and certain terms demanded by practical written or spoken language, towards which he expressed seemingly limitless reservations.[31] To speak or write descriptively about his work would have been beside the point, since the object *is* the statement and should therefore 'speak' for itself. Nevertheless, his circumspection and minimal, often irrational explanations have been translated as secrecy about something specific; an interpretation reinforced by the fact that he had, indeed, a genuine interest in secrecy and concealment. This informs works such

as *With Hidden Noise* 1916 (with its unknown hidden object), *Paysage fautif* (shown after Duchamp's death to be made from seminal fluid) and *Etant donnés* (whose existence was revealed only after his death).

However, Duchamp's concern with secrecy in these works has helped promote the belief in some sort of deception and underlying message, creating a kind of rumour industry determined to discover the Big Secret that explains the readymades, the *Large Glass*, or, preferably, the whole *œuvre*. Given its diverse allusions to secrecy, it is not surprising that Duchamp's work should encourage interpretation on such a colossal scale; as pointed out throughout the first half of this chapter, for readers, indeterminism requires some determining gesture, and, as all commentators agree, no individual's work is so imbued with indeterminism, uncertainty and undecidability as Marcel Duchamp's. But these are less problems requiring resolution, than manifestations of his practice to be observed. In this light, secrecy is the *purloined letter* of his work, directing our attention not to what is supposedly behind, hidden or secret, but to that which has disappeared because it is on show; not to *what* is purportedly concealed, but to the *act* of concealment; not to *what* the work means, but to what it *does* (how it suggests meanings).[32]

This is less an argument 'against interpretation' (interpretation is essential and unavoidable and there is plenty in this book) than one that tries to comprehend how Duchamp's work acts upon its audience,

though there is a history of useful critical writing under that rubric. Reflecting on the state of literary criticism in 1964, in her important article 'Against Interpretation', Susan Sontag already saw the malign effects of certain kinds of intrepretive approach, rooted, as she saw it, in anxiety:

The modern style of interpretation excavates, and as it excavates, destroys; it digs 'behind' the text, to find a sub-text which is the true one. The most celebrated and influential modern doctrines, those of Marx and Freud, actually amount to elaborate systems of hermeneutics, aggressive and impious theories of interpretation.[33]

In most modern instances, interpretation amounts to the philistine refusal to leave the work of art alone. Real art has the capacity to make us nervous. By reducing the work of art to its content and then interpreting *that*, one tames the work of art. Interpretation makes art manageable, comfortable.[34]

Doubtless, Sontag would have lamented the interpretation industry just sprouting up around Duchamp's work in the early 1960s, but at that time she probably could not have anticipated its intensification. For she was writing at the historical juncture that saw a social and cultural turn take place, beginning with the proliferation of conspiracy theories about the assassination of John F. Kennedy, which has continued, accelerated and spread up to our own time, where we are swamped in conspiracy theories, mirroring today's interpretation industry in the humanities and social sciences.

Conspiracy theories

Literature on conspiracy theories has begun to emerge in sociology and media studies over the last few years, which can help shed light on the attraction held by Duchamp.[35] Sociologist Martin Parker writes, 'the role of the seemingly ubiquitous conspiracy "*theorist*" is to connect things which were previously unconnected – to posit causes, motives, plans and plots',[36] and might almost be referring to the endless adaptability of alchemy and psychoanalysis to the Duchamp corpus when he adds 'conspiracy theories are never falsifiable, but they are never verifiable either', calling them 'entirely self-confirming belief systems'.[37] Parker does not regard the pursuit of truth by the conspiracy theorist as one that is unhinged from reason, however, but one lodged in established models of investigation and inquiry, and keen to declare itself as such:

Importantly, the grammar of these theories is not insane speculation – or a romantic poetic wildness – but a form of detective work which uses the tools of the hypothetico-deductive method. Photographs, documents, eye witness accounts and so on are used to demonstrate that a particular explanation successfully draws together a series of events and causes.[38]

Details of conspiracies are framed as events that must have substantiated 'causes', and 'Like a detective looking for evidence – a stray hair, a missing minute, a footprint – everything is a clue,' Parker writes.[39] 'Once Sherlock Holmes has us trapped within the

web of causes,' he continues, 'there can be no uncaused event.'[40] Accordingly, publications like *UFO Magazine* are, Parker claims, 'decidedly rationalist', at least in the way they collate and present their findings.[41]

Parker goes on to point out, too, the close structural relationship between 'respectable' theory and conspiracy theory, arguing, 'much of sociology, psychology, economics, geography and so on shares the same project and narrative structure' with conspiracy theory.[42] For instance, as an 'elevated' theory claiming that 'economic decisions are not "ours" but caused by the hidden hand of markets',[43] Marxism, for Parker, 'has functioned as a pervasive conspiracy theory for most of this century'.[44] By an 'elevated' theory, Parker means to refer to a certain way of representing and explaining events, shared by conspiracy and the human sciences, which extends to theories of Duchamp, of course:

Representation is architectural, in that sense of constructing a perspective from which to look towards the earth. Correspondingly, if you cannot see the plan then the plot will not be clear. A comprehension of the past and the construction of the future will be beyond your understanding. Importantly then, in order to see the plan, you must be elevated, lifted, from the terrain

It seems that elevation from the 'here and now' allows for time to be thought. Once time can be thought, then so can lineages of explanation which require separate 'events' and 'causes', 'pre-cedents' and 'ante-cedents'. Plots, plans and conspiracies share this grammar of a series of 'events', and some 'causes' to tie them together, but they also share the sense of an elevated place for the observer.[45]

Art theory claims with history, social theory and conspiracy theory (not to mention theories about art theory and conspiracy theory) a privileged position from which to view the causes lying behind events – the Bigger Picture. Like them, it comes under the heading of 'dietrology' ('behindology'), because it searches for a 'hidden' reality, indicated by and secreted beneath the surface code.[46] Duchamp's work has a peculiar tendency to attract a particularly tenacious kind of dietrologist, and to generate a remarkable determination to be seen as a 'problem' in need of resolution. This happens in spite of Duchamp's own view that his work does not fit with the grammar of cultural explanation (the requirement to turn things into problems and the subsequent search for explanations), and his indication that language offers a poor translation of his work, both of which are encapsulated in his endlessly quoted 'there is no solution because there is no problem'.

The discipline of art history continues to present itself as one arguing towards a position of, let us say, 'soft objectivity', aiming to construct a version of the way things were or are; yet, in its practices, it frequently offers speculative 'poetic' readings, without declaring them as such. Formally speaking, these arguments are often beautiful baroque structures, and it is undoubtedly legitimate to make things

up about works of art with the aid of, say, psychoanalysis, so long as the author of the text acknowledges this as part of the methodology. However, the acknowledgement of lyrical or imaginative invention cannot take place in an avowedly empirical field such as art history and theory, with the result that certain approaches quickly become implausible because of their reluctance to relinquish their claims to objective truth and their insistence on authorial intentionality. Yet, the writings discussed in this chapter and the last might have conceded they were ironic or fictional and actually gained from it, because irony is a mode regulated to Duchamp's own playful spirit, and, as recent work in the field of historiography has argued, avowedly subjective, fictional accounts of historical figures and events can carry at least as much weight as conventional historical narratives.[47]

Duchamp's assent to missing links of various kinds – vagueness, lack, irresolution; blind spots, absences, secrets – intrigues his readers versed in traditional and orthodox techniques of deductive interpretation and explication: *intrigues* in the fullest sense of that word: intricating, entangling, trapping. Far from encouraging scholars to observe and comment on its *disconnectedness*, the heterogeneity and obscurity of his *œuvre* act as a cue for rampant *connectivity*. Yet even if it were agreed that his work demonstrates a kind of inconsistent wandering, which has led many of his critics deeply into the wilderness of hermetic drift, it could easily

be countered that this habit of linking carried out by writers is essential nevertheless, as it is identical with the processes of argument and even thinking itself. To link cognitively, psychologically, historically or theoretically is to rationalise and coordinate a disorderly field in the service of narrative mastery. In fact, this chapter has done the same thing, making a series of linked manoeuvres to give a kind of theory of art theory, tautologically implicated in its own critical appraisal (as predicted in the introduction to this book). Commentary as play offers an alternative to this, as discussed in the final chapter.

With Hidden Noise

By 1916, Duchamp was an ex-painter happily ensconced in New York, wondering aloud in a series of 'experimental' works what art was and what it could become. The chosen objects known as readymades are the best-known manifestation of this exploratory process, though Duchamp came up with other objects around the same time that do not really fit the (rather unstable) definition of readymades. Like them, some of these works ask questions not only about how we define art, but about how and why we define anything at all. In other words, they are objects that have to do with the theory of knowledge (epistemology).

Among these is *With Hidden Noise*, a work of the same period as the readymades and sometimes defined as one, even though Duchamp intervened heavily in its material fabrication (he did not simply choose it), creating a unique object that begs questions about art and art history's habitual reduction of the work of art to a single biological individual. After securing a ball of string between two brass plates with four long screws, Duchamp asked his friend and patron Walter C. Arensberg to open it, place an object inside the hole in the centre of the string and secure the plates again, requesting Arensberg keep the identity of the concealed object a secret, even from Duchamp himself. Arensberg died in 1954 without having disclosed the secret, then years later at the time of his Pasadena retrospective in 1963, Duchamp gave another friend, the curator Walter Hopps, permission to look inside the ball of string, again asking that knowledge of the hidden component be kept from him.

Duchamp's atypical way of thinking is brought to the fore by *With Hidden Noise*, as the requirement *not* to know goes squarely against the traditional social, philosophical and pedagogical grain of Western custom and habit. The shortfall he wantonly created in his own knowledge of a work of which he was the main author – his incorporation of 'incompletion' into *With Hidden Noise* as an element of its composition – is completely at odds not only with the desire for mastery and the universalising thirst for wisdom and search for truth that have historically characterised inquiry in the arts, humanities and sciences, but also with basic human curiosity. For his part, Duchamp was, of course, unperturbed by the mysterious hidden object, cheerfully conceding on one occasion that he would 'never know whether it is a diamond or a coin.' However, for its audience, *With Hidden Noise* has always possessed a strange epistemological function and uncertainty that have since been dramatised further by the death of Hopps in March 2005, and the transmission of the knowledge of the secret fragment to Anne d'Harnoncourt, director of the Philadelphia Museum of Art.

Ideas of secrecy and exclusion suggested by the unknown contents of *With Hidden Noise* are emphasised by three lines of white, capitalised script combining French and English on its upper and lower surfaces:

P.G ECIDES DÉBARRASSE.
LE. D.SERT. F.URNIS ENT
AS HOW.V.R COR.ESPONDS

.IR. .CAR.É LONGSEA
F.NE, HEA., .O.SQUE
.TE.U S.ARP BAR.AIN

As with *The*, there are breaks in the text along with handwritten instructions on the upper and lower surfaces suggesting we replace the full stops with letters, but, again, when we fill in the gaps as invited, we are confronted with a message making no sense at all, which Duchamp compared on one occasion to the effect of a neon sign with an unlit letter. He was helped in the composition of this bilingual text by the French-speaking American journalist and playwright Sophie Treadwell, hence the 'signature' 'Sophie Marcel' on the underside of the upper plate that, typically for Duchamp, splits authorial responsibility for the work while bi-gendering it (years before the arrival on the scene of Rrose Sélavy).

The secrets carried by, and characterising, *With Hidden Noise* invite us to speculate in order to find a solution to the puzzle and 'complete' the work. As with Duchamp's work in glass, *With Hidden Noise* cannot be seized comprehensively in a past or in the present. For just as the fragility of the works on glass seems to announce an uncertain future in their very

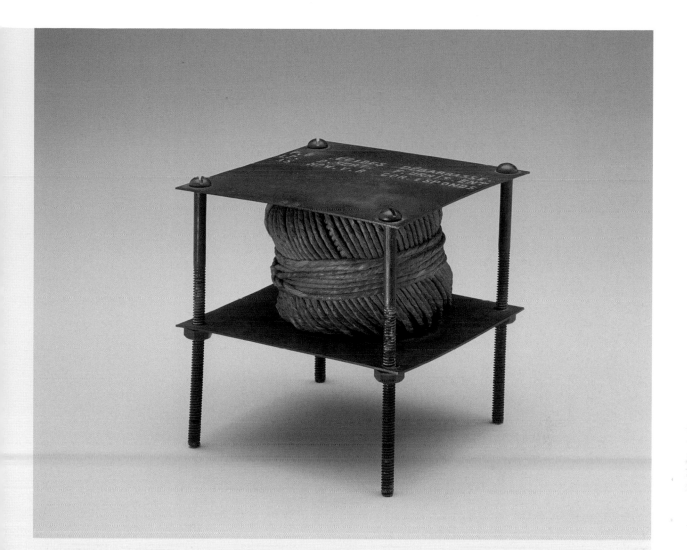

83
With Hidden Noise 1916
Twine, brass, metal and
paint
12.7 x 12.7 x 13 cm
Philadelphia Museum of
Art. The Louise and Walter
Arensberg Collection,
1950

material, so *With Hidden Noise* is designed in such a way that It Is not fully present (its key component is hidden), although it has the tantalising potential, imminently, to be so.[1] This ambivalence is extended by the English title *With Hidden Noise* (*A bruit secret* is the French), which reminds us that it was meant to be shaken like a rattle in its earlier days so the holder might guess what lay inside (no longer a possibility for the larger museum-going public). Paradoxically, the *noise* is said to be hidden in this title, not the element inside. Can a noise be hidden, or does it cease to exist for a listener if it lies beyond their hearing (like the sound of trees falling in empty forests)? The title is of a piece with the rumination by Duchamp that first appeared in the note in *The Box of 1914*, 'One can look at seeing;/one can't hear hearing', which might have spurred him on to create a work that can now be seen yet not heard, containing an element that could once be heard but not seen.

As with the readymade *Pharmacy*, three versions of *With Hidden Noise* were created in 1916, to get away from the idea of a unique, one-only original, though only one of these survives, in the Philadelphia Museum of Art. Ulf Linde made a replica in 1963 that Duchamp signed the following year, now in the Moderna Museet, Stockholm, and an edition of eight replicas with hidden constituents chosen by Teeny Duchamp was produced under the patronage of Arturo Schwarz in 1964 with Duchamp's approval and guidance.

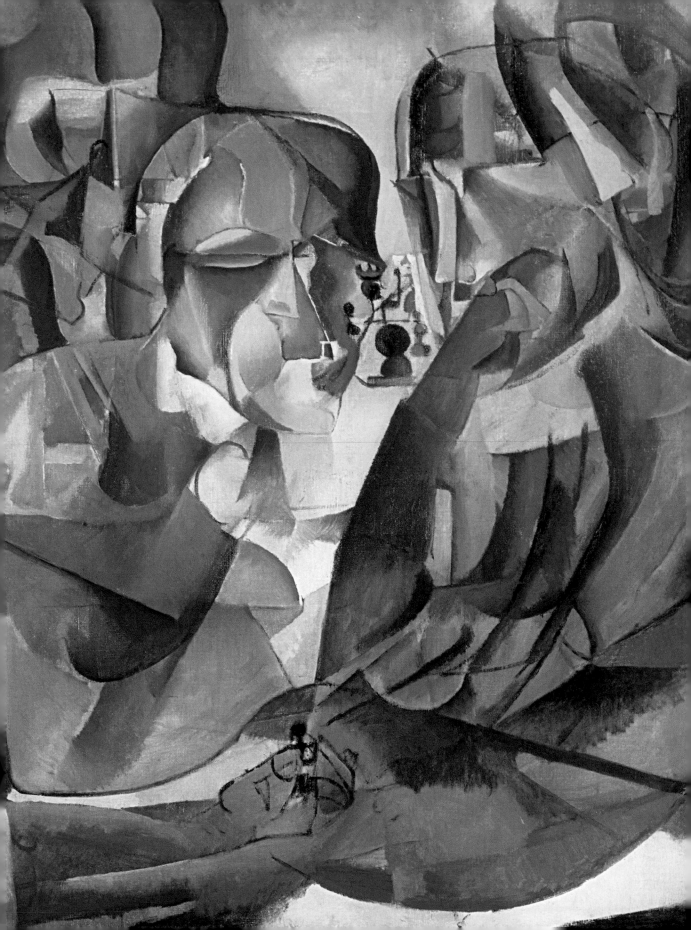

From its beginnings in the Renaissance up to our own day, the connections forged and plots hatched in academic art history are constrained by a will to determine, resembling a game demanding obedience to a strict set of rules. Notwithstanding his love of chess, Duchamp was a gifted game-player himself, evident in his interest in chance and indeterminism and acceptance of self-contradiction, which can be viewed as his passive consent to a kind of game without rules:

I don't want to be pinned down to any position. My position is the lack of a position, but, of course, you can't even talk about it; the minute you talk you spoil the whole game. I also mean that words are absolutely a pest as far as getting anywhere. You cannot express anything through words.[1]

In so far as the standard practices and conventions of art history grasp the object of their inquiry through description, demarcation, categorisation, classification, circumscription and determination, the discipline can never attain its desired contact with Duchamp's work, because it misrepresents it through the very act of attempting to get in touch with it. Through that response, the work's play is stilled; the object is altered; the game is spoilt.

Humour and play in art and art history
Humour and play contributed significantly to the atmosphere of Duchamp's work and its exhibition:

Humour and laughter – not necessarily derogatory derision – are my pet tools. This may come from my general philosophy of never taking the world too seriously – for fear of dying of boredom.[2]

This 'philosophy' is confirmed in one of the notes collected in *The Green Box*, in which Duchamp writes: 'Ironism of affirmation: differences from negative ironism dependent solely on Laughter.'[3] If humour and laughter were a way of life for Duchamp, as recorded in countless anecdotes by admirers,[4] then they themselves were also subject to the play of everyday inconsistency, for in one place he could speak of humour as indispensable, 'because seriousness is a very dangerous thing',[5] then in another he could say of the idea behind readymades, 'it was a humour that wasn't only intended to make people laugh . . . it wasn't even black humour. It was really a humour that added a note of – dare I say? – seriousness'.[6] Blinded in the headlights of Duchamp's nonchalant self-contradiction, we scramble for the theoretical means by which coherency and order in non-contradiction can be re-established; our discipline demands he be assigned a fixed spot in the play of differences.

It could be maintained, then, that the manner of response to his work discussed here, of drifting hermetically from one vibrant fragment to the next in an endless paper chase in pursuit of Duchamp's own true meaning, is appropriate to its subject. Duchamp is playing, and his commentators

6 Humour and Play

'There was no plot,' William said, 'and I discovered it by mistake.'
Umberto Eco, *The Name of the Rose*, 1980

are simply playing along. However, as Duchamp's biographer indicates, those who have written on his work have taken themselves and Duchamp very seriously indeed, anxious to encompass his amusement, humour and play within the serious business of 'high theory'.[7] In seeking an appropriate response to Duchamp's work we should concern ourselves with different kinds of play and their roles in Duchamp's practice and in its interpretation, for the knowing internal contradictions of the former, noticed by one and all, might be profitably met by a similarly reflexive response in the latter. That is to say that in the same way that Duchamp infiltrated art to point to its limitations, responses to it might do something comparable to the discipline of art history, less to delimit Duchamp's work than to point to the limitations of writing about it through the 'high seriousness' demanded by academic art history; a playful, reflexive art history for a playful, reflexive art.

Duchamp's humour and the readymades

Notwithstanding Duchamp's stab at becoming a humorist in his early drawings, and his later confession that *Yvonne and Magdeleine Torn in Tatters* 1911 was painted with the idea of 'Introducing humour for the first time in my paintings', it is the readymades that offer the earliest illustration of his dry sense of humour.[8] We surveyed his earlier mild, witty rebellion against the tiresome bureaucracy of standardisation in his *3 Standard Stoppages* and the blunt

provocation of *Fountain*, and also examined his droll reinvention of *Fountain* in 1950 and 1953, through his exhibition placement of a version of the urinal in the first instance against a wall at child height (fig.84), and in the second over a doorway, romantically adorned with mistletoe appendage.[9]

Like *Fountain*, his whiskered *Mona Lisa*, *L.H.O.O.Q.*, was a barbed Dada joke, guaranteed then as now to rile art lovers of a certain kind. Although it is hard at first to imagine a more Dada and Duchampian gesture than *L.H.O.O.Q.*, which recycles, sexualises and demeans a major work of the canon with such a light, witty touch, Duchamp himself provided one many years later in *L.H.O.O.Q. Shaved* 1965 (fig.85). Pasted to paper, this is a playing card bearing a reproduction of the *Mona Lisa*, unaltered by Duchamp in this case, carrying the title of Duchamp's original of 1919, along with the word '*raseé*' ('shaved').[10] As well as echoing the five letters of *L.H.O.O.Q.*, this word can also be said to indicate the missing moustache a second time in its brilliant anagram of 'erase'.

Other ideas for the readymade were given in the impudent Dada spirit of *L.H.O.O.Q.*, such as his succinct suggestion of a way to domesticate Rembrandt's genius, placed among the notes for *The Green Box*: 'Reciprocal Readymade = Use a Rembrandt as an Ironing Board –'.[11] Comparable in tone is the broadly comic idea he had around the same time of 'claiming' a landmark as a readymade through a coalition of graffiti and artist's signature: 'find inscription for

84
Photograph of *Challenge and Defy*, Sidney Janis Gallery, New York, 1950

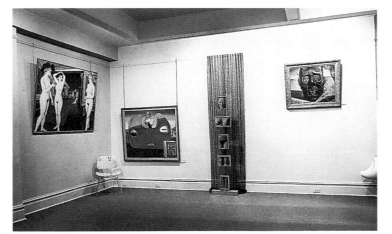

85
L.H.O.O.Q. Shaved 1965
Readymade: Playing card mounted on dinner invitation
8.8 x 6.2 cm
Israel Museum

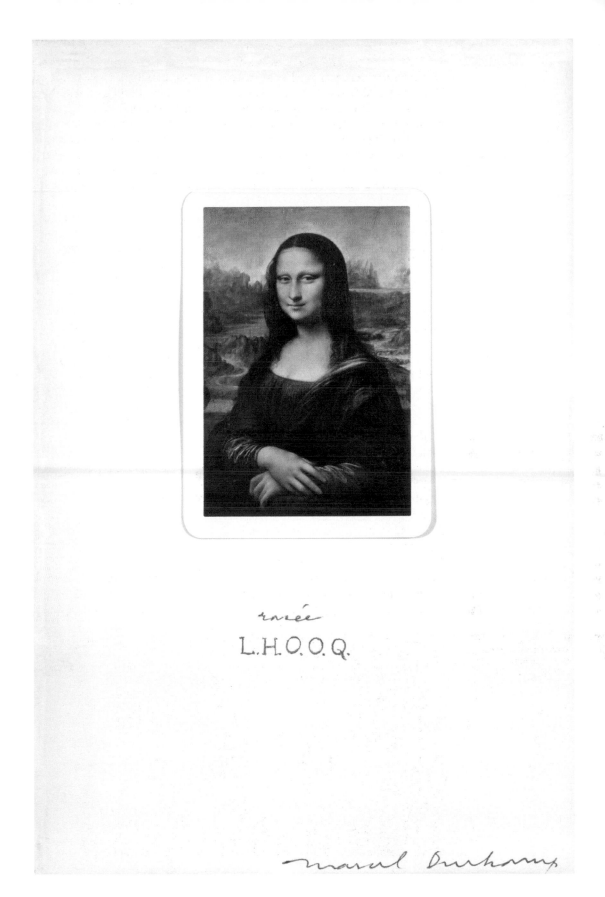

rasée

L.H.O.O.Q.

Marcel Duchamp

Woolworth Bldg. as readymade'.[12] Sadly, Duchamp never got around to carrying out this scheme, so what was then the world's tallest skyscraper never entered his *Complete Works*.

Among Duchamp's most impish and economical works is the 'empty' glass ampoule *Paris Air* 1919 (fig.86), made in the year that saw the first stirrings of Surrealism, and prefiguring in its agreeable sense of the absurd certain Surrealist objects such as Wolfgang Paalen's sponge umbrella, *Articulated Cloud* 1938 (fig.87). Through humour, Duchamp archly mimics with these gestures a kind of ethnological or scientific inquiry into the commonplace, isolating, sorting and labelling everyday objects through inscription and signature in preparation for their deposit in an imaginary cabinet of curiosities:

by planning for a moment to come (on such a day, such a date such a minute), '*to inscribe* a readymade' – The readymade can later be looked for.– (with all kinds of delays)

The important thing then is just this matter of timing, this snapshot effect, like a speech delivered on no matter what occasion but *at such and such an hour*. It is a kind of rendezvous.

– Naturally inscribe that date, hour, minute, on the readymade as *information*.[13]

Parodying scientific curiosity, pen at the ready to record his findings, Duchamp makes an exotic journey into the New York

86
50cc of Paris Air 1919
Glass ampoule
13.3 cm
Philadelphia Museum
of Art. The Louise and
Walter Arensberg
Collection, 1950

87
Wolfgang Paalen
Articulated Cloud 1938
Sponge
Height 50 cm
Moderna Museet,
Stockholm

'wilderness' that recalls Walter Benjamin's characterisation of the *flâneur* as one 'who goes botanizing on the asphalt'.[14] All of this is carried out in accordance with Duchamp's 'philosophy', with an ironic smile rather than a frown. It would be boring to take it too seriously.

Duchamp and the Surrealists were enthusiastic movie-goers, and it has been noted that there is a resemblance between comedy props such as Buster Keaton's anchor made of balsa wood, which floats on the surface of the water, and certain Surrealist objects such as Paalen's *Articulated Cloud*, where the materials so pointedly negate the object's purpose (simultaneously making it and rendering it useless, as in André Breton's image of the 'soluble fish').[15] Comparison with a field as 'base' as comedy is instructive for Duchamp's work, too, as the elevated, transcendent status given art was a favoured target of his easy-going mockery. A smile is the most obvious response to *Paris Air*, while several readymades, such as *Comb* and *Fountain*, possess a rather blunt literalism, towards which, in the context of 'art', the initial and perhaps most enduring response is laughter.

Others, such as the wood and metal coat rack nailed to the floor called *Trébuchet* 1917 (fig.88), have been discussed in the context of slapstick comedy, though the humour is usually drained out of the works by the 'raising' conferred by the seriousness of academic discourse, squarely opposed to the literal baseness of a floor-bound object like *Trébuchet*.[16] Duchamp once called readymades

'a form of denying the possibility of defining art', a rarified field that has insistently viewed artistic gravity and sobriety as 'elevated', by contrast with the 'baseness' of laughter and intoxication.[17] As such, art offered Duchamp a ripe target for humour and laughter, which were an important impetus behind the readymade.

Duchamp's funniest and most effective deployment of readymades was for his own amusement initially, and went unnoticed by his audience, for it entailed the (invisible) 'display' of sundry unknown readymades, perhaps in the umbrella stand or on the coat rack – accounts vary from the sole eyewitness, Duchamp – in the foyer of the Bourgeois Galleries in New York in 1916, where they went entirely overlooked, transformed back into utilitarian objects. In their ordinariness, readymades have colluded on several other occasions over the years in their own disappearance and abuse once outside of the art context, always to comic effect. As recorded by Duchamp scholar Francis Naumann, a caretaker in Minnesota put *In Advance of the Broken Arm* to good use in 1946, mistaking it for an actual snow shovel and clearing a snowdrift with it outside the museum where it was being shown; in 1963 a US customs official unsurprisingly failed to observe the artistic properties of the readymades sent over for Duchamp's Pasadena retrospective and tried to charge for them as non-art consumer goods; and at the Venice Biennale in 1978 builders mistook *Door: 11, rue Larrey* 1927 (fig.89) for the working door it had once been

88
Trébuchet 1964 (replica of 1917 original)
Assisted readymade: coat rack nailed to the floor
19 x 100.1 x 11.6 cm
Israel Museum

when attached to Duchamp's Paris flat from 1927 to 1963 (before its elevation to a work of art), returning it to its 'ordinary' status by installing it in the corner of a gallery and painting it.[18] The shambolic, Laurel and Hardy-like misadventures of the readymades would have delighted Duchamp.

The 'hilarious' *Large Glass* and Duchamp's wordplay

During the same period he created these one-liners, Duchamp was working away at the *Large Glass*, which represents the most extensive elaboration of his ideas through the medium of a manic humour, as in his crazy description of the activity and apparatus of the Wasp or Bride:

Reservoir.– concerning the nourishment layer of the wasp.

The reservoir will end at the bottom with a liquid layer from which the sex wasp will take the necessary dose to sprinkle the drum and to nourish the filament substance. The liquid layer will be contained in the oscillating bathtub (hygiene of the bride).[19]

Elsewhere, at his most Rousselian, Duchamp describes in his notes, with the aid of his 'playful physics', the jerking movement of the Glider (or Sleigh or Chariot) in the lower, Bachelor half of the *Large Glass*. The Glider bumps and grinds back and forth on rails of something called Emancipated Metal, powered by the rise and fall of a Bottle of Benedictine (suspended from a Hook of indeterminate weight),

89
Door, 11 rue Larrey, Paris
1964 (replica of 1927 original)
Wooden door
220 x 62.7 cm
Israel Museum

which goes to sleep as it is raised and wakes as it falls. Sliding to and fro, the Glider sings what Tomkins calls a 'melancholy litany',[20] presumably cued to the rhythm of its movement:

> Slow life.
> Vicious circle.
> Onanism.
> Horizontal.
> round trip for the buffer.
> Junk of life.
> Cheap construction.
> Tin, cords, iron wire.
> Eccentric wooden pulleys.
> Monotonous fly wheel.
> Beer professor.[21]

It is preposterous, of course, this despondent, singing Chariot, as is the intricate and clumsy mechanism stirring it into motion, echoing the hare-brained complexity of the sexual machinery of the *Large Glass* as a whole. Yet, even though Duchamp himself called the *Large Glass* a 'hilarious picture',[22] and, during its fabrication, declared to a journalist the importance of humour generally in modern art while complaining that this had been misunderstood, we have seen clearly enough the unsmiling reception that ridiculous contraption has been given from Breton onwards.[23] The unDuchampian insistence on taking art seriously in the modern period is a continuation and symptom of the religious solemnity attached to it in the Middle Ages and extended into the Renaissance,

Enlightenment and beyond, demonstrating again the requirement for an adjustment in the way we approach art today in the wake of Duchamp's peculiar practice.

In spite of all they shared, a gulf separated Breton and Duchamp as far as humour was concerned. Breton seems to have been largely untroubled by a sense of humour (though he was capable of turning humour into a serious subject in his writings), and even went so far as to contend that Duchamp's wordplay, the most demonstrably humorous of his activities, was set apart by 'the absence of the comic element, which was considered endemic to the genre and was enough to ruin it'.[24] Although meant to be amusing, Duchamp's puns have worn thin over the years, nowadays resembling the minimum activity of someone with too much time on his hands (which is what they were, in fact).

Better are his unclassifiable (and unanswerable) inquiries, experiments and 'inventions', tinged with Surrealist strangeness. Often idly parodying micro-speculation in physics, they recall his one-man revolt against the standardisation of measurement in his 3 *Standard Stoppages*, as in his observation, 'A full box of wooden matches is lighter than an opened box because it doesn't make any noise,'[25] and his irresistible directive under the heading 'Luggage Physics', to 'Determine the difference between the volumes of air displaced by a clean shirt (ironed and folded) and the same shirt when dirty'.[26] Several other of these epigrammatic statements share this farcical concern with negligible economies, such as his query,

'Should one react against the laziness of railway tracks between the passage of two trains?'[27] Best of all is his idea for a fantastic machine for collecting and recycling all the tiny, surplus amounts of energy expended in human activity:

> A transformer designed to utilize the slight, wasted energies such as:
> the excess of pressure on an electric switch.
> the exhalation of tobacco smoke
> the growth of a head of hair, of other body hair and of the nails.
> the fall of urine and excrement.
> movements of fear, astonishment, boredom, anger.
> laughter.
> dropping of tears.
> demonstrative gestures of hands, feet, nervous tics.
> forbidding glances.
> falling over with surprise.
> stretching, yawning, sneezing.
> ordinary spitting and of blood.
> vomiting.
> ejaculation.
> unruly hair, cowlicks.
> the sound of nose-blowing, snoring.
> fainting.
> whistling, singing.
> sighs, etc.[28]

Gathering up the excremental excesses of mundane human behaviour and activity, Duchamp's grotesque machine satirises in a preposterous way the Western economy of efficiency, equivalence and exchange, absurdly insisting on the rationalisation and use of the most pointless gestures.[29]

Interpretation through humour

Given the consistent drollery of many of Duchamp's creations, it is to be expected that art historians would elect to determine his work entirely through humour, ironic or otherwise. Jeffrey Weiss attempts to articulate meaning in Duchamp through bluff, mystification and irony, specifically through the philosophy of *blague*.[30] Rejecting the mountain of interpretation built over the years on Duchamp's slim output, Weiss seeks to present us with a 'simpler Duchamp' whose 'agenda belongs with specificity to the debates of the period' (from the late nineteenth to the early twentieth century) in the popular spirit of hoax, which Weiss characterises as ' 'ironic *blague* and *mystification*'.[31] Noting that 'the dynamics of mistrust are peculiar to the avant-garde debates', he claims, 'Duchamp's proximity to hoax shows him to have been transposing the experience in precise ways,'[32] and 'his secession from painting is a prank that was almost overdetermined by the situation at hand'.[33] Although writing under cultural conditions that most would agree have long since privileged irony – with the art to prove it, from Andy Warhol to Jeff Koons – Weiss foregrounds historical context to insist Duchamp's 'decision to stop painting is startling in retrospect, not because it represents a wholly original or improbable gesture, but because, as a joke, it was fully

organic to the conditions of the moment'.[34]

Tracing its trajectory from the Goncourt brothers' praise for *blague* in 1865 through its adjustments under the Third Republic – the starring role it plays in the pamphlet of sarcastic anecdotes, *La Blagueur fin-de siècle* (1894), its definition as a nihilistic pose in Jules Wogue's 1902 article 'La Philosophie de la "Blague"', its presence in Joseph Conrad's *Nostromo* (1904) and prominent references to *blague* during the Cubist period – Weiss steers his admirable historiography of *blague* to the heart of Duchamp's work with the 1917 scandal of *Fountain*, discovering Louise Norton's use of the term in her essay 'Buddha of the Bathroom', which defended and justified 'Mr Mutt's' submission of *Fountain* to the first exhibition of the Society of Independent Artists.[35] Observing the 'readymade's basic allegiance to the joke',[36] Weiss shifts gear and extends the domain of *blague* to the *Large Glass*, *The Green Box*, the *3 Standard Stoppages* and Duchamp's word games, asserting, '*blague* asks us to note that the indifferent deadpan conforms to an extant comic strategy of 1912'.[37] As a good historian, Weiss rolls irony, parody, absurdity, the comic and the hoax into the logic of *blague*, then unites Duchamp's work under its banner, thus determining his indeterminism and giving meaning to his non-meaning, on the familiar bedrock of artistic intentionality.[38]

Like most writers on Duchamp, Weiss recognises him as a joker and player of games.[39] However, his interpretation is unusual because, at first anyway, it takes this largely at face value rather than looking 'behind' this surface to step away from such a reading – that Duchamp is joking – as is usually the case once the conspiratorial magnetism of the work and the 'secrecy' shrouding it takes hold, requiring remedy in an elaborate, hidden cause. Ultimately, however, Weiss steers clear of the unpleasant task of confronting the potential meaninglessness of the readymades, opting instead for their classification through the logic of *blague*. Yet, emancipated from their servitude to some theoretical end, readymades (for instance) are returned some of their digressive facility as souvenirs of a game lacking a single, carefully plotted origin or end, manifesting only absurdity beyond any context that can bestow 'healthy' reason on them such as art historians demand. This is not to give a coherent theory of the readymade and it makes little sense in the field of art history or theory (which share the task of making sense of art by translating it into written and spoken language). But that is the point. In its insistence on the right of art to incoherence and limitless play, it is an argument that yields some of the obscurity, dissonance and self-contradiction of Duchamp's work, exposing its scattered heterogeneity without reducing it. The irony is that *all* Duchamp scholars agree on the plurivalency and unruliness of Duchamp's *œuvre* in the first instance. However, they are then compelled into a second step, which aims to quell this play through the application of yet further meaning-as-truth.

☺∞£♂♠♪☼♫♀@↑△♪♠☺@≠♂@♀♠♪@£♠♀@●♂☼
£♂☼♀☺∞%♀@£%∞↑☺♠£≠♠♀♠&@@♪≠☼?@£&☼≠
☼€∞@%△≠♂%♀@●♂%?@♀☼>£@&@♠☺@?@
&<≠♂☼>!$<♂☼♠♪♀♠∞>●♂@>♂@♀%♥@%△♠&
@>♀$@&!♀£&<≠%!&♠♂<≠%☼@&&@£♠$♠>>@☼
>√↔♂♂♀♠<☼>!'♠&@>♀$@&!≠●☼♀♀≠@☺●%&
☺♀≠%♪♠♥@≠♂@♪♀♠<●♂♠≠♂@●♠>≠@☺↑☼♥
@@?@&<%>@●♂%☺%@♀≠♂♠≠♥☼>☺%△●%
&♥'⁴⁰☼↑@♠?@≠♂☼♀£%>£@♠↑@☺∞>☺@&♪<%
●♂>☺∞£♂♠♪£%☺@≠%♠?%☼☺@♂@&@☺∞£≠☼
%>%△♪<&@♠☺☼>!♠%♠∞≠♂%&☼♠↑☼>≠@>≠☼
%>♠↑@↑♂≠<≠%☺@↑♠<≠♂@'&@♀@>£@'%△≠♂☼♀
&@♀@>≠♠≠☼%>≠%♪♪♫☼£●☼≠♂♂☼♀☺@>>
%☼♀@☼>≠♂@△%&♪%△≠♂☼♀!♠♪@♠>●≠%↑♠<
●☼≠♂♪<♠∞☺☼♀@>£@♪☼↑☺↑<>%≠♪♠↑☼£☼%∞♀
↑<.

The chess player as artist

In contrast to the lack of method and rigour
expressed in that view, some might argue
that Duchamp's expertise in chess gave him
the edge on his opponents/interpreters,
allowing him to think several moves ahead
in the game of art. Evident in the subject
matter and titles of paintings such as *The
Chess Game* 1910, *Portrait of Chess Players* 1911
(fig.90) and *The King and Queen Surrounded by
Swift Nudes* 1912, his interest in chess began
at an early age within his family, and this
knowledge can clearly be useful as a means
of 'decoding' some of his imagery.

In particular, Duchamp's letters from
Buenos Aires and after reveal his dramatically
increasing enthusiasm for playing chess at
the expense of making art. After the 'incom-
pletion' of the *Large Glass*, his interest in art
waned considerably, while he began to enter
chess competitions with greater frequency.[41]
Duchamp competed in the world amateur
chess championship in 1924, in four French
chess championships between 1924 and 1928,
and in four Chess Olympiads from 1928 to
1933. In addition, he was placed equal first at a
tournament in Hyères in 1928 (alongside the
German Vitaly Halberstadt, with whom he
wrote a book in 1932 on a rare endgame,
entitled *Opposition and Sister Squares are Recon-
ciled*), and first in the Paris tournament of
1932. Duchamp was captain of the French
team in the first International Chess by Cor-
respondence Olympiad, which began in 1935
and ran for four years (with Duchamp himself
achieving the highest individual score), and,
during the 1930s, he contributed a weekly
chess column anonymously to the Parisian
newspaper *Ce Soir*, then edited by recent
departure from the Surrealist group, Louis
Aragon. Certainly for the ten-year period
following his abandonment of the *Large Glass*
in 1923, and probably for many more years
after that, Duchamp ceased to think of
himself as a working artist, and this is borne
out, along with his preference for chess, by his
letters of the period and by his lacklustre
activity recorded in Schwarz's *Complete Works*.

Can we compare the strategies of
Duchamp the chess player with those of
Duchamp the 'artist'? Given the differences
between the worlds of chess and art, the play
of the first, strictly circumscribed by set
rules, cannot be the same as what we see
in Duchamp's work, where there are no
consensual laws, limits, languages or
techniques. Duchamp might have organised
chess games between 'Marcel versus
Duchamp',[42] but his recollection of having
'forced myself to contradict myself in order
to avoid conforming to my own taste'[43] and
endeavour to initiate a 'little game between
"I" and "me"' are of a different order.[44]

Expertise in guessing the behaviour of one's opponent in the first does not transfer to the second or to any other field requiring skills of anticipation and speculation, otherwise chess players would be equally adept at being conceptual artists or of carrying out speculation on the stock exchange or at detective work. Although chess enters into Duchamp's work in various ways, the game of chess and the game of 'art' are clearly played in two entirely different registers.

Anti-interpretation and radical play

In the context of play, the following account of the attributes of Hermes takes on significance for Duchampians:

[Hermes] has to do with oracles, including a dubious sort known as *klēdōn*, which at the moment of its announcement may seem trivial or irrelevant, the secret sense declaring itself only after long delay, and in circumstances not originally foreseeable. Hermes is cunning, and occasionally violent: a trickster, a robber. So it is not surprising that he is also the patron of interpreters. Sometimes they proclaim an evident sense, like a herald; but they also use cunning, and may claim the right to be violent, and glory in it.[45]

In the shade of Hermes, the seemingly cryptic, apparently inexhaustible paper chase of ambiguity Duchamp left behind takes on the aura of a hermetic text, lending him the mask of a *pharmakeus* or magician. Linking through this term the Egyptian god Thoth, Hermes, Eros and Socrates, Jacques Derrida lists their attributes, to define their resistance to limit and meaning:

90
Portrait of Chess Players
1911
Oil on canvas
100.6 x 100.5 cm
Philadelphia Museum of
Art. The Louise and Walter
Arensberg Collection,
1950

the figure of Thoth takes shape and takes its shape from the very thing it resists and substitutes for. But it thereby opposes *itself*, passes into its other, and this messenger-god is truly a god of the absolute passage between opposites. If he had any identity – but he is precisely the god of non-identity – he would be that *coincidentia oppositorum* He cannot be assigned a fixed spot in the play of differences. Sly, slippery and masked, an intriguer and a card, like Hermes, he is neither king nor jack, but rather a sort of *joker*, a floating signifier, a wild card, one who puts play into play ...

Every act of his is marked by this unstable ambivalence. This god of calculation, arithmetic, and rational science also presides over the occult sciences, astrology and alchemy. He is the god of magic formulas that calm the sea, of secret accounts, of hidden texts: an archetype of Hermes, god of cryptography no less than of every other –graphy.[46]

Socrates in the dialogues of Plato often has the face of a *pharmakeus*. That is the name given by Diotima to Eros... Eros... is a fearsome sorcerer (*deinos goēs*), magician (*pharmakeus*), and sophist (*sophistēs*). A being that no 'logic' can confine within a noncontradictory definition.[47]

The mask of Thoth-Hermes as delineated here by Derrida in 'Plato's Pharmacy' fits almost perfectly the Duchamp described through all of the themes of this book. In fact, Hermes – patron of interpreters, *jouer*, god of secrecy and messengers, *pharmakeus* – is even made available as a point of reference to Duchamp's audience (perhaps in relation to the readymade *Pharmacy*?) through the 'horned' portrait of *Monte Carlo Bond* 1924.[48]

However, it is a *coincidence*, and I would not argue for a moment that Duchamp consciously or unconsciously identified with Thoth-Hermes/Mercury, any more than I would claim that Ulf Linde's use of bricks for the pedestal of his 1963 version of *Fountain* has any link to the bricks of Duchamp's *Etant donnés* or that Walter Hopps' 'peephole' design for the invitation to the opening reception of Duchamp's 1963 Pasadena retrospective has any connection with the viewing holes in the doors of that last work.[49] Instead, the identification I am pretending to make through Derrida should be regarded parodically, as a kind of 'anti-interpretation'.

Even though there are such connections made within Duchamp's *œuvre* by Duchamp himself, we cannot allow these to be '*merely*' playful (pleasurable, solipsistic expansions of the semiotic field constituted by his work) but must locate their deeper meaning. Art history, even more than is usual in scholarship, is a sober business dealing with a serious subject. Although humour has never enjoyed a comparable role in art to that which it has held historically in literature or theatre, for instance, significant changes have taken place thanks largely to Duchamp's example. All the same, art history is still wedded to high seriousness and unpractised in levity, and its discourse therefore naturally and insistently lifts Duchamp's playful, pointless, idle gestures out of the playpen to an esteemed and supposedly more substantial level of inquiry. Hence its recourse to holistic explanation through alchemy, Hermeticism, psycho-analysis and so on, to sustain the transcendence and

seriousness of Duchamp's work, even in the face of the comical deflation of those categories by *Fountain*, the *Large Glass* and the *Boîte-en-valise*.

Rather than putting forward a theory or interpretation of Duchamp through play, this final chapter openly plays in the context of his work, avoiding giving it origin and source in meaning (let alone truth) as facilitated by the game of hermetic drift, allowing Duchamp's work to retain its frivolity and incomprehensibility while writing around it anyway. This option has a precedent in philosophy. Future interpretations of Friedrich Nietzsche's rootless sentence, '"I have forgotten my umbrella",' found in quotation marks among his unpublished manuscripts, have been derided in these terms:

psychoanalysis, familiar as it is with forgetting and phallic objects, might yet aspire to a hermeneutic mastery of these remains. And if not, the psychoanalysts . . . can still continue to suspect that, if these generalities were to be articulated and narrowed and the context itself thus prudently completed, they would one day be able to satisfy their interpretive expectations. In this respect the analyst . . . rejoins in principle the impulsive reader or hermeneut ontologist in their common belief that this unpublished piece is an aphorism of some significance.[50]

There is no end to its parodying play with meaning, grafted here and there, beyond any contextual body or finite code. It is quite possible that that unpublished piece, precisely because it is readable as a piece of writing, should remain forever secret. But not because it withholds some secret. Its secret is rather the possibility that indeed it might have no secret, that it might only be pretending to be simulating some hidden truth within its folds. Its limit is not only stipulated by its structure but is in fact intimately confused with it. The hermeneut cannot but be provoked and disconcerted by its play.[51]

Neither this umbrella nor Nietzsche's sentence are readymades, but Derrida's remarks on the relentless will to interpret such fragments act as a further cautionary word for those who seek and find (*because* they seek) all manner of Freudian and other categories in the readymades. It is not so much the readymades that should be interpreted than theories presuming to interpret them.

With Derrida's writings in mind, the philosopher Richard Rorty outlined twenty years ago the liberation of late twentieth-century philosophy from 'ideological, institutional, and disciplinary constraints', arguing, 'this development has made possible a more playful, more cosmopolitan, less professional tone in which to philosophize'.[52] Art history, however, remains on its perch of high seriousness and refuses to come down to play. By giving an argument 'grounded' in an absence – called 'The Duchamp Code' or 'With Hidden Paragraph' – this final chapter is presented without being entirely present. It aims to play off Duchamp's play rather than giving it form and meaning, and to push art history more towards art than history. It would be boring to take it too seriously.

Monte Carlo Bond

Between his 'incompletion' of the *Large Glass* in 1923 and drawing close to the Surrealists from the early 1930s, Duchamp spent more time thinking about and playing chess than he did making art. This fact alone illustrates the difficulty of identifying Duchamp through a 'role,' whether that of artist or any other – a problem exacerbated by his attraction to gambling during this period. Away from Paris for long intervals competing in chess tournaments, Duchamp found the time not only to try his luck at roulette and *trente-et-quarante*, but also to dream up and test various systems for winning. From early 1924 well into 1926, Duchamp made a series of futile attempts to discover a 'martingale,' technically a term describing a system that consists in doubling the stake each time one loses to recoup the money, but which seems to have been used by Duchamp to mean any system for winning at gambling. In a letter from Nice in March 1924 to his patron of the time Jacques Doucet, Duchamp announces this new enthusiasm for the casino, describing his improvement as a player and his search for a formula that would consistently pay dividends. By the following month, he was telling Francis Picabia that his system was now paying off in small amounts through a 'deliciously monotonous' procedure carried out with 'not a trace of emotion', a claim in line with Duchamp's aim to escape expressivity in art (and life, apparently).

In a letter of March 1925 to Doucet, Duchamp talked up his gambling system, referring enigmatically and delicately to the 'unfortunate experience of last year' and claiming to have now 'eliminated the word chance.' In an effort to gain funds for his new hobby, Duchamp had the idea of launching around this time his own bond issue, facilitated by the creation and distribution of thirty copies of a photocollage signed in his own name and that of Rrose Sélavy (though Schwarz states that fewer than eight were made in the end), which is now titled *Monte Carlo Bond* (1924). Investors would buy these at 500 francs each, entitling them to a twenty percent return on their investment. The 'company statutes' are printed on the reverse of the document, detailing the aims and rights of the company and its shareholders and outlining the means of accumulating the annual income

from a system 'experimentally based on one hundred thousand throws of the ball'. These parody the stiff, formal language of legal documents, which Duchamp found amusing and had plenty of access to earlier in life due to his father's occupation as a notary. But Duchamp was no businessman, and one look at the bond would have been enough to put most potential investors off. A cropped photograph by Man Ray of Duchamp lathered up with shampoo and/or shaving cream making his hair into horns, framed against a diagram of a roulette wheel, adorns the front. Religious, mythological and historical cross-references have been made with Duchamp's self-representation in *Monte Carlo Bond*. Printed in green 150 times as background ornament on three sides around the representation of a gaming table is the pun *moustiques domestiques demistock* ('domestic mosquitoes half stock). Some of the issue are numbered with a fifty-centime stamp, and these were the only ones that entitled their owners to a dividend.

Duchamp attempted to publicise the bond issue by sending one along to Jane Heap, editor of the literary journal *The Little Review*, who told her readers it was worth buying one at 500 francs for Duchamp's signature alone. In the end, Duchamp seems to have found about twelve 'investors', including Ettie Stettheimer and the dentist Daniel Tzanck, who probably entered into the scheme more out of friendship and respect than in the expectation of making their fortune. Only Doucet benefited, to the tune of just fifty francs in December 1925. By then, Duchamp had signalled his waning confidence in the enterprise, conceding in a letter to Doucet that he would never be bankrupt but he would never be a millionaire either. It is not clear how many of the hundred thousand throws of the roulette ball Duchamp actually made, but the system seems to have tested his patience to its limit, and although he continued to try it out up to late 1925 and early 1926 and even thought of writing a pamphlet on it late in 1926, his gambling ambitions along with his business were long defunct by then.

A run of two thousand colour lithographs of *Monte Carlo Bond* was executed in 1938 and a miniature version of the work entered the *Boîte-en-valise*. The 'delicious monotony' that

characterised the game of roulette for Duchamp recalls his remark about the pleasure he gained from gazing at the spinning wheel of *Bicycle Wheel*. As well as its obvious conceptual link with the many wheeled and rotary contraptions of Duchamp's *œuvre*, *Monte Carlo Bond* recalls Duchamp's perennial interest in chance, best seen in the *3 Standard Stoppages*.

Supplement: Reviewing *The Duchamp Book*

There is no reason to assume that even the most extravagant series of unveilings would ever reach anything but another veil.
J. Hillis Miller, *Hawthorne & History*, 1991

The Duchamp Book aims throughout to address two audiences, attempting to give a clear account of sometimes difficult work by Duchamp and the way it has been viewed by critics, while wondering how it might be considered in the twenty-first century. It suggests that the irresistible play of that *œuvre*, which all commentators agree upon – its tantalising air of uncertainty, inner contradictions and mesmerising availability to resolution into a pattern, which only make us try harder to manage and restrain it – should be accepted at face value and 'played off' instead of being circumscribed by fixed meaning.

Its argument is not that Duchamp was 'too clever for us' and is therefore beyond interpretation (on the contrary, at times Duchamp's ingenious readers seem too clever for him), nor does it claim to know him any better than others (both text and footnotes refer favourably to existing arguments near to and far from the one presented in *The Duchamp Book*). It is more of an appeal for some consideration of how we respond to art generally; a request that we should neither attempt to say what Duchamp's body of work definitively *is* or *means* (while 'covering our backs' by saying we are playing along with Duchamp, only to reinstate the yearned-for certainty and 'truth' of 'artist's intention' demanded by a discipline such as art history) but to say what we feel it *does*, and to act accordingly (to play, in this case). In this way, it can be a creative spur for writers on art who wish to test the boundaries of their discipline, just as it has been an inspiration for artists seeking to explore the outer reaches of art. Although the nature of this book prevents this performative response throughout and only allows it to be alluded to in the first five chapters, there is a tentative attempt to demonstrate what is meant by this in the final chapter with reference to *With Hidden Noise*, and there are some footnote references there for where to go to find more of the same.

London, 17 July 2007

Duchamp's Writings

Jean (Hans) Arp (sculptor, painter, writer), 1949

Based on the metaphysical implications of the Dadaist dogma, Arp's *Reliefs* between 1916 and 1922 are among the most convincing illustrations of that anti-rationalistic era. The important element introduced then by Arp was 'humour' in its subtlest form; the kind of whimsical conceptions that gave to the Dada Movement such an exuberant liveliness as opposed to the purely intellectual tendencies of Cubism and Expressionism. Arp showed the importance of a smile to combat the sophistic theories of the moment. His poems of the same period stripped the word of its rational connotation to attain the most unexpected meaning through alliteration or plain nonsense. His contribution to Surrealism, his Concretions, show his masterly technique in the use of different materials, and in many instances are like a three-dimensional pun – what the female body 'might have been'. For Arp, art is Arp.

Umberto Boccioni (painter, sculptor, writer), 1943

Unlike other art movements, Futurism had a dynamic literary leader in Marinetti – but the prince of Futurism was Boccioni, who conceived the most convincing manifestos at a time when the world was thirsty for new art expressions. Boccioni's paintings and sculptures demonstrated the theory and completed point by point the explanations which words are unable to give. Of all the Futurists, Boccioni was the most gifted, and his premature death was certainly a reason for the breaking up of the movement in its further development. But since movements in art remain only as vague labels representing a period, the artist continues to live through his work. Thus Boccioni will be remembered, not so much as a Futurist but as an important artist.

Giorgio de Chirico (painter, writer, illustrator), 1943

Witnessing the rise of new esthetics, in contact with the different expressions of the 'heroic' period in the early part of the twentieth century, de Chirico found himself

in 1912 confronted with the problem of following one of the roads already opened or of opening a new road. He avoided Fauvism as well as Cubism and introduced what could be called 'metaphysical painting'. Instead of exploiting the coming medium of abstraction, he organized on his canvases the meeting of elements which could only meet in a 'metaphysical world'. These elements, painted in the minutest technique, were 'exposed' on a horizontal plane in orthodox perspective. This technique, in opposition to the Cubist or purely abstract formula in full bloom at the moment, protected de Chirico's position and allowed him to lay down the foundation of what was to become Surrealism ten years later. About 1926 de Chirico abandoned his 'metaphysical' conception and turned to a less disciplined brush-stroke. His admirers could not follow him and decided that de Chirico of the second manner had lost the flame of the first. But posterity may have a word to say.

André Derain (painter, graphic artist), 1949
At the turn of the century, when Impressionism and Pointillism were a 'recognised revolution', the younger generation felt the urge for further experimentation in the realm of colour. Among the Fauves, Derain stands out as a pioneer of this experiment, based on optical contrasts of vivid colours applied to a systematic distortion of the natural form. While at the same time the 'Intimists', Bonnard, Vuillard and others, were applying Impressionist technique to indoor scenes, Derain and the Fauves rehabilitated black as a colour and used the heavy lined form in reaction to the delicate and nebulous painting of Monet and Cézanne. The three important 'Fauves', Matisse, Braque, and Derain, had too great personalities to keep to a strict common formula. And as early as 1907 Derain had already switched away from Fauvism proper to a more sombre technique, in many ways a forerunner of the Cubist palette. Braque turned to Cubism and Matisse became Matisse. Derain is consistently adverse to 'theories'. He has always been a true believer in the artistic message unadulterated by methodical explanations and to this day

belongs to the small group of artists who 'live' their art.

Raymond Duchamp-Villon (sculptor), 1943
Raymond Duchamp-Villon had already received recognition as a sculptor when the new art theories tempted him and made him the first exponent of Cubist sculpture. His well known *Horse* will always be remembered as one of the landmarks of the Cubist Movement. His premature death makes one feel, very acutely, the significance of the far too few pieces he left behind. His *Baudelaire* and *Seated Woman* are two fine examples of his simplification which at the time the work was done, about 1908, even exceeded Rodin's synthesis of the Walking Man, and are still in advance of much of the sculpture of today.

Max Ernst (painter, sculptor, author), 1945
The Dada Movement was an anti-movement which corresponded to a need born of the first World War. Although neither literary nor pictorial in essence, Dada found its exponents in painters and writers scattered all over the world. Max Ernst's activities in Cologne in 1917 made him the foremost representative of the Dada painters. Between 1918 and 1921 his paintings, drawings and collages depicting the world of the subconscious were already a foretaste of Surrealism. Among his technical discoveries the use of the old Chinese 'frottage' or rubbing technique shows 'automatic' textures of wood and different materials. When the Surrealist Movement took shape in 1924, Max Ernst was the only painter in the group of Dadas who joined the writers in the Surrealist venture. In fact his previous achievements had certainly influenced, to a great extent, the literary Surrealist exploration of the subconscious. Extremely prolific, Max Ernst has had a long Surrealist career and given through his work a complete exposé of the different epochs of Surrealism.

Paul Klee (painter, graphic artist, writer), 1949
A deep conception of the use of watercolour, a personal method in oil painting applied to apparently decorative forms, have made Klee stand out in contemporary painting as

unrelated to anyone else. On the other hand his experiments over the last thirty years have been used by other artists as a basis for new developments in the different fields of art. The first reaction before a painting by Paul Klee is a pleasant realization of what we all might have done when drawing in childhood. Most of his compositions show this delightful side of unsophisticated, naïve expression. But this is only the first contact with his work and a very appealing one. When we look closer we immediately discover how incomplete the first impression was and if Klee often uses a 'childish' technique, it is applied to a very mature form of thinking which an analysis of his work discovers. His extreme fecundity never shows signs of repetition as is generally the case. He has so much to say that a Klee is never like another Klee.

Henri Matisse (painter, sculptor, graphic artist), 1943

As early as 1904 Henri Matisse began his search for new fields of expression using thin, flat, coloured surfaces, framed in a drawing of heavy lines – to oppose Pointillism, the last stronghold of Impressionism. The movement which was to be called Fauvism was sponsored by a number of young painters who felt the necessity of avoiding the impasse to which Impressionism and Pointillism had brought them. But Matisse, like all pioneers, was more than a theoretician of the moment. His first important reaction was in the treatment of form, starting from natural representation. He purposely ignored all conventions of anatomy and perspective in order to introduce whatever drawing he felt adequate to give maximum values to the flat hues of colours inserted within the intentional outlines. Coming just after the recognition of Van Gogh, Cézanne and Seurat, Matisse's idea was a deliberate attempt to open new roads in the physics of painting. Around 1907 he showed several large compositions which contained all the elements of his masterly conception. Perspective had been discarded and replaced by the relationship of strong forms which produced a three-dimensional effect of its own. Figures and trees were

indicated in heavy lines, building the arabesque adjusted to the flat areas of colour. The ensemble created a new scenery in which the objective composition appeared only as a remote guide. Ever since these early achievements, Matisse has added to his physical treatment of painting a very subtle chemistry of brushwork which amplifies the completeness of his latest work.

Joan Miró (painter), 1946

Miró came of age as an artist just at the time World War I ended. With the end of the war came the end of all the new pre-war art conceptions. A young painter could not start as a Cubist or a Futurist, and Dada was the only manifestation at the moment.

Miró began by painting farm scenes from the countryside of Barcelona, his native land. Although realistic in appearance, these first pictures were marked with a definite sense of unreal intensity.

A few years later he came to Paris and found himself among the Dadaists who were, at that time, transmuting into Surrealism. In spite of this contact Miró kept aloof from any direct influence and showed a series of canvases in which form submitted to strong colouring expressed a new two-dimensional cosmogony, in no way related to abstraction. He also made some constructions directly related to Surrealism but his real self was best exteriorized in the play of coloured elements one upon another.

Francis Picabia (painter, writer), 1949

Picabia's career is a kaleidoscopic series of art experiences. They are hardly related one to another in their external appearances, but all are definitely marked by a strong personality.

In his fifty years of painting Picabia has constantly avoided adhering to any formula or wearing a badge. He could be called the greatest exponent of freedom in art, not only against academic slavery, but also against slavery to any given dogma.

As a lad of fourteen he joined the Impressionists and showed a great talent as a young follower of an already old movement. About 1912 his first personal contribution as an artist was based on the possibilities of a non-figurative art. He was a pioneer in this

field alongside Mondrian, Kupka and Kandinsky. Between 1917 and 1924 the Dada Movement, in itself a metaphysical attempt towards irrationalism, offered little scope for painting. Yet Picabia in his paintings of that period showed great affinity with the Dada spirit. From this he turned to paint for years watercolours of a strictly academic style representing Spanish girls in their native costumes.

Later, Picabia took great interest in the study of transparency in painting. By a juxtaposition of transparent forms and colours the canvas would, so to speak, express the feeling of a third dimension without the aid of perspective.

Picabia, being very prolific, belongs to the type of artist who possesses the perfect tool: an indefatigable imagination.

Pablo Picasso (painter, sculptor, graphic artist, writer), 1943

Picasso as a name represents the living expression of a new thought in the realm of esthetics. Between 1905 and 1910 Picasso, inspired by the primitive negro sculpture introduced into Europe, was able to reject the heritage of the Impressionist and Fauve schools and to free himself from any immediate influence. This will be Picasso's main contribution to art. To have been able to start from a new source, and to keep this freshness with regard to whatever new expressions mark the different epochs of his career. Cubism, in itself, was an art movement of which Picasso was only a 'pioneer'. He never felt bound to follow through a theory of Cubism, even though he might have been responsible for its elaboration. Picasso in each one of his facets, has made clear his intention to keep free from preceding achievements. One of the important differences between Picasso and most of his contemporaries is that until today he has never shown any sign of weakness or repetition in his uninterrupted flow of masterpieces. The only constant trend running thorough his work is an acute lyricism, which with time has changed into a cruel one. Every now and then the world looks for an individual on whom to rely blindly – such worship is comparable to a religious appeal and goes beyond reasoning. Thousands today in quest of supernatural esthetic emotion turn to Picasso, who never lets them down.

Jacques Villon (painter, engraver), 1949

Four of the seven children in the Duchamp family became artists; Jacques Villon, the oldest; Raymond Duchamp-Villon, the sculptor and architect; Marcel Duchamp; and Suzanne Duchamp. Jacques Villon first made a name for himself as a cartoonist around 1900, but his real avocation was etching and oil painting. His many etchings show the technical perfection and traditional respect for that medium. He expressed still more personality in his oil paintings; after joining the Cubist Movement among the first he never lost his lyrical qualities and kept true to himself even during his most severe Cubist period. After passing through the various experiments of his long career, Villon has now reached an incisive formula, where the relationship of colour is supported by an architectural drawing, an affirmation, a conclusion, which brings added joy to those who have witnessed his constant growth and great achievement.

'THE CREATIVE ACT' [2]

Let us consider two important factors, the two poles of the creation of art: the artist on one hand, and on the other the spectator who later becomes the posterity.

To all appearances, the artist acts like a mediumistic being who, from the labyrinth beyond time and space, seeks his way out to a clearing.

If we give the attributes of a medium to the artist, we must then deny him the state of consciousness on the esthetic plane about what he is doing or why he is doing it. All his decisions in the artistic execution of the work rest with pure intuition and cannot be translated into a self-analysis, spoken or written, or even thought out.

T.S. Eliot, in his essay on 'Tradition and the Individual Talent', writes: 'The more perfect the artist, the more completely separate in him will be the man who suffers

and the mind which creates; the more perfectly will the mind digest and transmute the passions which are its material.'

Millions of artists create; only a few thousands are discussed or accepted by the spectator and many less again are consecrated by posterity.

In the last analysis, the artist may shout from all the rooftops that he is a genius; he will have to wait for the verdict of the spectator in order that his declarations take a social value and that, finally, posterity includes him in the primers of Art History.

I know that this statement will not meet with the approval of many artists who refuse this mediumistic role and insist on the validity of their awareness in the creative act – yet, art history has consistently decided upon the virtues of a work of art through considerations completely divorced from the rationalized explanations of the artist.

If the artist, as a human being, full of the best intentions toward himself and the whole world, plays no role at all in the judgement of his own work, how can one describe the phenomenon which prompts the spectator to react critically to the work of art? In other words how does this reaction come about?

The phenomenon is comparable to a transference from the artist to the spectator in the form of an esthetic osmosis taking place through the inert matter, such as pigment, piano or marble.

But before we go further, I want to clarify our understanding of the word 'art' – to be sure, without an attempt to a definition.

What I have in mind is that art may be good, bad or indifferent, but, whatever adjective is used, we must call it art, and bad art is still art in the same way as a bad emotion is still an emotion.

Therefore, when I refer to 'art coefficient', it will be understood that I refer not only to great art, but I am trying to describe the subjective mechanism which produces art in a raw state – *à l'état brut* – bad, good or indifferent.

In the creative act, the artist goes from intention to realization through a chain of totally subjective reactions. His struggle toward the realization is a series of efforts, pains, satisfactions, refusals, decisions, which

also cannot and must not be fully self-conscious, at least on the esthetic plane.

The result of this struggle is a difference between the intention and its realization, a difference which the artist is not aware of.

Consequently, in the chain of reactions accompanying the creative act, a link is missing. This gap which represents the inability of the artist to express fully his intention; this difference between what he intended to realize and did realize, is the personal 'art coefficient' contained in the work.

In other words, the personal 'art coefficient' is like an arithmetical relation between the unexpressed but intended and the unintentionally expressed.

To avoid a misunderstanding, we must remember that this 'art coefficient' is a personal expression of art '*à l'état brut*', that is, still in a raw state, which must be 'refined' as pure sugar from molasses, by the spectator; the digit of this coefficient has no bearing whatsoever on his verdict. The creative act takes another aspect when the spectator experiences the phenomenon of transmutation; through the change from inert matter into a work of art, an actual transubstantiation has taken place, and the role of the spectator is to determine the weight of the work on the esthetic scale.

All in all, the creative act is not performed by the artist alone; the spectator brings the work in contact with the external world by deciphering and interpreting its inner qualifications and thus adds his contribution to the creative act. This becomes even more obvious when posterity gives its final verdict and sometimes rehabilitates forgotten artists.

'APROPOS OF "READYMADES"' [3]

In 1913 I had the happy idea to fasten a bicycle wheel to a kitchen stool and watch it turn.

A few months later I bought a cheap reproduction of a winter evening landscape, which I called *Pharmacy* after adding two small dots, one red and one yellow, in the horizon.

In New York in 1915 I bought at a hardware store a snow shovel on which I wrote 'In Advance of the Broken Arm'.

It was around that time that the word 'readymade' came to mind to designate this form of manifestation.

A point which I want very much to establish is that the choice of these 'readymades' was never dictated by esthetic delectation.

This choice was based on a reaction of visual indifference with at the same time a total absence of good or bad taste ... in fact a complete visual anesthesia.

One important characteristic was the short sentence which I occasionally inscribed on the 'readymade.'

That sentence instead of describing the object like a title was meant to carry the mind of the spectator towards other regions more verbal.

Sometimes I would add a graphic detail of presentation which in order to satisfy my craving for alliterations, would be called 'readymade aided'.

At another time wanting to expose the basic antinomy between art and readymades I imagined a 'reciprocal readymade': use a Rembrandt as an ironing board!

I realized very soon the danger of repeating indiscriminately this form of expression and decided to limit the production of 'readymades' to a small number yearly. I was aware at that time, that for the spectator even more than for the artist, art is a habit forming drug and I wanted to protect my 'readymades' against such contamination.

Another aspect of the 'readymade' is its lack of uniqueness ... the replica of a 'readymade' delivering the same message; in fact nearly every one of the 'readymades' existing today is not an original in the conventional sense.

A final remark to this egomaniac's discourse:

Since the tubes of paint used by the artist are manufactured and ready made products we must conclude that all the paintings in the world are 'readymades aided' and also works of Assemblage.

INFRA-MINCE [4]

When the tobacco smoke smells also of/the mouth which exhales it, the 2 odors/marry by *infra mince* (olfactory/*infra mince*)

inframince (adject.)/not noun – never/use as/a substantive

Subway gates – The people/who go through at the very last moment/*infra mince* –

Velvet trousers –/their whistling sound (in walking) by/brushing of the 2 legs is an/*infra mince* separation signaled/by sound. (it is **not ?** an *infra mince* sound).

The warmth of a seat (which has just/been left) is *infra-mince*.

The possible is/an *infra-mince* –/ ... The possible implying/the becoming – the passage from/one to the other takes place/in the *infra mince*.

inframince **separation** – better/than screen, because it indicates/interval (taken in one sense) and/screen (taken in another sense) – separation/has the 2 senses male and female –

The convention of the arrow/sign produces an *infra mince*/reaction on the sense of displacement/agreed to

allegory/(in general)/is an application of the *infra mince*

Painting on glass/seen from the unpainted side/gives an *infra/mince*

Colours and *infra mince*/Transparency 'attenuating' the colours/into *infra mince*

'Lamination' to isolate an/*infra mince* – Between 2 sheets of glass/a substance that solidifies without/adhering to the sheets of glass –/compression – rather than lamination –

piece of iridescent cloth bought at Grenoble/shot silk – (support for the visible/*infra mince* ...).

All 'identicals' as/identical as they may be,
(and/the more identical they are)/move
toward this/*infra mince* separative/difference

Two men are not/an example of
identicality/and to the contrary move
away/from a determinable/*infra mince*
difference – but there exists the crude
conception/of the déjà vu which leads
from/generic grouping/(2 trees, 2 boats)/to
the most identical 'castings'/It would be
better/to try/to go/into the/*infra
mince*/interval which separates/2 'identicals'
than/to conveniently accept/the verbal
generalization/which makes/2 twins look
like 2/drops of water

WORDPLAY[5]

Strangles strangers
[*Etrangler l'étranger*]

Ruined, urined
[*Ruiner, uriner*]

Litter erasure
[*Lits et ratures*]

Sacristy, crassity
[*Eglise, exil*][6]

Anemic cinema

Question of intimate hygiene:
Should you put the hilt of the foil in the
quilt of the goil?
[*Question d'hygiene intime;*
Faut-il mettre la moelle de l'épée dans le poil de
l'aimée?]

Abominable abdominal furs
[*Abominables fourrures abdominals*]

A Guest + a Host = a Ghost

We deliver domestic mosquitocs (half-stock)
[*Nous livrons des moustiques domestiques*
(demi-stock)]

SELECTED CORRESPONDENCE

**To Jacques Villon and family, 26 September
1912, Berlin**[7]
Hello dears,

Here I am again, back in the swing of
Berlin life— My second impression is better
than the first time around, probably because
I've been to see a few paintings – without fail,
the museums here are incredibly well set
out. Why is the Louvre such a 'mess'?—

And then the Berlin Secession, which
finally allowed me to see how young French
painting was looking abroad. There's a
special room for Friez, Marquet, Valtat,
Herbin and 4 for Picasso— I was really
pleased to find they have Cubism here, it was
so long since I'd seen any. And that certainly
played a part in my having a soft spot for
Berlin.

I take buses, trams, as though I'd lived
here all my life.

The underground is not as big as in Paris.
(There's just one main line and one that runs
across it— very pleasant in fact.)

The horse-drawn buses, for there are still
plenty of those here, are so small they look
like our Auteuil St. Sulpice (slight
exaggeration) =

And then the Lindens, yes, the Lindens!
Except without the lime trees in question.
It's a very wide avenue and not very long.

The Tiergarten is the only really pleasant
place.

I've been informed officially that the Jury
at the Salon d'Automne liked my drawing.
Much good may it do me! I finally found the
Gil Blas and will be interested to follow,
hopefully, the opening in the Autumn, no
doubt with descriptions by our friend
Vauxcelles.

I'm writing to you from a so-called
'literary' café. There are mainly a lot of
women here who have nothing literary about
them at all—

I hope that my friend will meet me here at
the beginning of next week and will show me
'Berlin by night'. It's a local speciality.

I hope to return to Paris around the 10th.
On my way back I'll most probably stop off
in Cologne.

My dear Raymond should have a bit of

leave around now.

What about Gaston, has he finished his military service yet—

I'm beginning to feel the need to see old faces.

See you soon now anyhow
Very affectionately to all
Marcel

To Walter Pach (critic, artist and friend of Duchamp), 27 April 1915, Paris [8]

My dear friend,

I got your double letter this morning — I was really delighted. I have, indeed, received the catalogue from the Montross Gallery and was very surprised not to see you next to Messrs Davies and Kuhn. Also, you seem to me somewhat demoralized in your letter!

You miss Paris. Yes, I can understand that because you were living the free life of an artist with all the joys and the bad times one so likes to recall—

As for my trip to New York, that's altogether different. I'm not looking for anything there except individuals.

– If you remember our conversations of the Boulevard St Michel or Raspail, you will see that my intention to leave is the unavoidable consequence of these conversations.

– I am not going to New York, I am leaving Paris. That's quite different.

Long before the war, I already had a distaste for the 'artistic life' I was involved in.— It's quite the opposite of what I'm looking for.— And so I tried, through the Library, to escape from artists somewhat.

Then, with the war, my incompatibility with this milieu grew. I wanted to go away at all costs. Where to? My only option was New York where I knew you and where I hope to be able to escape leading the artistic life, if needs be through a job which will keep me very busy.

I asked you to keep all this secret from my brothers because I know my leaving will be very painful for them.

– The same goes for my father and sisters.

But at the end of the day, as you guard me against New York, if I can't live there any more than in Paris, I can always come back or go elsewhere.—

– I have impressed upon you my preoccupation with earning money so as to have a secure existence over there. That's the way it has to be. I consider that my father has done enough for me already. And I'm not after leading the life of an artist in search of fame and fortune. I am very happy to hear that you sold these canvases for me and thank you very sincerely for your friendship. But I am afraid of getting to the stage of needing to sell canvases, in a word, of being a painter for a living.

– So I'll be leaving probably on the 22nd or rather 29th May, if the police authorities allow me to take the steamer

M. Duchamp

To Suzanne Duchamp, c. 15 January 1916, New York [9]

My dear Suzanne,

A huge thank you for having taken care of everything for me— But why didn't you take my studio and go and live there? I've only just thought of it— Though I think, perhaps, it wouldn't do for you.

In any case, the lease is up on 15th July and if you were to renew it, make sure you ask the landlord to let it 3 months at a time, the usual way. He's bound to agree. Perhaps Father wouldn't mind getting a term's rent back if there's a possibility you'll be leaving La Condamine by 15th April— But I don't know anything about your plans and I'm just making a suggestion—

Now, if you have been up to my place, you will have seen, in the studio, a bicycle wheel and a bottle rack.— I bought this as a ready-made sculpture [*sculpture tout faite*]. And I have a plan concerning this so-called bottle rack. Listen to this.

Here, in N.Y., I have bought various objects in the same taste and I treat them as 'readymades'. You know enough English to understand the meaning of 'readymade' [*tout fait*] that I give these objects— I sign them and think of an inscription for them in English. I'll give you a few examples.

I have, for example, a large snow shovel on which I have inscribed at the bottom: *In advance of the broken arm*, French translation: *En avance du bras cassé*— Don't tear your hair out trying to understand this in the

Romantic or Impressionist or Cubist sense –
it has nothing to do with all that.

Another 'readymade' is called: *Emergency in favor of twice*, possible French translation: *Danger\Crise\en faveur de 2 fois*.

This long preamble just to say:

Take this bottle rack for yourself. I'm making it a 'readymade', remotely. You are to inscribe it at the bottom and on the inside of the bottom circle, in small letters painted with a brush in oil, silver white colour, with an inscription which I will give you herewith, and then sign it, in the same handwriting, as follows:

[after] Marcel Duchamp.

To Carrie, Ettie and Florine Stettheimer (friends of Duchamp from New York), 3 May 1919, Buenos Aires [10]

Dear three,

I have been wanting to write to you for some time, but never have time, so absorbed am I in playing chess. I play night and day and nothing in the whole world interests me more than finding the right move. Therefore please find it in you to forgive a poor fool, a maniac. I know that you have enough natural goodness in you to forgive. Nothing transcendental going on here – strikes, a lot of strikes, the people are on the move. Painting interests me less and less.

I'm leaving B.[uenos] A.[ires] 15th June for France on an English ship of which I don't yet know the name. I hope to arrive over there toward 15th July, say hello to my family for a few months and come back to New York to execute some drawings I've been doing here

To Henri-Pierre Roché, c. 15 February 1922, New York [11]

No, I really don't feel like broadening my horizons.

When I get a little money, I will do different things— But I don't think that the few hundred francs or whatever cash I would get out of it would make up for the hassle of seeing this reproduced for the public.—

I've had it up to here with being a painter or a cinematographer. The only thing that would arouse my interest right now is a wonder drug that would make

me play chess divinely—

That would really turn me on.

Goodbye old chap, say hello to the Coraux and write again,

Duchamp

1947 Broadway Room 312 N.Y. City

To Katherine S. Dreier, 11 September 1929, Paris [12]

You have all the rights to be furious, but I have been actually unable to write: I had so many things to decide on—
You must understand:

My attitude toward the book is based upon my attitude toward 'Art' since 1918—

So I am furious myself that you will accept only partly that attitude.

It can be no more question of my life as an artist's life: I gave it up ten years ago; this period is long enough to prove that my intention to remain outside of any art manifestation is permanent

The second question is that, according to my attitude, I don't want to go to America to start anything in the way of an 'Art' museum of any kind.

The third question is that I want to be alone as much as possible.

This abrupt way to speak of my 'hardening process' is not meant to be mean, but is the result of '42 years of age'. Summing up—

I am a little sick— physically— my bladder is beginning to speak— So I have to take care of myself— doctors included—

My opinion is that anything one does is all right and I refuse to fight for this or that opinion or their contrary

Don't see any pessimism in my decisions: They are only a way toward beatitude—

Please understand, I am trying for a minimum of action, gradually—

I would never let Waldemar George write anything about me, if it were in my power—

My brother never said a word . . . Yet to me—

All this is very annoying
so let's forget it—

I wrote to Dr. Fox. and sent him the photos and prices of the bird.

According to Brancusi (sick in Aix les Bains, better now), it is the same Bird in

marble as Mrs Steichen's one— Let us hope this will succeed.

I will go to Nice in October for 2 months I hope— Chess.

10 000 apologies for this rough letter and affectueusement

Dee—

To Katherine S. Dreier, 5 March 1935, Paris [13]

This is a long time since I wrote: I have been very busy with two new ideas.

I want to make, sometime, an album of approximately all the things I produced.

Before I do this, I want to prepare the album by making ten color reproductions of my better things.— Selling these 10 reproductions separately like color photographs (but really color 'phototypie' like the one reproduced in my box [*The Green Box* 1934]) I hope to get enough money to do the complete album.

Then I will ask you to have a photograph (in black and white) made of every painting and object of mine you possess.

But this won't come before 6 months from now—

For the big glass which I intend to reproduce in color, I will make an interpretation (for the colors) from the other paintings made for it— Anyway it would be too difficult to make a color photograph of the glass in the condition it is now.

I am going to make a playtoy with the discs and spirals I used for my film—

The designs will be printed on heavy paper and collected in a round box.

I hope to sell each box 15 francs and many— (Each disc is to be seen turning on a Victrola).

This second project is less expensive than the other and I am working very seriously at it. Please don't speak of this as simple ideas are easily stolen.

There we are—. . .

To Yvonne Chastel, 8 January 1949, New York [14]

Dear Yvonne, yes indeed what have we been up to? I feel rather like I've retired to the country, in some remote province, for that's what my life is like in N.Y.

I see few people and people don't try to see me anymore as they know they bore me.

I write to the Arensbergs once a year and they do the same. There is a general weariness which, I think, is not confined to our generation. To tell the truth, most people prefer war to peace.

Is food rationing still as severe in England? You hear so many things that aren't true.

As you will know from the radio, it snowed a lot in December— It's mild now, like in springtime. Long may it last!!

By the way, I looked for your percolator, but never found the manufacturers. I expect it doesn't exist anymore.

Would you like something like it or anything else you might have seen in advertisements in magazines?

Just tell me and I'll send it to you.

Do you want any coffee, tea, rice—

How easy is it to send things to England?

Well there you are, my dear Yvonne. Nothing as usual. Chess as much as possible: at least chess players don't talk—

Very pleased for Penrose. And Mesens? Is there the same collapse in painting in London as there is here?

Do write from time to time.

You are one of the few people one can speak freely to—

Affectionately,

Marcel.

To Jean Suquet (art historian), 25 December 1949, New York [15]

Dear Suquet,

Received your letter and, almost at the same time, the long text at which I was overjoyed. You no doubt know that you are the only person in the world to have put together the gestation of the glass in all its detail, including even the numerous intentions which were never executed. Your patient work has enabled me to relive a period of long years during which the notes were written for the green box at the same time as the glass was taking shape. And I confess to you that, not having read these notes for a very long time, I had completely lost all recollection of numerous points not illustrated on the glass and which are a delight to me now.

One important point for you is to know

how indebted I am to Raymond Roussel who, in 1912, delivered me from a whole 'physicoplastic' past which I had been trying to get out of. A production at the Antoine theatre of 'Impressions of Africa' which I went to see with Apollinaire and Picabia in October or November 1912 (I would be grateful if you would check the date), was a revelation for the three of us, for it really was about a new man at that time. To this day, I consider Raymond Roussel all the more important for not having built up a following.

Naturally, my dear Suquet, have reproduced whatever you deem necessary to your brilliantly lucid text.

'To have the apprentice in the sun,' if I remember the exact caption accompanying the silhouette of a cyclist going up a hill, part of a short series of short texts in a box of photographic plates (1912 or 1913?) – I'm glad you've been able to see one (there are only three) at Villon's who knows plenty more about me. Use the apprentice, naturally, if you think it's worthy.

Another important point which you so very accurately sensed concerns the idea that the glass in actual fact is not meant to be looked at (with 'aesthetic' eyes). It should be accompanied by a 'literary' text, as amorphous as possible, which never took shape. And the two elements, glass for the eyes, text for the ears and understanding, should complement each other and above all prevent one or the other from taking on an aesthetico-plastic or literary form. All in all, I am hugely indebted to you for having stripped bare my Bride stripped bare.

Most sincerely,
Marcel Duchamp.

To Jean Crotti (Duchamp's brother-in-law) and Suzanne Duchamp, 17 August 1952, New York [16]
You were asking my opinion on your work of art, my dear Jean— It's very hard to say in just a few words— especially for me as I have no faith – religious kind – in artistic activity as a social value.

Artists throughout the ages are like Monte Carlo gamblers and the blind lottery pulls some of them through and ruins others— To my mind, neither the winners nor the losers are worth bothering about— It's a good business deal for the winner and a bad one for the loser.

I do not believe in painting per se— A painting is made not by the artist but by those who look at it and grant it their favours. In other words, no painter knows himself or what he is doing— There is no outward sign explaining why a Fra Angelico and a Leonardo are equally 'recognized'.

It all takes place at the level of our old friend luck— Artists who, in their own lifetime, have managed to get people to value their junk are excellent travelling salesmen, but there is no guarantee as to the immortality of their work— And even posterity is just a slut that conjures some away and brings others back to life (El Greco), retaining the right to change her mind every 50 years or so.

This long preamble just to tell you not to judge your own work as you are the last person to see it (with true eyes)— What you see neither redeems nor condemns it— All words used to explain or praise it are false translations of what is going on beyond sensations.

You are, as we all are, obsessed by the accumulation of principles or anti-principles which generally cloud your mind with their terminology and, without knowing it, you are a prisoner of what you think is a liberated education—

In your particular case, you are certainly the victim of the 'Ecole de Paris', a joke that's lasted for 60 years (the students awarding themselves prizes, in cash).

In my view, the only salvation is in a kind of esotericism— Yet, for 60 years, we have been watching a public exhibition of our balls and multiple erections— Your Lyons grocer speaks in enlightened terms and buys modern painting—

Your American museums want at all costs to teach modern art to young students who believe in the 'chemical formula'—

All this only breeds vulgarization and total disappearance of the original fragrance.

This does not undermine what I said earlier, since I believe in the original fragrance, but, like any fragrance, it evaporates very quickly (a few weeks, a few

years at most). What remains is a dried up nut, classified by the historians in the chapter 'History of Art'—

So if I say to you that your paintings have nothing in common with what we see generally classified and accepted, and that you have always managed to produce things that were entirely your own work, as I truly see it, that does not mean you have the right to be seated next to Michelangelo—

What's more, this originality is suicidal as it distances you from a 'clientele' used to 'copies of copiers', often referred to as 'tradition'—

One more thing, your technique is not the 'expected' technique— It's your own personal technique, borrowed from nobody— And there again, this doesn't attract the clientele.

Obviously, if you'd applied your Monte Carlo system to your painting, all these difficulties would have turned into victories. You would even have been able to start a new school of technique and originality.

I will not speak of your sincerity because that is the most widespread commonplace and the least valid— All liars, all bandits are sincere. Insincerity does not exist— The cunning are sincere and succeed by their malice, but their whole being is made up of malicious sincerity.

In a word, do less self-analysis and enjoy your work without worrying about opinions, your own as well as that of others

Affectionately
Marcel

To Jehan Mayoux (Surrealist), 8 March 1956, New York[17]

Dear Mayoux,

Thank you for sending me your study in Bizarre which I read with 'wonder' as your unrelenting analysis of Carrouges' text enlightened me on a number of points that I had overlooked for want of 'analytic technique'—

I am a great enemy of critical writing as all I see in these interpretations and comparisons with Kafka and others is just an opportunity to open up the floodgates of words which, overall, amounts to Carrouges or at times a translation of Carrouges – very

free to make his ideas look good.

– Obviously any work of art or literature, in the public domain, is automatically the subject or the victim of such transformations— and this is not just confined to the case of Carrouges. Every fifty years, El Greco is revised and adapted to the tastes of the day, either overrated or underrated. The same goes for all surviving works of art.

And this leads me to say that a work is made entirely by those who look at it or read it and make it survive by their acclaim or even their condemnation.

– As far as I remember what I wrote in the letter that appeared in Medium, I refuse to think of the philosophical clichés rehashed by each generation since Adam and Eve in every corner of the planet—. I refuse to think about it or to talk about it because I don't believe in language. Language, instead of expressing subconscious phenomena, in reality creates thought through and after words (I readily declare myself a 'nominalist', at least in this simplified form).

All this twaddle, existence of God, atheism, determinism, free will, societies, death etc. are the pieces of a game of chess called language and are only entertaining if one is not concerned about 'winning or losing this chess match'—.

As a good 'nominalist', I propose the word Patatautologies which, after frequent repetition, will create the concept I have been trying to express by the execrable means of subject, verb, complement etc.

– I was in Paris last year— but I suppose you don't go there often—

Maybe next time
Most sincerely yours
Marcel Duchamp

To Man Ray, 26 November 1958, New York[18]

Dear Man,

The American Fed. of Arts wants to organize an exhibition of objects (Art in the found Object) and, thankfully, will steer clear of interior design—

Roy Moyer, who is organizing this exhibition (which is to go around the USA for a year) — is asking me if you have the Metronome [*Indestructible Object* 1923] and the iron [*Gift* 1921]—

I would also like to know whether you have my bottle dryer—

Could you send these three objects by Lefebvre Foinet, Air Freight, to the following address:

ROY MOYER
American Federation of Arts
1083 Fifth Avenue
New York City

Expenses charged to me at Lefebvre Foinet, I will be reimbursed here.

In any case, send a reply by return saying what is available out of these three objects—

The exhibition opens in January in N.Y. (Life and Time Magazine Bldg.—)

P.S.— Tell Lef. F. to put a very low value on them to get around American customs. $10 for my bottle dryer.

If you've lost it, maybe buy another one at the Bazar de l'Hôtel de Ville.

Affectionately to you both
Marcel

To André Breton, 1 December 1960, New York[19]
Dear André,

The opening met with expected success and the press likes us— (it's mutual).

You will receive, in a few days' time, articles which are due to come out next Sunday (4th Dec.) in the N.Y. Times and Herald Tribune and also in Time Magazine 12th Dec.

To give you some idea of how it was set up, here is a list.

Opening only: a fortune-teller (professional, who has been taken up the whole evening).

Permanently:

3 white hens (alive) in a cupboard made into a hen house

a ray of sunshine at sunrise (or sunset).

a reel of tape recorded specially with a little girl doing painful exercises on the piano in the house next door.

a tarot card (Arcane 17) projected onto the ceiling

a hosepipe nonchalantly snaking its way through the entire gallery.

electric train set in a shop window on the street—

each painting carries its own little flag (nationality of the artist).

a mirror between practically all the paintings

4 clocks (one in each room) all showing different times

a pair of firedogs with some wood slightly burnt without chimney

a 1900-style typewriter

a large pharmacy jar (green red, yellow)

the tobacconists' sign (carrot) outside

cigarette packets stuck onto a window inside

clocking-on machine like at a factory entrance.

Tarnaud, apart from the translations he had to do at great speed for the catalogue, helped us a great deal setting things out.

There's also talk of taking the exhibition to Chicago, Milwaukee and even Rio.

Let us know how you are—

Our affections to Elisa and yourself

Affectionately

Marcel

I'm sending a catalogue to you tomorrow by airmail—

(until you get a packet of 30 which will take longer).

Criticism and Commentary on Duchamp's Art, 1913–2006

1913 Perhaps it will be the task of an artist as detached from aesthetic preoccupations, and as intent on the energetic as Marcel Duchamp, to reconcile art and the people.[1]

[Duchamp] looks like a young Englishman and talks very urgently about the fourth dimension.[2]

1928 [T]he most singular man alive as well as the most elusive, the most deceptive.[3]

1935 Marcel Duchamp thought that an artist should never crystallize, that he should remain open to change, renewal, adventure, experiment. Yet he himself looks like a man who died long ago. He plays chess instead of painting because that is the nearest to complete immobility, the most natural pose for a man who died.[4]

1937 Saw Duchamp this morning, same Café on Blvd. St. Germain . . . Showed me his painting *Nu descendant un escalier* in a reduced format, coloured by hand en pochoir. breathtakingly beautiful. maybe mention.[5]

1945 I say that Marcel Duchamp's journey *through the artistic looking-glass* determines a fundamental crisis of painting and sculpture which reactionary manoeuvres and stock-exchange brokerages will not be able to conceal much longer.[6]

1951 [I]t is evident, thirty-five years later, that the bottle rack he chose has a more beautiful form than almost anything made, in 1914, as sculpture.[7]

[Duchamp is] a one man movement but a movement for each person and open to everybody.[8]

1959 His finest work is his use of time.[9]

1964 Few men could better exemplify the antithesis of my work than Marcel Duchamp. Please remember I speak without rancour – I have known Duchamp personally and well for many years.[10]

The Silence of Marcel Duchamp is Overrated.[11]

1965 Marcel Duchamp over the years brilliantly has consolidated a position that is practically invulnerable to serious criticism.[12]

1966 No living artist commands a higher regard among the younger generation than Marcel Duchamp.[13]

1968 He made a mistake.[14]

The art community feels Duchamp's presence and his absence. He has changed the condition of being here.[15]

1969 At a Dada exhibition in Düsseldorf, I was impressed that though Schwitters and Picabia and the others had all become artists with the passing of time, Duchamp's work remained unacceptable as art.[16]

All art (after Duchamp) is conceptual (in nature) because art only exists conceptually. The 'value' of particular artists after Duchamp can be weighed according to how much they questioned the nature of art; which is another way of saying 'what they *added* to the conception of art' or what wasn't there before they started.[17]

1970 [M]any people believe him to be a great thinker and I believe him to be an iconoclast whose mania for iconoclasm and the individual position robbed him of any penetrative power of judgement he might have had.[18]

1973 The prewar period was dominated by Matisse and Picasso and the post-World War II period was dominated by Duchamp.[19]

1983 Duchamp's readymade does nothing but actively and parodistically signify this constant process of dispossession of the craft of painting or even of being an artist.[20]

1987 In Duchamp's case, those readymades were demonstrations, you know, they were making a point. They weren't meant to be relished in themselves, though I happen to think the bottle-rack isn't bad, by accident, and the urinal . . . would be much better a sculpture if it were much bigger.[21]

1988 Marcel Duchamp could have been my father.[22]

1990 Today Duchamp's readymade technique is no longer as viable as it used to be. It's 'broken' through overuse. It has lost its potency like a medicine that has been taken too routinely.[23]

1994 The guy is everywhere. What is 'Duchamp'? Is that the name of a great artist? A genius? Or is it the name for a set of conditions? What does 'Duchamp' refer to?[24]

2002 I'm a great admirer of Duchamp but I love the idea of the 'unmade' more than the readymade.[25]

2005 It is impossible to talk about the influence of Duchamp at the moment within the ongoing activated art world.[26]

2006 Duchamp was very important to me as a young artist. He's also been very important to the YBAs. They couldn't have existed without him.[27]

Chronology

The best chronology of Duchamp's life can be
found in a remarkable, impractical book, which
is all chronology, and, as such, an endless
source of information, Pontus Hultén, (ed.),
Marcel Duchamp: Work and Life, Cambridge,
Mass., 1993

1887	Henri-Robert-Marcel Duchamp born on 28 July in Blainville, Normandy.
1902	First important paintings and drawings.
1904	Moves to Paris, joining older brothers Jacques Villon and Raymond Duchamp-Villon.
1905	Begins military service, reduced to one year as an *ouvrier d'art*, October.
1907	Five drawings accepted for the first Salon des Artistes Humoristes, Paris.
1908	First public exhibition at the Salon d'Automne, Paris, where he shows three paintings.
1909	Exhibits work at the Salon des Indépendants and the Salon d'Automne in Paris.
1911	Paints *Coffee Mill*, a precursor to *The Bride Stripped Bare by Her Bachelors, Even* or the *Large Glass*, for brother Raymond's kitchen, as well as *Yvonne and Magdeleine Torn in Tatters*. Birth of Duchamp and Jeanne Serre's daughter, Yvonne Serre (who later changed her name to Yo Sermayer), whom Duchamp never publicly acknowledges as his own.
1912	A key year in Duchamp's life. Major paintings *The Passage from Virgin to Bride*, *The King and Queen Surrounded by Swift Nudes* and *Bride*. Also, *Nude Descending a Staircase, No.2*, which he withdraws from the Salon des Indépendants, Paris, when his brothers ask him to make changes to it. Abandons career as painter and begins notes and drawings for the *Large Glass*. Sees performance of Raymond Roussel's *Impressions d'Afrique*. First glimmerings of the *Large Glass* on trip to Switzerland along the Paris–Jura road. Important friendships with Apollinaire and Picabia consolidated. Spends Summer in Munich. Enrols on a librarian's course at the Ecole des Chartes.
1913	First readymade, *Bicycle Wheel*. Scandal caused by *Nude Descending a Staircase, No.2* at the massive Armory Show (International Exhibition of Modern Art) in New York, giving Duchamp worldwide fame and notoriety.
1914	Assembles *The Box of 1914* in four replicas, which include notes and drawings of work in progress. Selects second readymade, *Bottle Rack*, and creates *Chocolate Grinder, No.2*.
1915	Begins construction of the *Large Glass*. Moves from Paris to New York, June. Meets Man Ray and future patrons Walter C. and Louise Arensberg. Creates *The*.
1916	Exhibits at the Bourgeois Galleries and Montross Gallery (*Four Musketeers*) in New York. Henri-Pierre Roché joins him in New York. Creates *With Hidden Noise* and the readymades *Comb*, *Traveller's Folding Item* and *Rendez-vous du dimanche 1916*.
1917	Resigns from the organising committee of the Society of Independent Artists when it rejects *Fountain*, the urinal that Duchamp himself had chosen and submitted under the pseudonym R. Mutt. Completes *Apolinère Enameled*.
1918	Deaths of Apollinaire and of Duchamp's brother, Raymond, at the end of the First World War. Moves to Buenos Aires, August. Beginning of fascination with chess. Creates last painting, *Tu m'*.

1919	Returns to Paris via England, June–July. Creates *L.H.O.O.Q.* and *Paris Air*.
1920	Returns to New York, January. Helps found Société Anonyme with Katherine Dreier and Man Ray. First appearance of female alter ego, Rrose Sélavy. Makes *Rotary Glass Plates* (*Precision Optics*), an attempt to escape from conventional art practice, and *Fresh Widow*.
1921	Publishes with Man Ray *New York Dada* (one issue only). Creates *Why Not Sneeze Rose Sélavy?*. Travels to Paris, June.
1922	Returns to New York. André Breton publishes his first essay on Duchamp in *Littérature* in October.
1923	Abandons work on the *Large Glass*. Returns to Paris via Brussels in February. Increasingly fascinated with chess, Duchamp loses interest in being a practising artist. Produces *WANTED: $2,000 REWARD*.
1924	Meets Mary Reynolds. Publication of *Manifesto of Surrealism*. Duchamp visits Monte Carlo, inventing a system with which one neither wins nor loses. Appears with Man Ray in a film by Picabia and/or René Clair, *Entracte*. Competes in amateur world chess championship.
1925	Deaths of both parents. Spends six months in Nice finishing sixth in the French chess championships (for which he designed the poster) and trying out his roulette system. 'Invents' *Rotary Demisphere* (*Precision Optics*).
1926	Completes collaboration with Man Ray on film *Anémic Cinéma*. Visits New York. *Large Glass* is damaged on way back to Dreier's in Connecticut after its exhibition at Brooklyn Museum in *International Exhibition of Modern Art*, though this is not discovered until a few years later. Organises Brancusi exhibitions in New York and Chicago.
1927	Moves to 11, rue Larrey. Marries Lydie Sarazin-Levassor, 8 June.
1928	Divorces Lydie Sarazin-Levassor, 25 January. By now one of the best chess players in France, Duchamp is a member of the French team in the First Chess Olympiad. Comes equal first in chess tournament in Hyères.
1929	In the *Second Manifesto of Surrealism*, Breton criticises Duchamp for his apparent immersion in an 'interminable game of *chess*'.
1930	Plays in the Third Chess Olympiad, held in Hamburg.
1931	Damage to the *Large Glass* is discovered.
1932	Publication with Vitaly Halberstadt of chess book *Opposition and Sister Squares are Reconciled*. Placed first in the Paris chess tournament. In September, several of Duchamp's notes appear in a Surrealist number of the English journal *This Quarter* under the title 'Marcel Duchamp: The Bride Stripped Bare by Her Own Bachelors'.
1933	Visits New York. In May, three notes for the *Large Glass* appear in *Le Surréalisme au service de la Révolution* under the title 'La mariée mise à nu par ses Célibataires mêmes'.

1934	Returns to Paris. Publishes *The Green Box* in edition of 320. Breton uses this for his article 'Lighthouse of the Bride', published in the review *Minotaure*. This is the first comprehensive study of the *Large Glass*, given in the context of Duchamp's other work.
1935	Begins the miniatures for the *Boîte-en-valise*. Failed commercial enterprise, *Rotoreliefs* (*Optical Discs*). Captain of the French team in the First International Chess by Correspondence Olympiad.
1936	Visits New York to repair the *Large Glass*. Artistic profile raised further in Paris and New York by the appearance of his work in three exhibitions of Surrealism. Designs cover for journal *Cahiers d'Art*.
1937	One-man exhibition at the Arts Club of Chicago.
1938	Helps organise the Paris *Exposition Internationale du Surréalisme* under the appropriate title of 'generator-arbitrator'.
1939	On holiday in the South of France with Mary Reynolds when Germany invades Poland in September. Miniatures for the *Boîte-en-valise* brought close to completion.
1940	In Arcachon on the Atlantic coast when Germans take Paris. Eventually returns to Paris.
1941	Final pieces gathered for the *Boîte-en-valise* in furtive journeys between Paris in the Occupied Zone and Marseilles in the Free Zone. Announces its publication. Lives in Sanary-sur-Mer with sister Yvonne with occasional trips to Grenoble, Monte Carlo and Marseilles, planning departure for America.
1942	On 14 May sails from Marseilles via Casablanca and Bermuda for New York, where he will live for the rest of his life. Becomes editorial adviser for *VVV*, the review of Surrealism in America. Helps Breton with the organisation of Surrealist exhibition *First Papers of Surrealism*, designing the 'twine' installation and catalogue. Contributes to Peggy Guggenheim's gallery, Art of This Century. Meets Joseph Cornell and John Cage.
1943	Mary Reynolds arrives in New York from France, April. *Large Glass* loaned to Museum of Modern Art. Duchamp moves into modest accommodation at 210 West 14th Street, where he will remain for twenty-two years. Joins London Terrace Chess Club. Makes *Genre Allegory*.
1944	Exhibition of work by the Duchamp brothers at the Mortimer Brandt Gallery. Publication of first book on Duchamp, by Katherine S. Dreier and Matta, *Duchamp's Glass, La Mariée mise à nu par ces célibataires, meme: An Analytical Reflection*.
1945	Exhibition of work by Duchamp brothers at Yale University Art Gallery. Special issue of the periodical *View* devoted to Duchamp, March. Mary Reynolds returns to Paris. Duchamp holidaying on the shores of Lake George in the Adirondacks when news reported of atomic bomb on Hiroshima on 6 August.
1946	Begins an affair with Brazilian artist Maria Martins, who is the inspiration for his last major piece, *Etant donnés*, started that year. Its existence is revealed only after his death in 1968. Makes *Paysage fautif*. Visits Paris.

1947	Returns to New York. Opening in Paris of the exhibition *Le Surréalisme en 1947*, on which Duchamp advised and in which he participated. Designs front and back cover of the catalogue.
1948	Increasing obscurity. Mary Reynolds visits New York.
1949	Participates in 'Western Round Table on Modern Art' at San Francisco Museum of Art. Visits the Arensbergs in Los Angeles, and Max Ernst and Dorothea Tanning in Sedona, Arizona.
1950	Creates *Female Fig Leaf*. Second version of *Fountain* featured in the exhibition *Challenge and Defy* at the Sidney Janis Gallery, New York. Duchamp facilitates bequest of the Louise and Walter Arensberg Collection, the core of which is formed by his own work, to the Philadelphia Museum of Art after their deaths. Contributes writings to the catalogue *Collection of Société Anonyme*. Visits Paris to see the ailing Mary Reynolds, who dies in September.
1951	Publication of major reassessment of Duchamp and Dada, *The Dada Painters and Poets*, edited by Robert Motherwell, with whom Duchamp had cooperated extensively. Meets Alexina (Teeny) Sattler, who had been married to Pierre Matisse. Makes *Dart-Object* (*Objet-Dard*).
1952	Exhibition *Duchamp Frères & Sœur: Oeuvres d'Art* at the Rose Fried Gallery, New York. This led directly to the important, ten-page rehabilitation article by Winthrop Sargeant in *Life*, 'Dada's Daddy'. Collaborates with Hans Richter on the film about chess, *8 x 8*. Death of Katherine Dreier, March.
1953	Organises the exhibition *Dada, 1916–1923* at the Sidney Janis Gallery, New York, which includes authorised versions of *Fountain* and *Bicycle Wheel*. Deaths of Louise Arensberg and Francis Picabia, November.
1954	Marries Alexina (Teeny) Sattler, 16 January. Makes *Chastity Wedge*, which is given to Teeny on their wedding day. Death of Walter C. Arensberg, January. Opening of the Louise and Walter Arensberg Collection, Philadelphia Museum of Art, where most of Duchamp's work, including the *Large Glass* (bequeathed by Katherine Dreier), resides today. Prostate operation.
1955	Becomes naturalised citizen of the USA.
1956	Televised interview with James Johnson Sweeney at the Philadelphia Museum of Art gives further evidence of Duchamp's new prominence.
1957	Exhibition *Jacques Villon, Raymond Duchamp-Villon, Marcel Duchamp* at Solomon R. Guggenheim Museum, New York. The exhibition travels to Houston, Texas, where Duchamp gives the important, brief lecture, 'The Creative Act'.
1958	Duchamps spend most of the Summer in Europe.
1959	Publication of *Sur Marcel Duchamp* by Robert Lebel in Paris and New York, and of *Marchand du sel, écrits de Marcel Duchamp*. Solo exhibitions at the Sidney Janis Gallery, New York, Galerie La Hune, Paris, and Institute of Contemporary Arts, London. With Breton organises the exhibition *Exposition Internationale du Surréalisme*, held at the Galerie Daniel Cordier, Paris, on eroticism.

1960	Organises the exhibition *Surrealist Intrusion in the Enchanters' Domain* with Breton at the D'Arcy Galleries, New York. George Heard Hamilton and Richard Hamilton publish English translation and typographic version of *The Green Box* notes. Duchamp meets Robert Rauschenberg and Jasper Johns.
1961	Second version of the *Large Glass* created in Stockholm by Ulf Linde, authorised and signed by Duchamp along with replicas of readymades. Works included in *The Art of Assemblage*, Museum of Modern Art, New York. Delivers important lecture at the accompanying symposium, 'Apropos of Readymades'.
1962	Designs poster for exhibition in New York marking fiftieth anniversary of Armory Show. Second prostate operation.
1963	Authorises exhibition of readymades created by Ulf Linde at Galerie Burén, Stockholm. First solo retrospective exhibition, *Marcel Duchamp Retrospective (by or of Marcel Duchamp or Rrose Sélavy)*, Pasadena Art Museum, California. Duchamp visits Los Angeles and Las Vegas. Deaths of brother Jacques Villon, 9 June, and of sister Suzanne Crotti.
1964	Exhibition *Omaggio a Marcel Duchamp* held at Galeria Schwarz, Milan. Thirteen readymades produced in editions of eight by Galleria Schwarz.
1965	Exhibition *NOT SEEN and/or LESS SEEN of/by MARCEL DUCHAMP/RROSE SELAVY 1904–64*, Cordier & Ekstrom Gallery, New York. Produces nine etchings of details of the *Large Glass* for Schwarz. Moves possessions, including *Etant donnés*, from 210 West 14th Street to 80 East 11th Street. Creates *L.H.O.O.Q. Shaved*.
1966	Exhibition *The Almost Complete Works of Marcel Duchamp*, Tate Gallery, London. Completes *Etant donnés: 1. La chute d'eau, 2. Le gaz d'éclairage* and reveals it to the artist and gallerist William Copley. It is purchased by the Philadelphia Museum of Art. Third version of the *Large Glass* created in England by Richard Hamilton, along with several readymades, authorised and signed by Duchamp. Appears in Andy Warhol's twenty-minute film, *Screen Test for Marcel Duchamp*. Extensive interviews with Pierre Cabanne. Death of André Breton.
1967	Publication of *A l'Infinitif (The White Box)*. Exhibition *Les Duchamps: Jacques Villon, Raymond Duchamp-Villon, Marcel Duchamp, Suzanne Duchamp* at Musée de Peinture et de Sculpture, Rouen. Produces nine more etchings for Schwarz, on the theme of *The Lovers*, one of his final pieces of work. Publication of Pierre Cabanne's *Entretiens avec Marcel Duchamp*. Bronze plaque devoted to the Duchamp family of artists unveiled by Duchamp on parents' last home in Rouen.
1968	Work included in exhibitions *Dada, Surrealism, and their Heritage* and *The Machine as Seen at the End of the Mechanical Age*, both at the Museum of Modern Art, New York. Arturo Schwarz gives lecture on Duchamp at the Institute of Contemporary Arts, London, June. Participates in *Reunion* by John Cage, Toronto. Jasper Johns creates set based on the *Large Glass* for Merce Cunningham's *Walkaround Time*. Dies on 2 October at Neuilly. Buried with Duchamp family, Rouen.
1969	Installation of *Etant donnés* in Philadelphia Museum of Art with the Louise and Walter Arensberg Collection in June. Publication of *The Complete Works of Marcel Duchamp* by Arturo Schwarz.
1971	Exhibition *Duchamp, Johns, Rauschenberg, Cage*, held at the Contemporary Arts Museum, Cincinnati, Ohio.

1972	Exhibitions *Marcel Duchamp: 66 Creative Years: From the First Painting to the Last Drawing* at Galleria Schwarz, Milan, and *Marcel Duchamp at the Israel Museum* in Jerusalem.
1973	Exhibition *La Delicata Scacchhiera: Marcel Duchamp, 1902–1968*, Palazzo Reale, Naples. Major exhibition and publication, *Marcel Duchamp*, Philadelphia Museum of Art and Museum of Modern Art, New York. Also travels to Art Institute of Chicago.
1974	Special numbers of *L'Arc* and *Opus International* on Duchamp and his influence.
1975	Supplement of January–February number of *Studio International* given over to Duchamp.
1976	Exhibition *Su Marcel Duchamp* held at Framart Studio, Naples. Death of Man Ray.
1977	Major exhibition *L'oeuvre de Marcel Duchamp, 1887–1968* presented at the Musée Nationale d'Art Moderne, Centre Georges Pompidou, Paris.
1978	Exhibition *Duchamp Readymades* held at Vancouver Art Gallery.
1979	Publication of *Marcel Duchamp: Tradition de la rupture ou rupture de la tradition?*
1980	Publication of *Marcel Duchamp, Notes*, edited by Paul Matisse.
1981	Seibu Museum of Art, Tokyo, puts on *Exhibition of Marcel Duchamp*. Fourth version of *Large Glass* created for this show, by Yoshiaki Tono. Publication of *Marcel Duchamp: Eros, c'est la vie: A Biography* by Alice Goldfarb Marquis.
1984	Major exhibition *Duchamp* held at the Fundació Joan Miró, Barcelona. End of ban on photography of the interior of *Etant donnés*, which had stood since its installation at the Philadelphia Museum of Art in 1969.s
1986	Included in the exhibition *The Brothers Duchamp: Jacques Villon, Raymond Duchamp-Villon, Marcel Duchamp* at Arnold Herstand, New York.
1987	Centennial exhibitions and accompanying events at Luhring Augustine & Hodes Gallery, New York, Moderna Museet, Stockholm, Philadelphia Museum of Art, Nova Scotia College of Art, Halifax, São Paolo Biennial, Kunstmuseum Winterthur, Menil Collection, Houston.
1989	Publication of *Marcel Duchamp: The Portable Museum. The Making of the Boîte-en-valise* by Ecke Bonk and the important collection of essays *Marcel Duchamp: Artist of the Century* edited by Rudolph E. Kuenzli and Francis M. Naumann. Republication of *Marcel Duchamp*, Philadelphia Museum of Art and Museum of Modern Art, New York.
1990	Publication of *Duchamp's TRANS/formers* by Jean-François Lyotard.
1991	Exhibitions *West Coast Duchamp* held at Shoshana Wayne Gallery, Miami Beach and *Marcel Duchamp* at the Galerie Ronny van de Velde, Antwerp. Publication in English of *Pictorial Nominalism: On Marcel Duchamp's Passage from Painting to the Readymade* by Thierry de Duve, and the important collection of essays *The Definitively Unfinished Marcel Duchamp* edited by de Duve.
1992	Death of John Cage.

1993	Major exhibition and publication, *Marcel Duchamp*, Palazzo Grassi, Venice.
1994	Special number of journal *October* devoted to Duchamp and his influence.
1995	Teeny Duchamp dies. Exhibition *Marcel Duchamp Respirateur* held at Staatliches Museum, Schwerin, Germany.
1996	Exhibition *Marcel Duchamp: Sculptures and Boxes* held at Entwistle Gallery, London. Work included in exhibition *Making Mischief: Dada Invades New York* held at Whitney Museum of American Art, New York. Publication of *The Duchamp Effect* by Martha Buskirk and Mignon Nixon.
1997	Publication of revised and expanded edition of *The Complete Works of Marcel Duchamp* by Arturo Schwarz, and *Duchamp: A Biography* by Calvin Tomkins.
1998	Exhibition *Joseph Cornell/Marcel Duchamp in resonance* held at Philadelphia Museum of Art and Menil Collection, Houston. Publication of Linda Dalrymple Henderson, *Duchamp in Context: Science and Technology in the Large Glass and Related Works*.
1999	The publication of *Marcel Duchamp: The Art of Making Art in the Age of Mechanical Reproduction* by Francis M. Naumann and a stack of other new books over these years confirms Duchamp's importance to art at the end of the twentieth century, further borne out by the launch of two new journals devoted entirely to Duchamp, *Etant donné Marcel Duchamp* and *tout-fait: The Marcel Duchamp Studies Online Journal*.
2000	Exhibitions *Brancusi et Duchamp* held at Centre Georges Pompidou, Paris, and *Marcel Duchamp, Man Ray: Fifty Years of Alchemy* at the Sean Kelly Gallery, New York. Publication of Duchamp's letters, *Affect^t Marcel.— The Selected Correspondence of Marcel Duchamp*, edited by Francis M. Naumann and Hector Obalk. Inauguration of the *Prix Marcel Duchamp*, an annual prize aimed at contemporary artists living in France and supported by the Centre Pompidou.
2001	Exhibition *Marcel Duchamp on Display: Optics, Exhibition Installations, Portable Museums* held at Zabriskie Gallery, New York. Publication of *Marcel Duchamp dans les collections du Centre Georges Pompidou, Musée National d'art moderne*.
2002	Exhibition *Marcel Duchamp* held at Musée Tinguely, Basel.
2003	Exhibition *Debating American Modernism: Stieglitz, Duchamp, and the New York Avant-Garde* beginning at the Georgia O'Keeffe Museum, Santa Fe, New Mexico. Included in exhibition *Aftershock: The Legacy of the Readymade in Post-War and Contemporary American Art* held at Dickinson Roundell, New York.
2005	Included in major exhibition *Dada*, beginning at Centre Pompidou, Paris, and in the exhibition *Part Object, Part Sculpture* at the Wexner Center for the Arts, The Ohio State University, Columbus, Ohio.
2006	Included in traveling exhibition organised by Yale University Art Gallery, *The Société Anonyme: Modernism for America*, beginning at the Hammer Museum, Los Angeles.
2007	Exhibition *Marcel Marcel* held at Speed Art Museum, Louisville, Kentucky.
2008	Major exhibition *Duchamp, Man Ray, Picabia* held at Tate Modern, London.

Works in Public Collections

An unusually high percentage of Duchamp's work resides in a single place: the Philadelphia Museum of Art. This has an obvious benefit for those keen to research it, in the sense that a fairly comprehensive grasp of Duchamp's output can be gained in a single visit. However, the sheer lack of work available for perusal by the 'initiated' has led to a surprising paucity of knowledge of Duchamp on the part of the general public, a lack of understanding about his work compared with equally significant figures of the modernist period with a range of their art in important public collections (such as Picasso and Matisse) and even misunderstandings about its material on the part of those unwilling or unable to make a special trip to Philadelphia.

This situation is eased somewhat by the facsimiles made of the *Large Glass* and by several 'copies' of readymades (especially those made by Duchamp in collaboration with Arturo Schwarz in 1964), and also by the many accessible versions of *The Green Box* and *A l'Infinitif (The White Box)*. It is relieved further by the presence of a *Boîte-en-valise* in just about every major public collection of twentieth-century art, suggesting Duchamp might have anticipated the problem of availability because of the rarity of his work, resolving it in a typically witty, ironic and economical fashion, by engineering the means by which his 'complete works' could be seen anywhere, presented in miniature form in the *Boîte*. Furthermore, a handful of important works by Duchamp can be found in other collections, including one of his masterpieces (*Tu m'*) and another I have made great claims for in this book (*Paysage fautif*).

As replicas of readymades and copies of *The Green Box* and *Boîte-en-valise* turn up everywhere, this list cannot claim to be comprehensive. I mention only major collections in possession of works by Duchamp, and less well-known collections containing important instances of his odd, limited, yet somehow sprawling output.

United Kingdom

London

TATE MODERN

Coffee Mill 1911; *3 Standard Stoppages* 1964 (replica of 1913–14 original); *Fountain* 1964 (replica of 1917 original); *Fresh Widow* 1964 (replica of 1920 original); *Why Not Sneeze Rose Sélavy?* 1964 (replica of 1921 original); the *Large Glass* 1965–6 (replica of 1915–23 original); *The Green Box (The Bride Stripped Bare by her Bachelors, Even)* 1934; *Boîte-en-valise* 1941–71; *Female Fig Leaf* 1950 (cast 1961); *Dart Object* 1951 (cast 1962); *Chastity Wedge* 1954 (cast 1963).

France

Paris

CENTRE NATIONAL D'ART ET DE CULTURE GEORGES POMPIDOU

Among less important works: the early paintings *Two Nudes* 1910; *Chess Players* 1911; the first drawing for *The Bride Stripped Bare by Her Bachelors, Even*; *Bicycle Wheel* 1964 (replica of 1913 original); *3 Standard Stoppages* 1964 (replica of 1913 original); *The Box of 1914* 1913–14; *Bottle Rack* 1964 (replica of 1914 original); *Nine Malic Moulds* 1914–15; *In Advance of the Broken Arm* 1964 (replica of 1915 original); *Comb* 1964 (replica of 1916 original); *With Hidden Noise* 1964 (replica of 1916 original); *Traveller's Folding Item* 1964 (replica of 1916 original); *Fountain* 1964 (replica of 1917 original); *Trébuchet* 1964 (replica of 1917 original); *Hat Rack* 1964 (replica of 1917 original); *Paris Air* 1964 (replica of 1919 original); *Fresh Widow* 1964 (replica of 1920 original); *Why Not Sneeze Rose Sélavy?* 1964 (replica of 1921 original); three versions of a *Green Box* 1934; *Boîte-en-valise* 1941–71; *Genre Allegory* 1943; *With My Tongue in My Cheek* 1959; *Torture-morte* 1959; and *Sculpture-morte* 1959.

MUSEE MAILLOL

Bottle Rack 1964 (replica of 1914 original); *Apolinère Enameled* 1916–17; *Fountain* 1964 (replica of 1917 original); *Fresh Widow* 1964 (replica of 1920 original).

Germany

Schwerin

STAATLICHES MUSEUM

Nine Malic Moulds 1964 (replica of 1914 original); *In Advance of the Broken Arm* 1964 (replica of 1915 original); *Comb* 1964 (replica of 1916 original); *Traveller's Folding Item* 1964 (replica of 1917 original); *Trap (Trébuchet)* 1964 (replica of 1917 original); *L.H.O.O.Q.* 1964 (replica of 1919 original); *Paris Air* 1964 (replica of 1919 original); *Fresh Widow* 1964 (replica of 1920 original); *The Green Box* 1934; *Bride* 1934; *Rotoreliefs* 1935; *Nude Descending a Staircase* 1937; *Boîte-en-Valise* 1941–71; *Pocket chess set* 1943; *Female Fig Leaf* 1950 (cast 1951); *Chastity Wedge* 1954 (cast 1963); *L.H.O.O.Q. Shaved* 1965.

Stuttgart

STAATSGALERIE

The Brawl at Austerlitz 1921.

Israel

Jerusalem

THE ISRAEL MUSEUM

Selected works include: *Bicycle Wheel* 1964 (replica of 1913 original); *3 Standard Stoppages* 1964 (replica of 1913–14 original); *Bottle Rack* 1964 (replica of 1914 original); *Comb* 1964 (replica of 1916 original); *With Hidden Noise* 1964 (replica of 1916 original); *Traveller's Folding Item* 1964 (replica of 1916 original); *Fountain* 1964 (replica of 1917 original); *Trébuchet* 1964 (replica of 1917 original); *Hat Rack* 1964 (replica of 1917 original); *Paris Air* 1964 (replica of 1919 original); *L.H.O.O.Q.* 1964 (replica of 1919 original); *Tzanck Cheque* 1919; *Fresh Widow* 1964 (replica of 1920 original); *Why Not Sneeze Rose Sélavy?* 1964 (replica of 1921 original); *In the Manner of Delvaux* 1942.

Italy

Rome

GALLERIA NAZIONALE D'ARTE MODERNA E CONTEMPORANEA

Bicycle Wheel 1964 (replica of 1913 original); *3 Standard Stoppages* 1964 (replica of 1913–14 original); *Bottle Rack* 1964 (replica of 1914 original); *Traveller's Folding Item* 1964 (replica of 1916 original); *Comb* (replica of 1916 original); *With Hidden Noise* (replica of 1916 original); *Apolinère Enameled* 1964 (replica of 1916–17 original); *Fountain* 1964 (replica of 1917 original); *Trébuchet* 1964 (replica of 1917 original); *Hat Rack* 1964 (replica of 1917 original); *Paris Air* 1964 (replica of 1919 original); *Fresh Widow* 1964 (replica of 1920 original); *Why Not Sneeze Rose Sélavy?* (replica of 1921 original).

Venice

PEGGY GUGGENHEIM FOUNDATION

Nude (Study), Sad Young Man on a Train 1911–12; *Boîte-en-valise* 1941–71.

Japan

Tokyo

COLLEGE ART MUSEUM OF THE GRADUATE SCHOOL OF ARTS AND SCIENCES, UNIVERSITY OF TOKYO, KOMABA

The *Large Glass* 1981 (replica of 1915–23 original).

Toyama

MUSEUM OF MODERN ART

Boîte-en-valise 1941–71 (includes *Paysage fautif* 1946).

Sweden

MODERNA MUSEET, STOCKHOLM

Among less important works: *Bicycle Wheel* 1960/1977 (replica of 1913 original); *3 Standard Stoppages* 1964 (replica of 1913–14 original); *Bottle Rack* 1963 (replica of 1914 original); *Pharmacy* 1963 (replica of 1914 original); *In Advance of the Broken Arm* 1963 (replica of 1915 original); the *Large Glass* 1961/1986 (replica of 1915–23 original) and 1991–2 (another replica of 1915–23 original); *Comb* 1963 (replica of 1916 original); *Traveller's Folding Item* 1963 (replica of 1916 original); *With Hidden Noise*

1963 (replica of 1916 original); *Fountain* 1963 (replica of 1917 original); *Paris Air* 1974 (replica of 1919 original); *L.H.O.O.Q.* 1963 (replica of 1919 original); *Fresh Widow* 1961 (replica of 1920 original); *Rotary Glass Plates (Precision Optics)* 1960 (replica of 1920 original); *Why Not Sneeze Rose Sélavy* 1963 (replica of 1921 original); *Rotoreliefes* 1935; *Boîte-en-valise* 1941–71; sketch for *Etant donnés* 1947; *Etant donnés: 1. La chute d'eau, 2. Le gaz d'éclairage* 1948–9; *Objet Dard* 1951; *Coeur Volants* 1936–61; *Marcel Duchamp Art Medal* 1964; *A l'Infinitif* 1966.

United States

California: Pasadena

NORTON SIMON MUSEUM

Bottle Rack 1963 (replica of 1914 original); *3 Standard Stoppages* 1963 (replica of 1913–14 original); *Nine Malic Moulds* 1963 (replica of 1914–15 original); *L.H.O.O.Q.* 1964 (replica of 1919 original); *Boîte-en-valise* 1941–71; *In the Manner of Delvaux* 1963 (replica of 1942 original); *Boîte Alerte (Mailbox)* 1959; *Couple of Laundress's Aprons* 1959.

Connecticut: New Haven

YALE UNIVERSITY ART GALLERY

In Advance of the Broken Arm 1945 (replica of 1915 original); *Tu m'* 1918; *Rotary Glass Plates (Precision Optics)* 1920.

New York State: New York

MUSEUM OF MODERN ART

Among less important works: *Bicycle Wheel* 1951 (replica of 1913 original); *The Passage from Virgin to Bride* 1912; *3 Standard Stoppages* 1913–14; *Network of Stoppages* 1914; *In Advance of the Broken Arm* 1964 (replica of 1915 original); *To Be Looked at (From the Other Side of the Glass) with One Eye, Close to, for Almost an Hour* 1918; *Fresh Widow* 1920; *Why Not Sneeze Rose Sélavy?* 1964 (replica of 1921 original); and a *Green Box (La Mariée mise à nu par ses célibataires, même (The Bride Stripped Bare by Her Bachelors, Even))* 1934; *Boîte-en-valise* 1941–71; *Female Fig Leaf* 1950; *Chastity Wedge* 1954; *L.H.O.O.Q. Shaved* 1965.

PHILADELPHIA MUSEUM OF ART

Permanently installed at the Philadelphia Museum of Art are the *Large Glass* and *Etant donnés*. Alongside these two works are displayed original readymades and assisted readymades and copies of lost originals, including *Bicycle Wheel* 1964 (replica of 1913 original); *Bottle Rack* 1961 (replica of 1914 original); *Comb* 1916; *With Hidden Noise* 1916; *Apolinère Enameled* 1916–17; *Fountain* 1950 (replica of 1917 original); *Paris Air* 1919; *Why Not Sneeze Rose Sélavy?* 1921; and others. Also in Philadelphia are most of Duchamp's significant early sketches and paintings, such as: *Portrait of the Artist's Father* 1910; *Portrait of Dr Dumouchel* 1910; *The Chess Game* 1910; *The Bush* 1910–11; *Yvonne and Magdeleine Torn in Tatters* 1911; *Sonata* 1911; and *Portrait (Dulcinea)* 1911. Most of the breakthrough paintings of 1912 can be found there: *Nude Descending a Staircase, No.2*; *The King and Queen Surrounded by Swift Nudes*; *Bride*; both versions of *Chocolate Grinder* 1913 and 1914; and the *Glider Containing a Water Mill in Neighbouring Metals* 1913–15.

Notes

1. Work and Contexts

1 For further details of Duchamp's life see the two biographies by Calvin Tomkins, *Duchamp: A Biography*, London 1998, and Alice Goldfarb Marquis, *Marcel Duchamp: The Bachelor Stripped Bare*, London and New York 2002.

2 In fact, none of the Duchamp children ever lived in this later parental home. Several exhibitions have presented the work of the Duchamp brothers and sister collectively, including Rose Fried Gallery, New York: *Duchamp Frères & Sœur: Oeuvres d' Art*, 1952; Guggenheim Museum, New York: *Jacques Villon, Raymond Duchamp-Villon, Marcel Duchamp*, 1957; Musée National d'Art Moderne, Paris: *Raymond Duchamp-Villon, Marcel Duchamp*, 1967; Arnold Herstand, New York: *The Brothers Duchamp: Jacques Villon, Raymond Duchamp-Villon, Marcel Duchamp*, 1986.

3 Quoted in Anne d'Harnoncourt and Kynaston McShine (eds.), *Marcel Duchamp*, exh. cat., Philadelphia Museum of Art 1973 and revised ed. New York 1989, p.233.

4 These similarities are summarised by Hellmut Wohl, 'Beyond the *Large Glass*: Notes on a Landscape Drawing by Marcel Duchamp', *Burlington Magazine*, vol.119, no.896, Nov. 1977, pp.763–72, 764, n.10.

5 d'Harnoncourt and McShine 1989, p.233.

6 Duchamp's 'career' of recycling already made objects as his own began here, for, as he told it, he passed an examination to be an *ouvrier d' art* by presenting to the jury as his own work a set of prints pulled from a copper plate engraved by his maternal grandfather, Emile-Frédéric Nicolle, a fairly successful painter and engraver of the 1870s.

7 Albert Gleizes and Jean Metzinger, *Du Cubisme*, Paris 1912; Albert Gleizes and Jean Metzinger, *Cubism*, London 1913.

8 For more on Duchamp and Symbolism, see David Hopkins, *Marcel Duchamp and Max Ernst: The Bride Shared*, Oxford 1998.

9 Quoted in d'Harnoncourt and McShine 1989, p.243.

10 Quoted in d'Harnoncourt and McShine 1989, p.252.

11 Pierre Cabanne, *Dialogues with Marcel Duchamp*, trans. Ron Padgett, London 1971, p.34. For more on *Sad Young Man on a Train*, see Angelica Zander Rudenstine, 'Henri-Robert-Marcel Duchamp', *Peggy Guggenheim Collection, Venice*, New York 1985, pp.259–69.

12 Quoted in Caroline Tisdall and Angelo Bozzolla, *Futurism*, London 1977, p.33.

13 'It was fundamentally Roussel who was responsible for my glass, *The Bride Stripped Bare by her Bachelors, Even*,' Marcel Duchamp, 'The Great Trouble with Art in this Country', *Salt Seller: The Essential Writings of Marcel Duchamp* (eds.) Michel Sanouillet and Elmer Peterson, London 1975, pp.123–6, 126. For more, see Rosalind Krauss, 'Forms of Readymade: Duchamp and Brancusi', *Passages in Modern Sculpture*, Cambridge, Mass., 1977, pp.69–103; and, especially, Linda Dalrymple Henderson, *Duchamp in Context: Science and Technology in the Large Glass and Related Works*, Princeton 1998, pp.51–7.

14 A contextual account of Duchamp's Munich excursion is given in Thierry de Duve, 'Resonances of Duchamp's Visit to Munich', Rudolph E. Kuenzli and Francis M. Naumann (eds.), *Marcel Duchamp: Artist of the Century*, Cambridge, Mass., 1989, pp.41–63.

15 Duchamp, 'The Green Box', Duchamp 1975, pp.26–71, 26.

16 The most extensive account of this legendary journey together with a detailed discussion of military references in Duchamp's work is by Kieran Lyons, *Conscripting the 'Jura–Paris Road' : Military Themes in the Work of Marcel Duchamp*, dissertation submitted for the degree of Ph.D., University of Wales, Newport, 2007.

17 Duchamp, 'A l'Infinitif', Duchamp 1975, pp.74–101, 74.

18 For more on Dada activities in New York, see *Making Mischief: Dada Invades New York*, exh. cat., Whitney Museum of American Art, New York 1996.

19 Marcel Duchamp, *Affect^t Marcel._ The Selected Correspondence of Marcel Duchamp*, ed. Francis M. Naumann and Hector Obalk, trans. Jill Taylor, London 2000, p.102.

20 Duchamp 2000, p.106. The term is Gertrude Stein's, which works as a thumbnail sketch of the picaresque womaniser and writer Roché.

21 Duchamp 2000, pp.82, 85

22 André Breton, 'Marcel Duchamp', *The Lost Steps*, trans. Mark Polizzotti, Lincoln and London 1996, pp.86–8. Two issues later in December, Breton described Duchamp's puns hyperbolically in *Littérature* as 'the most remarkable thing to happen in poetry in a long time', Breton, 'Words without Wrinkles', Breton 1996, pp.100–2, 102.

23 Breton 1996, p.88.

24 Breton 1996, p.86.

25 André Breton, *Conversations: The Autobiography of Surrealism*, trans. Mark Polizzotti, New York 1993, p.201.

26 André Breton, 'Manifesto of Surrealism', *Manifestoes of Surrealism*, trans. Richard Seaver and Helen R. Lane, Michigan 1972, pp.1–47, 26.

27 Breton, 'Second Manifesto of Surrealism', Breton 1972, pp.117–94, 170.

28 Breton 1996, p.85.

29 Marcel Duchamp, 'La mariée mise à nu par ses Célibataires mêmes', *Le Surréalisme au service de la Révolution*, no.5/6, 15 May 1933, pp.1–2.

30 André Breton, 'Lighthouse of the Bride', *Surrealism and Painting*, trans.

Simon Watson Taylor, London and New York 1972, pp.85–99.

31 See the account given by John Bernard Myers, *Tracking the Marvelous: A Life in the New York Art World*, London 1984, p.32.

32 Robert Lebel, 'Marcel Duchamp: Liens et Ruptures, Premiers essais, le Cubisme, le Nu descendant un escalier', *Le Surréalisme, même*, no.3, Autumn 1957, pp.21–31.

33 Winthrop Sargeant, 'Dada's Daddy', *Life*, vol.23, no.17, 28 April 1952, pp.100–11.

2. Authorship and Identity

1 Marcel Duchamp, *Affectionately, Marcel: The Selected Correspondence of Marcel Duchamp*, ed. Francis M. Naumann and Hector Obalk, trans. Jill Taylor, London 2000, pp.43–4.
2 Because bottle racks of this kind are unusual and less recognisable to, say, a British audience, than to a French one, *Bottle Rack* takes on a kind of curiosity value outside its native land and consequently has ethnological interest that may or may not have been intended by Duchamp.
3 For a more wide-ranging interpretation of *Tu m'* than can be given here, see Karl Gerstner, *Marcel Duchamp: Tu m', Puzzle upon Puzzle*, Ostfildern-Ruit 2003.
4 Amelia Jones, *Postmodernism and the En-Gendering of Marcel Duchamp*, Cambridge 1994, p.163.
5 Jones 1994, pp.163–6.
6 'In effect, I wanted to change my identity, and the first idea that came to me was to take a Jewish name. I was Catholic, and it was a change to go from one religion to another!' Pierre Cabanne, *Dialogues with Marcel Duchamp*, trans. Ron Padgett, London 1971, p.64.
7 André Breton, 'Marcel Duchamp', *The Lost Steps*, trans. Mark Polizzotti, Lincoln and London 1996, pp.86–8.
8 The phrase belongs to Robert Harvey, 'Where's Duchamp? – Out Queering the Field', *Yale French Studies*, no.109, 2006 ('Surrealism and Its Others'), pp.82–97, 85.
9 An alternative course to withholding his signature or using a pseudonym was to sign anything placed in front of him, creating an impossible task for the editor of his *Complete Works* and an endless one for those prepared to interpret any object signed by Duchamp. See, for example, Paul B. Franklin, 'It's in the Bag: The Story of a Brown Paper Sack', *Etant donné Marcel Duchamp*, no.6, 2005, pp.171–82.
10 The *Large Glass* (*La Mariée mise à nu par ses célibataires, même*) is relevant to all the themes in this book. On authorship and identity, it is worth noting that Duchamp signed full-scale copies of the *Large Glass* made by others (Ulf Linde's 1961 version in Stockholm, Richard Hamilton's 1966 replica in Tate Modern), and gave several names in his notes to many features of the *Large Glass* (the Bride

is also the *Pendu femelle* and Wasp; the Bachelors are also the Nine Malic Moulds, Eros Matrix and Cemetery of Uniforms and Liveries), which can be themselves and other at the same time, in keeping with Duchamp's pseudonymity and concern with 'shape-shifting'. Identification is here, too, in the self-referentiality of the choice of a MARiée and her CELibataires.
11 See Ecke Bonk, *Marcel Duchamp: The Portable Museum. The Making of the Boîte-en-valise*, trans. David Britt, London 1989.
12 Duchamp used *WANTED: $2000 REWARD* as the poster for his first solo exhibition (entitled *A Poster Within a Poster* in the *Complete Works*), the retrospective held in 1963 in Pasadena, adding to it 'by or of Marcel Duchamp or Rrose Sélavy'.
13 Roland Barthes, 'The Death of the Author', *Image-Music-Text*, ed. and trans. Stephen Heath, New York 1977, pp.142–8 (Barthes 1977a).
14 Barthes 1977a, p.142.
15 Barthes 1977a, p.142–3.
16 Barthes 1977a, p.146.
17 For a detailed, critical discussion of the 'author debate' in literature and philosophy, see Seán Burke, *The Death and Return of the Author: Subjectivity in Barthes, Foucault and Derrida*, Edinburgh 1992. Also see Seán Burke (ed.), *Authorship: From Plato to the Postmodern, A Reader*, Edinburgh 1995.
18 For a comparison between Duchamp and Barthes in the context of contemporary art which at times perfunctorily and ahistorically triangulates Duchamp, Barthes and Ferdinand de Saussure but is subtle on the readymade as both linguistic sign and referent, see Benjamin H.D. Buchloh, 'Ready Made, *Objet Trouvé*, *Idée Reçue*' in *Dissent: The Issue of Modern Art in Boston*, Boston 1985, pp.107–21. A useful article on the readymades, which brings in Barthes's essay in an effort to redefine authorship in art history and makes suggestive though incomplete remarks about criminology, is by Thierry de Duve, 'Authorship Stripped Bare, Even', *Res: Anthropology and Aesthetics*, no.19/20, 1990–1, pp.235–41.
19 *Aspen*, no.5/6, Fall–Winter 1967. An excellent *Aspen* website exists at www.ubu.com/aspen. As an artist, O'Doherty works under the name of Patrick Ireland. For his most significant writings, see Brian O'Doherty, *Inside the White Cube: The Ideology of the Gallery Space*, Berkeley, Los Angeles, London 1986. For this section of my chapter, I am indebted to some of the findings of Molly Nesbit, 'What Was an Author?' *Yale French Studies*, no.73, 1987 ('Everyday Life'), pp.229–57.
20 For more on Duchamp and Mallarmé, see Molly Nesbit and Naomi Sawelson-Gorse, 'Concept of Nothing: New Notes by Marcel Duchamp and Walter Arensberg', Martha Buskirk and Mignon Nixon (eds.), *The Duchamp Effect*, Cambridge, Mass., 1996, pp.131–75;

and Mary Ann Caws, 'Mallarmé and Duchamp: Mirror, Stair, and Gaming Table', *The Eye in the Text. Essays on Perception, Mannerist to Modern*, Princeton, New Jersey 1981, pp.141–57. For a more speculative connection between Duchamp (whose work can be linked to anything) and Mallarmé (whose work can also be linked to anything), see Lawrence D. Steefel, Jr, *The Position of Duchamp's Glass in the Development of his Art*, New York and London 1977, pp.305–7.
21 Cabanne 1971, p.30.
22 Cabanne 1971, p.105.
23 An excellent comparison with Mallarmé and discussion of the limits of iconographic interpretation made available by Duchamp's work are to be found in one of the most insightful essays ever written about Duchamp by Jonathan Crary, 'Marcel Duchamp's *The Passage from Virgin to Bride*', *Arts Magazine*, vol.51, no.5, Jan. 1977, pp.96–9.
24 Marcel Duchamp, 'The Great Trouble with Art in this Country', *Salt Seller: The Essential Writings of Marcel Duchamp*, eds Michel Sanouillet and Elmer Peterson, London 1975, pp.123–6, 126.
25 Barthes, too, was deeply suspicious of expression in literature, observing and respecting the self-conscious lack of it in Mallarmé and others, and tying it closely to calls for the displacement of the 'pure' authorial voice from the text. For an example of this criticism in action, see Roland Barthes, *S/Z*, trans. Richard Miller, New York 1974, and, for a relevant discussion that predates *S/Z*, see Susan Sontag, 'Against Interpretation' [1964], *Against Interpretation*, London 2001, pp.3–14.
26 Stéphane Mallarmé, 'Crisis in Poetry', *Mallarmé: Selected Prose Poems, Essays & Letters*, ed. and trans. Bradford Cook, Baltimore 1956, pp.34–43, 40–1.
27 Michel Foucault, *The Order of Things: An Archaeology of the Human Sciences*, London 1994, pp.305–6. His further reflections on authorship are to be found in the widely read Michel Foucault, 'What is an Author?', David Lodge (ed.), *Modern Criticism and Theory: A Reader*, London and New York 1988, pp.197–210.
28 Barthes 1977a, pp.145–6.
29 Marcel Duchamp, 'The Creative Act', Duchamp 1975, pp.138–40. For Duchamp and postmodernism, see Amelia Jones, *Postmodernism and the En-Gendering of Marcel Duchamp*, Cambridge 1994; and Moira Roth and Jonathan Katz (eds.), *Difference/Indifference: Musings on Postmodernism, Marcel Duchamp and John Cage*, Amsterdam 1998.
30 Duchamp 1975, p.139.
31 Duchamp 1975, p.139.
32 Duchamp 1975, p.138. Cabanne has it that, after the talk, Duchamp referred to himself as an 'artistic clown' (*pitre artistique*), Cabanne 1971, p.89. Evidently, the idea of art as a passage or 'outlet toward regions which are not

ruled by time and space' had been on Duchamp's mind for a while, as he used the same words in an interview with James Johnson Sweeney, Director of the Solomon R. Guggenheim Museum, in January 1956, Duchamp, 'Regions which are not ruled by time and space', Duchamp 1975, pp.127–37, 137.

33 Duchamp 1975, p.138. Described as 'the classic statement of modernist impersonality', Eliot's influential essay can be found in Burke 1995, pp. 73–80, 65.

34 Duchamp 1975, p.138.

35 Duchamp 1975, p.139.

36 Duchamp 1975, p.138.

37 Duchamp 1975, p.139.

38 Duchamp 1975, p.139. In his analysis of 'The Creative Act', Terry Atkinson pushes against an open door by taking Duchamp to task for being a vague and inconsistent theorist, see Atkinson, 'From an Art & Language Point of View', Art-Language, vol.1, no.2, Feb. 1970, pp.25–60.

39 Cabanne 1971, pp.89–90. See also Duchamp's sceptical remarks on the notions of being and consciousness in Arturo Schwarz (ed.), The Complete Works of Marcel Duchamp, vol.1, revised and expanded ed., London 1997, p.34.

40 Roland Barthes, Roland Barthes, trans. Richard Howard, London and Basingstoke 1977 (Barthes 1977b). Barthes's book opens with the inscription 'All this must be considered as if spoken by a character in a novel', ironically written in his own handwriting as though to confirm at once the presence and absence of a unitary self. The same sentence is extended in the book, displacing him from his person and fragmented: 'All this must be considered as if spoken by a character in a novel – or rather by several characters', Barthes 1977b, p.119. Barthes deepened the irony by reviewing Roland Barthes under his own name in the journal La Quinzaine littéraire in 1975.

41 Barthes 1977b, p.120.

42 Barthes 1977, p.68.

43 Barthes 1977, p.147.

44 Duchamp quoted in 1958, Arturo Schwarz (ed.), The Complete Works of Marcel Duchamp, vol.1, revised and expanded ed., London 1997, p.256.

45 Among the short essays Duchamp wrote on various artists for Katherine Dreier's Société Anonyme – the organisation Duchamp and Man Ray helped to set up in 1920 as a means to publicise and promote the modern art in Dreier's collection – he alleged that this property had attached itself to Picasso, 'Every now and then the world looks for an individual on whom to rely blindly – such worship is comparable to a religious appeal and goes beyond reasoning. Thousands today in quest of supernatural esthetic emotion turn to Picasso, who never lets them down,' 'Pablo Picasso', 'From the Catalog Collection of the Société Anonyme', Duchamp 1975, pp.143–59, 157.

46 'The curious thing about the readymade is that I've never been able to arrive at a definition or explanation that fully satisfies me,' Duchamp quoted in Katharine Kuh, 'Marcel Duchamp', The Artist's Voice: Talks with Seventeen Modern Artists, New York 2000, pp.81–93, 90.

47 Barthes 1977a, p.146.

Fountain

1 Beatrice Wood, I Shock Myself: The Autobiography of Beatrice Wood, San Francisco 1988, pp.29–30.

2 The history of Fountain is told comprehensively in William Camfield, Marcel Duchamp/Fountain, Houston, Texas, 1989. Also see Edward Ball and Robert Knafo, 'The R. Mutt Dossier', Artforum, vol.27, no.2, Oct. 1988, pp.115–19.

3. Eroticism and *Infra-Mince*

1 See photograph in Ecke Bonk, Marcel Duchamp: The Portable Museum. The Making of the Boîte-en-valise, trans. David Britt, London 1989, p.282.

2 The research on Paysage fautif was requested by Walter Hopps, who was then Director of the Menil Collection in Houston. Twelve copies of the Boîte-en-valise contained an 'original' by Duchamp, usually one of the handcoloured miniatures he made to steer the printers in its construction. The Paysage fautif was made for the Boîte given to the sculptor Maria Martins, with whom Duchamp had a passionate, clandestine relationship in the late 1940s. Another is the 'figure' made with hair the same year for Matta's Boîte.

3 Lawrence D. Steefel, Jr, The Position of Duchamp's Glass in the Development of his Art, New York and London 1977, p.312.

4 Pierre Cabanne, Dialogues with Marcel Duchamp, trans. Ron Padgett, London 1971, p.88.

5 Cabanne 1971, p.88.

6 Francis M. Naumann, Marcel Duchamp: The Art of Making Art in the Age of Mechanical Reproduction, New York 1999, p.15.

7 Louise Norton, 'Buddha of the Bathroom', The Blind Man, no.2, May 1917, pp.5–6.

8 David Hopkins, 'Men Before the Mirror: Duchamp, Man Ray and Masculinity', Art History, vol.21, no.3, Sept. 1998, pp.303–23, 306. Sigmund Freud, 'Leonardo da Vinci and a Memory of his Childhood', Art and Literature, Harmondsworth 1990, pp.151–231.

9 Paul B. Franklin, 'Object Choice: Marcel Duchamp's Fountain and the Art of Queer Art History', Oxford Art Journal, vol.23, no.1, 2000, pp.23–50.

10 Franklin 2000, p.37.

11 A mountain of scholarship now exists on Duchamp and Leonardo. See, for instance, Jack J. Spector, 'Freud and Duchamp: The Mona Lisa "Exposed"', Artforum, vol.6, no.8, April 1968, pp.54–6; Theodore Reff, 'Duchamp & Leonardo: L.H.O.O.Q.–Alikes', Art in

America, vol.65, no.1, Jan.–Feb. 1977, pp.82–93; 'Letters', Art in America, vol.65, no.3, May–June 1977, p.5; 'Letters', Art in America, vol.65, no.4, July–August 1977, p.5; Molly Nesbit, 'The Rat's Ass', October, no.56, Spring 1991, pp.7–20.

12 Susan Rubin Suleiman, Subversive Intent: Gender, Politics, and the Avant-Garde, Cambridge, Mass., and London 1990, p.157. Suleiman's reading is extended into Lacanian territory in an essay that also sees penises in Picabia's version of L.H.O.O.Q., George Baker, 'The Artwork Caught by the Tail', October, no.97, Summer 2001, pp.51–90, 62, n.8.

13 According to Tomkins, their confusion and apprehension at the spectacle of the Nude demonstrates that among the Puteaux Cubists, 'there was not much room for eroticism or for humour', Calvin Tomkins, Duchamp: A Biography, London 1998, p.81.

14 Quoted in Arturo Schwarz (ed.), The Complete Works of Marcel Duchamp, vol.2, revised and expanded ed., London 1997, p.569.

15 Cabanne 1971, p.41.

16 'Kind of Subtitle/**Delay in Glass**/Use "delay" instead of picture or painting; picture on glass becomes delay in glass – but delay in glass does not mean picture on glass,' Marcel Duchamp, 'The Green Box', Salt Seller: The Essential Writings of Marcel Duchamp, eds Michel Sanouillet and Elmer Peterson, London 1975, pp.26–71, 26. Keeping things muddled, Duchamp is typically inconsistent on this, and sometimes in the notes refers to the Glass as a 'picture' and 'painting', Duchamp 1975, pp.32, 43.

17 Duchamp 1975, p.43.

18 Duchamp 1975, p.63.

19 Duchamp 1975, p.57.

20 One of the best writers on Duchamp states: 'To interpret is futile. You might as well try to circumscribe the true effect of the Large Glass and hence its true content; the Glass is made precisely in order not to have a true effect, nor even several true effects, according to a mono-, or polyvalent logic, but to have uncontrolled effects.' Jean-François Lyotard, Duchamp's TRANS/formers, trans. Ian McLeod, Venice, California, 1990, p.65.

21 Duchamp's original jotting is published as note 11 (verso) in Paul Matisse (ed.), Marcel Duchamp, Notes, Paris 1980, n.p. All the infra-mince notes quoted in this chapter are taken from this unpaginated book.

22 Francis Naumann, 'Marcel Duchamp: A Reconciliation of Opposites', Rudolf E. Kuenzli and Francis M. Naumann (eds.), Marcel Duchamp: Artist of the Century, Cambridge, Mass., 1989, p.20.

23 Yoshiaki Tono, 'Duchamp i "inframince"'/'Duchamp and "Inframince"', Marcel Duchamp, Barcelona 1984, p.55.

24 Juan Antonio Ramírez, Duchamp: Love and Death, Even, trans. Alexander R. Tulloch, London 1998, p.193.

25 For moulds, see Craig Adcock, 'Duchamp's Eroticism: A Mathematical Analysis', Kuenzli and Naumann 1989, pp.149–67, and Dawn Ades, Neil Cox and David Hopkins, *Marcel Duchamp*, London and New York 1999, pp.172–89; for photography, see Jean Clair, *Duchamp et la photographie*, Paris 1977, pp.94–112; for both, see Dalia Judovitz, *Unpacking Duchamp: Art in Transit*, Berkeley, Los Angeles, California, and London 1998, pp.215–17. An attempt to engage with uncertainty and tautology in Duchamp's thought and work introduced by some remarks on *infra-mince* has been made by Molly Nesbit, 'Last Words (Rilke, Wittgenstein) (Duchamp)', *Art History*, vol.21, no.4, Dec. 1998, pp.546–64.

26 Quoted in Calvin Tomkins, *Duchamp: A Biography*, London 1998, p.328.

27 Denis de Rougemont, 'Marcel Duchamp mine de rien', *Preuves*, Year 18, no.204, Feb. 1968, pp.43–7, 46.

28 In *infra-mince* notes 7 and 9, Duchamp uses the words *intervalle* and *séparation* respectively. He uses *intervalle* also in note 35.

29 Schwarz 1997, 1, p.168.

30 Schwarz 1997, 1, p.169.

31 Duchamp described the number three as 'a kind of magic number . . . number one is the unity, number two is the couple, and three is the crowd. In other words, twenty millions or three is the same for me', quoted in Schwarz 1997, 1, p.128. His notes for the *Glass* show that he added the word *même* to the title during the work's construction, which not only confers an air of uncertainty but also gives the title nine words (3 x 3), in keeping with Duchamp's triadic scheme. In contrast with the recurring number eleven of Joyce's *Finnegans Wake*, symbolising there the Resurrection, Duchamp's nearly-but-not-quite nine ('Malic Moulds', 'Shots') is further incompletion, shortfall, suspension.

32 Later, Duchamp introduced some uncertainty into the form when he had a detail of *Female Fig Leaf* photographed and reproduced to make it convex instead of concave for the cover of *Le Surréalisme même*, no.1, Winter 1956.

33 Cabanne 1971, p.128.

34 Duchamp 1975, p.39.

35 Duchamp 1975, pp.27, 28.

36 Tomkins 1998, p.461.

37 Exceptions are Anne d'Harnoncourt and Walter Hopps, *Etant donnés: 1 la chute d' eau. 2 le gaz d' éclairage: Reflections on a New Work by Marcel Duchamp*, exh. cat., Philadelphia Museum of Art 1973; Octavo Paz, '⋆ water writes always in ⋆ plural', Anne d'Harnoncourt and Kynaston McShine (eds.), *Marcel Duchamp*, exh. cat., Museum of Modern Art, New York 1989, pp.143–58; Dalia Judovitz, 'Rendezvous with Marcel Duchamp: Given', Kuenzli and Naumann 1989, pp.184–202; Lyotard 1990; Rosalind Krauss, 'Where's Poppa?', Thierry de Duve (ed.), *The Definitively Unfinished Marcel Duchamp*, Cambridge, Mass., and

London 1991, pp.433–59; Mason Klein, 'Embodying Sexuality: Marcel Duchamp in the Realm of Surrealism', Maurice Berger (ed.), *Modern Art and Society: An Anthology of Social and Multicultural Readings*, New York 1994, pp.139–57; Amelia Jones, *Postmodernism and the En-Gendering of Marcel Duchamp*, Cambridge 1994, pp.191–204. Bemusement itself seems to be the subject of the brief note by Molly Nesbit, 'Marcel Duchamp: *Etant donnés*', *Artforum*, vol.32, no.1, Sept. 1993, pp.158–9. A recent spate of deductive activity has suggested some link between Duchamp's last work and the notorious 'Black Dahlia' murder that took place in Los Angeles in 1947: Jonathan Wallis, 'Case Open and/or Unsolved: Marcel Duchamp and the Black Dahlia Murder,' *The Rutgers Art Review*, vol. 20, 2003, pp.7–23, reprinted as Wallis, 'Case Open and/or Unsolved: *Etant donnés*, the Black Dahlia Murder, and Marcel Duchamp's Life of Crime,' *tout-fait, The Marcel Duchamp Studies Online Journal* 2005; Mark Nelson and Sarah Hudson Bayliss, *Exquisite Corpse: Surrealism and the Black Dahlia Murder*, New York and Boston 2006; and Jean-Michel Rabaté, *Given: 1° Art 2° Crime: Modernity, Murder and Mass Culture*, Eastbourne 2007, pp.33–77.

38 Cabanne 1971, p.88.

4. Alchemy and Science

1 See the excellent fourth chapter of M.E. Warlick, *Max Ernst and Alchemy: A Magician in Search of Myth*, Austin, Texas, 2001, pp.61–104.

2 See Betty Jo Teeter Dobbs, *The Janus Faces of Genius: The Role Of Alchemy in Newton's Thought*, Cambridge 1991.

3 For some recent perspectives on alchemy in art and literature, see Alexandra Lembert and Elmar Schenkel (eds.), *The Golden Egg: Alchemy in Art and Literature*, Berlin and Cambridge, MA, 2002, and my review in *HYLE: International Journal for Philosophy of Chemistry* (special issue. 'Aesthetics and Visualization in Chemistry'), vol.9, no.2, 2003, pp.219–24. Also see Alexandra Lembert, *The Heritage of Hermes: Alchemy in Contemporary British Literature*, Berlin 2004.

4 Quoted in Robert Lebel, *Marcel Duchamp*, trans. George Heard Hamilton, London 1959, p.73.

5 Stanislas Klossowski de Rola, *Alchemy: The Secret Art*, London 1992, p.9.

6 See the latest contribution to the alchemy thesis: John F. Moffitt, *Alchemist of the Avant-Garde: The Case of Marcel Duchamp*, New York 2003.

7 For an excellent, concise historiography of the scholarship on Duchamp and alchemy, see Linda Dalrymple Henderson, *Duchamp in Context: Science and Technology in the Large Glass and Related Works*, Princeton 1998, pp.231–2.

8 For Duchamp's subsequent rebuttals,

see quotation and citations in Henderson 1998, p.231. In a letter of 1967, he responded frankly to a correspondent's questions about Surrealism and alchemy, 'No, I never had any interest in the occult sciences,' quoted in Paul B. Franklin, 'Accounting for the Occult: A Letter from Marcel Duchamp to Jacques van Lennep', *Etant donné Marcel Duchamp*, no.4, 2002, pp.156–7, 156.

9 Linde's then-unpublished findings were first reported by Pontus Hultén in *The Machine as Seen at the End of the Mechanical Age*, exh. cat., Museum of Modern Art, New York 1968, p.209, note 53. See Ulf Linde, 'L'Esotérique', *Marcel Duchamp, 1887–1968*, exh. cat., Centre National d'Art et de Culture Georges Pompidou, Paris, vol.3, 1977, pp.60–85.

10 Jean Clair, 'La Fortune critique de Marcel Duchamp: Petite Introduction à une herméneutique du *Grande Verre*', *Revue de l' Art*, no.34, 1976, pp.92–100. The same striking image was reproduced alongside an unusually nuanced discussion of Duchamp and alchemy by John Golding, *Duchamp: The Bride Stripped Bare by her Bachelors, Even*, London 1973, pp.83–93, 85. The other major text on the subject is by Maurizio Calvesi, *Duchamp invisibile: La costruzione del simbolo*, Rome 1975. Alchemic, Tantric, Buddhist and Hindu imagery is brought into play by Octavio Paz, *Marcel Duchamp: Appearance Stripped Bare*, trans. Rachel Phillips and Donald Gardner, New York 1990.

11 Moira Roth, 'Robert Smithson on Duchamp, An Interview' [1973], Joseph Mashek (ed.), *Marcel Duchamp in Perspective*, New Jersey 1975, pp.134–7, 137. Smithson probably meant 1965, as that was the year of Duchamp's solo exhibition at Cordier & Ekstrom, *NOT SEEN and/or LESS SEEN of/by MARCEL DUCHAMP/RROSE SELAVY 1904–64*.

12 Arturo Schwarz (ed.), *The Complete Works of Marcel Duchamp*, vol.1, revised and expanded ed., London 1997.

13 Arturo Schwarz, 'The Alchemist Stripped Bare in the Bachelor, Even', Anne d'Harnoncourt and Kynaston McShine (eds.), *Marcel Duchamp* [1973], exh. cat., Museum of Modern Art, New York 1989, pp.81–98.

14 Schwarz, 'The Alchemist Stripped Bare', d'Harnoncourt and McShine 1989, p.83.

15 Schwarz, 'The Alchemist Stripped Bare', d'Harnoncourt and McShine 1989, p.84.

16 Schwarz, 'The Alchemist Stripped Bare', d'Harnoncourt and McShine 1989, p.86.

17 Schwarz, 'The Alchemist Stripped Bare', d'Harnoncourt and McShine 1989, p.89.

18 Schwarz, 'The Alchemist Stripped Bare', d'Harnoncourt and McShine 1989, p.90. See Marcel Duchamp, 'The Green Box', *Salt Seller: The Essential Writings of Marcel Duchamp*, eds Michel Sanouillet and Elmer Peterson, London 1975, pp.26–71, 44. Franklin argues that

this note refers to the urine of a gent's public lavatory, Paul B. Franklin, 'Object Choice: Marcel Duchamp's *Fountain* and the Art of Queer Art History', *Oxford Art Journal*, vol.23, no.1, 2000, pp.23–50, 37. Another commentator sees revelatory, ambivalent, erotic, creative, properties in this colour, also regarding it as a 'sign of hope', Jack Burnham, 'Marcel Duchamp: *MASTER LUDI*', *The Structure of Art*, New York 1973, pp.158–70, 160. Every theory, alchemical or otherwise, can find a colour in the notes to back it up, as every colour of the rainbow and several more besides are mentioned by Duchamp in his reflections on colour among the notes of *The White Box*, Duchamp, 'A l'Infinitif', Duchamp 1975, pp.74–101, 79–83.

19 Duchamp's wife Teeny was furious that such a piece of writing would accompany the *Complete Works* and reported later that Duchamp himself said it was 'rubbish', Calvin Tomkins, *Duchamp: A Biography*, London 1998, p.447. For more anecdotal detail of the reception of Schwarz's theory, see Francis M. Naumann, 'Arturo's Marcel', *Art in America*, vol.86, no.1, Jan. 1998, pp.35–9, and Arturo Schwarz and Francis M. Naumann, 'Letters. Dueling Duchampians: An Exchange', *Art in America*, vol.87, no.1, Jan. 1999, pp.25–31.

20 Jack Burnham, *Great Western Salt Works: Essays on the Meaning of Post-Formalist Art*, New York 1974, pp.71–88, 89–117.

21 Burnham 1974, p.71.

22 Burnham 1974, p.72.

23 Burnham 1974, p.71.

24 Burnham 1974, p.75.

25 Burnham 1974, p.77.

26 Burnham 1974, p.84.

27 Burnham 1974, p.75–6.

28 Burnham 1974, p.84.

29 Burnham 1974, p.86.

30 Burnham 1974, p.89.

31 Burnham 1974, p.93.

32 Burnham 1974, p.109. Strangely, Burnham pauses to substantiate his reading by noting that 'Duchamp never went out of his way to correct critics with fertile imaginations', thus apparently excluding himself from their ranks, p.89.

33 Burnham 1974, p.92. See Duchamp 1975, p.44. Schwarz leaps on the same note, regarding it as meaning 'a symbolic wedding of Earth and Sky, and ploughing being associated with semination and the sexual act', Schwarz, 'The Alchemist Stripped Bare', d'Harnoncourt and McShine 1989, p.90.

34 See a book that began life as a doctoral dissertation in the 1980s, David Hopkins, *Marcel Duchamp and Max Ernst: The Bride Shared*, Oxford 1998, as well as an earlier reference, Moffitt 2003, prefigured by an article in that decade, John F. Moffitt, 'Marcel Duchamp: Alchemist of the Avant-Garde', *The Spiritual in Art: Abstract Painting 1890–1985*, exh. cat., Los Angeles County Museum of Art, Los Angeles 1987, pp.257–71. See the overview of the backlash against alchemical readings in Moffitt 2003, pp.3–4, 377, note 4.

35 Hopkins 1998, p.53.

36 Hopkins 1998, p.53.

37 The Raphael is reproduced in Golding 1973, p.91, and a wide selection of Assumptions, including Titian's, are reproduced in Calvesi 1975.

38 Hopkins 1998, p.59. For some perceptive remarks on the pyramiding of inferences and speculations in writing on Duchamp, see Sheldon Nodelman, 'The Once and Future Duchamp' [books review], *Art in America*, vol.88, no.1, Jan. 2000, pp. 37–43.

39 André Breton, 'Fronton-Virage' [1948], *Free Rein*, trans. Michel Parmentier and Jacqueline d'Amboise, Lincoln and London 1995, pp.175–95. Breton's essay was written about, and later used as the preface for, Jean Ferry's book, *Une étude sur Raymond Roussel*, Paris 1953. Ferry mistakenly counted twenty-two scene changes in Roussel's play (there are, in fact, twenty-three), and by the time he realised his error, Breton had matched the figure to 'the number of signs of the Hebrew alphabet, or of paths linking the Sephiroth of the Cabala, or of the major arcana of the tarot', Breton, 1995, p.191. Ferry's later amusement at what he called the 'monumental garbage' of Breton's interpretation is recorded in two letters, which include a discussion of interpretation relevant to writing on Duchamp, Jean Ferry, 'Two Letters to Jacques Brunius' [1965], *Raymond Roussel: Life, Death and Works*, London 1987, pp.106–10, 106.

40 See Francis M. Naumann, 'Cryptography and the Arensberg Circle', *Arts*, vol.51, no.9, May 1977, p.129.

41 Pierre Cabanne, *Dialogues with Marcel Duchamp*, trans. Ron Padgett, London 1971, pp.51–2.

42 Golding 1973, p.88.

43 Golding 1973, p.85.

44 Golding 1973, p.92.

45 See chiefly Craig Adcock, *Marcel Duchamp's Notes from the Large Glass. An N-Dimensional Analysis*, Epping 1983; Linda Dalrymple Henderson, *The Fourth Dimension and Non-Euclidean Geometry in Modern Art*, Princeton 1983; Henderson 1998.

46 Duchamp 1975, p.49.

47 Duchamp, 1975, p.71.

48 Henderson 1998, p.23.

49 Henderson 1998, p.24.

50 Henderson 1998, p.10.

51 Henderson 1998, pp.47–57.

52 Henderson 1998, p.19.

53 Cabanne 1971, p.39.

54 Henderson 1983, p.210.

55 Duchamp 1975, p.89.

56 Duchamp reported in Lawrence D. Steefel, Jr., *The Position of Duchamp's Glass in the Development of his Art*, New York and London 1977, p.110.

57 Cabanne 1971, p.40.

58 Henderson 1998, p.81.

59 Rhonda Roland Shearer, 'Marcel Duchamp's Impossible Bed and Other "Not" Readymade Objects: A Possible Route of Influence From Art to Science, Part I', *Art & Academe*, vol.10, no.1, 1997, pp.26–62.

60 Shearer 1997, 10, no.1, p.40.

61 Shearer 1997, 10, no.1, p.41.

62 Shearer 1997, 10, no.1, p.57.

63 Quoted in William A. Camfield, *Marcel Duchamp/Fountain*, Houston, Texas, 1989, p.39.

64 Werner Heisenberg, *Physics and Philosophy: The Revolution in Modern Science*, Harmondsworth 1990, p.37.

65 See Gerald Holton, 'The Roots of Complementarity', *Thematic Origins of Scientific Thought: Kepler to Einstein*, Cambridge, Mass., 1974, pp.115–61.

66 Rudy Rucker, *Infinity and the Mind: The Science and Philosophy of the Infinite*, Harmondsworth 1997, pp.157–8.

67 Rucker 1997, p.161.

68 For some detail, see John T. Blackmore, 'Mach's Influence on Early Logical Positivism and on Quantum Theory', *Ernst Mach: His Work, Life, and Influence*, Berkeley 1972, pp.300–18.

69 Cabanne 1971, p.107. See Molly Nesbit, 'Last Words (Rilke, Wittgenstein) (Duchamp)', *Art History*, vol.21, no.4, Dec. 1998, pp.546–64.

70 The first public airing for Duchamp's well-known Wittgensteinian statement was in an article published in *View* in the special 'Duchamp' number of *View* magazine in 1945, reprinted as Harriet and Sidney Janis, 'Marcel Duchamp: Anti-Artist', Robert Motherwell (ed.), *The Dada Painters and Poets*, second ed., Cambridge, Mass., and London 1981, pp.306–15, 313. When Duchamp was asked in an important *Life* article about a deeper meaning behind the *Boîte-en-valise*, he responded 'What would you consider the proper solution?' He then continued, 'Obviously there can be no solution when there is no problem. Problems are inventions of the mind. They are nonsensical,' Winthrop Sargeant, 'Dada's Daddy', *Life*, vol.32, no.17, 28 April 1952, pp.100–11, 108. 'The solution of the problem of life is seen in the vanishing of the problem,' Ludwig Wittgenstein, *Tractatus Logico-Philosophicus*, trans. D.F. Pears and B.F. McGuinness, London 1972, p.149, prop. 6.521. The similarity between the two quotations is not observed in Nesbit's article.

71 Marcel Duchamp, *Affect' Marcel._ The Selected Correspondence of Marcel Duchamp*, ed. Francis M. Naumann and Hector Obalk, trans. Jill Taylor, London 2000, p.344.

72 Marcel Duchamp, 'I Propose to Strain the Laws of Physics', interview with Francis Roberts, *Art News*, vol.67, no.8, Dec. 1968, pp.46–7, 62–4, 62.

73 Duchamp 1975, p.29.

74 Arkady Plotnitsky, *Complementarity: Anti-Epistemology after Bohr and Derrida*, Durham and London 1994, p.112.

75 See my *Surrealism, Art and Modern*

Science: Relativity, Quantum Mechanics, Epistemology, New Haven and London 2008.
76 Rosalind E. Krauss, *The Optical Unconscious*, Cambridge, Mass., and London 1993, pp.95–146.
77 Duchamp 2000, pp.197–8.
78 Duchamp 1975, p.42.
79 Henderson 1988, p.29.
80 Against the disorderly spirit of the box format, for example, Schwarz has attempted to establish a sequence for the notes of *The Green Box* and *The White Box*, Marcel Duchamp, *Notes and Projects for the Large Glass*, Arturo Schwarz (ed.), trans. George H. Hamilton, Cleve Gray and Arturo Schwarz, London 1969, pp.3–6.

3 Standard Stoppages

1 For some detail, see Francis M. Naumann, 'Marcel Duchamp: A Reconciliation of Opposites', Kuenzli and Naumann 1989, pp.21–40.
2 Linda Dalrymple Henderson, *The Fourth Dimension and Non Euclidean Geometry in Modern Art*, Princeton 1983, p.131.
3 Albert Gleizes and Jean Metzinger, *Du Cubisme*, Paris 1912, p.17.
4 Pierre Cabanne, *Dialogues with Marcel Duchamp*, trans. Ron Padgett, London 1971, p.39.

5. Language and Secrecy

1 Michel de Certeau, 'The Scriptural Economy', *The Practice of Everyday Life*, trans. Steven Rendall, Berkeley, Los Angeles, London, 1984, pp.131–53, 136. Although de Certeau believes the *Large Glass* figures 'the lure of communication', he regards its theme as a 'laughable tragedy of language: being mixed together by an optical effect, these elements are neither coherent nor conjoined . . . the bride is never married to a reality of a meaning', de Certeau 1984, p.151. His sources are a book Duchamp did not care for by Michel Carrouges, *Les Machines célibataires* [1954], Paris 1976, and Jean Clair and Harald Szeemann, *Junggesellen-maschinen/Les Machines célibataires*, Venice 1976 (to which de Certeau contributed). See Michel de Certeau, 'The Arts of Dying: Celibatory Machines', *Heterologies: Discourse on the Other*, trans. Brian Massumi, Manchester 1986, pp.156–67.
2 One commentator imputes artistic intention to this, describing Duchamp's work as 'a free-floating, ceaselessly interactive semiotic field rather than a set of discrete, determinate units of meaning', Sheldon Nodelman, 'The Once and Future Duchamp' [books review], *Art in America*, vol.88, no.1, Jan. 2000, p.37.
3 Dalia Judovitz, *Unpacking Duchamp: Art in Transit*, Berkeley, Los Angeles and London 1995, p.106.
4 I am grateful to Anna Dezeuze for help with the translation of the phrase *tu m' emmerdes*.
5 Hubert Damisch, 'The Duchamp

Defense', *October*, no.10, Autumn 1979, pp.5–28; Jon Wood, 'Brancusi's "White Studio"', *Sculpture Journal*, vol.7, 2002, pp.108–20. Both of these essays are richer than my shorthand can do justice to here.
6 John Cage, '26 Statements *re* Duchamp', Joseph Mashek (ed.), *Marcel Duchamp in Perspective*, New Jersey 1975, pp.67–9, 68.
7 Arturo Schwarz (ed.), *The Complete Works of Marcel Duchamp*, vol.2, revised and expanded ed., London 1997, p.197.
8 Ulf Linde in Schwarz 1997, 1, p.189.
9 Juan Antonio Ramírez, *Duchamp: Love and Death, Even*, trans. Alexander R. Tulloch, London 1998, pp.34, 38, 42.
10 Thierry De Duve, 'The Readymade and the Tube of Paint', *Artforum*, vol.24, no.9, May 1986, pp.110–21. For reasons that will become clear, De Duve's essay is treated as an exemplary object here, and a point-for-point response to his theory will not be given. The intention is not to dismiss de Duve's contributions to the Duchamp scholarship: *Pictorial Nominalism: On Marcel Duchamp's Passage from Painting to the Readymade*, trans. de Duve and Dana Polan, Minnesota 1991; *Kant After Duchamp*, Cambridge, Mass., and London 1996.
11 De Duve 1986, p.111.
12 De Duve 1986, p.112.
13 See, for instance, Marcel Duchamp, 'A Propos of "Readymades"' [1961], *Salt Seller: The Essential Writings of Marcel Duchamp*, eds Michel Sanouillet and Elmer Peterson, London 1975, pp.141–2, 142.
14 De Duve 1986, p.113.
15 De Duve 1986, p.114.
16 De Duve 1986, p.115.
17 De Duve 1986, p.115.
18 De Duve 1986, p.115.
19 Paul Matisse (ed.), *Marcel Duchamp, Notes*, Paris 1980, n.p.
20 Philippe Duboy, *Lequeu: An Architectural Enigma*, London 1986, p.352.
21 Umberto Eco, *Interpretation and Overinterpretation*, Cambridge 1992. Eco's principal target is freewheeling interpretation in mainly American literary theory influenced by Jacques Derrida's deconstruction, though he does not necessarily blame Derrida for this, and holds a complex relation to his work. For a fuller context for this phase of Eco's writings, see Michael Caesar, 'Secrets, Paranoia and Critical Reading', *Umberto Eco: Philosophy, Semiotics and the Work of Fiction*, Cambridge 1999, pp.145–61. My own approach towards interpretation in the Duchamp business and art history generally does not really entail a critique of deconstruction. The literary criticism that most resembles the interpretation I am commenting upon here can be found in the amazing over-reading offered by Ted Hughes, *Shakespeare and the Goddess of Complete Being*, London 1992, and in a book in which the author claims bewildering access to his

subject's unconscious through his work, Christopher Ricks, *Dylan's Visions of Sin*, London 2003.
22 Eco 1992, p.30.
23 Eco 1992, p.30.
24 Caesar 1999, p.147.
25 Eco 1992, p.30.
26 Simmel quoted in Eco 1992, p.38. See Georg Simmel, 'Secrecy', *The Sociology of Georg Simmel*, trans. and ed. Kurt H. Wolff, London and New York 1964, pp.330–44, 333.
27 Umberto Eco, *Foucault's Pendulum*, trans. William Weaver, New York 1989, pp.377–8.
28 Umberto Eco, *The Limits of Interpretation*, Bloomington and Indianapolis 1994, p.27.
29 Peter Bondanella, *Umberto Eco and the Open Text: Semiotics, Fiction, Popular Culture*, Cambridge 1997, pp.132–3.
30 'I shall call Hermetic drift the interpretive habit which dominated Renaissance Hermetism and which is based on the principles of universal analogy and sympathy, according to which every item of the furniture of the world is linked to every other element (or to many) of this sublunar world and to every element (or to many) of the superior world by means of similitudes or resemblances,' Eco 1994, p.24.
31 Interviewed in 1962, Duchamp said words, 'such as truth, art, veracity, or anything else are stupid in themselves, so I insist *every word I am telling you now is stupid and wrong*'. Quoted in Calvin Tomkins, *Duchamp: A Biography*, London 1998, p.419. Duchamp's position is eloquently expressed by Pierre de Massot, *The Wonderful Book: Réflections on Rrose Sélavy*, Paris 1924, while the spirit of negation some have seen in his acts and behaviour is contextualised in the 'history of the art of the No' by Enrique Vila-Matas, *Bartleby & Co.*, trans. Jonathan Dunne, London 2005.
32 A reference, of course, to Poe's tale here, in which the queen's incriminating letter is stolen by the minister and 'hidden' by being left on show, debated extensively and collected in John P. Muller and William J. Richardson (eds.), *The Purloined Poe: Lacan, Derrida & Psychoanalytic Reading*, Baltimore and London 1988.
33 Susan Sontag, 'Against Interpretation', *Against Interpretation*, London 2001, pp.3–14, 6–7.
34 Sontag 2001, p.8.
35 For what follows, I draw mainly upon Martin Parker, 'Human Science as Conspiracy Theory', Jane Parish and Martin Parker (eds.), *The Age of Anxiety: Conspiracy Theory and the Human Sciences*, Oxford 2001, pp.191–207. Another symptom is the genre of the conspiracy novel, which includes the ubiquitous works of Dan Brown, but is at its best in the novels of Eco, Thomas Pynchon and Don DeLillo. For a brilliant reading of paranoia in Pynchon, see Leo Bersani, 'Pynchon, Paranoia, and Literature',

Representations, no.25, Winter 1989, pp.99–118.

36 Parish and Parker 2001, p.192.

37 Parish and Parker 2001, p.194. For an introduction to falsification criteria, see Karl Popper, *Unended Quest: An Intellectual Autobiography*, London 1986, pp.39–44.

38 Parish and Parker 2001, p.192.

39 Parish and Parker 2001, p.194.

40 Parish and Parker 2001, p.194.

41 Parish and Parker 2001, p.196.

42 Parish and Parker 2001, p.192.

43 Parish and Parker 2001, p.202.

44 Parish and Parker 2001, p.198. Parker's target here is Frederic Jameson's view that conspiracy is 'the poor person's cognitive mapping in the postmodern age' and that real truths are to be gained from Marxism. See Frederic Jameson, 'Cognitive Mapping', Cary Nelson and Lawrence Grossberg (eds.), *Marxism and the Interpretation of Culture*, Basingstoke and London 1988, pp.347–57, 356.

45 Parish and Parker 2001, p.193. Given the attraction held by deductive method in art history, it is perhaps not surprising that there is a theory claiming that 'Duchamp was merely aping the thoughts and gestures of the greatest artist of all times, Sherlock Holmes . . . To Duchamp, Holmes was the perfect embodiment of art and its spirit', which goes on to argue that the *Large Glass* was inspired by Holmes's *Practical Handbook of Bee Culture with Some Observations Upon the Segregation of the Queen* while the Swiss waterfall and *Bec Auer* gas lamp of *Etant donnés* reproduce respectively Holmes's 'death' at the hands of Professor Moriarty over the Reichenbach Falls in Switzerland and his return, 'formally announced by a shadow caused by the gas lamps in his apartment', Gary Glenn, 'Letters', *Artforum*, vol.11, no.3, Nov. 1972, pp.6–9, 7. This theory was expanded in an exchange of unpublished letters and has been unexpectedly described as, 'of all the various Duchampian hermeneutics . . . the most attractive', regarded as more plausible than the alchemy thesis for the strange reason that it rests on 'the complete absence of direct reference to Holmes in all Duchamp's known utterances', Gavin Bryars, 'Notes on Marcel Duchamp's Music', *Studio International*, vol.192, no.984, Nov.–Dec. 1976, pp.274–9, 274.

46 The Italian word *dietrologia* is used by Don DeLillo, *Underworld*, London 1998, p.280. See the discussion in Peter Knight, 'Dietrology', *Conspiracy Culture: From Kennedy to The X Files*, London and New York 2000, pp.230–3.

47 Examples are Thomas Mann, *Lotte in Weimar* [1939], trans. H.T. Lowe-Porter, Harmondsworth 1982 and Simon Schama, *Dead Certainties (Unwarranted Speculations)*, London 1991. The line of argument in this chapter is rooted in scepticism about a theory that emerged from New York in the late 1990s, in which the artist Rhonda

Roland Shearer, claiming to use scientific method, freely employed the language of detection, Rhonda Roland Shearer, 'Marcel Duchamp's Impossible Bed and Other "Not" Readymade Objects: A Possible Route of Influence From Art to Science, Part I', *Art & Academe*, vol.10, no.1, 1997, pp.26–62, 29, 30, and Shearer II 1998, pp.76–94. Unfortunately, Shearer's way of proving her inventive claim that Duchamp had fabricated the readymades (not chosen them), partly with recourse to old, grainy photographs of Duchamp's studio, bears an uncanny resemblance to theories about the Loch Ness Monster and claims that the moon landing was faked.

With Hidden Noise

1 Duchamp's friend Charles Demuth said in 1926, 'dear Marcel, having used glass so often seems to have added difficulties for the Future – he would, of course', Pontus Hultén (ed.), *Marcel Duchamp: Work and Life*, Cambridge, Mass., 1993, 20 October 1926.

6. Humour and Play

1 Duchamp quoted in Arturo Schwarz (ed.), *The Complete Works of Marcel Duchamp*, vol.1, revised and expanded ed., London 1997, p.256.

2 Duchamp quoted in Katharine Kuh, 'Marcel Duchamp', *The Artist's Voice: Talks with Seventeen Modern Artists*, New York 2000, pp.81–93, 90.

3 Marcel Duchamp, 'The Green Box', *Salt Seller: The Essential Writings of Marcel Duchamp*, eds Michel Sanouillet and Elmer Peterson, London 1975, pp.26–71, 30.

4 See, for instance, Alice Goldfarb Marquis, *Marcel Duchamp: The Bachelor Stripped Bare*, London and New York, 2002, pp.292–4.

5 Duchamp quoted in 1961, Alain Jouffroy, 'Conversations avec Marcel Duchamp', *Une révolution du regard: A propos de quelques peintres et sculpteurs contemporains*, Paris 1964, pp.107–24, 118. Duchamp continues, 'To avoid seriousness, one must bring in humour. The only subject I would consider serious is eroticism . . . that's serious!' Jouffroy 1964, p.118.

6 Duchamp quoted in 1963, Francis M. Naumann, *Marcel Duchamp: The Art of Making Art in the Age of Mechanical Reproduction*, New York 1999, p.233.

7 Perhaps unkindly, he reports: 'Like many of the leading authorities on Duchamp, Arturo Schwarz has very little sense of humour, and this sometimes makes his writings extremely funny,' Calvin Tomkins, *Duchamp: A Biography*, London 1998, p.53.

8 Quoted in Anne d'Harnoncourt and Kynaston McShine (eds.), *Marcel Duchamp*, New York [1973], 1989, p.251.

9 The discomfiting experience of, in a single visit, viewing Tate Modern's version of *Fountain* and using the still similar urinals in the gent's lavatory uncannily bridges the gap between

'high' art and 'base' human functions, giving a very immediate impression of Duchamp's wry sense of humour and 'debasement' of art.

10 This was made in an edition of 100, created as invitations for a preview of the 1965 New York exhibition at the Cordier & Ekstrom Gallery, *Not Seen and/or Less Seen of/by Marcel Duchamp/Rrose Sélavy 1904–64*.

11 Duchamp 1975, p.32.

12 Duchamp 1975, p.75.

13 Duchamp 1975, p.32.

14 Walter Benjamin, *Charles Baudelaire: A Lyric Poet in the Era of High Capitalism*, trans. Harry Zohn, London 1992, p.36.

15 Patrick Hughes, 'Lead Balloons: Verbal & Visual Oxymorons', *Transformaction*, no.8, 1977, pp.36–7, 36.

16 Helen Molesworth, 'Work Avoidance: The Everyday Life of Marcel Duchamp's Readymades', *Art Journal*, vol.57, no.4, Winter 1998, pp.50–61.

17 Quoted in Tomkins 1998, p.405.

18 Naumann 1999, p.294.

19 Duchamp 1975, p.45.

20 Tomkins 1998, p.9.

21 Duchamp 1975, p.56.

22 Duchamp 1975, p.30.

23 Quoted in Pontus Hultén (ed.), *Marcel Duchamp: Work and Life*, Cambridge, Mass., 1993, 6 May 1920.

24 André Breton, 'Words without Wrinkles' [1922], *The Lost Steps*, trans. Mark Polizzotti, Lincoln and London 1996, pp.100–2, 102. Breton could well have been making a distinction between comedy and humour (or perhaps he just changed his mind), as he later included several of the puns in his appraisal of Duchamp's contribution to the Surrealist category *humour noir*, André Breton, 'Marcel Duchamp' [1940], *Anthology of Black Humor*, trans. Mark Polizzotti et al., San Francisco 1997, pp.277–82.

25 Duchamp 1975, p.113.

26 Duchamp 1975, p.192.

27 Duchamp 1975, p.113.

28 Duchamp 1975, pp.191–2.

29 For this reason they can be situated within the field of Bataillean 'sovereignty'. Beyond mastery, this term and others had major significance for French theorists such as Jacques Derrida from the 1960s and 1970s, as Susan Rubin Suleiman explains: '[Bataille's] theoretical texts provided a set of concepts or "key words" whose applicability extended from the realm of cultural and individual experience to the realm of writing: expenditure, transgression, boundary, excess, heterogeneity, sovereignty – this last being a key term in Bataille's vocabulary, whose implications, as Derrida brilliantly demonstrated are the very opposite of Hegel's term "mastery". Mastery is linked to work, and above all to the affirmation and preservation of meaning; sovereignty, on the other hand, is precisely that which enables an individual to expose himself to play, to risk, to the

destruction or "waste" of meaning,' Susan Rubin Suleiman, 'Pornography, Transgression, and the Avant-Garde: Bataille's *Story of the Eye*', Nancy K. Miller (ed.), *The Poetics of Gender*, New York 1986, pp.117–36, 121. Suleiman refers to the indispensable text on Bataille by Derrida, 'From Restricted to General Economy: A Hegelianism without Reserve' [1967], *Writing and Difference*, trans. Alan Bass, Chicago 1978, pp.251–77. For more on Duchamp's odd economy and its relation to Bataille's writings, see my parody 'The Laughter and Tears of Eros', Marc Décimo (ed.), *Marcel Duchamp and Eroticism*, Newcastle upon Tyne 2007, pp. 149–59.

30 Jeffrey Weiss, *The Popular Culture of Modern Art: Picasso, Duchamp, and Avant-Gardism*, New Haven and London 1994, pp.107–63.

31 Weiss 1994, p.110.

32 Weiss 1994, p.112.

33 Weiss 1994, p.116.

34 Weiss 1994, p.119. In this way, Weiss stabilises Duchamp's still-extraordinary decision by means of the historicist and anachronistic rhetoric of 'inevitability'. See the discussion in E.H. Carr, *What is History?* (1961), second ed., Harmondsworth 1987, pp.91–9.

35 Weiss 1994, p.125.

36 Weiss 1994, p.136.

37 Weiss 1994, p.129.

38 For a neighbouring interpretation emphasising the American context, seemingly unaware of Weiss's, see Michael Leja, 'Humbugs for Highbrows: Duchamp's Readymades in New York', *Looking Askance: Skepticism and American Art from Eakins to Duchamp*, Berkeley, Los Angeles and London 2004, pp.221–47.

39 Although Duchamp declared himself satisfied with the content of the 1966 interviews with Pierre Cabanne, Robert Lebel and others were bothered by their tone, which recalled for Lebel that of the '*blagueur*', Lebel, 'Marcel Duchamp maintenant et ici', *L' Oeil*, no.149, May 1967, pp.18–23, 77, 19.

40 ☺∞£♂♣♪\∞%⌿@☺☼>*@∆∆ &@< ● @☼♀♀�⨍♂@%∞↑♠&£∞↑⨍∞ &@%∆♪%@@&>♠&⨍☼£♠♀♀%@∞ £♂♠♣♠>@♠?♠>⧣⨍♠& @☼♀♪>@ ● ♂♠ ?(@>♠>☺↑%>☺%>♠↑@∞>☼?@& ♀☼⧣<&@♀♀√↔↔^√∂=

41 More detail on the factual information that follows, along with a useful bibliography of articles on Duchamp and chess, can be found in P.N. Humble, 'Marcel Duchamp: Chess Aesthete and Anartist Unreconciled', *Journal of Aesthetic Education*, vol.32, no.2, Summer 1998, pp.41–55. The best article yet written on the subject is by Hubert Damisch, 'The Duchamp Defense', *October*, no.10, Autumn 1979, pp.5–28.

42 'I noticed he had in his hand a pocket chess set, the black and white men arrayed against each other. I asked him whom he might be playing against and he answered, "Marcel versus Duchamp",' John Bernard Myers,

Tracking the Marvelous: A Life in the New York Art World, London 1984, pp.33–4.

43 Quoted in Harriet and Sidney Janis, 'Marcel Duchamp: Anti-Artist' [1945], Robert Motherwell (ed.), *The Dada Painters and Poets* [1951], second ed., Cambridge, Mass., and London 1981, pp.306–15, 307.

44 Quoted in Kuh 2000, p.83.

45 Frank Kermode, *The Genesis of Secrecy: On the Interpretation of Narrative*, Cambridge, Mass., and London 1979, p.1.

46 Jacques Derrida, *Dissemination*, trans. Barbara Johnson, London 1981, p.93.

47 Derrida 1981, p.117. For a relevant approach to Pop Art, Duchamp and Derrida, see Sarat Maharaj, 'Pop Art's Pharmacies: Kitsch, Consumerist Objects and Signs, the "Unmentionable"', *Art History*, vol.15, no.3, Sept. 1992, pp.334–50. For reasons outlined in this chapter and the last, I would be extremely wary of holistic readings of Duchamp through Derrida's *différance*, as (virtually) given by Yishan Lam, 'Unpacking the *Boîte-en-valise*: Playing off Duchampian Deferral and Derrida's "'différance"', *tout-fait: The Marcel Duchamp Studies Online Journal*, 2005, and Gavin Parkinson, '"*Physique Amusante*"': Marcel Duchamp, Logic, and the *Infra-Mince*', *Physique du Surréalisme: Surrealism, Modern Physics, and Epistemology*, dissertation submitted for the degree of Ph.D., Courtauld Institute of Art, University of London, 2000, pp.213–68. Maharaj progressed to a strategy of play, in line with the argument presented in this chapter, stating 'Monkeydoodle is a way of looking and thinking that apes the straight essay only to muck up its system by letting loose the baboonery of counterforce,' Sarat Maharaj, 'Monkeydoodle: Annotating the Anti-essay "after History"', *Art Journal*, vol.56, no.1, Spring 1997, pp.65–71, 65. Derrida's writings are vital to debates about writing and representation in the age of postmodernism, and an excellent and instructive guide can be found in Gregory L. Ulmer, 'The Object of Post-Criticism', Hal Foster (ed.), *The Anti-Aesthetic: Essays on Postmodern Culture*, Port Townsend, Washington DC 1983, pp.83–110. One of the few essays on Duchamp to perform the kind of writing advocated here, in so far as it does not impute the connections it feverishly creates within Duchamp's *œuvre* to Duchamp's own intention, is by George H. Bauer, 'Duchamp's Ubiquitous Puns', Rudolph E. Kuenzli and Francis M. Naumann (eds.), *Marcel Duchamp: Artist of the Century*, Cambridge, Mass., 1989, pp.127–48. In freely creating an unbelievable number of links within Duchamp's work, Bauer's anti-essay parodies interpretation, corresponding with Martin Parker's attempt to thwart *dietrologia* by an 'ironic hyper-conspiracism', Martin Parker, 'Human Science as Conspiracy Theory', Jane Parish and Martin Parker (eds.), *The Age of Anxiety: Conspiracy Theory and the Human Sciences*, Oxford 2001,

pp.191–207, 205. See also Ulmer's claim in his review of Derrida's *The Post Card*, that Derrida's 'running commentary on the post card is a deliberately wild hermeneutic', Gregory L. Ulmer, 'The Post-Age', *Diacritics*, vol.11, no.3, Autumn 1981, pp.39–56, 52.

48 Notably in an article by Seymour Howard, 'Hidden Naos: Duchamp Labyrinths', *Artibus et Historæ*, vol.15, no.29, 1994, pp.153–80, 168–9. To be fair, Howard introduces this piece by saying that his analysis of *With Hidden Noise* and 'related' works will be made 'sometimes with tongue in cheek' (which is just as well, as he goes on to claim that Duchamp's 1936 *Fluttering Hearts* cover for the journal *Cahiers d' Art* has some connection with the heart condition that kept him out of the First World War), Howard 1994, pp.153, 168. See also Schwarz 1997, 1, pp.128, 219. For an interpretation of the Duchamp of *Monte Carlo Bond* as Medusa, facilitated by puns and psychoanalysis, see Dawn Ades, 'Duchamp's Masquerades', Graham Clarke (ed.), *The Portrait in Photography*, London 1992, pp.94–114; as a castrated John the Baptist, see Mason Klein, 'Embodying Sexuality: Marcel Duchamp in the Realm of Surrealism', Maurice Berger (ed.), *Modern Art and Society: An Anthology of Social and Multicultural Readings*, New York 1994, pp.139–57, 151; as an (anti-) Oedipus, see David Joselit, 'Marcel Duchamp's *Monte Carlo Bond* Machine', *October*, no.59, Winter 1992, pp.8–26, 25; and as the prophet Moses, see Dawn Ades, Neil Cox and David Hopkins, *Marcel Duchamp*, London 1999, p.139. To spell it out again, I am arguing that rather than throwing further interpretations on the pile, we might now reflect on the existence of the pile itself; we might take the top-heaviness of the Duchamp business as a cue to interpret interpretation in the discipline of art history.

49 The atmosphere of connectivity generated around Duchamp's gestures has made it difficult to find a place for simple coincidence, such as the similarities between quantum mechanics and Duchamp's thought highlighted in Chapter 4. For a brief but illuminating discussion of Duchamp, coincidence and the pleasures and pitfalls of 'tampering with the relation between the disciplinary expectations about meaning and the disruptive possibilities latent in those same expectations' (which is nevertheless too conservative about the potential for such strategies in art history), see James Elkins, *Why Are Our Pictures Puzzles? On the Modern Origins of Pictorial Complexity*, New York and London 1999, p.83.

50 Jacques Derrida, *Spurs/Nietzsche's Styles*, trans. Barbara Harlow, Chicago and London 1979, p.131.

51 Derrida 1979, p.133.

52 Richard Rorty, 'From Logic to Language to Play: A Plenary Address

to the InterAmerican Congress',
*Proceedings and Addresses of the
American Philosophical Association*,
vol.59, no.6, June 1986, pp.747–53, 748.

Duchamp's Writings

1 All extracts in this section,
'Appreciation of Other Artists', are
taken from Marcel Duchamp, 'From
the Catalog *Collection of the Société
Anonyme*', *Salt Seller: The Essential
Writings of Marcel Duchamp*, eds
Michel Sanouillet and Elmer Peterson,
London 1975, pp.143–59.
2 Duchamp 1975, pp.138–40.
3 Duchamp 1975, pp.141–2.
4 All *infra-mince* notes are from Paul
Matisse (ed.), *Marcel Duchamp, Notes*,
exh. cat., Centre National d'Art et de
Culture Georges Pompidou, Paris
1980, n.p.
5 Duchamp, 'Rose Sélavy & Co.',
Duchamp 1975, pp.103–19.
6 André Breton, 'Marcel Duchamp'
[1940], *Anthology of Black Humor*,
trans. Mark Polizzotti et al., San
Francisco 1997, pp.277–82, 280.
7 Marcel Duchamp, *Affect' Marcel._
The Selected Correspondence of Marcel
Duchamp*, ed. Francis M. Naumann and
Hector Obalk, trans. Jill Taylor, London
2000, pp.25–6.
8 Duchamp 2000, pp.35–7.
9 Duchamp 2000, pp.43–4.
10 Duchamp 2000, pp.81–3.
11 Duchamp 2000, pp.105–6.
12 Duchamp 2000, pp.170–1.
13 Duchamp 2000, pp.197–8.
14 Duchamp 2000, pp.267–8.
15 Duchamp 2000, pp.282–4.
16 Duchamp 2000, pp.318–22.
17 Duchamp 2000, pp.347–8.
18 Duchamp 2000, pp.358–9.
19 Duchamp 2000, pp.370–1.

Criticism and Commentary on
Duchamp's Art, 1913–2006

1 Guillaume Apollinaire, *The Cubist
Painters: Aesthetic Meditations*, trans.
Lionel Abel, New York 1944, p.32.
2 Gertrude Stein quoted in Linda
Dalrymple Henderson, *The Fourth
Dimension and Non-Euclidean
Geometry in Modern Art*, Princeton
1983, p.207.
3 André Breton, *Nadja* [1928], trans.
Richard Howard, New York 1960, p.31.
4 Anaïs Nin, *The Journals of Anaïs Nin,
1934–1939*, London 1967, p.56.
5 From the diary of Walter Benjamin
quoted in *Joseph Cornell/Marcel
Duchamp . . . in resonance*, exh. cat.,
Philadelphia Museum of Art 1998,
p.102.
6 André Breton, 'Testimony 45: On
Marcel Duchamp' [1945], *What is
Surrealism? Selected Writings*, Franklin
Rosemont (ed.), London 1978,
pp.254–5, 254.
7 Robert Motherwell (ed.), *The Dada
Painters and Poets: An Anthology*
[1951], second ed., Cambridge, Mass.,
and London 1981, p.xxiii.
8 Willem de Kooning quoted in John

Tancock, 'The Influence of Marcel
Duchamp', Anne d'Harnoncourt and
Kynaston McShine (eds.), *Marcel
Duchamp*, exh. cat., Philadelphia
Museum of Art 1973 and revised ed.
New York 1989, p.233.
9 Henri-Pierre Roché, 'Souvenirs of
Marcel Duchamp', Robert Lebel, *Marcel
Duchamp*, trans. George Heard
Hamilton, London 1959, pp.79–87, 87.
10 Clyfford Still, 'Letters', *Artforum*,
vol.2, no.8, Feb. 1964, p.4.
11 Work of art by Joseph Beuys, collage
with chocolate, felt paper and brown oil
pigment, dating from 1964.
12 Thomas Hess, 'J'Accuse Marcel
Duchamp' [1965], Joseph Mashek (ed.),
Marcel Duchamp in Perspective, New
Jersey 1975, pp.115–20, 115.
13 Richard Hamilton quoted in *The
Almost Complete Works of Marcel
Duchamp*, exh. cat., Tate Gallery,
London 1966, p.5.
14 Picasso, on hearing of Duchamp's
death, quoted in Genêt (Janet Flanner),
'Letter from Paris', *The New Yorker*,
vol.44, no.37, 2 Nov. 1968, pp.170–9,
173.
15 Jasper Johns, 'Marcel Duchamp
(1887–1968),' *Artforum*, vol.7, no.3,
Nov. 1968, p.6.
16 John Cage quoted in Moira Roth and
William Roth, 'John Cage on Marcel
Duchamp: An Interview' [1973], Mashek
1975, pp.150–61, p.153.
17 Joseph Kosuth, 'Art after Philosophy'
[1969], *Art after Philosophy and After:
Collected Writings, 1966–1990*,
Cambridge, Mass., and London 2002,
pp.13–32, 18.
18 Terry Atkinson, 'From an Art &
Language Point of View', *Art-Language*,
vol.1, no.2, Feb. 1970, pp.25–60, 59.
19 Robert Smithson quoted in Moira
Roth, 'Robert Smithson on Duchamp,
An Interview' [1973], Mashek 1975,
pp.134–7, 137.
20 Jean-François Lyotard, *The
Postmodern Condition: A Report on
Knowledge* [1979], trans. Geoff
Bennington and Brian Massumi,
Manchester 1999, p.75.
21 Clement Greenberg quoted in Thierry
de Duve, *Clement Greenberg Between
the Lines*, trans. Brian Holmes, Paris
1996, p.140.
22 Louise Bourgeois quoted in Donald
Kuspit, *Bourgeois: An Interview with
Louise Bourgeois*, New York 1988, p.31.
23 Hans Haacke quoted in Mark
Thomson, 'Interview with Hans Haacke',
Anthony Hill (ed.), *Duchamp: passim*,
London 1994, pp.169–70, 169.
24 Thierry de Duve quoted in Benjamin
Buchloh et al., 'Conceptual Art and the
Reception of Duchamp', Martha Buskirk
and Mignon Nixon (eds.), *The Duchamp
Effect*, Cambridge, Mass., 1996,
pp.205–24, 224.
25 Cornelia Parker, interviewed by Lisa
Tickner, 'A Strange Alchemy: Cornelia
Parker', *Art History*, vol.26, no.3, June
2003, pp.364–91, 368.
26 Liam Gillick quoted in Caroline Cros,
Marcel Duchamp, trans. Vivian Rehberg,
London 2006, p.7.

27 Peter Blake quoted in Nicholas Roe,
'Profile: Peter Blake. The Bigger
Picture', http://books.guardian.co.uk/
review/story/0,,1690076,00.html (as at
27 February 2007).

Select Bibliography

Part of the point of *The Duchamp Book* is its complaint about what Duchamp himself called the 'floodgates of words' aspect of scholarship, and, of course, this features alongside superior writings in this Select Bibliography, the aim of which is to give an extensive representative sample of literature on Duchamp for English readers. To that end, I have drawn selectively on, and supplemented, the two most substantial bibliographies in the literature till now, in Rudolph E. Kuenzli and Francis M. Naumann (eds.), *Marcel Duchamp: Artist of the Century*, Cambridge, Mass., 1989, and Arturo Schwarz (ed.), *The Complete Works of Marcel Duchamp*, 2 vols, revised and expanded ed., London 1997. Readers are also directed towards the two journals dedicated to Duchamp, the high-quality *Etant donné Marcel Duchamp*, 1999– (which carried updated bibliographies covering 1996–99 in its second number in 1999, and 2000–2003 in its fifth number in 2003), and *tout-fait: The Marcel Duchamp Studies Online Journal*, 1999–, at www.toutfait.com. Further writings on Duchamp can be sourced in the International Online Bibliography of the University of Iowa's International Dada Archive, at www.lib.uiowa.edu/dada/. There is also a 'Marcel Duchamp World Community', at www.marcelduchamp.net.

Craig Adcock, *Marcel Duchamp's Notes from the Large Glass. An N-Dimensional Analysis*, Epping 1983

Craig E. Adcock, 'Conventionalism in Henri Poincaré and Marcel Duchamp', *Art Journal*, vol.44, no.3, Autumn 1984, pp.249–58 Dawn Ades, 'Duchamp's Masquerades', Graham Clarke (ed.), *The Portrait in Photography*, London 1992, pp.94–114

Dawn Ades, Neil Cox, David Hopkins, *Marcel Duchamp*, London 1999

The Almost Complete Works of Marcel Duchamp, exh. cat., Tate Gallery, London 1966

William Anastasi, 'Duchamp on the Alfred Jarry Road,' *Artforum*, vol.30, no.1, Sept. 1991, pp.86–90

L'Arc, no.59, 1974

Art and Artists, no.4, July 1966 (Marcel Duchamp special number)

Art in America, vol.57, no.4, July–Aug. 1969 (Marcel Duchamp special number)

Christoph Asendorf, 'The Propeller and the Avant-Garde: Léger, Brancusi, Duchamp', Dorothy Kosinski (ed.), *Fernand Léger, 1911–1924: The Rhythm of Modern Life*, Munich and New York 1994, pp.203–9

Dore Ashton, 'An Interview with Marcel Duchamp', *Studio International*, vol.171, no.878, June 1966, pp.244–7

Aspen, no. 5/6, Fall–Winter 1967

Terry Atkinson, 'From an Art & Language Point of View', *Art-Language*, vol.1, no.2, Feb. 1970, pp.25–60

Edith Balas, 'Brancusi, Duchamp and Dada', *Gazette des Beaux-Arts*, vol.95, no.1335, April 1980, pp.165–73

Edward Ball and Robert Knafo, 'The R. Mutt Dossier', *Artforum*, vol.27, no.2, Oct. 1988, pp.115–19

Timothy W. Bartel, 'Appreciation and Dickie's Definition of Art', *The British Journal of Aesthetics*, vol.19, no.1, Winter 1979, pp.44–52

Roland Barthes, *Roland Barthes* [1975], trans. Richard Howard, London and Basingstoke 1977

Gianfranco Baruchello and Henry Martin, *Why Duchamp: An Essay on Aesthetic Impact*, New York 1985

George H. Bauer, 'Enamouring a Barber Pole', *Dada/Surrealism*, no.12, 1983, pp.20–36

Lucia Beier, 'The Time Machine: A Bergsonian Approach to the *Large Glass Le Grand Verre*', *Gazette des Beaux-Arts*, vol.88, no.1294, Nov. 1976, pp.194–200

Timothy Binkley, 'Piece: Contra Aesthetics', *Journal of Aesthetics and Art Criticism*, vol.35, no.3, Spring 1977, pp.265–77

Susi Bloch, 'Marcel Duchamp's *Green Box*', *Art Journal*, vol.34, no.1, Fall 1974, pp.25–9

Ecke Bonk, *Marcel Duchamp: The Portable Museum. The Making of the Boîte-en-valise*, trans. David Britt, London 1989

Brancusi et Duchamp, exh. cat., Musée National d'Art Moderne, Centre Georges Pompidou, Paris 2000

André Breton, 'Testimony 45: Point of View', *View*, Series V, no.1, ('Marcel Duchamp Number'), March 1945, p.5

André Breton, 'Lighthouse of the Bride' [1934], *Surrealism and Painting*, trans. Simon Watson Taylor, London and New York 1972, pp.85–99

André Breton, 'Marcel Duchamp' [1922], *The Lost Steps*, trans. Mark Polizzotti, Lincoln and London 1996, pp.86–8

André Breton, 'Marcel Duchamp' [1940], *Anthology of Black Humor*, trans. Mark Polizzotti et al., San Francisco 1997, pp.277–82

The Brothers Duchamp: Jacques Villon, Raymond Duchamp-Villon, Marcel Duchamp, exh. cat., Arnold Herstand, New York 1986

Gavin Bryars, 'Notes on Marcel Duchamp's Music', *Studio International*, vol.192, no.984, Nov.–Dec. 1976, pp.274–9

Benjamin H.D. Buchloh, 'Ready Made, Objet Trouvé, Idée Reçue', *Dissent: The Issue of Modern Art in Boston*, exh. cat., Institute of Contemporary Art, Boston, 1985, pp.107–21

Gabrielle Buffet-Picabia, 'Coeurs volants', *Cahiers d' Art*, Year 11, no.1/2, 1936, pp.34–43

Jack Burnham, 'Marcel Duchamp: *MASTER LUDI*', *The Structure of Art*, New York 1973, pp.158–70

Jack Burnham, *Great Western Salt Works: Essays on the Meaning of Post-Formalist Art*, New York 1974

Martha Buskirk and Mignon Nixon (eds.), *The Duchamp Effect*, Cambridge, Mass., 1996

Pierre Cabanne, *Dialogues with Marcel Duchamp*, trans. Ron Padgett, London 1971

Pierre Cabanne, *Duchamp & Co.*, trans. Peter Snowdon, Paris 1997

Craig Cabell, *Witchfinder General: The Biography of Matthew Hopkins*, Stroud 2006

Maurizio Calvesi, *Duchamp invisibile: la costruzione del simbolo*, Rome 1975

William Camfield, *Marcel Duchamp/Fountain*, Houston, Texas 1989

Michel Carrouges, *Les Machines célibataires*, Paris 1954

Mary Ann Caws, 'Mallarmé and Duchamp: Mirror, Stair, and Gaming Table', *The Eye in the Text. Essays on Perception, Mannerist to Modern*, Princeton, New Jersey 1981, pp.141–57

Mary Ann Caws, 'Partiality and the Ready Maid, or Representation by Reduction', *The Journal of Aesthetics and Art Criticism*, vol.42, no.3, Spring 1984, pp.255–60

Centre Culturel International de Cerisy-La-Salle, *Marcel Duchamp: Tradition de la rupture ou rupture de la tradition?*, Paris 1979

Dominique Chateau, *Duchamp et Duchamp*, Paris 1999

Jean Clair, *Marcel Duchamp ou le grand fictive: essai de mythanalyse du Grand Verre*, Paris 1975

Jean Clair, *Duchamp et la photographie*, Paris 1977

Jean Clair, 'Duchamp and the Classical Perspectivists', *Artforum*, vol.16, no.7, March 1978, pp.40–9

Jean Clair, 'Opticeries', *October*, no.5, Summer 1978, pp.101–12

Jean Clair, *Sur Marcel Duchamp et la fin de l' art*, Paris 2000

Bonnie Clearwater (ed), *West Coast Duchamp*, Miami Beach 1991

Albert Cook, 'The "Meta-Irony" of Marcel Duchamp', *The Journal of Aesthetics and Art Criticism*, vol.44, no.3, Spring 1986, pp.263–70

Joseph Cornell/Marcel Duchamp . . . in resonance, exh. cat., Philadelphia Museum of Art 1998

Charles A. Cramer, 'Duchamp from Syntax to Bride: *sa langue dans sa joue*', *Word & Image*, vol.13, no.3, July–Sept. 1997, pp.279–303

Jonathan Crary, 'Marcel Duchamp's *The Passage from Virgin to Bride*', *Arts Magazine*, vol.51, no.5, Jan. 1977, pp.96–9

David Cunningham, 'Making an Example of Duchamp: History, Theory, and the Question of the Avant-Garde', Dafydd Jones (ed.), *Dada Culture: Critical Texts on the Avant-Garde*, Amsterdam and New York 2006, pp.254–79

Salvador Dalí, 'The King and the Queen Traversed by Swift Nudes', *Art News*, vol.58, no.2, April 1959, pp.22–5

Salvador Dalí, 'Why they Attack the Mona Lisa', *Art News*, vol.62, no.1, March 1963, pp.36, 63–4

Hubert Damisch, 'The Duchamp Defense', *October*, vol.10, Autumn 1979, pp.5–28

Dieter Daniels, 'Points d'interférence entre Frederick Kiesler et Marcel Duchamp', *Frederick Kiesler: Artiste-architecte*, exh. cat., Musée National d'Art Moderne, Centre Georges Pompidou, Paris, 1996, pp.119–30

Ivor Davies, 'New Reflections on the *Large Glass*: the Most Logical Sources for Marcel Duchamp's Irrational Work', *Art History*, vol.2, no.1, March 1979, pp.85–94

Marc Décimo, *La bibliothèque de Marcel Duchamp, peut-être*, Dijon 2002

Marc Décimo (ed.), *Marcel Duchamp and Eroticism*, Newcastle upon Tyne 2007

Thierry De Duve, 'The Readymade and the Tube of Paint', *Artforum*, vol.24, no.9, May 1986, pp.110–21

Thierry De Duve, 'Marcel Duchamp, or the "Phynancier" of Modern Life', *October*, no.52, Spring 1990, pp.60–75

Thierry De Duve, 'Authorship Stripped Bare, Even', *Res: Anthropology and Aesthetics*, no.19/20, 1990–1, pp.235–41

Thierry De Duve, *Pictorial Nominalism: On Marcel Duchamp's Passage from Painting to the Readymade*, trans. de Duve and Dana Polan, Minnesota 1991

Thierry De Duve (ed.), *The Definitively Unfinished Marcel Duchamp*, Cambridge, Mass., 1991

Thierry De Duve, *Kant After Duchamp*, Cambridge, Mass., and London, 1996

T.J. Demos, 'Duchamp's Labyrinth: *First Papers of Surrealism*, 1942', *October*, no.97, Summer 2001, pp.91–119

T.J. Demos, *The Exiles of Marcel Duchamp*, Cambridge, Mass., 2007

Denis De Rougemont, 'Marcel Duchamp mine de rien', *Preuves*, Year 18, no.204, Feb. 1968, pp.43–7

Hans Maria De Wolf, 'Les hasards de l' Oasis. Une carte postale envoyée par Marcel Duchamp en 1933', *Cahiers du Musée national d' art moderne*, no.71, Spring 2000, pp.81–93

Anne d'Harnoncourt and Walter Hopps, *Etant donnés: 1 la chute d' eau, 2 le gaz d' éclairage: Reflections on a New Work by Marcel Duchamp*, Philadelphia Museum of Art 1973 and 1987

Anne d'Harnoncourt and Kynaston McShine (eds.), *Marcel Duchamp*, exh. cat., Philadelphia Museum of Art 1973 and revised ed. New York 1989, p.233.

George Dickie, 'Defining Art', *American Philosophic al Quarterly*, vol.6, no.3, July 1969, pp.253–6

T.J. Diffey, 'On Defining Art', *The British Journal of Aesthetics*, vol.19, no.1, Winter 1979, pp.15–23

Willis Domingo, 'Meaning in the Art of Duchamp, Part I', *Artforum*, vol.10, no.4, Dec. 1971, pp.72–7; 'Meaning in the Art of Duchamp, Part II', vol.10, no.5, Jan. 1972, pp.63–8

Katherine S. Dreier and Matta, *Duchamp' s Glass, La Mariée mise à nu par ses célibataires, même; An Analytical Reflection*, New York 1944

Philippe Duboy, *Lequeu: An Architectural Enigma*, London 1986

Duchamp, Johns, Rauschenberg, Cage, exh. cat., Contemporary Arts Museum, Cincinnati, Ohio 1971

Duchamp Frères & Sœur: Oeuvres d' Art, exh. cat., Rose Fried Gallery, New York 1952

Duchamp Readymades, exh. cat., Vancouver Art Gallery 1978

Marcel Duchamp, 'La mariée mise à nu par ses célibataires mêmes', *SASDLR*, no.5/6, 15 May 1933, pp.1–2

Marcel Duchamp, *The Bride Stripped Bare by her Bachelors, Even: A Typographic Version by Richard Hamilton of MARCEL DUCHAMP'S Green Box*, trans. George Heard Hamilton, London 1960

Marcel Duchamp, exh. cat., Galerie Burén, Stockholm 1963

Marcel Duchamp, 'I Propose to Strain the Laws of Physics', interview with Francis Roberts, *Art News*, vol.67, no.8, Dec. 1968, pp.46–7, 62–4

Marcel Duchamp, *Notes and Projects for the Large Glass*, Arturo Schwarz (ed.), trans. George H. Hamilton, Cleve Gray and Arturo Schwarz, London 1969

Marcel Duchamp, *Duchamp du signe: écrits*, ed. Michel Sanouillet and Elmer Peterson, Paris 1975

Marcel Duchamp, *Salt Seller: The Essential Writings of Marcel Duchamp*, eds Michel Sanouillet and Elmer Peterson, London 1975

Marcel Duchamp, exh. cat., Fundació Joan Miró, Barcelona, 1984

Marcel Duchamp, *Affect' Marcel._ The Selected Correspondence of Marcel Duchamp*, ed. Francis M. Naumann and Hector Obalk, trans. Jill Taylor, London 2000

Marcel Duchamp Respirateur, exh. cat., Staatliches Museum, Schwerin 1999

Les Duchamps: Jacques Villon, Raymond Duchamp-Villon, Marcel Duchamp, Suzanne Duchamp, Musée des Beaux-Arts, Rouen, 1967

Sidney Feshbach, 'Marcel Duchamp or Being Taken for a Ride: Duchamp was a Cubist, a Mechanomorphist, a Dadaist, a Surrealist, a Conceptualist, a Modernist, a Post-Modernist – and None of the Above', *James Joyce Quarterly*, vol.26, no.4, Summer 1989, pp.541–60

Lydie Fischer Sarazin-Levassor, *Un échec matrimonial. Le cœur de la mariée mis à nu par son célibataire, même*, Paris 2004

Andrew Forge, 'In Duchamp's Footsteps: Richard Hamilton's Reconstruction of *The Bride Stripped Bare by her Bachelors, Even*', *Studio International*, vol.171, no.878, June 1966, pp.248–51

Paul B. Franklin, 'Object Choice: Marcel Duchamp's *Fountain* and the Art of Queer Art History', *Oxford Art Journal*, vol.23, no.1, 2000, pp.23–50

Karl Gerstner, *Marcel Duchamp: Tu m'*, *Puzzle upon Puzzle*, Ostfildern-Ruit 2003

Albert Gleizes and Jean Metzinger, *Du Cubisme*, Paris 1912; English edition, *Cubism*, London 1913

John Golding, *Duchamp: The Bride Stripped Bare by her Bachelors, Even*, London 1973

Steven Goldsmith, 'The Readymades of Marcel Duchamp: The Ambiguities of an Aesthetic Revolution', *The Journal of Aesthetics and Art Criticism*, vol.42, no.2, Winter 1983, pp.197–208

Jennifer Gough-Cooper and Jacques Caumont, *Plan pour écrire une vie de Marcel Duchamp*, exh. cat., Musée National d'Art Moderne, Centre Georges Pompidou, Paris 1977

Lanier Graham, *Duchamp & Androgyny: Art, Gender, and Metaphysics*, Berkeley, California 2003

Cleve Gray (ed.), 'Feature: Marcel Duchamp, 1887–1968', *Art in America*, vol.57, no.4, July–Aug. 1969, pp.20–43

Stuart Greenstreet, 'Kripke, Duchamp & the Standard Metre', *Philosophy Now*, May/June 2003, pp.23–5

Richard Hamilton, *The Bride Stripped Bare by her Bachelors Even Again: A Reconstruction by Richard Hamilton of Marcel Duchamp's Large Glass*, Newcastle upon Tyne 1966

Richard Hamilton, 'Towards a Typographical Rendering of the *Green Box*' [1959], and 'The Green Book', *Collected Words, 1953–1982*, London 1982, pp.182–94, 195–7

Robert Harvey, 'Where's Duchamp? – Out Queering the Field', *Yale French Studies*, no.109, 2006 ('Surrealism and Its Others'), pp.82–97

Linda Dalrymple Henderson, *The Fourth Dimension and Non-Euclidean Geometry in Modern Art*, Princeton 1983

Linda Dalrymple Henderson, *Duchamp in Context: Science and Technology in the Large Glass and Related Works*, Princeton 1998

Anthony Hill (ed.), *Duchamp: passim*, London 1994

Gerald Holton, 'Henri Poincaré, Marcel Duchamp and Innovation in Science and Art', *Leonardo*, vol.34, no.2, 2001, pp.127–34

David Hopkins, 'Questioning Dada's Potency: Picabia's "La Sainte Vierge" and the Dialogue with Duchamp', *Art History*, vol.15, no.3, Sept. 1991, pp.317–33

David Hopkins, 'Men Before the Mirror: Duchamp, Man Ray and Masculinity', *Art History*, vol.21, no.3, Sept. 1998, pp.303–23

David Hopkins, *Marcel Duchamp and Max Ernst: The Bride Shared*, Oxford 1998

Seymour Howard, 'Hidden Naos: Duchamp Labyrinths', *Artibus et Historæ*, vol.15, no.29, 1994, pp.153–80

Pontus Hultén (ed.), *Marcel Duchamp: Work and Life*, exh. cat., Cambridge, Mass., 1993

P.N. Humble, 'Duchamp's Readymades: Art and Anti-Art', *British Journal of Aesthetics*, vol.22, no.1, Winter 1982, pp.52–64

P.N. Humble, 'On the Uniqueness of Art', *The Journal of Aesthetics and Art Criticism*, vol.42, no.1, Autumn 1983, pp.39–47

P.N. Humble, 'Marcel Duchamp: Chess Aesthete and Anartist Unreconciled', *Journal of Aesthetic Education*, vol.32, no.2, Summer 1998, pp.41–55

Jacques Villon, Raymond Duchamp-Villon, Marcel Duchamp, exh. cat., Guggenheim Museum, New York 1957

The Imagery of Chess Revisited, exh. cat., The Isamu Noguchi Foundation and Garden Museum, New York 2006

Carol Plyley James, 'Marcel Duchamp: Naturalized American', *French Review*, vol.49, no.6, May 1976, pp.1097–1105

Carol P. James, 'Duchamp's Pharmacy', *Enclitic*, vol.2, no.1, Spring 1978, pp.65–80

Carol P. James, 'Reading Art through Duchamp's *Glass* and Derrida's *Glas*', *Sub-Stance*, no.31, 1981, pp.105–28

Carol P. James, 'Duchamp's Early Readymades: The Erasure of Boundaries between Literature and the Other Arts', *Perspectives on Contemporary Literature*, vol.13, 1987, pp.24–32

Ronald Johnson, 'Poetic Pathways to Dada: Marcel Duchamp and Jules Laforgue', *Arts Magazine*, vol.50, no.9, May 1976, pp.82–9

Amelia Jones, *Postmodernism and the En-Gendering of Marcel Duchamp*, Cambridge 1994

Amelia Jones, 'Eros, That's Life, or the Baroness' Penis', *Making Mischief: Dada Invades New York*', exh. cat., Whitney Museum of American Art, New York 1996, pp.238–47

Amelia Jones, 'Equivocal Masculinity: New York Dada in the Context of World War I', *Art History*, vol.25, no.2, April 2002, pp.162–205

David Joselit, *Infinite Regress: Marcel Duchamp 1910–1941*, Cambridge, Mass., 1998

Dalia Judovitz, 'Anemic Vision in Duchamp: Cinema as Readymade', Rudolph Kuenzli (ed.), *Dada and Surrealist Film*, New York 1987, pp.46–57

Dalia Judovitz, *Unpacking Duchamp: Art in Transit*, Berkeley, Los Angeles, California and London 1995

Lewis Kachur, *Displaying the Marvelous: Marcel Duchamp, Salvador Dalí and Surrealist Exhibition Installations*, Cambridge, Mass., 2001

Michael Klein, 'John Covert's *Time*: Cubism, Duchamp, Einstein – A Quasi-Scientific Fantasy', *Art Journal*, vol.33, no.4, Summer 1974, pp.314–20

Mason Klein, 'Embodying Sexuality: Marcel Duchamp in the Realm of Surrealism', Maurice Berger (ed.), *Modern Art and Society: An Anthology of Social and Multicultural Readings*, New York 1994, pp.139–57

Joseph Kosuth, 'Art After Philosophy' [1969], *Art After Philosophy and After: Collected Writings, 1966–1990*, Cambridge, Mass., and London 1993, pp.13–32

Rosalind Krauss, 'Notes on the Index', *October*, no.3, Spring 1977, pp.68–81

Rosalind Krauss, 'Forms of Readymade: Duchamp and Brancusi', *Passages in Modern Sculpture*, Cambridge, Mass., 1977, pp.69–103

Rosalind Krauss, 'The Blink of an Eye', David Carroll (ed.), *The States of 'Theory': History, Art, and Critical Discourse*, New York 1990, pp.175–99

Rudolph E. Kuenzli and Francis M. Naumann (eds.), *Marcel Duchamp: Artist of the Century*, Cambridge, Mass., 1989

Pierre Lartigue, *Rrose Sélavy, et cætra*, Paris 2004

Robert Lebel, *Marcel Duchamp*, trans. George Heard Hamilton, London 1959

Robert Lebel, 'Marcel Duchamp maintenant et ici', *L'Oeil*, no.149, May 1967, pp.18–23, 77

Michael Leja, 'Humbugs for Highbrows: Duchamp's Readymades in New York', *Looking Askance: Skepticism and American Art from Eakins to Duchamp*, Berkeley, Los Angeles, London 2004, pp.221–47

Jean-François Lyotard, *Duchamp's TRANS/formers*, trans. Ian McLeod, Venice, California 1990

Thomas McEvilley, 'I Think Therefore I

Art', *Artforum*, vol.23, no.10, Summer 1985, pp.74–84

Making Mischief: Dada Invades New York, exh. cat., Whitney Museum of American Art, New York 1996

Marcel Duchamp, exh. cat., Pasadena Museum of California Art 1963

Marcel Duchamp: Ready-mades, etc. (1913–1964), exh. cat., Galleria Schwarz, Milan 1964

Marcel Duchamp, exh. cat., Galleria Schwarz, Milan 1966

Marcel Duchamp: 66 Creative Years: From the First Painting to the Last Drawing, exh. cat., Galleria Schwarz, Milan 1972

Marcel Duchamp, 1887–1968, 4 vols, exh. cat., Musée National d'Art Moderne, Centre Georges Pompidou, Paris 1977

Marcel Duchamp dans les collections du Centre Georges Pompidou, Musée National d' art moderne, Musée National d'Art Moderne, Centre Georges Pompidou, Paris 2001

Alice Goldfarb Marquis, *Marcel Duchamp: The Bachelor Stripped Bare*, London and New York 2002

Joseph Mashek (ed.), *Marcel Duchamp in Perspective*, New Jersey 1975

Paul Matisse, 'Marcel Duchamp', *Cahiers du Musée national d' art moderne*, no.3, Jan.–March 1980, pp.14–25

Paul Matisse, 'Some More Nonsense about Duchamp', *Art in America*, vol.68, no.4, April 1980, pp.76–83

Paul Matisse (ed.), *Marcel Duchamp, Notes*, Centre National d'Art et de Culture Georges Pompidou, Paris 1980

Annette Michelson, '"Anemic Cinema", Reflections on an Emblematic Work', *Artforum*, vol.12, no.2, Oct. 1973, pp.64–9

John F. Moffitt, 'Marcel Duchamp: Alchemist of the Avant-Garde', *The Spiritual in Art: Abstract Painting 1890–1985*, exh. cat., Los Angeles County Museum of Art, 1987, pp.257–71

John F. Moffitt, *Alchemist of the Avant-Garde: The Case of Marcel Duchamp*, New York 2003

Helen Molesworth, 'Bathrooms and Kitchens: Cleaning House with Duchamp', Nadir Lahiji and D.S. Friedman (eds.), *Plumbing: Sounding Modern Architecture*, New York 1997, pp.75–92

Helen Molesworth, 'Work Avoidance: The Everyday Life of Marcel Duchamp's Readymades', *Art Journal*, vol.57, no.4, Winter 1998, pp.50–61

Helen Anne Molesworth, *At Home with Duchamp: The Readymade and Domesticity*, Ph.D thesis (unpublished), Cornell University, 1998

Helen Molesworth, 'Duchamp: By Hand, Even', *Part Object Part Sculpture*, Columbus, Ohio 2005, pp.178–201

Robert Motherwell (ed.), *The Dada Painters and Poets* [1951], second ed., Cambridge, Mass., and London 1981

Toby Mussman, 'Marcel Duchamp's Anemic Cinema', Gregory Batcock (ed.), *The New American Cinema: A Critical Anthology*, New York, 1967, pp.147–55

Francis M. Naumann, 'The Bachelor's Quest', *Art in America*, vol.81, no.9, Sept. 1993, pp.72–81, 67, 69

Francis M. Naumann, *New York Dada, 1915–23*, New York, 1994

Francis M. Naumann, 'Arturo's Marcel', *Art in America*, vol.86, no.1, Jan. 1998, pp.35–9

Francis M. Naumann, *Marcel Duchamp: The Art of Making Art in the Age of Mechanical Reproduction*, New York 1999

Mark Nelson and Sarah Hudson Bayliss, *Exquisite Corpse: Surrealism and the Black Dahlia Murder*, New York and Boston 2006

Molly Nesbit, 'What Was an Author?', *Yale French Studies*, no.73, 1987 ('Everyday Life'), pp.229–57

Molly Nesbit, 'The Rat's Ass', *October*, no.56, Spring 1991, pp.7–20

Molly Nesbit, 'Readymade Originals: The Duchamp Model', *October*, no.37, Summer 1996, pp.53–64

Molly Nesbit, 'Last Words (Rilke, Wittgenstein) (Duchamp)', *Art History*, vol.21, no.4, Dec. 1998, pp.546–64

NOT SEEN and/or LESS SEEN of/by MARCEL DUCHAMP/RROSE SELAVY 1904–64, exh. cat., Cordier & Ekstrom Gallery, New York 1965

Opus International, no.49, March 1974 ('Duchamp et Après')

Octavio Paz, *Marcel Duchamp: Appearance Stripped Bare*, trans. Rachel Phillips and Donald Gardner, New York 1990

Marjorie Perloff, 'The Conceptual Poetics of Marcel Duchamp', *21st–Century Modernism*, London 2002, pp.77–120

Jessica Prinz, 'The Fine Art of Inexpression: Beckett and Duchamp', Alan Warren Charles Rossman Friedman, Dina Sherzer (eds.), *Beckett Translating/Translating Beckett*, University Park and London 1987, pp.95–106

Jean-Michel Rabaté, *Given: 1° Art 2° Crime: Modernity, Murder and Mass Culture*, Eastbourne 2007, pp.33–77.

Juan Antonio Ramírez, *Duchamp: Love and Death, Even*, trans. Alexander R. Tulloch, London 1998

Raymond Duchamp-Villon, *Marcel Duchamp*, exh. cat., Musée National d'Art Moderne, Paris 1967

David Reed, 'The Developing Language of the Readymades', *Art History*, vol.8, no.2, June 1985, pp.209–27

Theodore Reff, 'Duchamp & Leonardo: L.H.O.O.Q.-Alikes', *Art in America*, vol.65, no.1, Jan.–Feb. 1977, pp.82–93; 'Letters', *Art in America*, vol.65, no.3, May–June 1977, p.5;

'Letters', *Art in America*, vol.65, no.4, July–August 1977, p.5

Henri-Pierre Roché, *Victor (Marcel Duchamp): Roman*, Musée National d'Art Moderne, Centre Georges Pompidou, Paris 1977

Moira Roth and Jonathan Katz (eds.), *Difference/Indifference: Musings on Postmodernism, Marcel Duchamp and John Cage*, Amsterdam: G +B Arts International, 1998

Joel Rudinow, 'Duchamp's Mischief', *Critical Inquiry*, vol.7, no.4, Summer 1981, pp.747–60

Adelaide Russo, 'Marcel Duchamp and Robert Desnos: A Necessary and an Arbitrary Analogy', *Dada/Surrealism*, no.9, 1979, pp.115–23

Adelaide M. Russo, 'An Exchange of Tokens: Michel Leiris, Marcel Duchamp, and Jacques Derrida', Richard Fleming and Michael Payne (eds.), *Criticism, History, and Intertextuality*, London and Toronto, 1988, pp.77–97.

Irving Sandler, 'The Duchamp-Cage Aesthetic', *The New York School: The Painters and Sculptors of the Fifties*, New York 1978, pp.163–73

Winthrop Sargeant, 'Dada's Daddy,' *Life*, vol.23, no.17, 28 April 1952, pp.100–111

Naomi Sawelson-Gorse, 'On the Hot Seat: Mike Wallace Interviews Marcel Duchamp', *Art History*, vol.23, no.1, March 2000, pp.35–55

Henry M. Sayre, 'Ready-mades and Other Measures: The Poetics of Marcel Duchamp and William Carlos Williams', *Journal of Modern Literature*, vol.8, no.1, 1980, pp.3–22

Arturo Schwarz (ed.), *The Complete Works of Marcel Duchamp*, 2 vols, revised and expanded ed., London 1997

Arturo Schwarz and Francis Naumann, 'Letters. Dueling Duchampians: An Exchange', *Art in America*, vol.87, no.1, Jan. 1999, pp.25–31

Rhonda Roland Shearer, 'Marcel Duchamp's Impossible Bed and Other "Not" Readymade Objects: A Possible Route of Influence From Art to Science, Part I', *Art & Academe*, vol.10, no.1, 1997, pp.26–62

Thomas Singer, 'In the Manner of Duchamp, 1942–47: The Years of the "Mirrorical Return"', *The Art Bulletin*, vol.86, no.2, June 2004, pp.346–69

Jack J. Spector, 'Freud and Duchamp: The Mona Lisa "Exposed"', *Artforum*, vol.6, no.8, April 1968, pp.54–6

Lawrence D. Steefel, Jr, 'Marcel Duchamp's *Encore à Cet Astre*: A New Look', *Art Journal*, vol.36, no.1, Autumn 1976, pp.23–30

Lawrence D. Steefel, Jr, *The Position of Duchamp's Glass in the Development of his Art*, New York and London 1977

Charles Stuckey, 'Duchamp's Acephalic Symbolism', *Art in America*, vol.65,

no.1, Jan.–Feb. 1977, pp.94–9

Studio International, vol.189, no.973, Jan.–Feb. 1975, pp.19–60 ('Supplement: Marcel Duchamp')

Jean Suquet, *Miroir de la mariée. Essai*, Paris 1973

Jean Suquet, *Le Guérdon et la virgule*, Paris 1976

Dickran Tashjian, 'Marcel Duchamp and Man Ray', *Skyscraper Primitives: Dada and the American Avant-Garde, 1910–1925*, Middletown, Conn. 1975, pp.49–70

Calvin Tomkins, *The Bride and the Bachelors*, London 1965

Calvin Tomkins, *Duchamp: A Biography*, London 1998

Yoshiaki Tono, 'Duchamp i "inframince"'/'Duchamp and "Inframince"', *Marcel Duchamp*, exh. cat., Fundació Miró, Barcelona 1984, pp.53–6

Jonathan Wallis, 'Case Open and/or Unsolved: Marcel Duchamp and the Black Dahlla Murder,' *The Rutgers Art Review*, vol. 20, 2003, pp.7–23, reprinted as Wallis, 'Case Open and/or Unsolved: *Etant donnés*, the Black Dahlia Murder, and Marcel Duchamp's Life of Crime,' *tout-fait, The Marcel Duchamp Studies Online Journal* 2005

20th Century Art, from the Louise and Walter Arensberg Collection, exh. cat., Art Institute of Chicago 1949

View, Series V, no.1 ('Marcel Duchamp Number'), March 1945

Jeffrey Weiss, *The Popular Culture of Modern Art: Picasso, Duchamp, and Avant-Gardism*, New Haven and London 1994

Jeffrey Wieand, 'Duchamp and the Artworld', *Critical Inquiry*, vol.8, no.1, Autumn 1981, pp.151–7

Hellmut Wohl, 'Beyond the *Large Glass*: Notes on a Landscape Drawing by Marcel Duchamp', *Burlington Magazine*, vol.119, no.896, Nov. 1977, pp.763–772

Beatrice Wood, 'Marcel's Mischief, and Other Matters', *Architectural Digest*, vol.41, no.5, May 1984, pp.38–46

Beatrice Wood, *I Shock Myself: The Autobiography of Beatrice Wood*, San Francisco 1988

Jon Wood, 'Brancusi's "White Studio"', *Sculpture Journal*, vol.7, 2002, pp.108–20

Giovanna Zapperi, 'Marcel Duchamp's *Tonsure*: Towards an Alternate Masculinity,' *Oxford Art Journal*, vol. 30, no. 2, 2007, pp.289–303.

Copyright Credits

Photographic Credits

Index

Page numbers in **bold** type refer to main entries.